Images of Victorian Womanhood in English Art

Images of Victorian Womanhood in English Art

SUSAN P. CASTERAS

RUTHERFORD • MADISON • TEANECK
FAIRLEIGH DICKINSON UNIVERSITY PRESS
LONDON AND TORONTO: ASSOCIATED UNIVERSITY
PRESSES

© 1987 by Susan P. Casteras

Associated University Presses
440 Forsgate Drive
Cranbury, NJ 08512

Associated University Presses
25 Sicilian Avenue
London WC1A 2QH, England

Associated University Presses
2133 Royal Windsor Drive
Unit 1
Mississauga, Ontario
Canada L5J 1K5

Library of Congress Cataloging-in-Publication Data

Casteras, Susan P.
 Images of Victorian womanhood in English art.

 Bibliography: p.
 Includes index.
 1. Art, Victorian—England. 2. Art, English.
3. Women in art—England. 4. Feminine beauty
(Aesthetics)—England. I. Title.
N6767.5.V52C37 1987 760′.04424′0942 85-45933
ISBN 0-8386-3281-5 (alk. paper)

Printed in the United States of America

Dedicated to the memory
of my parents,
Pauline Troyanovich Casteras
and
John M. Casteras

Contents

Acknowledgments

First, I WANT TO EXPRESS MY GRATITUDE TO THE YALE CENter for British Art, where the idea for the original project, *The Substance or the Shadow: Images of Victorian Womanhood*, began and ultimately culminated in an exhibition in 1982. The Director, Duncan Robinson, and Constance Clement were gracious in allowing me to greatly expand and revise the text for this book and in permitting me to reproduce several works of art from the Collection. Other colleagues there—Malcolm Cormack, Joan Friedman, Patrick Noon, and Marilyn Hunt—were also very helpful. A special note of thanks is due Michael Marsland, whose photographic work was invaluable.

Various individuals kindly have allowed me to reproduce paintings in their collections, and I am especially grateful to Her Majesty the Queen for permission to include some works from the Royal Collection. I also thank Edmund J. and Suzanne McCormick, Christopher Forbes, Sir David Scott, Alec Yates, Christopher Wood, Raoul Millais, Harriet Waugh Dorment, and David Daniels for permitting me to illustrate works of art from their collections. I am indebted as well to Christie's and Sotheby's in London for their permission to reproduce photographs and their general assistance with my inquiries about specific objects. In addition, Margaret Kelly, Julian Hartnoll, Frederick D. Hill, Jeremy Maas, Sir Oliver Millar, and Christopher Wood were all helpful in the course of my research, and fellow Victorianists Rosamond Allwood, Hilarie Faberman, Simon Taylor, Malcolm Warner, Mary Bennett, Robin Hamlyn, and Catherine Gordon also deserve mention for their help.

Myriad museums granted me permission to reproduce works of art from their institutions, and I gratefully acknowledge the following museums and galleries: Ashmolean Museum; Birmingham Museums and Art Gallery and Museum; Bradford City Art Gallery; Bristol City Art Gallery; The British Museum; Dundee Art Galleries and Museums; Fitzwilliam Museum; The FORBES Magazine Collection; Geffrye Museum; Glasgow Museums & Art Galleries; Guildhall Art Gallery; Harris Art Gallery; Johannesburg Art Gallery; Lady Lever Art Gallery; Lincolnshire Museums, Usher Gallery; Manchester City Art Galleries; Memorial Art Gallery of the University of Rochester; Metropolitan Museum of Art; Minneapolis Institute of Arts; Museo de Arte de Ponce; National Gallery of Canada, Ottawa; National Galleries of Scotland; National Museum of Wales, Cardiff; National Portrait Gallery, London; Philadelphia Museum of Art; Pre-Raphaelite Inc.; Royal Academy of Arts; Royal Albert Memorial Museum and Art Gallery; Tate Gallery; Tyne and Wear County Council Museums, Laing Art Gallery; Victoria and Albert Museum; Wadsworth Atheneum; Walker Art Gallery, Liverpool; Yale Center for British Art; Yale University Art Gallery; and the York City Art Gallery.

On a personal note, I owe a great deal to my husband, Eric Schnapper, for his patience throughout this project, and also to John Paul Schnapper-Casteras for his similarly good-natured forbearance.

Introduction

In the past decade the revival of interest in Victorian history has inspired numerous books specifically focusing on the female of this period. This new scholarship attempts both to rediscover and to reinterpret the experiences of Victorian women, and among these new publications are Lee Holcombe's *Wives and Property: The Reform of the Married Women's Property Law in Nineteenth-Century England*, Patricia Branca's *Silent Sisterhood: Middle Class Women in the Victorian Home*, Nina Auerbach's *Women and the Demon: The Life of a Victorian Myth*, and others. Some of these studies restate known elements of the Victorian woman by offering new evidence, while others destroy certain assumptions by scrutinizing facts in a new light. Another approach that synthesizes primary material of the real lives and thoughts of individual females is represented by Phyllis Rose's *Parallel Lives: Five Victorian Marriages*, Janet Murray's *Strong-Minded Woman and other Lost Voices from Nineteenth-century England*, and *Victorian Women: A Documentary Account of Women's Lives in Nineteenth-Century England, France, and the United States*, edited by Erna Olafson Hellerstein, Leslie Parker Hume, and Karen M. Offen. Still another direction is established by Jeffrey Weeks in *Sex, Politics and Society: The Regulation of Sexuality since 1800* and Peter Gay in *The Bourgeois Experience: Victoria to Freud*, authors who explore the truths or untruths of middle-class sexuality in divergent ways. My book markedly differs from such inquiries, however, for it attempts not to examine the history of the period per se, but rather the pictorial imagery that it constructed and reflected. The years of Victoria's reign (1837–1901)

were, of course, not a static phenomenon, and the very definitions of what constituted eroticism and impropriety changed accordingly. With this in mind an exploration is undertaken of how the Victorians at times amplified reigning stereotypes of femininity and managed to blend fine art with social history in a unique mixture. Victorian artists occasionally invented their own mythology and iconology, forging indelible images, poses, and locations for such characters as the courting couple, the sempstress, and the wayward woman.

This book is essentially based on research and a text I produced for a catalogue (and exhibition) entitled "The Substance or the Shadow: Images of Victorian Womanhood" for The Yale Center for British Art in 1982, but the contents have been greatly expanded and revised in many respects. Nonetheless, the title "the substance or the shadow" is still apt and owes its derivation to lines from Alfred, Lord Tennyson's poem "The Princess," first published in 1846. That poem treated the theme of ideal womanhood, shaping the action at the beginning and end with modern speakers and setting, and also posed a question that preoccupied the Victorians—namely, the nature of woman's quintessential capacities and duties. Tennyson postulated two extremes of attitude to consider—the one archreactionary ("Man for the field and woman for the hearth, . . . Man to command, and woman to obey") and the other the revolutionary feminism of the princess. Balanced between these two poles were the more moderate sentiments of the prince who pursued the "modern princess." Indeed, the concept of a quest to resolve

these polarities is the basis of this book, for the extremes of femininity—whether of class, morality, opportunity, temperament, or otherwise—obsessed Victorian artists and their literary brethren. As a result, this book investigates both the substantive and the insubstantial roles ascribed to women between about 1840 and 1900 in the realm of art, alluding both to the fiction created by painters and to relevant historical facts about a particular situation or class of woman. Sometimes, for example, the fictional ideal of womanhood seemed more popular and insistent than its real life counterpart, yet at other times the converse was true. Polarities of circumstance—poor and rich, virtuous and erring, weak and strong, idle and industrious—thus help to define the content of this investigation and are invoked when applicable.

Following introductory comments on the queen and some historical perspectives on the status of the females she ruled, the general organization of the book—with some necessary digressions—patterns itself partly after the salient stages of woman's life: from girlhood and education to leisure, courtship and marriage, old age and widowhood, and possible adversities. Interspersed with these concepts are those of the woman as worker—from the charitable efforts of middle-class ladies, to the creative female, to the women from the lower classes who toiled out of necessity in fields, factories, kitchens, classrooms, and garret chambers. Framing these ideas is the overriding female personality of the period, that of Queen Victoria, whose august presence (along with many more definitive factors) left an imprint on taste and mores during the years of her reign, 1837–1901. The main portions of the book study images of contemporary womanhood. Although there is more of an emphasis on the middle-class female, due to her greater popularity in art (among both painters and their largely middle-class audience), the women of other economic classes—laborers in factories and fields, for example—are also included. The entire spectrum of womanhood from ultimate virginity (as represented by the modern madonna or the nun) to the final degradation (as represented by the modern magdalen or prostitute) is thus examined. A woman of any social class could lose her honor through indiscretion, and a middle-class female's possible fall from grace is considered with some examples of the mistress and the adulteress, along with those of the female who went astray in the city. While prostitutes were at one end of the scale the representative of deviant

behavior, other shadowy sides of the female of the period are also explored. In this category are not only the defiant New Woman in her various forms (intellectual, aesthetic, and athletic), but also the femme fatale and the larger-than-life goddess that began to appear with greater frequency in Victorian art, especially after the 1870s.

For the sake of clarity and convenience, in order to impose some order on the material, this book utilizes numerous categories of femininity for each chapter, but it must be pointed out, of course, that many women embraced several of these hypothetical stages or classifications simultaneously. For example, a female in real life could be a bluestocking intellectual at the same time she was a wife, a fashionable aesthete, an ornamental lady of leisure, or even a New Woman in principle. Furthermore, many of these types of womanhood coexisted literally side by side, with radical daughters presiding in the family drawing room along with more dovelike ones. However, it must also be noted that some classifications—like the femme fatale or personified abstractions of women—were more prevalent at certain periods, in this case during the last quarter of the century. And as will be shown, certain prescriptive pictorial models—for example, the waiting woman in courtship, the dutiful wife in her self-enclosed "prison" of domesticity, and even the sempstress and the harlot—reigned throughout the Victorian era with varying degrees of longevity and constancy.

Narrative painting itself altered its course somewhat during Victoria's reign, and this is worth noting at the outset. Social themes first surfaced in the late 1830s and especially the 1840s, particularly with Richard Redgrave's pictorial inventions, and gradually genre painting replaced history pictures both in sheer numbers and popularity. Victorian viewers no longer favored the grander themes of eighteenth-century neoclassicism and romanticism; instead they demanded a more literary art as well as a more bourgeois subject matter, arguably more earthbound and domestic than was generally true of the previous century. Accordingly, the *Art-Union* in 1840 discussed the decline of history painting and the concomitant rise of genre pictures in the early years of Victoria's reign, for it was by then already apparent "that a preference for subject pictures is springing up, and has, indeed, rapidly increased . . . and the effect of attracting the public attention, already predisposed to the influence, has acted most beneficially upon the artists themselves. . . . Where the public now

takes an interest it will eventually extend its patronage." Regarding the key question of subject, the author continued that "but little interest is now excited by subjects taken from fabulous, heroic, or even accredited history of very ancient times. The day is gone by when the sympathies could be awakened for personages only known to scholars. . . . Fine drawing, skillful arrangement, appropriate character and expression, will always please, and will draw commendation from critics; but the great secret of success is to be found in another direction. Sympathy must be gained—sensibility must be excited—and the observer be made to identify himself with the subject, which can hardly be expected, when he is called upon to weep with Hecuba, or to rage with Achilles."[2] This was not an invitation, however, for artists to succumb to common or vulgar subjects, but rather to choose themes of affecting interest or didactic aims and to remember that "the object of art is not to gratify the taste of tinkers and cobblers; but there are minds in various states of advancement, and by attracting the attention of that class which may be uneducated and perhaps even coarse and vulgar, they may be improved, and, by degrees, acquire a relish for that which is beyond the usual range of their observation and preference."[3]

Out of such circumstances was born a focus on modern life and subjects which had appeal to all classes of viewers. The acceptability of certain themes was debated for years, with a writer in *Blackwood's* complaining in 1848 that modern life had "so many terrors, and horrors, too" that these effects ought to be moderated by "pleasant domestic scenes that . . . should gently move our love and pity." The escapist tendencies of art were therefore encouraged, for as this writer continued, it was a great mistake for an artist to "make of 'familiar life' as it is called, doleful, uncheerful, subjects, that are out of the role of love and pity. . . . I would have all such subjects prohibited by Act of Parliament . . . and fine the offending artists. Is the man of business, in this weary turmoil of the daily world, to return to his house, after his labour is over . . . and see upon his walls nothing but scenes of distress, of poverty, of misery, of hardheartedness—when he should indulge his sight and his mind with every thing that would tend to refresh his worn spirits, avert painful fears, either for himself or others, and should turn himself, by visible objects of rational hilarity, into the full and free harmonies of a vigorous courage and health of social nature?"[4] In spite of such com-

ments, however, "uncheerful" subjects were common on Royal Academy walls, if only because these "low" subjects were created with a moral aim to incite pathos and thereby instruct and uplift the audience. Those who attended these exhibitions were largely middle-class or above, for the entrance fee was a shilling, but engravings of these works of art appeared in popular periodicals and thus circulated often quite freely within all echelons of society and the viewing public. Although the writer in *Blackwood's* mentioned the importance of a national art that could soothe a man's spirit when he returned home after a day of tribulations in the outside world, it was often the female and her delicate sensibilities which were used as a test of a subject's suitability: was it too base, monstrous, or crude for her genteel and innocent gaze? For example, William Mulready's depiction of a widow seduced was deemed unfit for visual representation, for it supposedly did not provide a wholesome and instructive lesson.

The motivation for such loaded-with-detail paintings remained strong for much of the Victorian era, with the zenith of the popularity of narrative pictures occurring between the late 1840s and into the 1860s. The 1850s witnessed an expanding interest in modern-life subjects (with many more depictions of courtship and fallen women, for example), with a shift in the 1870s (along with an economic depression in England) to less anecdotal and more sober and earnest attempts at social realism by artists such as Frank Holl, Hubert von Herkomer, Luke Fildes, and others. By the 1880s and 1890s, however, a pluralism of styles and approaches ruled (and there were also more societies and galleries to challenge the primacy of the Royal Academy). Thus, neo-classicizing canvases coexisted with Newlyn School experiments, and heroic immortal females appeared simultaneously with domestic types.

Throughout the entire period it was more often in the realms of periodicals like *Punch* that women received more "realistic" treatment, for in spite of its satirical undertones, *Punch* at least humanized them as fallible beings and not paradigms of perfection. Interestingly, often *Punch* or a similar journal either anticipated a modern subject—as with the treatment of the needlewoman or the theme of emigration—or gave it a more scathing and acerbic examination in its cartoons (as with its lampooning of the Victorian lady or servant, for example). In many chapters of this book such cartoons are included to offer a representative balance to the typ-

ically idealized vision forged by painters. Parallel emphasis on such subjects was often similarly anticipated by literature of the period, especially novels or a poem such as Thomas Hood's "The Bridge of Sighs," and sometimes in the course of the text a few pertinent examples are cited. Both the literary themes and the realm of cartoon are worthy of separate investigation, but like the historical background provided and the comments on fantasies in the conclusion, references are necessarily kept to a minimum for the sake of simplicity as well as of space.

Of the modern-life subjects and genre pictures that proliferated in mounting numbers from midcentury until about 1900, among the most prolific were those concerning women. Feminine themes bordered on a cultural fixation, and the resulting imagery ranged vastly in quality from hopelessly insipid potboilers to undeniable masterpieces. Why the female became such a central image in art of this period, however, is a complicated question. One obvious answer lies in the conventional appeal of the "lovely lady" on canvas. Another concerns the individual obsession with the theme, for surely Dante Gabriel Rossetti's motives were different from Richard Redgrave's, although both participated in the epidemic "attachment" to feminine subject matter. The public attitude toward what constituted suitable subject matter also defined the destinies of art and artists throughout the Victorian era. In midcentury, for example, both Redgrave and Holman Hunt had been criticized for their sometimes startling and morbid themes, which were perceived as vulgar because they presented galvanizing or "unvarnished" truths. Even though *The Sempstress* and *The Awakening Conscience* were contrived artistic visions and not really social realism, these canvases were viewed as not eliciting pathos or as failing to be instructive or enlightening in the prescribed manner. The Victorians staunchly believed in the power of beauty—particularly female pulchritude—to elevate morality, but this tenet was not meant to be distorted or tested by outweighing the beautiful with the sordid, as some of the subjects clearly did. By the 1880s standards had changed somewhat to allow for the paean to beauty which the Aesthetic Movement had engendered, so that not much notice was given by critics to the dramatic shift which had occurred in the transition to Rossettian femmes fatales or Leighton's imposing goddesses.

There were thus multiple tensions, fomenting changes in politics, attitudes, and sexuality, and other ambiguities in terms of the perception of women throughout the Victorian era. As colleagues such as Lynn Nead in England now maintain, for example, the answer to why this fixation with feminine imagery was such a central discourse in Victorian art resides not in a chain of overlapping influences or iconographic traditions, but is instead embedded in complex layers of historical "constructs," deeper forces beyond repression or sublimation that affected both the artist and the audience. I have tried to take these shaping forces into consideration when writing about the art by offering information about contemporary laws, religion, literary preferences, critical reactions, and the like, but the reader is also urged to consult the extensive bibliography for additional directions of inquiry.

The wide scope of Victorian taste encompassing the depiction of women in art of the period is reflected as much as possible in my selection of examples included in this book, for not every painting reproduced is now considered to be of the highest caliber, however much revered in its own heyday. Some names and canvases will be familiar to Victorian scholars, while others are more obscure. In many cases the paintings were exhibited in the mainstream of public taste at the Royal Academy, a fact which enables the researcher to offer contemporary reaction and the reader to contrast his own response with earlier viewpoints. Whenever possible or pertinent, original accounts or reviews are cited to underscore the now-lost legibility or impact of a subject, as when the language of the flowers needs to be translated for modern viewers. However, in other cases a meaning may seem more obvious to twentieth-century spectators than to their Victorian forebears, for a particular motif (like the courting wall) gained meaning by sheer repetition and accretion over time before creating its own peculiar iconology or vocabulary of form and meaning. The circumstantial evidence and details of action and incident are revealed in varying ways and degrees, but the predominant style, as will be obvious, is a highly meticulous form of realism that transformed a painting into a novelette of pseudoliterature, a scenario that, then as now, invites informed viewers to probe and ultimately invent an accompanying story. Thus, as a writer for the *Art-Journal* in 1863 reaffirmed, the execution of such works in this virtual anthology of domestic ideologies had to be "clean and sharp, and the more sparkling the better; also, the grammar of the art should be of close

and literal construction, for inasmuch as the thoughts expressed are often even trivial, the success of the work will greatly depend on the felicity of the wording."[5] In this regard as well the Victorians have another impact on my text, for I often try to describe and analyze pictures in language that is deliberately *retardataire* or fulsome in order to evoke the nineteenth-century mode of exegesis. I have also chosen to analyze some paintings or strands of imagery (for example, the sempstress and other laborers, the adulteress, the New Woman, and the feminine aesthete), which while statistically rather rare in Victorian art, nonetheless convey ideas or offer an interesting counterpoint to the rest of the visual material. Twentieth-century viewers and authors undoubtedly have their own prejudices and preferences in subject matter, but I have tried to interrelate all the images in a logical way both from chapter to chapter and in the concluding remarks. The subject of the nude is deliberately absent, for it is a major area that demands separate inquiry, and the complex issues it raises are partly explored, for example, in the perceptive writing of Linda Nochlin (in *Woman as Sex Object:*

Studies in Erotic Art 1730–1970) and in Lynn Nead's 1983 review entitled "Representation, Sexuality, and the Female Nude."

To twentieth-century eyes the pictorial preoccupation that unfolds in the ensuing chapters constitutes a feminization of imagery that often went hand in hand with strong doses of sentimentality. In this respect, most of the examples in this book (excepting those mentioned in the concluding chapter) uphold the tenets of narrative art reasserted by the *Art Journal* in 1863: Not only did the critic salute the universality of emotions elicited by this vein of Victorian art, but he also elucidated the core of its appeal, one which still validly applies for modern readers and spectators:

> The public at large naturally bring such compositions to the test of their own experience and they are right in doing so. The more, for works of this class are successful as they awaken a dormant sympathy, just in the measure of the response they find within the breast of each one of us, beating to the same pulse of life. The life, indeed, which moves around us and within us is the same life which should live again within these pictorial transcripts.[6]

Images of Victorian Womanhood in English Art

1

Her Majesty the Queen

THE AGE OF THE WOMAN, WITH ALL ITS ATTENDANT IRON-ies, was ushered in when the eighteen-year old Princess Victoria ascended the throne and was made ruler of England in 1837. During her long reign many changes were precipitated which transformed the world which she and her subjects knew; at the outset of her rule, married women had few legal rights, but by 1901 the status of women, like the world they inhabited, had significantly altered. The modern world of 1901 was one of electric lights, typewriters, cars, telephones, submarines, and other technological advances; similarly, the modern woman symbolized a quantum leap over her predecessor—for she could finally own property, attend college, retain her own earnings, and fill certain important public posts, for example. (She would not gain the vote, however, in Great Britain until 1928, after considerable bloody struggle by the suffragettes.)[1] The end of the century and of Victoria's sovereignty was a prelude to the revolt of Mrs. Pankhurst and her ardent cohorts from about 1905 onward, but the seeds of feminine dissent—despite Queen Victoria's basic conservatism—had certainly been sown throughout the 1800s.

As might be expected, the personality of the queen often predictably dominated her sixty-four years in the public eye, but it would be an oversimplification to assert that her image dominated history totally. In fact, modern historians have commented that Victoria herself was in many crucial ways not a Victorian; nor was she, like Freud, responsible for the myths associated with her name or the load of meaning still signified by the usually pejorative term "Victorian."[2] Certain political and other changes had occurred even in the Regency period before her ascension, and she was heir to these as well as the creator of other new social realities during her long period of influence in Britain. One by-product of this was her effect on literature of the period, and it has been suggested that "As over the years the Queen developed into an ample matron, she created many images—all of them reflected in the novels as well as in the lifestyles of her subjects—devoted and submissive wife, loving mother, grieving widow, dominant matriarch, ruling empress. But her image was reflective rather than formative. The novel that developed in her reign owed nothing to her active influence but much to the social and moral development of the early nineteenth century that influenced and molded her as they did all her subjects."[3]

These multiple images accrued over a lifetime and were also mirrored in artists' depictions of her. Queen Victoria was "probably the most painted and photographed personality in history"[4] at this time, and her longevity, coupled with the growth of illustrated newspapers and magazines, resulted in a continuous flood of popular images in addition to scores of state and family portraits. It was upon her shoulders that not only the destiny of the British Empire rested, but also the onerous weight of serving as a role model for her female subjects.

Unlike the other women discussed in this book, Victoria, however, was a flesh-and-blood individual and not a fictional fabrication, yet in some respects she was forced to function as both real and fantasy, woman and national symbol. The burdens of such roleplaying must have been considerable, and undoubtedly Victoria was at times cast into stereotypes—of the tight-lipped authoritarian or the gloomy widow—which may have been exaggerated or unduly prolonged. In this respect she fell victim to the hyperbole used by artists or journalists, just as modern political figures are subjected to endless and often simplistic psychoanalyzing or are cast into unsympathetic and inaccurate characterizations.

In the realm of art the sting of such scrutiny was less abrasive in general. Painters such as Henry Selous, Jerry Barrett, William Powell Frith, Thomas Barker, Francis Grant, E. T. Parris, and others tended to idealize their monarch, showing her in official contexts as head of the nation, as the epitome of nobility and dignity as she visited soldiers wounded in the Crimea, as the liaison with foreign leaders, or as she presided at royal functions or reviewed the troops. Victoria had little real control, of course, over the commercialization or fabrication of these images or stereotypes, for then as now it was necessary for a renowned public figure to maintain a "public face" in order to survive life in a royal fishbowl. Nonetheless, in art in particular her image was steeped in dedication to country and family, respect for hard work, and respectability, and relatively few negative paintings exist of her.[5]

Early portraits of the youthful, even adolescent, queen often cast her more in the role of a demure and pretty female instead of a powerful monarch, and the sitter's rather sharp features were generally softened into a type somewhat reminiscent of *Keepsake* standards of daintiness and pulchritude. Biographers have remarked that in Victoria's youth, there was rather little of the dourness that marked her character in later years. Never a great beauty, she was nonetheless often described as lively in spirit and in mind as a girl, decidedly playful and not particularly prudish. Some of these qualities are apparent in Francis X. Winterhalter's 1843 portrait (Fig. 1), in which the subject's brown hair tumbles onto creamy shoulders that are partly bared by a low neckline and highlighted by a golden necklace. There is an almost sensuous, coquettish air to this female, who looks more like a peasant girl with a lover's locket around her neck than the queen of England. Perhaps this is why she

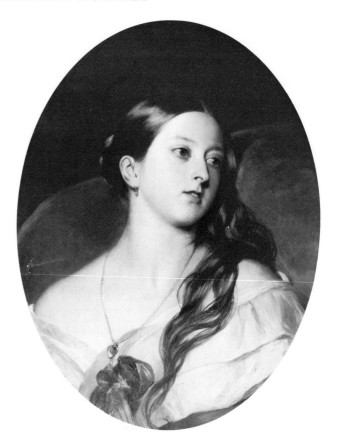

Fig. 1. Franz X. Winterhalter. *Queen Victoria.* 1843. Oil on canvas, 25⅜ × 21. Collection of Her Majesty the Queen.

is shown looking away, for it is a private and vulnerable image of pleasurable reverie that is captured, not an official representation of a clear-eyed, clear-headed monarch. Although she was at the time of this portrait a married woman, Winterhalter has depicted her as a dreamy-eyed maiden, perhaps with intimations of the younger princess who had—in spite of her independence and self-assurance—previously been infatuated with her mentor and paternal friend, Lord Melbourne. With him she would banter and even flirt, just as this image of her at age twenty-four suggests.

But this surprisingly intimate and casual side of the monarch was the exception. George Hayter's famous portrait of 1838 (Fig. 2) emphasizes the obviously formal side of his famous sitter. For her coronation in June 1838 in Westminster Abbey, Victoria was attired in a magnificent crimson velvet robe lined with ermine and crowned with a diamond circlet. The solemn ritual that ensued included eight trainbearers, a tumult of flags and gun salutes, and a church setting said to be ablaze with

peeresses clad in dazzling jewelry. While one observer said that the adolescent Victoria entered the abbey in a gay mood, "like a girl on her birthday," she was soon chastened by the huge crowds and the splendid decorations.[6] Other onlookers sensed her trembling and girlish presence, yet as one modern historian has noted, "The congregation . . . was deeply moved by the poignant dignity of the child-like figure in the centre of the great nave, surrounded by a cloud of silver and white trainbearers like the vapours of dawn. . . . More than one onlooker felt that there was something pathetic in this flower-like face, scarcely emerged from childhood, belonging to so great a personage."[7] Such reactions reinforce the impression made by Hayter's image, in which Victoria does look like a slim and somewhat childlike creature overwhelmed by the regalia of state robes and pomp. Her features

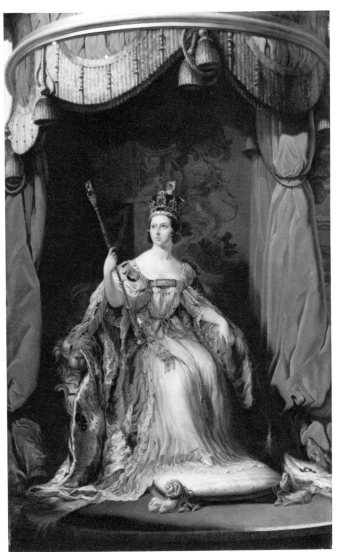

Fig. 2. George Hayter. *Queen Victoria.* 1863, after an 1838 portrait. Oil on canvas, 112½ × 70½. National Portrait Gallery, London.

have been tempered so that Victoria seems to resemble a typical *Keepsake* maiden with her rather bland features and expression, yet this may also be the facade of combined fear and youthfulness. Yet she is not a mere innocent child, for Hayter has represented the newly crowned queen with her scepter of power; he thus makes her a literally enthroned symbol of regal authority for England and does not emphasize her femininity except for a rather subtle inclusion of a symbolic rose that lies at her feet.

Prior to the death of the prince consort in 1861, artists such as Francis Winterhalter and Edwin Landseer enjoyed the status of being among Victoria's most esteemed court painters and portrayed her on horseback, at home, and on official business. Landseer's *Windsor Castle in Modern Times* (Fig. 3) of 1841–45 is a celebrated icon of the queen's life "at home" and underscores her personal belief that her success as a monarch depended upon her ability to inspire morality and harmony both at court and with her other subjects. Historians have attributed a certain alteration in her temperament following her marriage in 1840 to her German cousin, a rather sober-sided and even priggish man to whom she was nonetheless hopelessly devoted. Although she did not totally adopt all of her spouse's beliefs (for example, she gave him as a present a drawing of a male nude by William Mulready which she had admired), her views and behavior were undoubtedly modified by his influence. She was eager to decry "this mad, wicked folly of 'Women's Rights' with all its attendant horrors, on which the poor feeble sex is bent, forgetting every sense of womanly feeling and propriety,"[8] yet she also privately bemoaned the difficulties of a female's life, including the hardships of pregnancies. Yet in *Windsor Castle in Modern Times* the myth of domesticity betrays no sign of insincerity, and such a picture—without meaning to be propagandistic—would undoubtedly have conveyed an explicit message to viewers. A handsomely dressed, rather dewy-eyed Victoria in an evening gown is shown entering the drawing room at Windsor to welcome back her husband from a hunting expedition. Without further identification of the principals, this work might well be another genre paean to the cult of wifeliness. Although in their courtship Victoria at times had to play an assertive role (for example, it was she who proposed to Albert), here she is the submissive and docile woman and he is, ironically, the master of this castle, so to speak. This scene ostensibly cap-

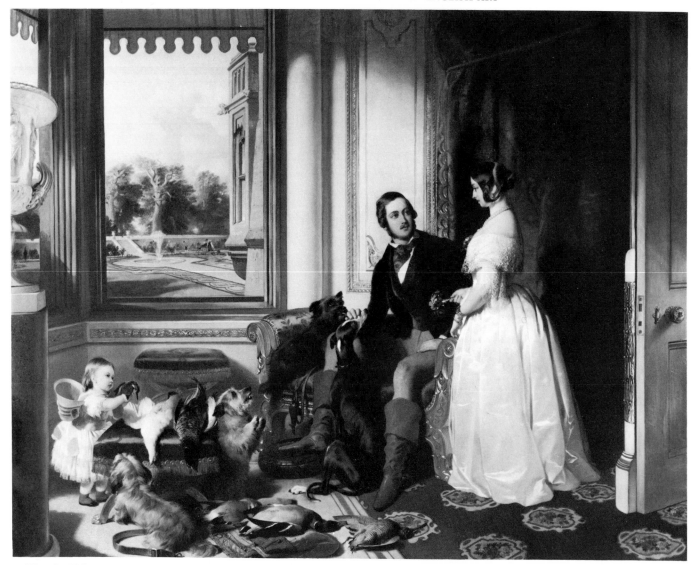

Fig. 3. Edwin Landseer. *Windsor Castle in Modern Times*. 1841–45. Oil on canvas, 44⅝ × 56⅞. Collection of Her Majesty the Queen.

tures a private moment made public—for the chambers are the private household ones of the royal family and the prince consort, seated in his hunting costume, does not even rise in the presence of his wife and monarch. His own activities are identified with the traditionally masculine, outdoor ones, while Victoria—who demurely holds a nosegay and attentively listens to her husband's words—represents the more classic feminine virtues and values. Their eldest child, the baby Victoria, plays with the specimens of the day's sport as the family's favorite dogs cavort nearby; even she takes interest in her father's activities and suspends her play to "pay homage" to his prowess. In their own safe haven from outside responsibilities, this husband and wife enjoy a relaxed and simple domesticity, yet they also gaze at one another directly

and with obvious affection and admiration, their mutual ardor being rather rare to see even in Victorian depictions of ordinary couples in a state of "connubial bliss." The continuing romantic note of their relationship may be alluded to by the nosegays Victoria carries and has pinned on her dress, more the signs of courtship than of marriage. The queen's love for Albert amounted almost to hero worship, and here the artist telescopes the passionate side of her youth with her wifely submissiveness. No doubt the total effect of these details made the queen prize this painting, for she described it as "very cheerful and pleasing."[9] Subsequent decades of widowhood and isolation made her cherish and monumentalize all the more such golden memories of the past with her beloved prince consort.

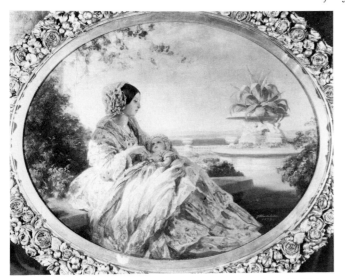

Fig. 4. Franz X. Winterhalter. *Queen Victoria with Prince Arthur.* 1850. Oil on canvas, 23¾ × 29⅝. Collection of Her Majesty the Queen.

The wholesomeness and "normality" of Victoria's behavior were echoed in numerous depictions emphasizing her role as a devoted mother. This is the implicit message in Winterhalter's 1850 *Queen Victoria with Prince Arthur* (Fig. 4). As with Landseer's *Windsor Castle,* except for the elaborate clothing and the identity of the sitter, this could be a portrait of almost any middle-class Victorian mother with her baby. The monarch alone—without benefit of nursemaids—interacts with her infant, nurturing and fondling it with intense "womanly" or maternal self-absorption. She is informally posed—not on a throne, but on the edge of a lovely garden wall (the latter site replete with connotations of the garden of love and romance); as such, this picture forges an icon of motherhood and its pleasures even to the monarch, who abjures both duties of state and frivolous activities in order to take care of her child. Nearby groupings of flowers and fruits seem to underscore the queen's fecundity as well as perhaps the abundant productivity of her reign, and these messages would not have been lost to Victorian viewers. In addition, the oval shape of the canvas recalls Renaissance *tondos* of holy mother and child, again reinforcing the sacred mission of motherhood that the Victorians venerated and saw their monarch personify for them—in private life and in art. Yet ultimately, this portrait seems more an intimate glimpse of Victoria's nonpublic life than a "state announcement" of her feminine duty to country and family. But it must be remembered, as a twentieth-century biographer of Victoria has pointed out, that among the

six queens in British history, for example, "Mary Tudor's efforts at child-bearing were fruitless, and Queen Anne was cursed with an inability to produce children that survived. Only Victoria had to combine in effect the needs of the nursery with the cares of office."[10] In this regard she perhaps qualified as the antecedent of the modern career woman, who strives to be conscientious and successful in "dovetailing the role of devoted wife and mother with that of chief consultant to a large international concern."[11]

The propaganda, if that word is carefully used, of domesticity and patient service and mother and wife is infused with a more melodramatic tone in John Calcott Horsley's *A Portrait Group of Queen Victoria with Her Children* (Fig. 5), a smaller version of a painting exhibited in 1865. Victoria's features (at this point in her life she was noticeably dumpy and already rather jowly) have been mellowed into Keepsake comeliness, and she stands in ceremonial garb and jewels amid a cluster of seven of

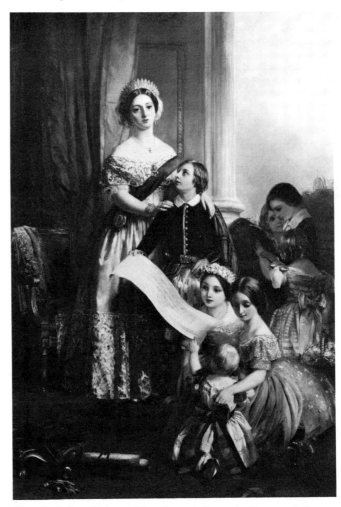

Fig. 5. John Calcott Horsley. *A Portrait Group of Queen Victoria with Her Children.* Ca. 1865. Oil on canvas, 47 × 35. The FORBES Magazine Collection, New York.

her nine children. The Prince of Wales, the future King Edward VII, stands in his tartan attire at his mother's side as her helpmate (although in later life, the two would not get along). He seems to share her unspoken grief at the death of Prince Albert in 1861. "Bertie" examines with her the blueprint plans that are inscribed "DESIGN FOR THE BUILDING FOR THE PROPOSED INTERNATIONAL EXHIBITION," the Crystal Palace extravaganza which was also called "the crystal house that Albert built." Another allusion to this project is the distinctive architecture of this edifice in the background right, for the Crystal Palace was demolished after the 1851 exhibition and re-erected more magnificently in Sydenham, near London. The Prince Consort had been President of the Royal Commission for this undertaking and had personally lobbied to make the exhibition truly international in scope. As one modern historian has suggested, "It was the Exhibition of 1851 which, above any other achievement in his life, merited the Prince the right to stand in his high place on the Albert Memorial. It was in Hyde Park that, to the minds of millions, a transfiguration took place, switching an obscure German princeling into a national figure and a leader in the spheres of industry, art, and science."[12] Ironically, his labors on behalf of this project created health problems that contributed to his early death. The Queen reveled in the success of this endeavor and here is shown as a resigned but proud widow maintaining all the memories of her spouse. (In fact, there may be a deliberate allusion to Winterhalter's earlier work entitled *First of May, 1851,* in which the Queen is shown at a symbolic moment before The Great Exhibition opened with Albert at her right and the Crystal Palace in the distance.) Here the pile of books and papers at the lower left alludes to the prince consort, as does the empty chair at the monarch's right, presumably once occupied by him. The void created by his conspicuous absence at left is counterbalanced on the right by the presence of the Prince of Wales and all the other children who formed his human legacy. Bolstered by their company and by his past accomplishments, this is an image of Victoria more as surrogate head of the household than as the invincible head of state.

By contrast, ultimately a less personal and more official (even officious) side of the monarchy is conveyed in T. Jones Barker's ca. 1861 *Queen Victoria Presenting a Bible in the Audience Chamber at Windsor* (Fig. 6). With Prince Albert—her confidant in state issues as well as family ones—at her side

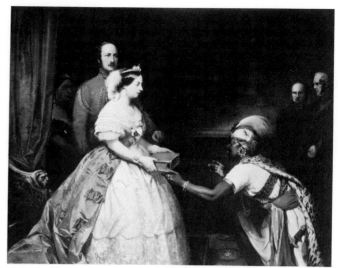

Fig. 6. Thomas J. Barker. *Queen Victoria Presenting a Bible in the Audience Chamber at Windsor.* Ca. 1861. Oil on canvas, 66 × 84⅛. National Portrait Gallery, London.

(but not for much longer, since he died that year), she bestows a Holy Book to the crouching "person of color" (as the Victorians might have termed him). Here she represents the civilizing force of England and the enlightenment of Western religion, and as head of state she also implicitly represents the Church of England and its doctrines. Of course, to modern spectators there seems to be more than a hint of racism and chauvinism in such an image, the white race assuming its culture is superior and therefore condescending to bring knowledge and progress to more "primitive" societies. Yet Victorian viewers would generally not have interpreted the vignette in this manner, preferring to see Victoria as the giver of life, knowledge, and pride in the heritage of England to religious and ideological "converts." Even so, there seems to be some psychic tension communicated in the picture, both in the rather sour expressions of the onlookers (especially Lord Palmerston and Lord John Russell at right) and in the literal and psychological distance between the queen and the native potentate from Africa in his exotic and alien attire. While this foreign "prince of darkness" is represented in a leopard skin and with a dagger—symbols of danger and violence—the ruler of the British Empire is adorned with the jewels of "civilization." The uncertain look on the faces of the two principals suggests that the obeisance being observed is a source of general uneasiness.

Queen Victoria propagated both publicly and in her personal life an image of the long-suffering, bereft widow well past the period of mourning that

society mandated, and she wore "widow's weeds" or black attire essentially for the rest of her life. Her excessive and maudlin mourning habits made her a virtual recluse, and her public images and popularity also suffered. As a result of these factors, later representations of the queen (both paintings and photographs) often realistically depicted her as imperious and stubborn, her sad and stony resolution bordering on lugubriousness. In spite of her increasing old age and isolation, however, Victoria enjoyed renewed popularity following her golden jubilee in 1887, an occurrence which helped restore her waning stature among the people. The apogee of her diverse roles and achievements is preserved in Laurits Tuxen's monumental *The Royal Family at the Time of the Jubilee* (Fig. 7). While a certain divisiveness can be inferred from T. J. Barker's icon of Victorian sovereignty over all the lands it had conquered and attempted to subdue and "civilize," quite a contrasting—and unifying—tone is as-

serted here. In this huge conversation piece—a multiplication many times over of Landseer's vignette at Windsor Castle—the queen is posited in a nearly central place and pictorially and otherwise plays the role of the matriarch of (most of) the kings and princes of Europe. She was at that time the oldest monarch as well, and the fruits of her reign are evidenced by the scores of grandchildren and great-grandchildren who extend her lineage. The connections from Prince Albert's and her own German ancestry with European nobility had been strengthened by the marriages of their children and their offspring, resulting in an amplification of Victoria's own power and progeny. This commemoration of the golden jubilee is actually a panoramic family gathering, with fifty-four members of the royal family surrounding the monarch, including the Prince and Princess of Wales, the crown princes of Germany, Prince William of Prussia, the duke and duchess of Edinburgh, and the duke and

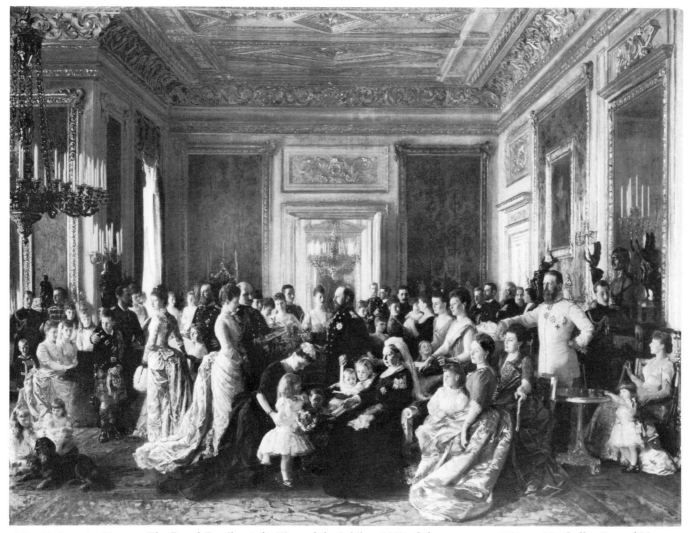

Fig. 7. Laurits Tuxen. *The Royal Family at the Time of the Jubilee.* 1887. Oil on canvas, 65¼ × 89. Collection of Her Majesty the Queen.

duchess of Connaught. The domestic, dedicated queen as mother seen in earlier examples here is transformed into the imperial grandmother, both of the empire at large and her own vast brood. Her "satellites" of influence and blood encircle her in a sprawling but orderly way, and among the dozens of women present there are some young mothers who are seen interacting with their children and therefore repeating the cycle of teaching and nurturing that Victoria herself personified and still symbolizes here as "materfamilias" of Europe.

In real life, the queen probably served as a stabilizing force in the Victorian era, her very stolid and unshakable presence and beliefs inspiring a certain faith in the status quo. Whether or not it was influenced by her deportment or by her conservative attitudes toward feminine rights and obligations, Victorian genre painting that flourished from 1837–1901 was, in general—as was the novel of the same period—characterized largely by its middle-class content and its emphasis on bourgeois themes. The affluent and aspiring women in the queen's shadow were the constant focus of artistic attention (this was less true of their lower-class sisters to a certain extent), and indeed it was the permutations of their "stages of life," not those of royal personages, which comprised a major percentage of the art that appeared annually at the Royal Academy.

2
The Rights and Duties of Englishwomen

ALTHOUGH QUEEN VICTORIA AS THE MONARCH OF THE land in its highest office was empowered or vested with full and equal rights, other females did not fare as well under English common law. In 1837 the rights and duties of Englishwomen were notably limited in many respects, the dividing line being whether or not a woman was married. A woman until betrothal had total control over the property she owned. The feme sole could enter into legal contracts and could sue or be sued; moreover, the personal liberties of the single female were also untrammeled.[1] Given such conditions, it is not surprising that in literature and in real life young women often had to weigh carefully the choice of a proper suitor and to ascertain his character and habits to avoid being duped or having her property usurped by a fortune hunter or a cad.

The liberties of a single woman largely ceased after engagement and decidedly after marriage. A married female was generally not allowed to keep her own property, and any funds she earned after marriage also belonged to her husband. As a wife, she owed absolute fidelity, service, obedience, and society (all these called consortium) to her spouse, to whom she essentially "belonged" as chattel. Barbara Leigh Smith Bodichon, a noted Victorian feminist and philanthropist, wrote in her 1854 pamphlet on the legal position of women that "A wife's *chattels real* (i.e., estates held during a term of years, or the next presentation to a church living,

etc.) became her husband's. . . ." Under his care and guardianship, she thus held the dubious status of a "perpetual infant," and following matrimony her separate legal identity was obliterated and merged into that of one person, her husband. As Smith Bodichon commented, "A man and wife are one person in law. . . . He is civilly responsible for her acts; she lives under his . . . cover, and her condition is called coverture."[2] A wife was forced to cohabit with her spouse even if he beat her or committed adultery, and thus her own personal freedom was limited. The Divorce Act of 1857 began to ease the procedure for dissolving marriages (divorce had hitherto been very expensive and time-consuming to obtain, mainly by an Act of Parliament), but for many years (until 1923, when grounds for divorce were made equal for both sexes) a woman had to prove a husband's adultery plus desertion, bigamy, incest, or cruelty, while her spouse need only point to his wife's adultery in order to file for a divorce.

On the other hand, a wife was entitled to receive maintenance from her spouse and "necessaries" or goods commensurate with his station in life. As the plot of countless novels revealed, it was the man's position which thus defined the course of the rest of his wife's life. However, as Smith Bodichon pointed out in her treatise on the institution of marriage, neither the courts of common law nor of equity had "any direct power to oblige a man to

support his wife. . . ."[3] Even if he deserted her or went off to live with his mistress, the property and earnings of his wife belonged to him; at any moment he could theoretically return home to insist upon cohabitation or claim custody of their offspring. A father had absolute authority over his legitimate children and even after his death a mother had no guaranteed right to serve as testamentary guardian. Illegitimate offspring, however, were the sole legal responsibility of the mother. And until 1880, even a widow had to struggle for legal recognition, since before then often only a third of her husband's estate might go to her after his death, the majority bequeathed instead to his male heirs.

A married woman, or feme covert, was generally not by law even entitled to her own personal belongings; her "paraphernalia" (clothes, jewels, ornaments, etc.) belonged to her during her lifetime only, and her spouse could sell such items if he liked. She received "pin money" as part of a wife's allowance, but these funds (see Fig. 86 for a pictorial example of this idea) were only to be spent on things which would "keep up appearances" appropriate to her spouse's social status, not hers. Affluent families thus often set up marriage settlements or prenuptial contracts intended by the courts of equity as a circuitous safeguard of a woman's property. For example, "separate use" clauses permitted a third party to serve as trustee of a married woman's property, this in theory protecting her funds from misuse by a profligate husband.

Many of these circumstances were ameliorated by the turn of the century, when divorce laws were being revised and relaxed. By 1886 a mother finally gained the right to possible guardianship of her children, and the 1880s also marked the expansion of a married woman's right to dispose of her property by will and to sue or be sued on her own in tort or in contract. Perhaps the key change was the Married Woman's Property Act of 1870, which enabled a female to retain her own earnings or rents. Twelve years later, complete control over property was given to married women, and in 1884 the Matrimonial Causes Act accorded females total personal freedom. More importantly, by the 1880s husband and wife were viewed as possessing separate identities, so that legally a female could be deemed an individual accountable for her own actions and thoughts.

The point of this chapter is primarily to provide background information on the legal restrictions that were imposed on Victorian women for most of the period. While this was the situation in actuality, there were rarely any paintings devoted to chronicling these legal phases or aspects of womanhood, and indeed artistic examples of this sort are more often found in the realm of popular periodicals than in fine art. For example, *Punch* published many derisive cartoons on the various campaigns for female suffrage, and George Cruikshank produced many of these, such as his 1853 "'The Rights of Women' or the Effects of Female Enfranchisement" (Fig. 8). In this frontispiece for the *Comic Almanack* of 1853, an annual journal with witty articles by the likes of William Makepeace Thackeray, the artist alludes to the galvanizing publication in 1851 of "The Enfranchisement of Women," a tract written by John Stuart Mill and his wife Harriet Taylor. Many Victorians viewed the average Englishwoman as essentially mindless and feared that women might cast ballots not on the basis of intelligent judgment and understanding of the issues, but rather on their instincts or sentiments, domains in which they were believed to be superior to males. Although a female monarch could head a nation, extending the vote to women in general was an entirely different matter. Cruikshank graphically represents this anxiety and focuses on a handsome "Ladies' Candidate" named Sir Charles Darling as the center of attraction and adulation. The accompanying text indicates Darling would live up to his name by favoring the legitimation of smuggling French ribbons and laces, of forced autumn holidays at the seaside, and an army composed exclusively of flashily attired horseguards, all ploys which would allegedly cause him to win by a landslide. Accordingly, the women around him nearly swoon and some carry banners emblazoned "Do not Vote for Ugly old Stingy" (referring to his rival) and also "Vote for Darling and Parliamentary Balls once a week," additional evidence of their frivolity. A knight in shining armor rides by at left with a banner for Darling, but the dissension this situation could potentially trigger in a family is suggested by the quarreling couple at lower left who stands beneath a placard ironically proclaiming "Husband and Wife Voters." Accordingly, the self-announced "gentlemen's candidate," Mr. Screwdriver, is as froglike and homely as the other man is attractive. Although Screwdriver's placard reveals his political platform may be quite pragmatic and rational, this candidate remains both ignored and powerless due to female enthusiasm for his opponent.

In contrast, Victorian paintings tended merely to

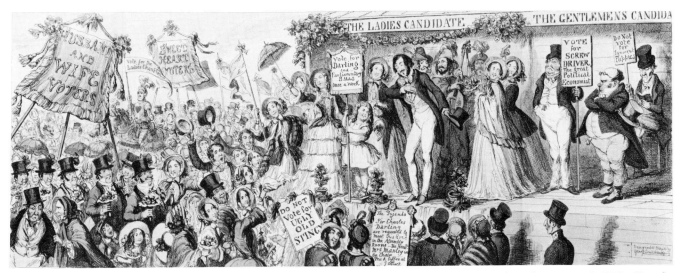

Fig. 8. George Cruikshank. "'The Rights of Women' or the Effects of Female Enfranchisement." 1853. Hand-colored etching from *The Comic Almanack, 1853*. Yale Center for British Art, Paul Mellon Collection.

imply the state of women's rights, unconsciously so in scores of paintings in this book with a domestic subject, such as James Hayllar's *The Only Daughter* (Fig. 9). Exhibited in 1875 at the Royal Academy, the canvas captures the moment of transition when the sole daughter of the house leaves her father's legal and moral protection for that of her future husband. The gray-haired patriarch, saddened and stunned, holds on to his daughter's hand while she presses her head against his temple. With her other hand a link is formed with her future: her swain clasps her delicate hand with both of his, seemingly not to pull her away but to reaffirm the strength of his commitment. The fiancé looks more imploringly not at his "rival" but at his beloved's mother, who has ceased her sewing and watches the tender vignette between father and daughter.

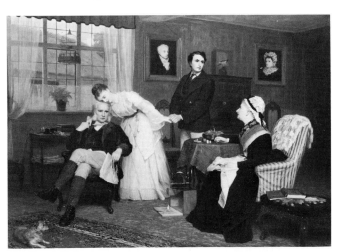

Fig. 9. James Hayllar. *The Only Daughter*. 1875. Oil on canvas, 43½ × 59½. The FORBES Magazine Collection, New York.

As if to emphasize the young man's predicament and his fiancée's choice, the artist has placed him between two ancestral portraits of a husband and wife and aligned his head closer to that of the male. With the past represented in such symbols, what will the future and the next generation signify? The lady's parents are old (the father has a cane nearby and the peaked cap may indicate he was a war veteran), and perhaps they wonder whether their only child will continue to tend to their needs after her marriage. Will her lot be as comfortable and happy with her husband as it has been with them? Will she enjoy such conveniences as the new sewing machine in the box on the floor? Other small details are also telling, from the chain at her waist with a tiny miniature and an anchor symbolic of hope and steadfastness to the pot of thriving, lacy ferns at the windowsill emblematic of her healthy state. Even the caged bird may be significant, and its implicit contrast with the stuffed bird on the mantel may suggest something about the dilemma facing the "dove" of the family, the young lady herself, as she is about to trade one life in the proverbial gilded cage for another.

Other works bore more legalistic titles, as was the case with Thomas Clater's lost 1838 Royal Academy entry *The Marriage Settlement*, Walter D. Sadler's untraced 1890s *Breach of Promise Case*, or W. F. Yeames's enigmatic *Defendant and Counsel* (Fig. 10) of 1895. Interpretation of this work in the press varied, the *Art-Journal* critic discerning a tinge of drollery in this visit of a pretty young woman to her lawyers "obviously for a matrimonial action. . . . A short study of the picture . . . will

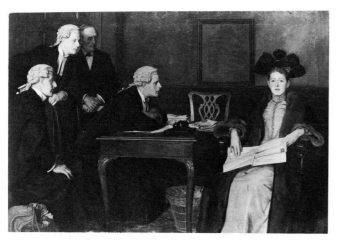

Fig. 10. William F. Yeames. *Defendant and Counsel.* 1895. Oil on canvas, 52 × 78. City of Bristol City Museum & Art Gallery.

show that Counsel has asked her an awkward question that the defendant finds difficult enough to answer."[4] Indeed, the young wife looks quite stunned, as uncomprehending of the words spoken as of the document she holds. It may be that her alarmed expression is due to her discovery that her husband has been involved in some wrongdoing that implicates her as well, and the *Athenaeum* guessed the paper in her hands was perhaps a forged deed of some sort. Her puzzlement is heightened by the apparent harassment she is undergoing by one of the male solicitors, "whose questions, pressed with a stern sort of energy, opened an abyss before her feet."[5] Her startled look and appearance of being overwhelmed are a testimony to her ignorance of "male matters" and of her inability to cope with the situation. There is thus a gulf—of her rights and responsibilities—between herself and the trio of lawyers. Even though some of the solicitors may be sympathetic (or condescending) about her plight, in a male world such a Victorian woman had little defense for her behavior aside from her femininity, which could protect her from certain charges or punishments at the same time that it hampered her freedom of choice and movement.

More compelling than the paintings with titles that specifically invoke this subject are those that communicate it by the force of their narrative content. The wife as a victim of male profligacy and of the prevailing legal system is depicted in John Everett Millais's 1854 drawing *Retribution* (Fig. 11). Along with a group of other drawings of this period, this work constitutes a revealing statement both about the artist's preoccupation at the time with what Holman Hunt called themes of "uncon-

secrated passion in modern life."[6] In the years 1853–54, especially after the summer of 1853 when he accompanied John Ruskin and his young wife on vacation in the Highlands in order to paint Ruskin's portrait, Millais fell in love with Effie Gray Ruskin, whose six-year marriage was still apparently unconsummated. A combination of events spurred an annulment of this marriage after Effie Ruskin ran away from her husband to her family. Millais's relationship with Effie at this point was innocent sexually; he clearly admired and perhaps even loved this woman, whose face appeared in several of his paintings of this period, yet he did not wish to court impropriety and waited until 1855 to marry her. As a result of this situation, Millais amid these confused emotions (his own, Effie's, and the indifferent Ruskin's) produced several drawings in 1853–54 in which the themes of respectability, dishonor, and amorousness are all explored. In *Retribution,* the triangle consists of two women and one man, not the obvious reverse parallel that might be drawn with the Ruskin/Effie Gray/Millais grouping. The wife in the drawing is also the "injured party," but she has children while her rival is barren; whether or not her husband has sought affection elsewhere because she (not he) is now frigid can only be speculated. At any rate, this is a drama of gestures and glances, from the tormented, beseeching expression of the wife, to the bent head of the errant male, to the curious peering of the maid at the door. The wife has ironically fallen on her knees with her arms outstretched like a kneeling saint; her wedding ring is being fingered by the amazed "other woman," who wears no such token of affection and commitment. This mistress not only looks with astonishment at the man being "shared"—she also touches him rather intimately on his thigh. Furthermore, the man's little daughter not only reaches out her arms to echo her mother's gesture, but also tugs at him near where the kept woman touches him. The girl is all eagerness to forgive and love her father, but the son, sullen and resentful, falls back into the folds of his mother's arms. There is a perfect counterpoint between his closed gesture and cap-in-hand with his father's hands in his pocket and oddly casual deportment; however, the man's slouching posture would have been deemed improper in the presence of a lady. Moreover, in terms of body language one woman drops to her knees like a penitent or suppliant, while the other female sits on a chaise lounge. The flowers also reflect these contrasting states, with several bouquets or tokens of love atop

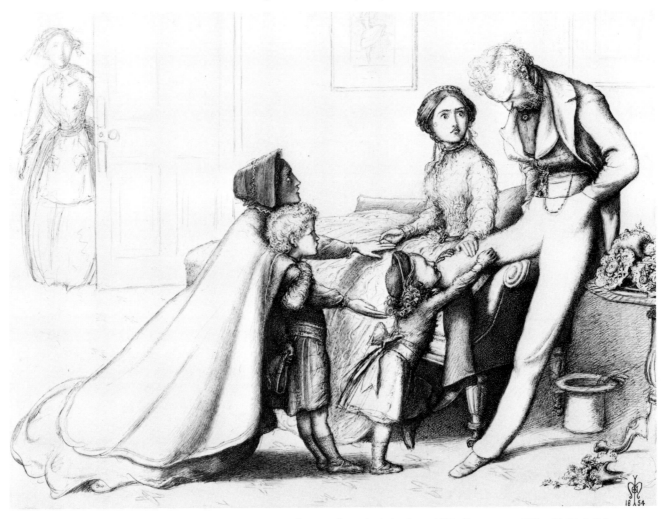

Fig. 11. John Everett Millais. *Retribution.* 1854. Pen and sepia ink, 8 × 10¼. Trustees of The British Museum.

a table (clustered above the dandyish detail of the man's hat and gloves) and a fallen posy nearby alluding to the downfall of the kept woman and the disgrace she has wrought. The pictures on the wall also reinforce these meanings, for above the mistress's head hangs a sketch of a ballerina, a rather frivolous creature of the theater generally perceived as possessing loose morals. To make the matter more pointed, literally, the mount on which the dancer balances in her picture forms an arrow that seems about to pierce the heart of the kept woman. As if to suggest a dire fate for the little girl, the artist portrays her pointing one of her own feet in a balletlike pose. Beneath her feet the rug is patterned with crosses, perhaps an indication of the need for salvation, not retribution, here.[7] In real life as well, of course, a man could maintain a married and an illicit relationship, but the consequences could be dire for all concerned, as this drawing demonstrates.

Another work that captures some of the dynam-

ics of the male/female relationship of this repressive era is Ford Madox Brown's *Take Your Son, Sir!* (Fig. 12), an unfinished picture of 1856–57 which by its very title indicates this is a confrontation scene. The offspring of an illicit union emerges from its womblike wrappings and is held out almost like a sacrificial object to the grasping father whose outstretched hands are reflected in the mirror. (Interestingly, she is a gigantesque madonna, while he is reduced to dwarflike stature.) A bizarre variation on the tradition of the holy mother and child in art, this modern magdalen has hair streaming down her back yet is also enframed with a halolike round mirror behind her and a blue-sprinkled wall suggesting a kind of heavenly backdrop or firmament for her actions. In truth, the woman depicted was the artist's wife Emma, while Brown seems to have portrayed himself as the bewhiskered man with outstretched hands waiting for the paradoxically shameful and shameless bundle. Perhaps he meant to cast Emma as a secular

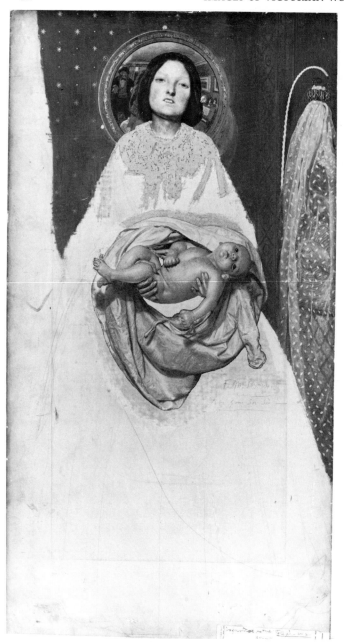

Fig. 12. Ford Madox Brown. *Take Your Son, Sir!* 1856–57. Oil on canvas, 27½ × 15. The Tate Gallery.

emblematic blossoms that—unlike their wearer—have been preserved from harm under glass. The reflections also reveal a piano with sheet music on it; this and the open window behind the man hauntingly suggest the fate of the female tormented by a moment of conscience in Holman Hunt's 1854 *The Awakening Conscience*. However, there is an implicit difference, for this woman has seemingly (although the title is somewhat ambivalent on this matter) opted to remain in her gilded—and paradoxically tarnished—cage. Whether an autobiographical statement by the artist or a more general exploration of a modern theme or both, *Take Your Son, Sir!* suggests the ideological importance placed by the Victorians on feminine chastity, for sexual waywardness was not permitted bourgeois and upper-class women, upon whom the socioeconomic demands of primogeniture, entail, and other intricacies of succession and inheritance all depended. A bastard child or an adulterous wife could be catastrophic, and as one modern scholar has pointed out, "The middle-class capitalist required the legitimacy of all his children not only to protect his possession from being enjoyed by the offspring of other men but to ensure the loyalty of his sons who might be business partners, and of his daughters who might be essential in marriage alliances."[9]

The opposite side of the problem—the darker side of marriage and the vulnerability of contemporary women to possible male prodigality—are conveyed in another, equally extreme and problematic canvas, Robert Martineau's 1861 *The Last Day in the Old Home* (Fig. 13). Virtually every detail in this room is meaningful as well as concrete, ultimately orchestrating the piece into a parable of masculine intemperance. The husband and father at right has drunk and wasted away the family estate and fortunes. It may be that the man has realized this wealth upon the death of his father, and that the latter's respectability is being followed by his heir's profligacy. The cover of the auction brochure is imprinted "CATALOGUE OF THE VALUABLE CONTENTS OF HARDHAM COURT IN THE COUNTY OF CHESHIRE. SIR CHARLES PULLEYNE BART./ TO BE SOLD BY AUCTION BY MESSRS. CHRISTIE AND MANSON ON THE PREMISES—OCTOBER 28 1860, AND TWENTY FOLLOWING DAYS (SUNDAYS EXCEPTED) PRECISELY AT ONE O'CLOCK," the very specificity of information adding to the modernity of the Hogarthian tale of the fall of an aristocratic family. An open newspaper reveals an advertisement for

madonna or to refer to the out-of-wedlock birth of one of their children, conflating the births of subsequent offspring into one symbolic baby whose existence is legitimized by the subject, pose, and the painting itself.[8] Although he may not have intended another level of meaning, this painting has often been construed as a depiction of a mistress rather contemptuously offering her bastard child to its father. In this interpretation some of the background details in particular may be significant: in the woman's hair is a wilting white rose, symbolic possibly of withered purity, while two reddish flowers (roses?) under individual bell jars may be

Fig. 13. Robert Martineau. *The Last Day in the Old Home*. 1861. Oil on canvas, 42½ × 57. The Tate Gallery.

an apartment, perhaps the family's next place of residence. It thus appears that the selfish young man is selling his boyhood home and family estate, leaving his mother homeless. There was no legal mandate for a son to be considerate of his mother's needs or wishes, and indeed English primogeniture recognized the male, especially the son, as the rightful heir, the widow often only entitled to a third or less of her spouse's estate.

Whatever the circumstances of his legacy, the heir (who has emptied the nearby liquor decanter) now blithely stands on a chair and raises a toast of champagne (at midday) in the air, while around him everything is being dismantled for the forthcoming auction owing to bankruptcy. His arm encircles his son, the next generation, who mimics his parent by holding the same type of glass, an action foreboding his own immoral development and future. Past generations of the family behold this moral as well as monetary bankruptcy, for the por-

traits on the wall include one by Holbein of Ralph Pulleyne and another by Jansen of Lady Pulleyne. On one frame a laurel wreath is carved with the date 1523 and alludes to past days of glory and victory, while the cap and bells with the date 1860 indicate the modern change of fate and the toll of warning bells for future generations. In addition, an equestrian painting of a racehorse leans on the sideboard, alluding to the gentleman's wagers and excesses of gambling at the track, as do the nearby betting book and dice box. On the floor the aforementioned auction catalogue lies, and lot numbers are already affixed to many objects; the doorway frames a glimpse of men impersonally removing armor from the walls of the mansion, interlopers "invading" a venerable home and denuding it of its history.

In spite of the accumulation of details, this is a Victorian "problem picture" par excellence, and thus differing interpretations of events or objects

are possible. It is clear, however, that the family home is in the process of becoming a mere shell or tomb of dead and destroyed memories. It is the females in the family who are aware of this transformation, not the males. The father encourages his son's recklessness but fails to notice that his wife reaches out to stop this. However, she is too weak to serve as a moral guardian, and her gesture falters in midair. Each spouse occupies a distinct psychological territory that overlaps yet is not truly shared in their crumbling domain, and there is no interaction between the two. The woman, seemingly too wan to protest or halt the progress of vice, holds some rosary beads and perhaps prays for deliverance or mercy. Her little girl also appears sickly and overwhelmed by the situation as she hides behind her mother and holds tightly to her own "child," a doll. She too has a somewhat spiritualized expression, and her gaze seems directed toward a small triptych with a crucifixion—perhaps she is reiterating her mother's silent plea for divine intervention. Another seated, passive female victim is the old woman at the table—perhaps the errant man's own mother. She seems to be relinquishing the keys of the house to an older male—a representative of Christie's or possibly a family servant who will spare his former mistress additional pain by attending to final details of dismantling the house. To heighten the melodrama, Martineau has added carvings on the mantelpiece representing scenes from the Garden of Eden—e.g., the Tree of Knowledge (and the fall from innocence) and also

an expulsion from Paradise that presage the pending exile of the family. While *The Last Day in the Old Home* is a tale about profligacy, it also reminded viewers about the possible male abuse of property and marriage. In addition, it reinforced Mrs. Ellis's advice in *The Daughters of England* of 1845 that a woman's "highest duty is so often to suffer and be still."[10] Such suffering, which at times bordered on masochism, had a certain appeal to Victorians, for as Thackeray emphasized in *Vanity Fair* of 1848: "I know of few things more affecting than that timorous debasement and self-humiliation of a woman. How she owns that it is she and not the man who is guilty; how she takes all the faults on her side; how she courts in a manner punishment for the wrongs she has not committed, and persists in shielding the real culprit."[11] Whether he was squandering his family fortune or hers, he could do so with impunity, for a married couple was one person according to English law and he could thus degrade his wife, mother, or children as he liked. The Englishwoman was thus, as John Stuart Mill wrote in *The Subjection of Women* in 1869, no better than a pathetic victim and "a personal bodyservant of a despot."[12] These differing responses from Ellis, Thackeray, and Mill could all have been written with Martineau's lady of the house in mind, for she is forced to be both weak and strong as an embodiment of the ideal Victorian woman faced with a crisis that she had never been prepared in any way to resolve.

3
The Ideal of Victorian Girlhood

"THE GIRL OF THE PERIOD," A FEMALE OF INDETERMINATE age whom Eliza Lynn Linton, a noted Victorian writer, described disparagingly in her 1870s essays, was nonetheless not a static entity, and her aspirations as well as her education changed markedly during the years of Victoria's reign. A brief recounting of her academic and social training helps to explain the nature of her image in paintings of the period.

Throughout most of the century the education of middle- and upper-class British girls was decidedly unsystematic and fragmented, with social skills emphasized over intellectual ones. (Elementary education was not compulsory for all children until 1870, prior to which any nonwealthy child of either sex was fortunate to receive even a piecemeal education at home, church, or at a ragged school. Girls of "the lower nation," however, had even fewer chances for schooling than boys. It was not until 1902 that the state established a Girls' Public Day School to provide opportunities for secondary education.)[1] Whether offered in the home or in small private day or boarding academies, the basic curriculum for girls included the typical feminine accomplishments of sewing, dancing, reading, a smattering of French or German, religious training, conversational arts, and music or art instruction. The English author and schoolmistress Elizabeth Missing Sewell upheld this traditional upbringing for girls, fearing that more "masculine" training and intellectual pursuits could seriously impair a female's health. Accordingly, she wrote in an 1866

book on the principles of education, "Girls are to dwell in quiet homes, amongst a few friends; to exercise a noiseless influence, to be submissive and retiring. . . . The girl . . . has been guarded from over fatigue, subject to restrictions . . . , seldom trusted away from home . . . , simply because, if she is not thus guarded, . . . she will probably develop some disease, which, if not fatal, will, at any rate, be an injury to her for life. . . . Any strain upon a girl's intellect is to be dreaded, and any attempt to bring women into competition with men can scarcely escape failure."[2] Thus, neither academic achievement nor, by extension, gainful employment was a primary goal for well-bred females. The daughters of gentlemen were inculcated with a strong and socially endorsed sense of their unique feminine mission, their supposedly superior inborn spirituality, tenderness, and intuition, which were meant to be touchstones of moral inspiration for their family and the state. As one woman rhapsodized about the daughter's place in the Victorian home in an 1887 article in *The Mother's Companion*:

> . . . The mother of the little woman-child sees in her the born queen, and, at the same time, the servant of the home; the daughter who is to lift the burden of domestic cares and make them unspeakably lighter by taking her share of them; the sister who is to be a little mother to her brothers and sisters; the future wife and mother in her turn, she is the owner of a destiny which may call on her to endure much and to suffer much, but which, as it also bids her love much . . . is well worthy of an

immortal creature. . . . A family without a girl . . . lacks a crowning grace, quite as much as a family without a boy misses a tower of strength.[3]

Thus, until later in the century (or in the case of more enlightened parents), daughters or "crowning graces" were instructed in only the rudiments of mathematics, science, Latin and Greek in order to fulfil such idealized expectations of femininity. Nonetheless, there was growing agitation for higher education for females from the late 1860s onward. Such a prospect was fearful to many, since too much book knowledge was thought to decrease femininity, endanger spirituality, encourage competition with men, and threaten the sanctity of marriage and the home. In actuality, women themselves were often divided on the issue of their own education, and many clergymen denounced the possibility of university-educated females as self-indulgent and a perversion of Christian humility. The ramifications of higher education could also affect women in the marriage market, and other major arguments centered on the Biblically ordained segregation of the sexes and on the "weaker" sex's alleged inferiority in mind and in body. It was not until the late 1840s that limited opportunities for university training began to evolve in London, with both Queen's and Bedford Colleges established in 1848 with the aim of educating governesses. Girton and Newnham Colleges were founded in 1869 and 1871, respectively; and although women had agitated for admission on equal terms to universities since the 1860s, it was the 1920s before Cambridge and Oxford awarded full degrees and honors to female scholars.[4]

In addition to the counsel of parents and the influence of Sunday school and classroom lessons, Victorian middle-class girls had a wide variety of books and magazines available for their perusal. Although periodicals primarily aimed at a female readership had long existed in England, specialized magazines for juvenile females were a distinctly Victorian invention of the late 1860s, their peak occurring in the 1880s and 1890s. Publications such as the *Girl's Own Annual* prided themselves on being sufficiently inexpensive to be affordable by the literate but less affluent youngster. Such magazines, which were read by adult women as well as the young or adolescent girls for whom they were mostly intended, often published guidelines for proper conduct that clearly reinforced the codes that both courtesy manuals and society at large dictated. There was much more than mere eti-

quette or sententious sermonizing in these pages, however, for this new breed of popular literature also printed short stories with occasionally spunky heroines, along with instructions for cooking, gardening, dressmaking, health and beauty problems, scientific experiments, and other subjects. In the realm of fine literature, however, many Victorian novelists seized on the inadequacies and follies of a female's irregular education as a prime target for their ridicule, losing few opportunities to satirize the curriculum of "fine ladyism" over achievement. Of scores of such books, among the most critical were Charles Dickens's *Great Expectations, David Copperfield*, and *Little Dorrit;* also in this category was Thackeray's *Vanity Fair*, Charlotte Brontë's *Jane Eyre* and *Shirley*, and George Eliot's *The Mill on the Floss* and *Amos Barton: Scenes of Clerical Life*.

Fig. 14. Thomas Gotch. *The Child Enthroned*. 1894. Oil on canvas, 62½ × 40. Photo courtesy of Berry-Hill Galleries, Inc.

In terms of pictorial imagery, both juvenile publications for young females like *The Girl's Own Annual* and paintings of the period often ennobled girlhood to a state approaching sainthood. This tendency was manifested throughout the Victorian era and even as late as 1894 was sustained in such works as Thomas Gotch's proto-symbolic *The Child Enthroned* (Fig. 14). Exhibited at the Royal Academy that year, the painting depicts a girl seated on a bright-colored throne, in a pose reminiscent of a static Renaissance icon of the Virgin Mary. Her holiness is further emphasized by the halo that emanates from behind her head. A contemporary writer interpreted this work as a sign of Gotch's progressive ideas on the status of women (the artist's wife was also a painter and may have influenced his philosophy) and on the superiority of the ideal woman.[5] For this artist, the female sex, particularly in girlhood, was endowed with almost divine, and certainly mystic, qualities, and in subsequent paintings he continued to pursue this idea. In his 1900 Royal Academy entry, *The Dawn of Womanhood*, for example, Gotch depicted another enthroned, idealized young female as the pivotal point of his quasi-symbolic statement about femininity. The accompanying quotation revealed that adulthood was fraught with anxieties and that girlhood was thus a higher and purer state of being: "The child, enthroned, sees in a vision approaching womanhood; the phantom figure wears a mask, since all who are no longer children must conceal themselves. The familiar spirit of childhood, on the steps of the throne, is aware of a strange presence and prepares to fly away."[6] How terrifying puberty might have been in real life for females, if even in art there could be such fears expressed about the ominous responsibilities of maturity.

While Gotch's image of girlhood makes the young female a ruling deity in a secret chamber of power and glory (an interesting variation on the icon Hayter created of the young Queen Victoria in Fig. 2), a different perspective is provided about contemporary childhood in Sophie Anderson's *No Walk Today* (Fig. 15) of the 1850s. The claustrophobic nature of girlhood—and of the attendant splendid finery and opulent surroundings—is undoubtedly more apparent to modern viewers than may have been intended by Victorian artists. This is the case in Anderson's painting, in which an absolutely exquisite girl with china-doll features and perfectly coiffed curls is held back, like some princess in exile, from going outdoors. Is she so

Fig. 15. Sophie Anderson. *No Walk Today.* Mid-1850s. Oil on canvas, 19¾ × 15¾. Collection of Sir David Scott.

fragile that the spring rain will damage her or cause her to melt? This was invariably thought to be true, for girls were deemed so frail that one inadvisable walk in damp weather was considered an invitation to pneumonia or worse. This little girl is a miniature adult, almost a coquette, and each item of clothing is pristinely arranged and very stylish. (She seems overdressed in winter garb given the flowers blooming outside.) There are no stray tendrils of hair or other evidence of activity, and her wistfulness is the only indication that she is a real child and not a toy. Perhaps the raindrops were meant to be construed as equivalents to the tears she musters at this sudden imprisonment, yet it is an absurd irony that the dire fate she must contend with is not poverty or death, but only a temporary halt to her plans for a promenade. In some respects this lovely child is the victim of involuntary incarceration, a captive held in her own home by the dictates of society concerning appropriate conduct for little girls. Will she linger at the window—frozen in a pose of disappointed desire and watching the rest of life go by from a hermetic parlor—forever? The resolution can only be surmised, for like the protagonist in Henry James's late-century novel *What Maisie Knew*, this girl is doomed to live

life vicariously, "as if she could only get at experience by flattening her nose against a pane of glass." The foliage in the outside world confirms her innocence and dependency, for in the language of the flowers both daisies and the climbing clematis at left generated such meanings, while fuchsia and jasmine had connotations of amiability.

Whether a willing or unwilling shut-in, even the youngest of girls was well-schooled in the notions of superior feminine moral instincts stressed by parents and in popular literature. The related concept of duty to family and friends was strongly endorsed for females of all ages, and even the youthful heroines of magazine stories and children's books exemplified this trait. The need to be selfless even in childhood—to help an older relative, assist the poor or the sick, and above all to minister to a brother's or a father's needs, were all lessons for females who might either in wedlock or spinsterhood lead a life of service to others. Thus, the dutiful and long-suffering girl "redeemers" in literature (like Dickens's little Dorrit, Florence Dombey, and Little Nell) seemed to outnumber the mischievous female child in art of the period.[7] In paintings the qualities of tender affection, solicitude for others, spotless morals, and generosity of spirit were also conveyed in youthful feminine form. James Collinson's 1855 *Childhood* (Fig. 16), for example, preserves the role of a little mother to which the little Victorian girl was often schooled in real life and in art. Here a child, her hair prematurely "put up" as if she plays at being an adult, fondles a smaller child on the piano bench in nose-to-nose contact. Her actions—like those in Frederic Leighton's *Sisters,* to be discussed shortly—foretell of adult maternal functions, and to endorse her surrogate behavior, on the wall above the pair hangs a print of a mother playing with her little one. The other accessories in the room may also be significant; the piano itself—so important in different ways in *The Awakening Conscience* for the chord of painful memories it strikes for a courtesan—is an instrument both of pleasure and of discipline, and the viewer is left to hope that the girl will "practice" on this wisely, too. An alphabet book and a Bible, both invaluable tools for teaching, lie on the floor; at left a globe represents the world external to this womblike security in the parlor. At the window a burgeoning plant, typically an index in genre pictures to the protagonist's thriving or atrophying state, attests to the flourishing environment enjoyed by the children.

The sister played an important role in Victorian life and literature, and both real filial bonds and close female friendships were praised by numerous male and female authors, who often waxed effusive about the kind of psychological nurture and empathy these sisterly ties provided, an intimate bonding that served as an important prelude to marriage.[8] Often in paintings of this subject there is a degree of physical and psychological intimacy, a proximity coupled frequently with a girlish embrace and a visible emotional response, which are in decided contrast to the absence of physical contact and the low-key, often masked, emotions of females that tend to prevail in courtship imagery. One example of this sisterly devotion is Frederic Leighton's *Sisters* (Fig. 17) of about 1862, which the *Art-Journal* praised as graceful and touching, with the "tall girl stooping over and caressing her little sister."[9] This painting was much admired by Millais and others who saw it at the Royal Academy that year, and F. G. Stephens wrote glowingly in the *Athenaeum* of "the garden porch of a noble house, looking on to dark arbutus, glistening laurel, and gloomy pines, over them the opal lines of glorious morning tinting the floating clouds islanded in blue. A lady, young and fair 'as English air could make her' has entered the colonnade; to her runs a child, her sister, who embracingly buries her face in the elder's lap, that is robed in soft, lustrous maize-hued silk."[10] The curving posture of the older sibling and her attentive expression and welcoming arms create, with the child's upstretched arm and openness, a moving vignette of mutual affection. No doubt the elder's tenderness was also viewed as a sign she would someday be a good mother as well. The setting evokes Mrs. Ellis's comments in *The Women of England* of 1839 that only sisters could have "roamed together over that garden whose very weeds are lovely—the fertile and luxuriant garden of childhood."[11] The garden itself, as will be shown in chapters 4 and 6, was the site of innocence as well as romance for females, and both associations are applicable here. In addition, Leighton has included a laurel bush, in Christian iconography symbolic of chastity and eternity, and the other foliage may generate similar meanings.

The mutual process of self-identification shared by women, blood sisters or not, could be expressed with more disquieting effects, as in Augustus Egg's *Travelling Companions* (Fig. 18) of about 1862, one of countless canvases that quite eerily twin the features, attire, and doppelgänger identity of the sitters. It is otherwise clear, however, that the two

Fig. 16. James Collinson. *Childhood*. 1855. Oil on canvas, 17¼ diameter. National Gallery of Canada, Ottawa.

females are quite different in spirit, an impression communicated by both the differentness and the psychological distance between the two. Their lives and dresses may nearly overlap, but the sister at left has fallen asleep amid her voluminous skirts, while her counterpart reads. Superficially, they are embodiments of idleness and industry, their hats seemingly confronting each other more than the women themselves do. But what kind of book is being read—a French novel or the classics? And what is the meaning of the bouquet of roses, which in a courtship context would connote impending romance? Do their pert, feathered hats allude to the same accoutrement in John Everett Millais's *My First Sermon* and its sequel, explorations of feminine moral vigilance in girlhood? Egg has chosen to create a "problem picture" for his viewers, who must also interpret the meaning of the journey that the sisters have embarked upon. Are they tourists and is the scenery real or imagined by them? Neither sister bothers to look out at the magnificent Italian hillside and water glimpsed through the

Fig. 17. Frederic Leighton. *Sisters.* Ca. 1862. Oil on canvas, 30 × 15. Pre-Raphaelite Inc.

own invented fancy costumes, romp in a rarefied, trouble-free realm that is akin to the enclosed garden or parlor that functioned both as a handsomely appointed prison and a feminine microcosm. It is a less enigmatic, but no less worshipful stance that is apparent in Greenaway's drawings, which Ruskin considered to be of high caliber and not mere book illustrations. Scenes from *The Marigold Garden* of 1885, for example, representing little girls having tea in a flower-filled environment, perpetuate the adult expectations of girls mimicking ladies' conduct. In *"Under the Rose Arches"* (Fig. 19), the poetry repeats the implicit identification of young girls with blossoms, thus underscoring and personifying the youthful naïveté and chastity of the protagonists. Since the Victorian woman was in many respects deemed a "perpetual infant," it is somewhat predictable that her pictorial progeny should repeat many of the same preoccupations and motifs.

The lines of sexuality, both in real life and art, blurred between the child-woman and the woman-child. What was womanly about the girl thus had visual and sexual appeal, and conversely, what was girlish about the woman was both socially encouraged and enticing, especially her purity, vulnerability, ingenuousness, and devotion. Greenaway's girls project an air of simplicity, but a more ambivalent meaning could lurk beneath the surface of such images of a childish *hortus conclusus*—at least to modern viewers.[12] In Frederic W. Burton's 1861 watercolor *Dreams* (Fig. 20), the languid pose and long wavy hair of the model, along with the highly detailed, richly patterned *horror vacui* qualities of the composition, are reminiscent of the indolence and repose of such specific works as Arthur Hughes's *In the Grass* or the general tendencies of Dante Gabriel Rossetti's enshrined femmes fatales or Albert Moore's sleeping goddesses. The prepubescent girl sensuously reclines in a mood replete with awakening eroticism.[13] She gazes at the somewhat phallic flower as if hypnotized, like a baby odalisque or golden-haired young siren. It would be inaccurate, however, to identify Burton as a Victorian Humbert Humbert, since he did not exclusively produce such images. However, representations of girls or adolescent females tinged with sexual associations did exist, and child pornography and prostitution were also rife. Charles Dodgson, alias Lewis Carroll, is notorious for his photographs of nude cherubs, particularly little girls, and the latent sensuality of this female being was seized upon by painters as well. Usually the

train window, and together the pair has managed to create quite a snug "portable parlor" to shield them from the dangers—and the beauty and the challenge—of the beckoning view.

Aside from religious, angelic, and romantic associations, girls in Victorian art and literature were commonly associated with flowers, delicate blossoms of young beauty that would someday mature into fertile womanhood. The ornamental girls in Kate Greenaway's fantasies, clothed in the artist's

Fig. 18. Augustus Egg. *The Travelling Companions.* Ca. 1862. Oil on canvas, 25⅜ × 30⅛. By courtesy of Birmingham Museums and Art Gallery.

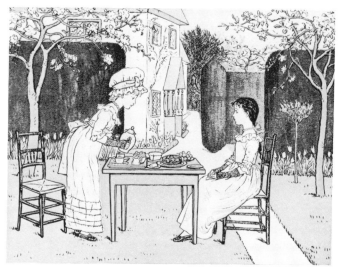

results were incorporated in a more subliminal, often unconscious way, one which seems blatant only to twentieth-century eyes. The underlying double-edged attitude to girlhood as both pure and sexy is understandable especially since females were legally considered adults when they were twelve, the legal age of consent (i.e., to wed) for much of the Victorian era.

The inherent sexual or erotic appeal of the little girl often went unacknowledged in the fine arts or literature, but the juxtaposition of good and bad girls was a familiar device in Victorian novels. The

Fig. 19. Kate Greenaway. *"Under the Rose Arches."* Ca. 1885. Color wood engraving from *The Marigold Garden*, 1885.

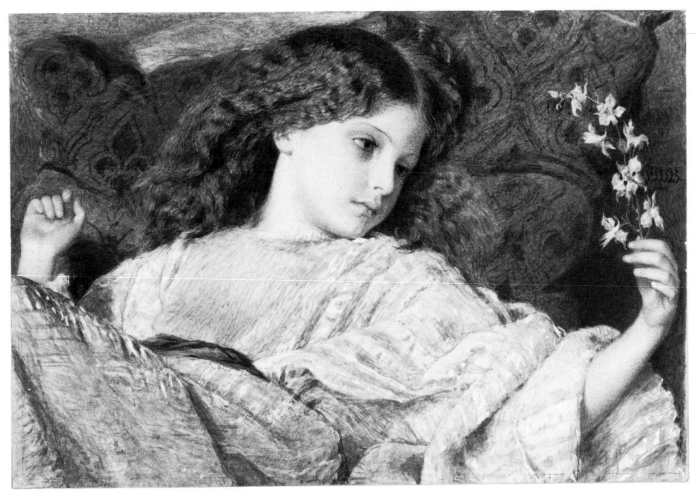

Fig. 20. Frederick W. Burton. *Dreams*. 1861. Watercolor and bodycolor over pencil with gum arabic, 8⅛ × 12. Yale Center for British Art.

"good" and "bad" types, often the docile versus the willful, found expression in paintings as well, often in the conflict that arose between the fair-haired and the dark-haired female. Overt adult rivalry of this sort is apparent in works such as Phillip H. Calderon's 1856 *Broken Vows* (see Fig. 64), but rivalry existed in the realm of childhood, too, as in William Maw Egley's 1861 two-part serial, *Just As the Twig Is Bent, So Is the Tree Inclined* (Fig. 21), (scene one only). The title is an ironic excerpt from Alexander Pope's *Moral Essays* (Epistle 1), but the format is a pure Victorian update of Hogarth's before-and-after sequences. The pair of pictures was exhibited at the Royal Institution in Manchester in 1861 and at the Crystal Palace in London the following year and was commented upon by reviewers in the *Art-Journal* and elsewhere. In the first part of the melodrama illustrated here, a pretty blond girl turns from her books and lessons to gaze admiringly and affectionately (even romantically, if one believes in "calf love") at the boy

playing soldier. She has also temporarily forgotten the soldier doll with which she has been playing, and he lies fallen at her feet, the choice of toy and its subjugation to her will both prophetic of the children's conduct in adulthood. More demurely seated is a darker-haired girl, who has interrupted her reading to behold this coquettish moment between her playmates. At her feet a sheaf of paper is marked "See the Conquering Hero Comes" (no sexual innuendo was probably intended), a line which the boy mimics with his military strut. Perhaps he is emulating an ancestor, for above the fireplace hangs the portrait of another real military man; on the mantelpiece below, two empty vessels and an object under glass may allude to maidenly purity. In the pendant, the flirtatiousness is far more blatant, with the grown-up personages restating their childish behavior. In the finale the blond beauty is still depicted as rather frivolous and playful as she fingers a locket while her suitor, an infatuated soldier, intently stares at her. However, the back-

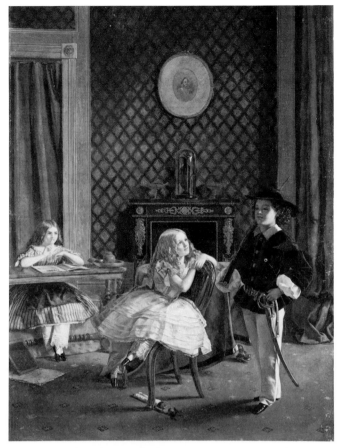

Fig. 21. William Maw Egley. *Just as the Twig Is Bent, So Is the Tree Inclined.* 1861. Oil on canvas, 18¼ × 24¼. Philadelphia Museum of Art. Purchase: Katherine Levin Farrell Fund.

ground mirror (occupying the space parallel in part one to the portrait of a soldier) reflects another level of drama. The more serious, "soulful" raven-haired sister or friend suspends her activities (her reading and piano playing) and once again plays the role of outsider. The sheet music she has been playing may or may not have been "See the Conquering Hero Comes," but the results are the same. A bell jar stands on the table near her, while her companion is framed on one side by a pot of flowers that may signify amorousness. While the blond belle receives rapt attention—her wistful suitor literally fans their ardor—her wistful, seemingly envious companion is a mere foil to the romantic overtures of the couple. As time goes by, she will witness further stages of the courtship and will perhaps wither into stereotypical Victorian spinsterhood, a prisoner of the drawing room and her needlework.

In contrast to the calculated charm and preciousness of the girl who appeared in paintings was the countervailing, and perhaps healthier, attitude often found in the pages of *Punch.* Pre-

cocious middle- and upper-class girls are frequently portrayed as enfants terribles misbehaving at dances, the seaside, and in the nursery, and generally they behave more impishly and saucily than their counterparts on canvas. In a middle-class context this would include examples of little girls uttering bons mots for an adult audience, as in a cartoon of the 1860s entitled "Late from the Schoolroom." The humor is overt, for a child, in response to her governess's instructions to say she is reading a narrative, not a tale, dutifully replies, "Yes, Ma'am; and do just look at Muff, how he's wagging his narrative!" Little boys, whether rich or poor, were much more often the target of *Punch's* satire, but even so, mischievous girls of all social levels were included among the cartoons by John Leech, George Du Maurier, and others. This lighter side to juvenile activities was rather a Victorian "invention," since prior to the 1840s this was not a popular topic in *Punch* for either artists or journalists.

In terms of lower-class protagonists, John Leech and other illustrators depicted little flower girls and other rather mischievous female vagrants in the pages of *Punch* from the 1840s through the 1860s in particular. These Cockney or slum children (of both sexes) roamed the London streets and caused a lot of trouble in cartoons, yet in truth such working-class girls were expected to be self-supporting (by going into domestic service or factory work, etc.) by the age of eleven or twelve. Yet in cartoons they are often shown aping adult actions.[14] In paintings the female urchin was invariably the quite cloying object of pity for viewers. For example, the picturesque and pathetic little flower girl in rags, and similar beggars, proliferated in Augustus E. Mulready's cult of the street child, as in his *Our Good-Natured Cousins* (Fig. 22). While a girl sells flowers, her social superiors saunter unselfconsciously down the sidewalk, even their little dog "putting on airs" with his upturned nose and anthropomorphized arrogance. But the other side of the street tells another story, for at right is a pawnbroker's shop and at left an undertaker's. Small coffins dot the storefront window, and a sign advertises "Funerals—short-term notice—children" for a little more than a pound in price. Ironically, in the doorway of the mortician's establishment stand a girl and a baby, the former replaying the favorite role of surrogate mother. Yet this is no game, and this pair may, like their fellow street vagrant (and unlike their affluent "good-natured" and self-centered male and female cous-

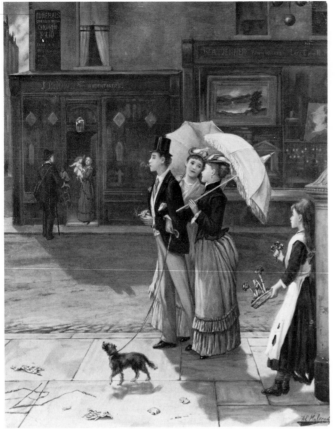

Fig. 22. Augustus E. Mulready. *Our Good-Natured Cousins.* Oil on canvas, 23½ × 19½. Photo courtesy of Christie's London.

ins) perish in the grim city. Indeed, these two classes or Victorian "nations," as Disraeli called them, coexist in such a way here as to suggest that the painting might be interpreted as a comparison both of affluence and penury and, along class lines, of idleness and industry.

The rural child was also a popular subject and was often viewed as an inherent paragon of innocence and simple country ways. At times this resulted in rather symbolic pictures, as is the case with Charles Collins's *The Good Harvest* (Fig. 23) of 1854, exhibited the following year at the Royal Academy. Although contemporary critics said very little about this work, it is evident that the arched format and ivy-covered brick wall allude to Millais's *A Huguenot* (Fig. 63) from the 1851 Academy exhibition. The child in her modest attire and sober expression seems to convey some Christian meaning. Is the good harvest a spiritual reaping? The girl carries a sheaf of wheat, perhaps as an offering to Christ or as a symbol of the bread of the Eucharist, and her hands are clasped in a prayerlike pose. Her work involves both the physical and spiritual levels, which she simultaneously seems to

embody. As in Hunt's 1854 *The Light of the World*, the figure may also be poised at the threshold of the human soul bringing both innocence and sustenance and reminding viewers of the purity of childlike faith.

While Collins's work serves as an emblematic mood piece, there were other images of the agricultural and non-middle-class girl which were more straightforward in meaning. Less "precious" than many interpretations was Hunt's portrait of a real child named Miriam Wilkinson in his 1859 panel entitled *The Schoolgirl*. Realism pervades the picture, from the frayed sweater the child wears to the leghorn hat through which light beautifully filters onto her forehead. Earnest but not saccharine, she swings a strapful of books over one shoulder and holds in her other hand a psalm and a hymn book. The latter materials indicate not only the curriculum she studies at the unseen rural schoolhouse, but also that she possesses good moral character that is being properly trained for the future. Whether or not she would end up as a farm worker, a female gone astray, or a teacher or

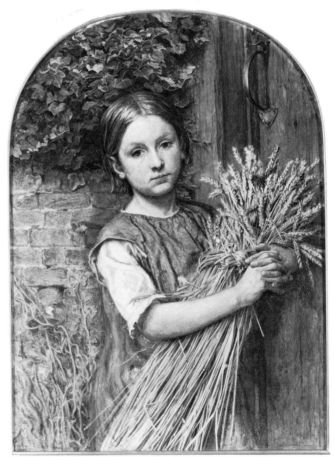

Fig. 23. Charles A. Collins. *The Good Harvest.* 1854. Oil on canvas, 17¼ × 13¾. By courtesy of the Board of Trustees of the Victoria and Albert Museum.

Fig. 24. George Clausen. *Schoolgirls.* 1880. Oil on canvas, 20½ × 30⅜. Yale Center for British Art, Gift of Paul Mellon.

mother was left up to the audience to decide. The preoccupation with this girlish type of innocent continued throughout the century and even appeared in the later work of artists who practiced a "new" realism indebted to contemporary French painters like Tissot. This is the case, for example, in George Clausen's 1880 *Schoolgirls* (Fig. 24), in which the subject is captured with results remarkably like that of a casual snapshot. The advancing females are frozen in a "frame" for the viewer so that the encounter seems sudden (and akin to the work of Gustave Caillebotte), but the theme itself may be a social comment somewhat in the tradition of Ford Madox Brown's celebrated canvas *Work.* For in spite of its title, *Schoolgirls* really focuses on the stages and states of Victorian females. There are well-dressed young girls perambulating along Haverstock Hill (with an upper-class mother and child doing the same on the other side of the street), but there are also lower-class females. These are the less fortunate laborers—the milk-vendor laden with heavy metal cans, a girl selling

posies to older females who seem not to even see her, and a pitiful governess (her visage shiny with eyeglasses underscoring her homeliness) bringing up the rear of this line or chain of femininity.

Whether upper-class or lower-class, the little girl was perceived as even more bathetic when portrayed as dying or orphaned. The consumptive young girl was a stock character in Victorian literature, often serving as an embodiment of virtue and selflessness too perfect to survive and yet eminently worthy of emulation by readers. The subject pervaded art as well, often merely as a picturesque combination of weakness and pulchritude. One example is Frank Holl's first Royal Academy entry, *The Convalescent* (Fig. 25) of 1867. Here the girl, as the title suggests, is perhaps suffering but nonetheless recovering and thus not in mortal danger. The closeup of the sick child focuses on her upturned face and the way her tresses cascade onto the pillows; she looks out from a pallet strewn with yellow buttercups (possibly symbolizing her former gaiety) and other flowers. There is also amid

Fig. 25. Frank Holl. *The Convalescent*. 1867. Oil on canvas, 18 × 22. The Suzanne and Edmund J. McCormick Collection.

this litter an orange, a rather expensive fruit often purchased for holidays or recuperative purposes. In spite of the title—or perhaps because of it—there is a certain latent sexiness which imbues this image of an ailing odalisque, a picture akin to Frederick Burton's *Dreams*, mentioned earlier. The death of a lovely female was all the more tragic to the Victorians because of the tender age and beauty of the expiring young woman or girl. Moreover, during the nineteenth century a number of childhood maladies dispatched Victorians to an early grave, as did tuberculosis or consumption, another major killer. In literature as in art, the merest hint of a cough or ailment portended ill for the sufferer. The pose of dreamy abandon apparent in Burton's and Holl's paintings of girlhood betokens a certain sensuality also evident in James J. Tissot's interpretation of a solitary and ailing older female in *Soirée d'Été* (Fig. 26) of 1881. In this etching there is additional meaning because the woman is Kathleen Newton Kelly, the artist's mistress and beautiful

Fig. 26. James J. Tissot. *Soirée d'Été (Summer Evening)*. 1881. Etching and drypoint on wove paper, second state, 9⅛ × 15⅝. Yale University Art Gallery, Gift of G. Allen Smith.

Fig. 27. H. Bourne, after Emily Osborn. *God's Acre*. 1879. Etching and engraving, 7¼ × 9½ to plate mark. Private collection.

Fig. 28. Frank Holl. *Her First Born*. 1876. Oil on canvas, 43 × 61¼. Dundee Art Galleries and Museums.

companion, who succumbed to tuberculosis in 1882. Tissot's image makes the consumptive creature both invalid and recumbent, languishing in a secret garden in which she too is a precious flower that is tragically wilting in the bloom of her youth. Her half-closed eyes, an expression of both pain and reverie, also allies her with scores of other languid and expressively sleepy women who proliferated in the last quarter of the century in paintings by Dante Gabriel Rossetti, Albert Moore, Frederic Leighton, and others.[15]

There was also considerable attention given to the orphan, a favorite victim in novels (as in several by Dickens). The female orphan in particular possessed the multiple appeal of abandonment, innocence, and helplessness. For example, the bereft, sometimes very attractive (even erotic) orphan was among the personages who appeared in novels such as Bulwer Lytton's 1846 *The New Timon*, Charles Kingsley's 1861 *Ravenshoe*, Anthony Trollope's *Dr. Thorne*, George Eliot's *Adam Bede*, and Charlotte Brontë's *Jane Eyre*.[16] In art this object of

pathos, typically an unbearably saccharine girl or woman, was depicted as a vigilant guardian of memory as well as a link between the past and the present. There is often also a sense of "divine" resignation infused into the plight of these orphaned females, who are often portrayed as being able to communicate with the dead, presumably an outgrowth of their allegedly superior sensitivity and emotions. Among the many examples in this category is H. Bourne's engraving after Emily Osborn's popular tear-jerker, *God's Acre* (Fig. 27) of 1879. In another exploration of this theme, *For the Last Time*, Osborn showed two sisters opening the door to a room where their parents' corpses reposed, and here as well the figures cling to one another for comfort, the elder child taking on the role of substitute mother. As in Frederick Sandys's *The Little Mourner* (ca. 1862) and other scenes of female distress, the setting is winter, and the frigid cemetery location is far removed from the idyllic garden enjoyed by Leighton's pair in *Sisters*. The hardships of the season heighten the destitution of

the humbly clad girls, who wear worn shoes and tug at their ragged shawls. Homeless and apparently friendless, their only shelter is a broken umbrella, a pathetic parody of a "roof" over their heads. In spite of their poverty, however, they have managed to obtain a memorial wreath for their parents' grave, and the encircling ivy in this has associations of remembrance and fidelity in the language of flowers. Tragically, there is no living rescuer—male or female—to deliver them from their chilly fate, and the artist (herself a female) leaves open-ended whether the little ones will pine away and perish or will move on to a less gloomy place and find future happiness.

Aside from the loss of her parents, sometimes in stories the "bad" girl died because of her wayward character, yet at other times it was the "good" one who succumbed, both reminders of the omnipresence and power of death. In reality, mortality rates among children were quite high throughout the century, so that the fatal illness or death of a child was not an uncommon occurrence within families of all classes. The young were often included in the elaborate mourning rituals that were practiced by both lower and upper classes, and a rural vision of this subject is found in Frank Holl's *Her First Born* (Fig. 28) from the 1876 Royal Academy. Although infant mortality was a grim reality,

especially among the lower classes, many believed that such a subject should be avoided in art. The reviewer for *The Spectator* deemed Holl's canvas unnecessarily depressing, and asked "what is the use of paintings like this? Is not this constant harping . . . on the one string of death and burial somewhat unworthy of a man?"[17] In spite of this harsh reaction, the painting remains a powerful statement about the darker side of both childhood and motherhood. While the death of a child was often cast in quite sentimental terms (complete with departing spirits ascending to heaven), Holl's approach is less mawkish. He depicts the rural custom of children—here girls—bearing the small casket, suspending it from their white handkerchiefs as they act as pallbearers. Will they also meet premature deaths? That answer is not supplied, but their presence adds to the stages of womanhood included in the picture, for both grieving mother and elderly grandmother appear in the procession, so that from infancy to old age the cycle of life unfolds, in this case both beginning and ending in the grave. The specter of death frequently loomed in the minds of the Victorian viewer and reader; for the female audience this made the transition to womanhood all the more poignant and the safety of home and family all the more reassuring.

4
"Of Queens' Gardens" and the Model Victorian Lady

I. THE GODDESS OF THE HEARTH

JOHN RUSKIN'S PIVOTAL ESSAY "OF QUEENS' GARDENS," first published in 1865 in *Sesame and Lilies*, captures admirably the tone of quasi-religious homage to woman and her ability to exercise a redemptive influence on her husband and family. Ruskin's writings, which constitute a panegyric of nostalgia for the Middle Ages and its chivalric codes of courtly love, concisely define the image of perpetual maidenhood which English females were urged to emulate. In one of the most often-quoted passages, he delineates the role of women and envisions the home as a holy refuge of womblike safety: "Woman's power is for rule, not for battle—and her sweet intellect is not for invention or creation, but for sweet ordering, arrangement, and decision. . . . This is the true nature of home—it is the place of Peace: the shelter, not only from all injury, but from all terror, doubt, and division. . . ."[1] To Ruskin, the enshrinement of a woman at home or in the walled garden kept her pure, protected, and remote from the external world, yet she was paradoxically supposed to shield men from the trials and tribulations of daily existence. She thus created a safe haven of domesticity that was both a zone for male recuperation and a sanctuary for the moral edification of children and others. In these ways a woman's very weakness and "inferiority" ironically also became her sources of strength, for her superior maternal wisdom and religious instincts were allowed to rule supreme even over male authority in their unassailable citadel.

The helpmate described by Ruskin as possessing wifely self-sacrifice and generous maternal instincts is a recurrent figure in Victorian paintings. While the wife is often portrayed in magazines like *Punch* as self-absorbed, imperious, and even intimidating—typically engaged in her own friendships and interests, caught up in the social whirl, or dealing with servants, etc.—her counterpart in art usually exuded a madonnalike serenity and perfection. One of the best statements of this type of woman as a literal and emotional mainstay of the family is found in George Elgar Hicks's *Woman's Mission: Companion to Manhood* (Fig. 29) of 1863. This was the central section of a triptych entitled *Woman's Mission.* The finished flanking pictures are lost, but preliminary oil sketches of this and the pendants, *The Guide of Childhood* and *The Comfort of Old Age* (all three, Dunedin Public Art Gallery, New Zealand) exist. The *Times* described the trilogy as depicting "woman in three phases of her duties as ministering angel,"[2] an assertion reminiscent of Coventry Patmore's poetical invocation and epithet of "the angel in the house." Hicks himself believed that woman fulfilled a sacrosanct function as wife and mother and wrote, "I presume no woman will

Fig. 29. George Elgar Hicks. *Woman's Mission: Companion to Manhood*. 1863. Oil on canvas, 30 × 25¼. The Tate Gallery.

make up her mind to remain single, it is contrary to nature."[3] The three paintings predate Ruskin's 1865 essay but are replete with similar messages and exhortations of female duty and submissiveness. The *Art-Journal* remarked of the paintings that "the sentiment is refined, not over-profound—goes just skin deep, and carries a surface of exquisite polish."[4] Yet the exquisite details, along with the gloss of emotion, were all recognizable to viewers for their simplicity and legibility. In the first scene, *The Guide of Childhood*, the role of maternal support is explored in the person of a young woman leading her child along a woodland path and "turning aside a mischievous bramble which besets his steps," as the *Art-Journal* remarked. The upturned gaze of the child and his arms form with the mother's gesture a literal full circle, a perfect and unending cycle of female selflessness and loving dedication. The symbolic maternal role to guide children in a moral way and to inculcate values is also implied; that the female keeps her baby from stumbling through her own solicitude and vigilant attention is another extension of her motherly function. In the second scenario, *The Companion of Manhood,* a man is shown receiving bad news from a letter, which is bordered in a wide black margin and therefore connotes a death in his close family. His wife resolutely consoles him in a clinging yet gently supportive manner, sheltering him from additional assault from the outside world, keeping him emotionally secure in their "vestal temple of the hearth." Their home furnishings and the details of the interior attest to her talents as a homemaker: there is a well-laid-out breakfast on the table, carpet slippers (probably sewn by her) on his feet, a glowing fire in the fireplace, and prints and flowers on the mantel. Hicks's buttressing wife conforms as well to Mrs. Ellis's "vestal virgin," a selfless wife whom she exhorted in *The Women of England* of 1835 to heed the advice: ". . . Not only must a constant system of activity be established, but peace must be preserved, or happiness will be destroyed. . . . Not only must an appearance of outward order and comfort be kept up, but around every domestic scene there must be a strong wall of confidence, which no internal suspicion can undermine, no external enemy break through."[5] This is one of those parlor bastions of feminine altruism, and this devotion to the female's prescribed role is also evident in the last stage of this series. *The Comfort of Old Age* depicts "a dying father, sedulously watched and waited on by a daughter's affection,"[6] additional evidence of her selflessness. Yet signifi-

cantly, this series is in some ways representative of the phases of a man's life, too, not just a woman's—for in each the female remains young, faithful, and dedicated as she ministers first to a child, then a husband, then an aging father. In this panegyric of feminine virtue, however, the woman's existence is in each stage defined by the needs of a male. Victorian viewers probably recognized how much this image complied with prevailing ideas about the feminine mission, and in this respect the canvas succeeds both as propaganda and as a slice of middle-class life.[7]

The notion of a Ruskinian womblike home and haven also filtered into other representations of domesticity in a lower-class context, for example G. E. Hicks's 1857 watercolor entitled *The Sinews of Old England* (Fig. 30). Accompanied by the quotation "For there is a perennial nobleness, and even sacredness, in Work," this vignette captures the essence of England's ties or sinews with the working class. Predating the *Woman's Mission* series by a few years, the watercolor serves as a paean to the concept of work, of assigned roles and places in society, a subject also treated in the best-known exploration of this subject, Ford Madox Brown's 1852–65 *Work* (Manchester City Art Gallery). Hicks

Fig. 30. George Elgar Hicks. *The Sinews of Old England*. 1857. Watercolor, 29⅞ × 20⅞. Private collection, England.

depicts a young navvy or excavator, a laborer realistically shown in characteristic garb, wearing a bright handkerchief and "yarks," or buckled straps; such a worker toiled on roads and railways to help England toward its goal of progress, in the faith that progress would advance humanity. The woman has pinned up the front of her trailing skirt in order to avoid dirtying her frock, this gesture reminiscent of Mrs. Beeton's advice to careful housewives on the maintenance of their wardrobe.[8] Yet she is also rather muscular and ready to work, and she aspires to be a good housewife, as her neat attire and orderly kitchen indicate. Although of limited financial means, she has managed to acquire various pieces of china, some pieces used for the tea she has prepared. Her gaze focuses clearly on her husband in almost a parody of hero-worship, while he looks out firmly and assertively to the tasks and future that await him. The general posing of the figures anticipates that in *Woman's Mission: Companion to Manhood*, although the woman here is less of a supportive column than her middle-class counterpart. Yet she too maintains a welcome and secure household in this cottage setting. There is also a healthy blond offspring of this union; while the husband hoists a pick-axe over his shoulder as a sign of his profession, his baby plays with a wooden shovel in imitation of his father's work. Each person has a role in this picture and embodies it appropriately. Furthermore, the arched format of the watercolor, along with the inclusion of an ivied brick wall, recalls John Everett Millais's *A Huguenot* (see Fig. 63); here as in *A Huguenot* the clinging ivy alludes to the faithfulness of the pair and also to the woman clinging to her husband as the creeper does to the solid brick wall.

Fairly or not, the proper Victorian lady was often considered to be basically asexual (although the loose morality of the lower-class female was often alleged). The physician William Acton's now classic remarks in 1857 on this subject categorized wives as sexless and mistresses as sexy, for the modest woman "submits to her husband, but only to please him . . . and for the desire of maternity."[9] In a sense, the wife was also a moral savior for her spouse, for she "saved" her libidinous husband from the "sins" of his own sexuality. Acton's generalizations are obviously simplistic and prejudiced, since it is impossible to verify what actually transpired behind closed bedroom doors. Nonetheless, pure and submissive women who embodied such ideas were often referred to as "doves," and this

Fig. 31. John Brett. *Lady with a Dove.* 1864. Oil on canvas, 24 × 18. The Tate Gallery.

sobriquet also found its way into the titles of paintings. For example, William Powell Frith in 1869 painted *Two Doves*, a portrait of a young woman and a bird. The artist described the sitter as a "gentle-looking rather dove-like creature,"[10] the epitome of Victorian docility. This notion is also conveyed in John Brett's 1864 *Lady with a Dove* (Fig. 31). She is a contemporary, secular saint of sorts, the "angel in the house"[11] who typically whisked (or, more aptly, fluttered) through the halls of home to dispense comfort, cheer, and a sense of well-being and security. The dove atop her shoulder affirms her divinity and functions as a holy messenger symbolizing, in both ancient and Christian art, peace and purity.

Accordingly, the image of the Victorian woman was of a physically pretty and also virtuous creature. Like the biblical symbols of the enclosed garden, the spring shut up, and the sealed fountain in the Song of Songs, the Victorian lady and the domicile she inhabited were both confined entities, reflecting the comfortable if suffocating seclusion and closure of middle-class life. The solitary con-

Fig. 32. Charles W. Cope. *Life Well Spent*. 1862. Oil on canvas, 23¾ × 19¾. Christopher Wood Gallery.

finement of a woman, particularly a young woman, even in opulently appointed surroundings, was inevitable, and the enforced idleness or surfeit of leisure which resulted was uncritically depicted in countless works. In John Calcott Horsley's *The Pleasant Corner* of 1864, for example, a doe-eyed, madonnalike heroine nestles in a corner of the parlor, and even when the captivity is pleasant—as in Robert Martineau's 1863 *The Last Chapter,* where a pretty girl kneels down to finish a book by the last rays of firelight—the identification of the Victorian lady with the home was almost total. The apotheosis, if not the parthenogenesis, of fair womanhood, made this the almost exclusively feminine sphere of activity, making the parlor (or another room) and the environs of home (including the garden) a metaphor of the female and her functions. Paintings of the Victorian era thus serve as visual correlatives of the fact that politically, legally, culturally, and even sexually the Victorian wife and her daughters were quite housebound, enclosed by those same wainscoted walls that simultaneously formed her glorious temple. In literature of the period as well the metaphor of the lady enclosed or imprisoned in a room, tower, parlor, or domestic sphere proliferates in works ranging from George Eliot's *Middlemarch,* Alfred Lord Tennyson's "The Lady of Shalott," Thomas Hardy's *The Mayor of Casterbridge,* and Charles Dickens's *Little Dorrit.*[12]

It is thus only fitting that the womb of home was occupied by sacred motherhood, and in art the Victorian mother fulfilled those instructive, pure, and comforting traits expected of a modern Virgin Mother in her shrine. For example, in Charles W. Cope's 1862 Royal Academy picture entitled *Life Well Spent* (Fig. 32), the female parent presides in her drawingroom as a religious teacher. Even as she listens to her sons' lessons (perhaps their catechism recitations), she is not idle; she knits as she sweetly encourages their answers to her queries. Her mission is almost divinely sanctioned, for the nearby table serves almost as a quasialtar of domesticity and purity of spirit: atop the Bible are small prayer books, and a madonna lily is also among the tabletop still-life objects. The wooden panel directly behind this grouping of symbolic items is carved with the image of Christ and inscribed "Feed My Lambs." While Christ offers spiritual sustenance to his followers, this woman offers similar nourishment to her own "lambs" or children. Given her exemplary behavior, it is likely that her daughter—who already reads her lessons solemnly as she rocks the cradle of the youngest child—will

emulate her own example. The accompanying quotation from the scriptures underscores the watchfulness of this young mother over her "flock's" moral and physical welfare: "She openeth her mouth with wisdom, and in her tongue is the law of kindness. She looketh well to the ways of her household, and eateth not the bread of idleness. Her children arise up and call her blessed."

Originally *Life Well Spent* was joined in one frame with a now lost pendant entitled *Time Ill Spent.* The attentive homemaker is contrasted with the idle mother, whom the *Art-Journal* critic described as "addicted to French novels, and whose household is confusion. . . . Both are mirrors of real life."[13] While the angelic mother keeps all her offspring and their environment tidy, her counterpart is neglectful, and the *Athenaeum* remonstrated that her "tawdry charms receive more care than do her children."[14] Absorbed in her novel, the vain mother thinks only of her attire and herself and virtually ignores the children who rather reluctantly appear for their daily visit. She is so unfeeling that her baby is far more attached to her nurse, "whom she loves more than her foolish parent."[15] The quotation from Proverbs which Cope selected for this lady thus underscores her shallow and heedless nature: "Favour is deceitful, and beauty is vain,"

Fig. 33. William Nicol. *Quiet.* 1860. Oil on canvas, 18 × 15¼. York City Art Gallery, Burton Collection.

and the pair thus become a didactic contrast of idleness and industry as well as vanity and altruism.

A different amplification of this theme, with an even more expressive and physically intimate type of bonding, is captured in William Nicol's *Quiet* (Fig. 33) of 1860. If idleness and industry were the lessons of Cope's pair, then tenderness is the meaning of Nicol's vignette. The mother and child nestle together amid an array of beautiful patterns, the baby toying with a tendril of its mother's hair as she fondles him. The child is being read a tale from a book (maybe a juvenile publication) and the lady's soothing voice seems to have a pacifying effect on her toddler, who seems otherwise rambunctious and active, as one sockless foot suggests. Behind them is a vase with a cluster of flowers, the white rose conveying maternal purity and devotion and the unopened buds the nascent state of the child's development. In addition, the lady wears a love-knot brooch, its entwined form an emblem of her infinite dedication to her child and family. The

original frame for *Quiet* enhances these meanings with its decorations of acorns and other foliage with ivy leaves, the latter emblematic of both fidelity and marriage. The fruits of a happy union are thus depicted both on the frame itself and in its pictorial contents extolling domestic harmony and maternal love.

Such sentimentalizations of the mother and child relationship by Cope and Nicol are particularly interesting in light of the fact that many middle- and upper-class mothers left child care primarily to governesses or nursemaids and thus had minimal contact with their offspring except at certain prescribed times of the day. Nonetheless, the Victorians—much more than their eighteenth-century forebears—held children in great esteem, and the vast numbers of toys and books produced during this period just for juveniles attest to the importance of the child and its place in family life. Yet while portrayals of mothers and children abound, those of pregnant women are rare, much as Dr. Acton would have recommended. Women in this "inter-

Fig. 34. Frank Holl. *Doubtful Hope*. 1875. Oil on canvas. 37½ × 53½. The FORBES Magazine Collection, New York.

esting condition," as the euphemism described it, were invisible from public scrutiny in real life, and in art as well this private state of femininity was not deemed a suitable subject. Occasionally a peasant or lower-class woman is depicted with a cradle or a newborn babe, but the Victorian lady was very infrequently shown with the new baby, except after her period of "confinement," reclining on a chaise longue.

In depicting the lower-class mother, artists sometimes indulged in the saccharine, at other times in the stark or melancholy. Frank Holl was well-known for his somber, even gloomy, images of social realism, and among his works in this category is *Doubtful Hope* (Fig. 34) of 1875. A forlorn mother seems consumed by her anguish as she waits and hopes for a cure for her sick baby. The infants of working mothers were apparently often drugged to quiet them, yet here the shabbily dressed woman is desperate enough to have sought "professional" medical help in the apothecary shop or dispensary. The pathos of this drama is conveyed particularly by the figures' varying facial expressions and by their telling gestures—the contrast between the woman's sad countenance and her frozen pose of worry and weariness, the chemist's intense concentration as he readies a prescription or potion, and the clerk's seeming preoccupation with his own tasks. The woman numbly fingers a coin—hard-earned and reserved for an emergency—as she holds her child; although there is a male on each side of her, she is alone in her grief. Will science or the knowledge of medicine as represented on the right side of the canvas save her child? Will the indifferent figure at left symbolically mete out justice with the scales on the nearby counter? Will the large basket brought by the woman carry home her infant alive or dead? It is up to the viewer to decide just how tragic the denouement will be in this narrative.

Besides the theme of motherhood, the sheltered life of the Victorian young woman prior to marriage was a favorite subject in scores of Victorian paintings. The virginity of the Victorian female before wedlock was a predictable obsession among the middle and upper classes, and a strict subculture of chaperonage reinforced the quasi imprisonment of the proper young lady's existence. Consequently, females of this type were depicted in art behind high walls of feminine virtue—at a balcony, window, or bower, or in the parlor or garden, all perimeters of their segregated spheres of home. Both paintings and literature of the period mirrored

Fig. 35. Daniel Maclise. *Mary.* 1836. Etching and Engraving from *The Keepsake,* 1836. 4 × 5½. Private collection.

these lines of sexual and social demarcation, enshrining the ideal middle-class female in a pure, secluded interior or a walled garden. The latter was a recurrent motif as well as a cultural symbol of female innocence and unavailability. Young women are commonly represented in this sequestered environment in scores of *Keepsake* images, such as Daniel Maclise's 1836 *Mary* (Fig. 35) from the pages of the popular series, *Heath's Book of Beauty.* This single figure waits in a garden or arbor for a lover presumably to appear; the keys hanging from her dress suggest she has bypassed her chaperone to sneak away for a tryst, and as she waits she gazes at a locket with her suitor's image or lock of hair. Almost at her feet a cluster of madonna lilies grows and attests to her virginity—a floral symbol that recurred often in the series. A kindred representation is Ford Madox Brown's *The Nosegay* (Fig. 36), a watercolor dating from 1865–66. The brick wall encloses the woman's demure activities, and the pose is altered to one reminiscent of a sixteenth-century seated madonna of humility in her *hortus conclusus.*[16] Here as well the white lilies, along with the roses and pansies, allude to the female's unblemished sexual state and pure thoughts. The reinvention of a modern "Mary Garden" with its castellated or fortified walls preserving purity and

Fig. 36. Ford Madox Brown. *The Nosegay.* 1865–66. Watercolor, 18⅝ × 12¾. Ashmolean Museum, Oxford.

guarding richly symbolic blossoms appears also in several canvases by J. Atkinson Grimshaw, including his *Rector's Garden: Queen of the Lilies* (Fig. 37) of 1877. Painted at an actual garden at Yew Court, Scalby, and probably portraying the artist's handsome wife, the painting nonetheless personifies the Ruskinian definition of pure womanhood. Such works may initially seem subjectless, yet they are charged with undertones of sexual innocence, though often with romantic hints of an impending rendezvous. This type of vignette was repeated hundreds of times in Victorian art in various guises, including the classicizing mode of Alma-Tadema, for example, but the most common context was a decidedly bourgeois one. It was with repetition that the setting and the juxtaposition of the woman and the garden gained meaning, particularly to modern viewers who can catalogue and interpret these myriad pictorial examples. Such seemingly innocuous representations of females in high-walled gardens with flowers or pets convey a certain ambiguity ultimately about whether the imprisoned plaything is the animal or the woman

Fig. 37. J. Atkinson Grimshaw. *The Rector's Garden: Queen of the Lilies.* 1877. Oil on canvas, 31½ × 48. Harris Museum and Art Gallery.

Fig. 38. Walter Deverell. *A Pet*. 1852–53. Oil on canvas, 33 × 22½. The Tate Gallery.

herself. The rarefied atmosphere of the womblike garden also proved to be a key motif in courtship imagery (see chapter 6) and the lady is in effect metamorphized into a garden of purity (and also of pleasure), which must be kept, like the Virgin in the medieval *hortus conclusus*, ultimately inaccessible to men. Beneath these seemingly chaste tableaux of inactive women and flowers there is a hidden eroticism, with the underlying assumption of the woman as a thornless garden. The desirable, coy, and often expressionless ladies are invariably unaware of intrusion as they interact with plants or pets, such images of passivity reinforcing contemporary beliefs about feminine frailty, idleness, humility, and withdrawal into a dreamy sanctuary that barely contains its precious hothouse bloom.

But there could be a disturbing aspect inherent in Ruskin's notion "of queens' gardens," and an excellent example of this is Walter Deverell's *A Pet*

(Fig. 38). When it was exhibited at Liverpool in 1853, the painting was accompanied by an unidentified quotation: "But after all, it is only questionable kindness to make a pet of a creature so essentially volatile." This remark underscores the ambivalence of the title, and the subject of the picture remains enigmatic. Throughout the Victorian era, women with birds—caged or otherwise—proliferate in works with equally provocative titles like "The Prisoner." Perhaps Deverell had intended a specific literary source here; for example, *A Pet* approximates a scene in Wilkie Collins's 1852 novel *Basil: A Story of Modern Life*. Although in the painting there is a delicious uncertainty about which creature qualifies as the "pet," in Collins's fiction the woman is an evil, heartless heroine named Margaret Sherwin who lures and mistreats her pet. As this passage suggests, she was capable of cruelty as well. "She was standing opposite to it [a bird cage], making a plaything for the poor captive canary of a piece of sugar, which she rapidly offered and drew back again. . . ."[17]

The quasi-erotic relationship between the lady and the bird was also noticed quite early in the work's history, when Michael William Rossetti wrote about *A Pet* in 1853. In a letter he associated Deverell's canvas with a sonnet by his brother, "Beauty and the Bird," which he felt "might almost have been written to describe this painting."[18] Rossetti cited the poem in its entirety in his correspondence with Madox Brown, but it is the first eight lines which especially amplify the mood of passion and the intensity with which the young woman presses her lips against the cage. In those lines the lady "flutes" her mouth and her "fond bird" responds in musical tones with a love song of sorts. Furthermore, she nearly seems to kiss him when she takes some seeds and places them on her tongue, "which rosily peeped as a piercing bud between her lips" and where the feathered pet can peck at the proffered reward of food and affection. William Michael Rossetti remarked that the poem "probably however . . . refers to Miss Siddall, to whom the phrase 'golden hind' rightly applies, whereas the hair of the lady portrayed is dark."[19] Even this association of Elizabeth Siddal, Dante Gabriel Rossetti's former model turned painter, lover, and wife, is provocative, implying to modern eyes and ears that she too was a beautiful but fickle captive or pet.

In actuality this canvas was painted at Kew Gardens, where the artist's family lived at the time, and also may include one of Deverell's sisters as the

model.[20] Yet beneath the sweetness of circumscribed atmosphere and the seeming lack of anecdote lurk possible erotic undertones. Like its antecedents in seventeenth-century Dutch genre painting—which may have been known to Deverell, representations of females with birds were not always mere scenes of everyday life, but also sometimes connoted loose morals and seduction. In seventeenth-century Dutch (and German) parlance, the verb to copulate—*vogelen*—was derived from the word meaning bird—*vogel*—and consequently could be euphemistically used as a term for genitalia. In seventeenth-century Dutch painting, sexual and vanitas connotations were implied in depictions of caged birds, and images of birds being lured by food also had romantic meanings. If a bird succumbed to the sensual seduction of human affection or a bit of proffered food, its fate might be entrapment, and this was read as a metaphor for love or marriage. Stronger sexual allusions existed in the unfettered bird, the fleeing bird being typically emblematic of the pursuit of love and the pending loss of virginity.[21]

In several respects, then, *A Pet* was a sort of visual double-entendre, making the motif of a female with her caged bird a symbol of love and of captured virginity. It may also have connoted to spectators that females themselves were, as Mary Wollstonecraft argued in *A Vindication of the Rights of Woman* in 1792. "Confined, then, in cages like the feathered race, . . . [with] nothing to do but to plume themselves, and stalk with mock majesty from perch to perch. It is true that they are provided with food and raiment, for which they neither toil nor spin, but health, liberty, and virtue are given in exchange. . . ."[22] The imprisoned bird in such Victorian vignettes was thus a symbol both of vanity and of threatened innocence, while the dog in the picture may be emblematic of fidelity, still another response to his mistress's affection as she obliviously coos to her bird. The only witnesses to this scene, of course, are the animal captives themselves and the voyeuristic spectator. The female's closed eyes suggest a state of rapture, and the profiled contours of her body are both voluptuous and rigid as she communicates with her pet. Standing within the privacy afforded by high walls, she is shown as unaware of the viewer or of unwelcome ideas and callers who might have intruded upon her. Here and in scores of kindred examples the blossoms and the brick-walled garden, together with the female, form part of a demure camouflage, for in spite of their visual loveliness, the

sentimental image that results is one of acquiescence, of a woman kept imprisoned and denied flesh-and-blood vitality by her spiritualized attributes and her supernatural, enclosed surroundings. There is overt sexual allure in such insular environments—as with similar ones associated with the cult of the nun to be discussed in the next chapter, thus offering a "keyhole" glimpse into the realm of literally encloistered womanhood. In addition, like many pictures analyzed in this book, *A Pet* in its brick wall format owed a debt to Millais's archetypal *A Huguenot* of 1851.

While virtue prevailed in the majority of depictions of the lady in the Victorian drawing room, there were "modern life" representations of women who had gone astray from the prescribed path of righteousness and wifeliness. One representative "problem piece" with its characteristic open-ended outcome was Alfred Elmore's 1865 Royal Academy entry, *On the Brink* (Fig. 39). Here the setting has

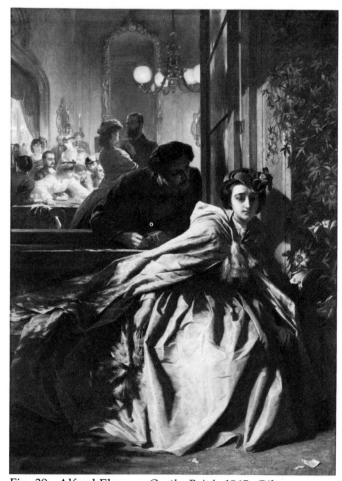

Fig. 39. Alfred Elmore. *On the Brink*. 1865. Oil on canvas mounted on wood, 45 × 32½. The Fitzwilliam Museum.

shifted from the moral enclosure of home or the romantic retreat of the garden to a hellish gambling den (probably in Homburg, Germany, since the artist witnessed a similar scene on a trip). Gambling saloons on the continent were notorious at the time and attracted the attention also of Victorian writers; for example, George Eliot in the 1860s placed some scenes from *Daniel Deronda* in a similar German den of iniquity. *On the Brink* caught the interest of many reviewers, the one for the *Art-Journal* remarking that the protagonist is "a lady who in high play has sustained fatal loss, rushes with empty purse from the scene of disaster and is here found 'on the brink' of certain ruin and possible suicide."[23] The *Athenaeum* expanded this interpretation by adding that "A man offers a fearful price to place her with a new chance of fortune at the table. . . ."[24] Every detail serves as a clue in the unfolding drama about a female gambler on the verge of succumbing to the greatest possible degradation, not loss of property but loss of virginity. The hellish glare of gaslight in the interior contrasts with the purple late-night shadows of moonlight, and between the two realms the man in the shadows beckons in temptation. The *Illustrated London News* asserted he was "whispering at her ear . . . offering her the wherewithal to return to the table, but at a price of ruinous slavery of obligation";[25] like Satan incarnate in the serpent, he hovers nearby to try to dissuade her from her pangs of conscience and thus to seduce her. Leaning over from a window, this devilish cad inhabits an interior which is hot and glaring, far removed from the amenities of a parlor. Glowing in red tones with a hellishness that is unmistakable and also bustling with almost feverish activity, this room is not a place for ladies. In fact, some of the women depicted may not be ladies at all, for they are shown flirting and eagerly conversing with the men around the gambling tables. An allusion may be intended to Hogarth's 1758–59 *The Lady's Last Stake*, another suspenseful tale of wavering feminine morality. At any rate, for the indecisive and distraught woman in the foreground, this is a moment of crisis; while the torn note on the ground may refer to her lost fortunes, the passion flowers signifying susceptibility and the drooping lily virginity in jeopardy suggest that the finale will be an anguished one.[26]

The marital status of Elmore's agonized gambler is unclear, but this is not the case in other representations of fallen women or wives. What happened when the married female abused her role as cor-

nerstone of the home and domestic tranquillity is captured in Augustus Egg's 1858 three-part unnamed series, now known as *Past and Present*. The first scene (Fig. 40) of this tripartite tour de force reveals a husband's discovery of his wife's adultery. A riveting *pièce de théâtre*, this opening scenario is staged in a middle-class drawing room that will soon be tragically destroyed and transformed by the wife's betrayal. Adultery committed by a woman was not a common central theme in Victorian novels when Egg painted his series, but one novel of 1834, *The Admiral's Daughter* by Mrs. Anne Marsh, did include a shattering scene in which she is confronted with a letter and in prostrate grief admits she has defiled her husband's trust. But a more topical reason for this subject lies in the fact that in 1857 new divorce laws were passed in England that made it easier to obtain a divorce through civil courts and not by Act of Parliament.[27]

In Egg's reconstruction, a husband has just returned from a journey, as his valise, mackintosh, and umbrella suggest, and he has found an incriminating pink letter that reveals his spouse's infamy. He responds by casting the note and his wife's "shame like a dash of vitriol full in her face."[28] Felled by this, her body points toward the door (reflected in the window), symbolic of her outcast status and forced removal from society. Swooning, she lies literally fallen, her arms braceleted with snake motifs emblematic of her transgression of sexual temptation. The fragile house of cards being built by the two daughters simultaneously collapses as the family's stability and respectability disintegrate, and there may be an allusion intended to seventeenth-century Dutch genre scenes with their complex and negative connotations of card playing as corrupting amusements. In particular, when children were represented playing cards, there were allusions to mischief, evil, deception, vanity, and even amorousness, for the dangers of love were part of this game of chance. It is not clear whether the girls themselves are therefore going to emulate their mother's sins, but this may be a possibility. In addition, the book that supports their card game is entitled *"Balzac,"* and this French author was perceived generally in England as being a purveyor of immoral or amoral attitudes towards adultery.[29] Benumbed in his chair, the husband pounds one fist on the table and tramples part of the letter beneath his foot, doing violence to an inanimate object rather than to his wife. Her culpability is compounded not only by the serpentine jewelry

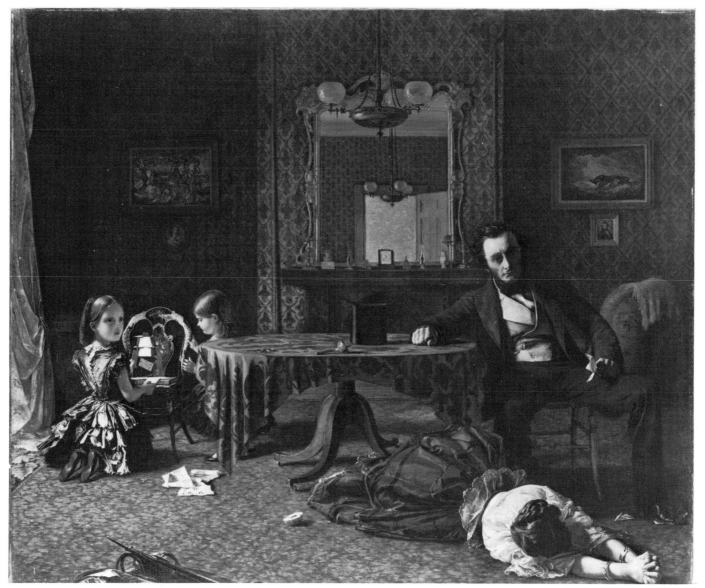

Fig. 40. Augustus Egg. *Past and Present, No. 1*. 1858. Oil on canvas, 25 × 30. The Tate Gallery.

she wears, but also by other allusions to Eve's disobedience and her surrender to Satan's temptations. The woman has been cutting an apple, the forbidden fruit taken from the Tree of Knowledge in the Garden of Eden; the still life on the blood-red tablecloth of a half apple pierced by a knife evokes the violence of the woman's deed and the stabbing pain she has inflicted on her more passive spouse. To extend the biblical associations, Egg includes the other half of the apple, which is wormy and has, like the woman, symbolically fallen to the floor.

Other objects support this sordid narrative. Above the small oval portrait of the wife at left is a representation of the expulsion of Adam and Eve from the Garden of Eden. It is balanced at right above the husband's portrait with Clarkson Stan-

field's *The Abandoned*, a painting of a storm-tossed, dismasted boat at sea. This nautical scene mirrors the fate of the husband, who like a wrecked ship will flounder and drift aimlessly before ultimately perishing (the motif recurs in the third section, see chapter 9 for exegesis of the finale). The homey nest of the family has been abused, so that the mirror above the mantelpiece bears no human reflections, only emptiness and harsh artificial lighting and the glimpse of an open window with patterned green foliage beyond. This garden outside the stricken parlor may allude to Holman Hunt's saga of a kept woman in *The Awakening Conscience* of 1854 (see Fig. 114). It is presumably out of this hitherto happy domestic "paradise" that the unfaithful wife must exit in order to face the

cruel penalties of social censure and abandonment. The enclosed garden of feminine virtue and home tranquillity is no longer her territory and will be replaced in the denouement with a foul and dangerous urban setting, for she will end up under the dank arches of a London bridge which was described by a contemporary writer as "the inferno of the Adelphi arches . . . the lowest of all the profound depths of human abandonment in this metropolis."[30]

The reaction of the press to *Past and Present* is an index to the era's preference for art with consoling or uplifting context and influences. The paintings provoked widespread criticism because the subject matter was deemed too ghastly and too realistic. As the *Athenaeum* reviewer stated, the series was "painted with such an unhealthy determination to dissect horror and to catalogue the dissecting room that we turn from what is a real and possible terror as from an impure thing that seems out of place in a gallery of laughing brightness, where young, unstained, unpained and happy faces come to chat and trifle. There must be a line drawn as to where the horrors that should not be painted for public and innocent sight begin, and we think Mr. Egg has put one foot at least beyond this line."[31] Such journalistic branding of the darker side of domestic subjects as terrible, loathsome, and inappropriate help to explain retrospectively why depictions of "safe" themes like womanly duty or those with a moral intention—i.e., the repentance of fallen women—proliferated instead. Victorians were thus in literature, art, and even real life given a heavy and sugary dose of ideal womanhood, immune to the moral imperfections of Egg's scandalous adulteress.

II. THE MIDDLE-CLASS HEROINE

The real Victorian heroine was simply the anonymous but morally omnipotent wife, Ruskin's guardian of the "place of Peace" as exemplified by the vignettes of sacred motherhood and wifeliness already described and by a work such as J. E. Millais's 1856 *Peace Concluded* (Fig. 41). Here the wife nearly envelops her recuperating husband (probably home on sick leave from the Crimean War), encircling him in an embrace that is as much maternal as otherwise. Her abiding affection and devotion are symbolized by the large myrtle plant nearby, for myrtle leaves were commonly associated with love, and the leaves even form a halo

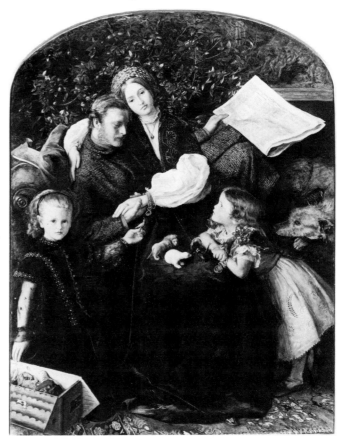

Fig. 41. John Everett Millais. *Peace Concluded.* 1856. Oil on canvas, 46 × 36. The Minneapolis Institute of Arts.

effect behind her head. As the *Art-Journal* reviewer said of this madonnalike woman, "The proposed sentiment upon the part of the wife is an inward tumultuous gratitude, too large and impetuous for mere words, for it has filled the citadel of her heart, and for a time overpowered the tongue to silence. . . ."[32] The peacemaker and preserver of domestic happiness, it is she who really presides over the group. She is even more visually prominent than her officer-spouse, who reclines on a sofa with a copy of the *Times* that announces the "conclusion of Peace" in the Crimea.[33] The separate spheres of the sexes are established, hers the home and his the often brutal outside world. Yet she may well have concurred with the sort of delineation of female roles mentioned in George Eliot's 1860 novel *Amos Barton: Scenes of Clerical Life:* "A loving woman's world lies within the four walls of her own home; and it is only through her husband that she is in any electric communication with the world beyond."[34]

The children in this painting also play significant roles, and the *Spectator* hypothesized that the wistful gaze of the child looking up intently at her

father indicated that "she had hardly got well acquainted with him yet."[35] Yet she too may be enacting a symbolic role as peacemaker, for the political circumstances of the subject—the pending peace treaty—are alluded to by the dove with an olive branch being given to the father. The other toys in their Noah's Ark also generate emblematic meaning, and the *Art-Journal* remarked that the warring nations or "four belligerent powers" were typified by a lion, a bear, a cock, and a turkey. But in spite of these political undertones it is the towering presence of the wife with her mountain of chestnut hair that rules as the feminized spirit of harmony and solicitude. In spite of her alleged weakness and inferiority, there is an inner strength which comes through in such pictures, a combination of the Victorian lady's maternalism and pacifism. Women mended the psyches of their injured families and husbands, and this benevolent nursing appeared in many other paintings in which war is a theme, with the implication that men are the aggressors or victims of wartime and women the preservers of life and tranquillity.

However, there were other dimensions to feminine heroism than the image of stalwart forbearance in the drawing room, most often figures culled from past history or even current events. As might be expected, there were portraits of eminent Victorian women of character, courage, and achievement, but in the realm of genre pictures this subject was relatively rare. Perhaps the most illustrious contemporary heroine was Florence Nightingale, who deplored the enforced idleness of middle-class life and instead struggled almost singlehandedly to reform the hitherto disreputable profession of nursing. Her greatest impact was on hospital procedures and policies, which she revolutionized during the Crimean War, and it was her battlefront dedication to this cause which earned her accolades. In spite of her fame, however, few pictures actually chronicle her amazing accomplishments, although several portraits exist. One example of a painting that immortalizes her contributions to Victorian society is Jerry Barrett's 1858 *The Mission of Mercy—Florence Nightingale Receiving the Wounded at Scutari, 1856* (Fig. 42). In the final version, the artist himself appears as a face at the window, for he was actually visiting Crimea about this time.[36] The work proved so popular that Thomas Agnew and Sons published an engraving with a key to the identities of all the persons depicted, including Mrs. Bracebridge, a close friend of "The Lady with the Lamp." Even Queen Victoria

Fig. 42. Jerry Barrett. *The Mission of Mercy. Florence Nightingale Receiving the Wounded at Scutari in 1856.* Ca. 1857. Oil on canvas, 16 × 24. National Portrait Gallery, London.

was interested in seeing the finished picture, according to a letter from Barrett,[37] for Nightingale's effective handling of the cholera epidemic in wartorn Crimea merited even royal attention. The "angel of mercy," as she was called (and even this nickname seems an unconscious permutation of the "angel in the house" syndrome), and her band of trained nurses thus almost immediately stirred the hearts and conscience of mid-Victorian England, and her pioneering attempts to reform hospital techniques had dramatic results. An upperclass, well-educated, and altruistic lady, Nightingale often expressed frustration at the restrictions for meaningful work placed upon a woman of her breeding and class. This modern history picture blends the real with the legendary in quasi-religious terms, for Nightingale is shown surrounded by "disciples" and raising her hand in a gesture of benediction, much like Christ performing a miracle. Exceptional in her desire to do good on such a large scale, she was hailed as a selfless "ministering angel" and Barrett's *Mission of Mercy* was lauded by *The Athenaeum* for having "redeemed English Protestant women from an old reproach; it showed us a Joan of Arc with the sword put away, and doing a nobler work."[38] Like Brett's *Lady with a Dove*, Nightingale was perceived as a saintly individual and eulogized in scores of poems, songs, articles, and broadsheets. Barrett painted other female heroines, too, including a related work which may have been intended as a patriotic pendant, *Albert and Victoria Visiting the Wounded at Chatham Hospital in 1855*.

The bravery of women outside of their normal domestic realm was also confirmed by other ennob-

Fig. 43. W. H. Simmons, after J. Noel Paton. *In Memoriam*. 1862. Engraving and stipple-engraving (with arched top), 34 × 27. Christopher Wood Gallery.

ling images of them on the battlefield. Many of these referred to the Indian Mutiny, and artists like Frederick Goodall, Abraham Solomon, Edward Hopley, and others followed shortly after this tragedy with canvases commemorating the steadfast bravery of the female victims. Hundreds of women and children were murdered in the Cawnpore massacre of 1857, and the siege of Lucknow in India also sorely tested the fortitude of the English women and men in the garrison there. A number of accounts and diaries were published on this ordeal, and one written by a chaplain's wife who was at Lucknow chronicled the constant firing upon the garrison and the deaths of the old and young alike amid this turmoil. A classical statement of this bloody struggle seen in terms of the females who survived it is found in an engraving after Joseph Noel Paton's lost painting, *In Memoriam* (Fig. 43) of 1862.[39] The canvas on which it was based dated from four years earlier and was inscribed "Designed to Commemorate the Christian Heroism of the British Ladies in India during the Mutiny of 1857, and their ultimate deliverance by British Prowess." The original version of the painting de-

picted Indian sepoys breaking into the subterranean chamber with their bayonets bared, but this rather gruesome scenario was modified into the happy ending shown here with the triumphant Highlanders arriving to rescue the group. In one lady's firsthand account, she noted that "the officers and engineers had announced that no human skill could avert their fate for twenty-four hours longer, and they must all prepare to die together."[40] Later a young Scotswoman recalled the sound of bagpipes amid the roar of cannons and musketry: "at that moment we seemed indeed to hear the voice of God in the distance, when the pibroch of the Highlanders brought us tidings of deliverance."[41] The editing of the subject here to include the Highlanders instead of the enemy forces was no doubt due to the bloodiness of the encounter, which was still fresh in the memory of the Victorian public. Instead Paton has chosen to paint a scene which one female survivor recalled about the dramatic rescue: "All by one simultaneous impulse, fell upon their knees, and nothing was heard but bursting sobs and the murmured voice of prayer."[42] A quotation accompanying the engraving underscores the power of faith in such a crisis: "Yea though I walk through the valley of the shadow of death, yet thou art with me."

Inspired by her religious faith, the central figure in Paton's *In Memoriam* holds a prayer book and casts her eyes and thoughts upward to heaven in her role as saintly martyr and modern heroine. Around her nestle various children, and whether these are her own or those orphaned by the fighting, they all look to her for strength or cling to her for motherly protection. Many babies perished from gunshot wounds or illness, and it is not clear whether the smallest children are already dead or merely have fallen asleep out of exhaustion. At the right an Indian nursemaid or ayah looks up fearfully as the other females pray or comfort one another; perhaps this "alien" woman fears being slaughtered by her own people or the Highlanders and beseeches her own god for deliverance. While the men charge through the door and serve as active rescuers or deliverers, the females personify Christian belief and fortitude in the midst of impending doom and recall one contemporary's description of "the passive endurance of the ladies of Lucknow, their domestic calamities, and their sacred patience."

A more unsung and unnoticed heroine was the impoverished but genteel middle-class (or slightly lower) Victorian woman who chose the drastic so-

lution of leaving England in order to improve her lot. Unmarried and invariably unqualified for real employment outside the home, she was often viewed as a "superfluous" or "redundant" being due to the demographic reality in midcentury and beyond of surplus numbers of Englishwomen. In the late 1850s and 1860s the stirrings of feminism, severe signs of economic crisis, and other factors stimulated public interest in encouraging distressed middle-class females to emigrate.[43] (Women of lower classes, for example needleworkers, were included in some schemes, but their fate was rarely the object of pictorial interest.) To some organizations such a plan offered a possible marital resolution to participants, while feminist groups deemed it a means to assert independence, financially and otherwise; either way, emigration was no panacea for the social ills faced by women, who had to defy social convention, unsavory conditions, a rough trip by sea, and other hardships. The Female Middle Class Em-

igration Society, for example, founded in 1862, endorsed emigration as a remedy for select single females, but only a few hundred women benefited from these efforts. Generally, the social justification for this scheme was that the civilizing and moralizing influence of women was needed even in penal colony settlements, where the gentling female presence might elevate standards of conduct and respectability.

Colonial exile, especially to Canada or Australia, was one alternative, indeed the one that *Punch* most often seized upon in numerous cartoons. *Punch* usually represented spinsters as homely, bespectacled, and ungainly, a harsh stereotype of ugliness attested to, for example, in an 1854 cartoon entitled "How to Get Rid of an Old Woman" (Fig. 44). (The face of the figure also resembles that either of Lord Palmerston or Lord Aberdeen, clearly a political reference.) It is not known who drew this cartoon/caricature, but the message conveyed about how to cope with the surplus population of females is quite clear. A handbill advertises for "nurses" (a profession previously held by many fallen women or camp followers and made respectable only by Nightingale's campaigns) in "The East." Yet actual accounts underscored the need for considerable valor, adaptability, and resourcefulness to undertake such an enterprise. And far from being helpless females or pathetic, empty-headed victims of circumstance, the governesses and other women who emigrated were often very strong both mentally and physically.

By contrast, representations of the female emigrant in paintings mollified *Punch*'s acerbity considerably, often making her merely one human element among groups of families, orphans, or other valiant souls of both sexes departing their homeland. This is the case, for example, in Ford Madox Brown's 1852–65 *The Last of England* (Fig. 45), in which the woman faces the unknown future perils along with her husband and child. Compared with the stereotype of unwed unattractiveness in *Punch*, such a work nearly monumentalizes the woman and child (with the man) as a Victorian equivalent to the Holy Family, here on its flight from England, not Egypt. Brown utilized his own family as models for this middle-class couple, forging a statement that also expressed his own dissatisfaction with his life (for he had also contemplated emigration at one point as a remedy to his poverty). The woman, a modern madonna with a beatific and earnest expression,

HOW TO GET RID OF AN OLD WOMAN.

Fig. 44. Artist unknown. "How to Get Rid of an Old Woman." 1854. Wood engraving from *Punch*, 1854.

Fig. 45. Ford Madox Brown. *The Last of England.* 1852–65. Oil on panel. 32½ × 29½. By courtesy of Birmingham Museums and Art Gallery.

shelters her child beneath a shawl, a comforting and protective gesture recalling Millais's heroine in *Peace Concluded*. She looks out into the unknown and feels the cold blasts of air while her husband, in the artist's own words, "broods bitterly over blighted hopes, and severance from all he has been striving for."[44] In the sonnet Brown later wrote to accompany the picture when it was exhibited in 1865 are the lines "She grips his listless hand and clasps her child,/ Through rainbow tears she sees a sunnier gleam,/ She cannot see a void, where HE will be."[45] The poem thus ends on an optimistic note praising the exalted courage and life-giving faith of the woman who follows her husband, almost in the biblical sense, to a new world and a new life. Like many other depictions of the contemporary heroine in paintings, she is passive and timorously ladylike and yet endowed with phenomenal fortitude that reveals the paradox of her femininity in Victorian minds. And as Ruskin wrote in "Of Queens' Gardens" of the ideal woman's ability to create a home and domesticity wherever she went, "Wherever a true wife comes . . . home is always around her. The stars only may be over her head; the glowworm in the night-cold

grass may be the only fire at her foot; but home is yet wherever she is; and for a noble woman it stretches far round her, better than ceiled with cedar, or painted with vermilion, shedding its quiet light far, for those who else were homeless."[46]

Yet by the end of the century there could be some doubt communicated about the pressures the Victorian woman withstood under the burden of fulfilling the roles of life-giver or preserver and dutiful wife or mother in times of national or personal upheaval. This anxiety surfaces in Byam Shaw's haunting *Boer War, 1900* (Fig. 46), painted and exhibited in 1901 at the Royal Academy and accompanied with these lines from Christina Rossetti's poetry: "Last summer green things were greener, brambles fewer, the blue sky bluer." Like a distracted Ophelia in modern attire, a rather distraught-looking young woman gnaws on her fingernails as she pauses on the edge of a brook or stream. A skein of bright wool hangs limply in one hand, for the bad news of war and the possible loss of a loved one have so unnerved the woman that she cannot perform her domestic duties. Her life, like the tangled threads she holds, is suddenly disordered and incomplete. Even the natural beauty and abundance of the setting (with some foliage that may connote sorrow) cannot console her, and she seems paralyzed with indecision and transfixed by the dark waters at her feet. Is she contemplating her own self-destruction or merely cursing the memory of past idylls on this bank? In truth the woman is the artist's sister, who was at the time mourning the death of a cousin killed in the Boer War. But the protagonist also functions as an "Everywoman" of sorts, and there is no narrative resolution as she stares blankly into the watery void as if it were a mirror of truth for a modern Lady of Shalott. Once a place of romance and fertility, this nook in nature is now wild and overgrown with brambles, the latter emblematic of the thorny tribulations that the female—alone, powerless, a modern Penelope on the home front—must endure. Furthermore, the presence of a hovering raven (symbolic of death) heightens the ominous mood. The ostensible title is *The Boer War*, but this is not a scene of bloody military campaign waged by men; instead it is an embodiment of the heroism of Englishwomen at home and of the personal sacrifices they made for their country and for their families.

Fig. 46. J. Byam Shaw. *The Boer War, 1900*. 1901. Oil on canvas, 39⅜ × 29½. By courtesy of Birmingham Museums and Art Gallery.

III. THE LADY OF FASHION AND LEISURE

The lady of fashion was a bellwether in the changing patterns of belief during Victoria's long reign.[47] Much of the time the middle- and upper-class lady seemed to exemplify Thorstein Veblen's late-century theory of conspicuous consumption and display of her husband's riches and social status, with conspicuous leisure and elaborate attire both attesting to the wearer's need for servants and others to produce her appearance. Moreover, a woman's sartorial style was a means of communicating with others within the social hierarchy. As the author of the "Art of Dress" wrote in 1847 for the *Quarterly Review*, "Dress becomes a very symbolic language—a kind of personal glossary—a special of body phrenology, the study of which it would be madness to neglect."[48] Thus, contemporaries also recognized that "every woman walks about with a placard on which her leading qualities are advertised."[49] Correct dress, like proper etiquette, was among a lady's principal adornments of breeding, and during the nineteenth century, in England especially, very elaborate rituals developed about what to wear at precise occasions or moments of the day. These details were the fare not only of such fashion periodicals as the *Ladies Treasury* and *Townsend's Costumes,* and of the columns on the latest Parisian fads in the *Illustrated London News,* but also in the pages of contemporary novels.[50] Readers knew the differences between appropriate garb for morning, afternoon, or evening events, as well as for walking, visiting, balls, mourning, court appearances, teas, traveling, and house or country activities.

Enforced ladylike idleness in the drawing room was literally reinforced by certain garments—for example, the midcentury tight sleeves, full, bell-shaped skirts, bulky petticoats, huge crinolines that impeded locomotion, and, of course, stays and the corset. The bodily curves of the hourglass figure were mostly artificially induced, a very symbol of womanly weakness, (as well as an unconscious sadomasochistic one); accordingly, many men expressed the opinion that corsets were a contrivance that inflamed the passions of one sex while curtailing those of the other.[51] The invisible challenge beneath voluminous dresses was enticing in itself, and the exaggerations of bust, hips, tiny waist, and derrière at different times during the century signaled a new sexiness for that particular body area.

Moreover, women often seemed to be "buried" in surface ornament (e.g., in flamboyantly trimmed gowns or hats), yet there was a certain degree of exhibitionism evident when female bosoms were ironically bared at night for fancy balls. Countless society portraits and even genre pictures unconsciously reflect the Victorian lady as a literal fashion plate, an exquisite creature whose garb might reveal more character than her face. *Haute couture* was in itself part of the contemporary appeal of a painting, with viewers (especially women) noting carefully the individual accessories that signified the wearer's station in life. While the women in elegant attire in paintings might sometimes seem like wooden mannequins, those fashionable females who appeared in the pages of magazines like *Punch* often revealed another side of the subject. For example, in numerous cartoons men often appear almost dwarfed by their dome-shaped female companions wearing hoops, and these ladies frequently seem lost in, or at least quite hampered by, their garments.

The importance of dressing properly is underscored by the etiquette of mourning borne mostly by the women of a family, for it was they who wore the full, half, and quarter-mourning colors and accoutrements to grieve on behalf of their relatives and their husband's. The restrictions for widows

Fig. 47. Richard Redgrave. *Throwing Off Her Weeds.* 1846. Oil on panel, 30 × 24. By courtesy of the Board of Trustees of the Victoria and Albert Museum.

were quite rigid and often long-term, with ladies in this category rarely returning to bright colors in apparel for the remainder of their lives. This predicament underlies the situation in Richard Redgrave's *Throwing Off Her Weeds* (Fig. 47) of 1846, a depiction of a woman's return to life after the deadness of mourning. The rather young widow has shocked the standards of modern society by stripping off "her sables for less sombre clothing,"[52] actions which constitute a prelude to her forthcoming remarriage. Such behavior was considered coarse, or as a writer for the *Critic* complained, "This is going too far for good taste in the lady, who, it should be remembered, is yet attired in mourning."[53] The figure's deportment also rankled the *Art-Union:* "The engagement of the widow is indelicately announced by the hasty entrance of the officer, which is assuredly ill-timed and ill-judged. . . ."[54] In this version the officer has been painted out, and it is an all-female drama except for the portrait of a male relative (or perhaps the deceased spouse) that peers down on the scene from above a screen. The screen is patterned with foliage and grapes, suggestive of fertility, and the trellis pattern on the wall at right also suggests ironically a symbol of fidelity. As a bird cage dangles above her—perhaps an allusion to the "gilded cage" of middle-class life—the lady considers various light-colored fabrics for her new dress, the hues in themselves an indication she is relinquishing her black garb or "widow's weeds." Both her maid and her friend or dressmaker seem to encourage her actions; in addition to the bolts of cloth, the sprig of orange blossoms on the vanity table and other details portend the woman's future nuptials.

In addition to cultivating a thorough knowledge of the right way to bedeck herself, a woman of middle-class stature or higher adhered to rigid codes for receiving and paying calls. Special apparel was to be worn by both the caller and the hostess, and only a limited range of topics—mostly small talk—was permissible during the brief (fifteen-minute) visit.[55] This is the ostensible theme in Frederick Walker's *Strange Faces* (Fig. 48) of 1862, in which the believable appearance of the little girl clinging to her smiling mother and the posture of the well-dressed lady trying to allay the child's fears contribute to the casual mood of the picture. According to etiquette, a lady was not to remove her shawl, mantle, or bonnet during a visit and a gentleman who placed his hat, stick, or gloves on the hallstand was considered ill-mannered, since this was a liberty only given inhabitants of the

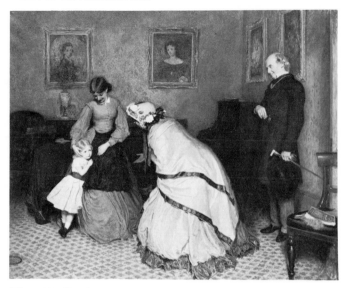

Fig. 48. Frederick Walker. *Strange Faces.* 1862. Watercolor and bodycolor on paper with white ground, heavy gum arabic, 26 × 31¼. Yale Center for British Art.

house.[56] Such formalities are preserved in *Strange Faces*, in which the man stands somewhat as an outsider on the threshold while the two women talk to and teach the child about the "right" behavior. Little girls would soon have to overcome their anxieties about "strange faces" in the process of paying calls, and this lesson is gently being reinforced here by the "civilizing" influences of the ladies.

The wealthy constituting the fabled "upper ten thousand" aristocrats lived primarily in Mayfair, Belgravia, and other chic areas of London, and it was their patterns of behavior which defined the late century cycles of the social Season, which ran roughly from the end of April to the close of July.[57] Their lives revolved around a number of almost obligatory functions—the public ones including the races at Derby, Ascot, and Goodwood, boating competitions at the famed Henley Regatta, Harrow and Eton cricket matches, and viewings (especially private ones) at the Royal Academy. Among the entertainments a lady took privately were charity work and bazaars, at-home receptions, concerts, breakfast teas, lunch or garden parties, balls, evening and court receptions, theater and the opera, and art galleries. Ladies usually chose the late morning and early afternoon hours to write letters, read, play cards, or shop. They also regularly found time to stroll, drive, and above all to see and be seen along the prestigious "Rotten Row" portion of Hyde Park—but never to do so alone, or with a male other than a close relative, a fiancé, or a groomsman. The responsibility of paying calls and

leaving cards (the latter according to an excruciatingly complex system) belonged to the lady of the house, and the feminine rituals of politeness that ensued in situations like that in *Strange Faces* could be fraught with complexities or an air of punctiliousness and compulsive "correctness."

One of the many representations of the leisured life of the middle-class female is Abraham Solomon's 1856 *Doubtful Fortune* (Fig. 49). As the title implies, the subject concerns the dubiousness of foretelling the future, particularly in a mere parlor game. When it was exhibited, the canvas was described as an exercise in rendering elaborate costume and millinery, and indeed Solomon has faithfully re-created the flounces and coiffures of contemporary fashion.[58] Although to modern eyes the figures seem to comply with the *Keepsake* brand of rather simperingly sweet comeliness, various reviewers at the time judged them to be realistic depictions, "graceful and natural, not characterized by that mistaken refinement which paints angels instead of women."[59] There is a mood of collective reverie as the females seemingly share a dream,

Fig. 49. Abraham Solomon. *Doubtful Fortune.* 1856. Oil on panel (with arched top), 15½ × 12. The Suzanne and Edmund J. McCormick Collection.

perhaps of matrimonial aspirations, for romance is alluded to in the inclusion of a cupidlike statue and a carved bluebird of happiness on the table leg.[60] This cozy domestic scenario—very Victorian compared with earlier treatments in art of the fortuneteller theme by Caravaggio and others—also reflects the contemporary fascination with the occult, table-rapping, and spiritualism. In lieu of a scurrilous or ragged old woman reading palms or cheating customers (especially males), the females themselves play at predicting the future by consulting tarot cards. The arched top is reminiscent of Millais's *A Huguenot;* moreover, the curtain parts on this coy vignette to reveal a garden in the background, perhaps an allusion to girlhood innocence as well as to the place where trysts would be staged. Once again the dark and light-haired physical opposites are paired, here not as rivals but possibly as temperamental opposites.

Perhaps the pinnacle of a lady's life of privilege was the possibility of being presented at court in the white robes of a debutante at one of the four annual royal drawing-room events. A young lady had to be sponsored by a married former debutante and had to be the daughter or wife of members of the aristocracy, the country or town gentry, or prominent members of the legal, military, clerical, medical, banking, merchant, or business classes.[61] The differentiation among classes at this high level was manifested at this occasion by whether the daughter kissed the queen's hand or was kissed by Her Majesty. Such glamour and luxury held their obvious appeal for artists, and the spectacles of presentation balls, private parties, and lavish receptions were reported in words and images in various magazines. It was a less popular subject in art, however, and James Hayllar's *Going to Court* (Fig. 50) of 1863 is one of the nonportrait depictions of this subject. The two young women, probably sisters given their similar facial features, are embedded in a sea of tulle and lace inside their carriage. Their crowns, feathers, fans, and dresses indicate that they are about to be presented, and the rose blossom in the lower left suggests their girlish ardor on this occasion. The composition evokes Augustus Egg's well-known *Travelling Companions* (Fig. 18) not only in the twinned young women, but also in the window aperture in the background with its shade and tassel danging. From their snug and undeniably superior station in life—and the safe, chrysalislike confines of a carriage that symbolizes their family's wealth and status—the pair of debutantes can look out at the

Fig. 50. James Hayllar. *Going to Court*. 1863. Oil on canvas, 24 × 29½. Christopher Wood Gallery.

world that passes by. Two young women walking on the street eye the vehicle, perhaps with envy, but no visible emotion is expressed on the faces of the debutantes.

James J. Tissot also frequently chronicles this opulent lifestyle, sometimes making the personages elegant but also cautious or guarded in their emotional responses. Yet at other times this temporary expatriate in England depicted the vicissitudes of social faux pas, as in his drama of feminine embarrassment in *Too Early* (Fig. 51) of 1873. Tissot was adept at subtly evoking, often quite wittily, the superficiality and yet the dazzling brilliance of British, particularly London, high life. Here the social "tragedy" consists of the young lady's premature arrival at a party. The posture of the disgraced

Fig. 51. James J. Tissot. *Too Early*. 1873. Oil on canvas, 28⅛ × 40. The Guildhall Art Gallery, City of London.

debutante communicates shame and humiliation, for her head is bowed and nearly touches her fan, and unlike the other people in the room, she stares at the floor, not at any of the other persons. The emptiness of the room is emphasized by the gleaming waxed floor, and pools of light distinguish three groups of observers as well as the psychic distance between each group and the "excommunicated" woman. The mistress of the house at upper left, for example, is still in the process of instructing the musicians about the evening's concert. The lady and the gentleman slouching casually in the doorway also convey that the formal party has not yet begun. The two females and the elderly man in the center of the room also seem to be pondering the early arrival, although the gentleman seems more sympathetic in expression than the rather smug females, presumably his daughters. Even the female servants of the household realize that a gauche act has been committed, and they peek out of the door to examine the embarrassed debutante in pink. There is a hint of slick humor in Tissot's representation, and perhaps this is why reviewers at times not only criticized the vulgar attention the artist lavished on what was deemed an unnecessary amount of petticoat and stocking exposed to viewers, but also believed that in this accumulation of luxurious detail Tissot wanted "to satirize the British plutocracy."[62]

While some of Tissot's poses or accessories might occasionally raise an eyebrow among critics, the more radical options to conventional dress virtually never appeared in paintings. One of the "challenges" to the prevailing standards of femininity throughout the Victorian era was found in the garment known as "bloomers," which first appeared in the late 1840s and 1850s and were associated with dangerously mannish (and also American) behavior in various articles and cartoons. The note of sexual ambiguity injected by such masculine innovations in attire remained a lingering threat through the end of the century and beyond, and paintings of women in this taboo garment are exceedingly rare. *Punch* often lampooned the wearers, stereotyping them as "strong-minded" creatures who were defiant in their choice to wear trousers or "rational" garb. While the fashionableness of sitters was certainly one way to gain the attention of middle-class viewers—a lesson Tissot knew well—details of dress were, along with others in a picture, subsumed into the overall meaning of the work. Contemporary spectators would have recognized the artist's efforts in this line, noticing, for example, the looser, more flowing "medievalizing" style of dress that Pre-Raphaelite damsels often wore or the robes in discordant, often outrageous, hues worn by female aesthetes.

Undoubtedly the middle and upper classes who flocked to the Royal Academy each year for the annual exhibitions were pleased to see their own *haute couture*, customs, furnishings, and cuisine mirrored in the fine art of the day. Nonetheless, to modern viewers, Victorian ladies of fashion both in art and in real life were mostly typecast as dainty paragons of leisure who are often encased in socially acceptable raiment or surroundings that were decidedly confining, uncomfortable, and ornamental. The passive prettiness of these creatures was part of the appeal that made them the darlings of the drawing room, and the Victorian myth of womanly weakness kept them there. For in spite of the bravery she displayed in times of war or crisis, the Victorian lady in art seemed doomed to the perimeters of home and garden and to carefully monitored outings in the external world.

5

The Victorian "Sister of Charity"

BEYOND THE CONFINES OF HOME, ONE OF THE FEW AREAS sanctioned for middle-class ladies' involvement was that of philanthropic or church work. The impulse to perform charitable or humanitarian acts was generally viewed as an innately feminine one, and after the 1850s unmarried women in particular were often encouraged in magazines and books to assist schools, asylums, prisons, workhouses, hospitals, and the local indigent of a district. By the end of the century such benevolent endeavors constituted a prelude to the profession of social work. This vast body of unpaid volunteers (for no genteel lady was to be paid for work) was represented at various levels of commitment—from the Lady Bountiful, to the amateur social reformer, the good Christian Sunday school teacher or relief society instructor, the dilettantish society matron, and the genuine activist.[1] Female distributors of tracts, social workers, and lady visitors superintending the poor were all popular literary types, featured in contexts ranging from Dickens's acid attacks in *Bleak House*, to Disraeli's view of the feminine conscience in *Coningsby*, to the idealism of Charlotte Yonge in various novels of the 1850s and 1860s. As one modern historian of the Victorian heroine has remarked, "For although the philanthropic movement which broke over the feminine world of the 50s and 60s owed its initial energy to the work of various outstanding women, it would not have increased so steadily in force and importance had its

doctrines not been of general appeal."[2]

Artists were well aware of the appeal of such charitable themes, and typically women were cast in the role of dispensing benevolence, but not social justice. Occasionally the approach was even sarcastic, Jane Coral Hurlstone exhibiting in 1852 a lost painting entitled *The Women of England in the Nineteenth Century* that the *Art-Journal* called "a satire on the charity of the times." One scene showed upper-class ladies in an opera box being entertained, while the other half portrayed "a creature starving and in rags, drudging for bread which is served to her in crumbs."[3] The splendor of dress and lifestyle of the rich is contrasted with the squalor of the poor, and here the destitute woman is significantly trying to make a shirt, a sure sign of her dreadful fate as a sempstress. In most cases, however, painters capitalized on the subject of feminine charity by portraying a lady's sense of responsibility to the poor and her largesse as a member of the privileged classes. This can strike an artificial or hollow note to modern viewers, but Victorian spectators did not seem to notice the shallowness of such generosity. In a work such as Thomas Brooks's 1860 *Charity* (Fig. 52) (seen here in a mezzotint by W. H. Simmons after the lost canvas), the Christian virtues of hope, faith, and charity are exemplified in three companion works. Exhibited at the Royal Academy with the legend "The true religion and undefiled," the painting focuses on a

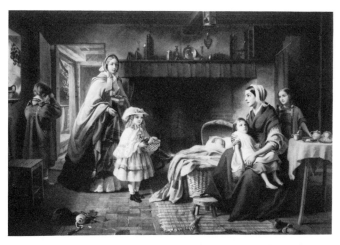

Fig. 52. W. H. Simmons, after Thomas Brooks. *Charity.* 1863 (after an 1860 painting). Mixed mezzotint, 26 × 24⅜. Private collection.

child learning to be charitable by imitating her mother's nobler instincts. Two women stand with their daughters, separated in a shabby setting by an invisible line of class as well as by the drastic difference in their ability to sustain domestic harmony. The pair descends into a dark cottage from the sunshine, the dimness of the interior emphasized by the absence of all but a small piece of candle for illuminating the chamber. The furnishings are tattered but clean, and the impoverished lady (perhaps a widow) with her children retains her dignity by offering some food to her visitors. The table has been set for guests, and the plate with some butter (a luxury for the poor) appears almost ludicrous next to the medicine bottle that announces the illness of at least one inhabitant. An ailing child is cradled in its mother's arms and looks up limply, as if gazing on another world, while a baby sleeps nearby in its wicker cradle. The elder children attempt to maintain the civilities of the situation, the son somewhat shamefully opening the door and the daughter arranging the tea things. But the real point of contrast centers on the standing affluent mother and child and her seated counterpart. The lady bears a Bible while her child offers a basket of fruit, these tokens symbolic of the notion of missionary teachings and personal almsgiving to the less fortunate. The contrast in attire is clear, the simplicity of the country folk quite different from the beribboned finery of their visitors. The rich little girl wears neatly buttoned shoes and a feathered hat, but her sick young acquaintance has dropped her heavy and rude hobnailed shoes on the floor. Moreover, the blond child bearing gifts has long curls, but her friend has dark hair

that is rather short, the locks perhaps shorn during her illness for the sake of sanitary reasons or health. The struggles of the family to keep their gentility in spite of adversity is manifest in small details such as the partly pared turnip on the floor, for this is the fare on which they subsist, not the bread and tea they offer guests. Whether or not the indigent resented such well-intentioned intrusions is not known (or apparent in this painting), but it is clear that Victorian ladies thought it their duty to offer charity to those in need.

In the same general category was the Lady Bountiful type, who arrived like some Dickensian character (a Mrs. Jellyby sort) filled with enthusiasm, philanthropy, and pocket handkerchiefs to "save" the poor. One representation of this is found in Richard Redgrave's 1860 *Young Lady Bountiful* (Fig. 53), in which a winsome and pretty "deliverer" daintily descends a set of steps in the countryside in order to bring a basket of food and presumably some cheer to the needy older woman. The ailing elderly female from a lower station in life

Fig. 53. Richard Redgrave. *The Young Lady Bountiful.* 1860. Oil on canvas, 20 × 30. Photo courtesy of Sotheby's London.

literally looks up at the youthful lady, and once again a gap of space seems to underscore the considerable social distance between the classes. Cottage and district visits, along with catechism and plain sewing, were deemed part of a woman's duties, and she was considered a naturally beneficent person with innate tendencies to do good works. As Isabella Beeton wrote on this subject in her *Book of Household Management* of 1861: "Visiting the houses of the poor is the only practical way really to understand the actual state of each family. . . . Great advantage may result from visits paid to the poor; for there being, unfortunately, much igno-

Fig. 54. James Collinson. *At the Bazaar (The Empty Purse)*. 1857. Oil on canvas, 24 × 19⅜. The Tate Gallery.

rance, generally, amongst them with respect to all household knowledge, there will be opportunities for advising and instructing them, in a pleasant and unobtrusive manner, in cleanliness, industry, cookery, and good management."[4] In spite of Beeton's reference to unobtrusiveness, however, the likelihood of a supercilious attitude on the part of the visitor was probably great, although no such haughty emotions appear on the face of Redgrave's young benefactress.

In a similarly dilettantish vein, society matrons frequently organized charity bazaars, the ostensible subject in James Collinson's 1857 *At the Bazaar* (Fig. 54). In this painting, subtitled *The Empty Purse*, the modishly dressed *Keepsake*-pretty woman stands amid a litter of seemingly rather useless goods. For example, there are embroidered suspenders on the wall, a handmade pincushion, a doll, a penwiper, and a bottle of cologne. The handbill affixed to the edge of the table reveals that the event is scheduled for the benefit of St. Bride's church and features "useful and fancy articles." The patroness mentioned is the Right Honourable Lady Dorcas, whose name may be an ironic reference to the Christian woman in the New Testament who provided clothing and charity for the poor.

The lady in this vignette is exquisitely dressed, her veil pulled neatly back from her maddonaish coiffure and vacuous face, and her hat ribbons pertly tied. As etiquette dictated, she wears gloves in public, in one hand proffering a thimble and in the other the reticule or beaded purse which forms the enigmatic subtitle. Yet *The Empty Purse* may refer to a lack of money, pin money or otherwise, to purchase such things. To modern eyes, the empty hat hanging on the wall seems to allude to the empty-headedness of this idle female. A more compelling detail is the exotic flower preserved under glass, for like the lady, this rare and beautiful blossom must be preserved under a bell jar to survive and to remain eternally pretty. Ultimately there seems to be some ambiguity about whether the goods themselves or the woman can be bought for the right price. Is she for sale or has she just spent all her money on this occasion? The meaning is unclear, although Collinson is said to have changed the title of the canvas in order to avoid its being misread by viewers. Perhaps the print on the wall of Christ bearing the Cross and emblazoned "Follow me" is meant to be an ironic exhortation to spectators to lead a truly virtuous Christian life and to perform good works of real merit, not of this superficial nature.

Teaching at Sunday schools and doing plain sewing projects were other options, although perhaps less glamorous than some of those already mentioned. Only a few women became very distinguished by their philanthropic efforts, the most outstanding being Florence Nightingale and Harriet Martineau. Less famous but nonetheless notable activists included Frances M. Buss and Dorothea Beale (who were both dedicated educational reformers), Octavia Hill (who investigated housing conditions of the poor), Susanna Winkworth (who labored on model low-cost housing projects), Angela Burdett-Coutts (who supported myriad welfare, educational, and other projects with her vast personal wealth), Frances Cobb and Louisa Twining (who established workhouse visiting societies and campaigned to have women appointed as Poor Law Guardians), and Mary Carpenter (who struggled to establish special facilities for vagrant, criminal, and delinquent children).

Distinct from the idea of doing good works as an auxiliary enterprise was that of women actively serving their communities and God by joining a religious order. John H. Newman, who was among those clerics who wanted to restore High Church ideals to the Church of England, went so far as to assert that convent life could function as a refuge for "redundant" females, since "as matters stand, marriage is the sole shelter which a defenceless portion of the community has against the rude world;—whereas foundations for single females, under proper precautions, at once hold out protection to those who avail themselves of them . . . , thus saving numbers from the temptation of throwing themselves rashly away upon unworthy objects, transgressing their sense of propriety, and embittering their future life."[5] The possibility of such service was a relatively recent and Victorian phenomenon, since the reestablishment of monastic communities in England began in the 1840s after a lapse of nearly two hundred years. Protestant (sometimes pejoratively nicknamed "Puseyite") nunneries were established in increasing numbers from the 1840s through the end of the century, and many writers and journalists viewed this development as an ominous sign of encroaching Roman Catholicism and papal aggression. Another primary objection concerned the way that Anglican sisterhoods supposedly posed a threat to the family structure by usurping patriarchal authority and by challenging the institution of marriage itself, for holy celibacy, enclosure, and perpetual vows were considered unnatural for

women and a denial of their destiny as wives and
mothers. In a society that idealized the sanctity of
motherhood and the family it was not readily con-
ceded that virginity could be a more honorable
spiritual state than matrimony—or that women had
any right to exercise their independent choice by
opting to dedicate their bodies and souls to God
instead of to a husband. There was thus a high
degree of palpable anxiety about this subject: often
fulminating denunciations of sisterhoods could be
found in the words of F. D. Maurice, Charles
Kingsley, and others, and *Punch* published many
scathing cartoons in the 1850s ridiculing the entire
idea of Victorian ladies taking seriously the vows of
chastity, obedience, and poverty. For example,
Punch published perhaps its most unflattering ap-
praisal of nascent Anglican sisterhoods in an anon-
ymous satirical piece of 1850. Since middle- and
upper-class ladies were most prone to succumb to
the promise of sisterhoods, it was alleged in this
article that women handed over their dowries com-
pletely and paid a monthly rent to the convent for
its services and lodging. The author moreover
claimed the vows and celibacy were both only
lightly taken, that Roman Catholic practices of flag-
ellation were being replaced by the use of stays (the
only stylish mortification of the flesh for English-
women), and that servants could be hired for the
upkeep of the individual cells, which were "fitted
upcomfortably, combining the boudoir and the or-
atory."[6] An 1850 cartoon entitled *Convent of the
Belgravians"* (Fig. 55) captured the tongue-in-cheek
description of the vogue enjoyed by sisterhoods
and parodied the subject with such comments as:
"The costume of the sisterhood will consist of a
judicious admixture of the conventual style with
the fashion of the day. The Nun will not be obliged
to sacrifice her hair, but only to wear it plain, à la
Madonna. . . ."[7]

Contemporaneous with this—from about 1840
until the close of the century—a spate of "nun
pictures" was shown at the yearly Royal Academy
and British Institution exhibitions.[8] There were
typically numerous voyeuristic scenes of pretty
postulants in their cells, as in Alexander Johnston's
The Novice (Fig. 56). This was hung in the 1850
British Institution display with the following lines
of verse: "This vestal cloak shall fold my fading
bloom,/ Of virgin vows and purity the token;/ This
cell sepulchral-like shall be the tomb/ Of withered
hopes, Vows broken as soon as spoken,/ Of Love
despised, of peace destroyed, and of a heart quite
broken." Here the decidedly romantic motive expe-

Fig. 55. Artist unknown. "The Convent of the Belgra-
vians." 1851. Wood engraving from *Punch*, 1851.

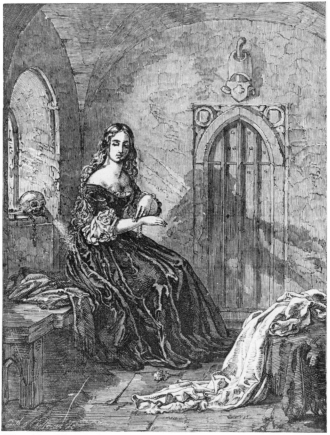

Fig. 56. Alexander Johnston. *The Novice*. 1850. Engrav-
ing with etching, 5 × 6¾. Private collection.

diting the young woman's decision—namely, a disappointed love affair—is made explicit, and in this voluntary prison the elegant young female abjures earthly things by removing her precious bracelet, as a skull on the windowsill watches her balefully. There is a curious sexual tinge to the boudoir/cell, for the woman with her streaming hair resembles a magdalen-type and her garments are disheveled as if in disarray after sex (a point perhaps subliminally made by the phallic aspect of a heraldic shield hanging over the door). Replacing her worldly adornment are rosary beads, and the woman's fading beauty and youth are paralleled by the fallen rose on the floor, a last vestige of the spurned love in the outside world. A skull serves as *memento mori*, reminding her of human mortality and of her own choice of "entombment" in a nunnery. The keyhole glimpse into the private cell and solitude of the postulant is made all the more daring here because she is about to disrobe; moreover, her surroundings are austere and cold, not the cozy parlor or bedchamber to which the woman was previously accustomed, and this too makes her asceticism all the more piquant.

Similarly, *Keepsake* annuals and artists in general seized upon the novice (for she was not yet a fully committed nun) as a likely subject, combining loveliness with the piquancy of having eschewed society for a Heavenly Bridegroom. This somewhat sensational subject found a ready market, and there were many closeup portraits—as in James Sant's *The Novice*, a characteristic representation of an attractive angelic "martyr" reading a Bible, praying, or involved in some saintly activity behind closed doors. The latent voyeurism of pictures like those by Johnston and Sant unconsciously expressed a delight in the forbidden and almost delectable nature of such virginity, for it seemed as if the decision to renounce marriage, attractiveness, and worldliness—not to mention sex and the family—merely enhanced the nun's desirability, creating an eroticism out of purity itself. In fact, this religious prototype of a "pinup" seemed in part fired by male fantasies (for representations of this subject by women artists were quite rare) about what actually took place in monastic life—scissoring of the hair, abjuring the external world, forgetting a disillusionment of the heart. There was also a somewhat prurient aspect to the subject beyond the mere wistfulness of the implied loss to the world of such beauty or femininity. There was a quasi-amorous allure to the novice or postulant, too, which stemmed from her having rejected real

suitors for the sake of a mystical union or marriage with Christ. Most of all, however, making the novice a victim who might still be saved helped to neutralize the threat and fear she posed in real life, for viewer sympathy could be transformed, as anxiety could not, into a constructive displacement of emotions.

Accordingly, this sort of potential displacement of uneasiness about the nun's independence or deviant asexuality resulted in scores of genre subjects in which there always seemed to be an absent lover, the whisper of a broken amorous relationship, or a denial of womanhood hovering in the background of the meanings of these paintings, or at least in the minds of the (mostly male) reviewers. For example, John Calcott Horsley's 1856 *The Novice* (Fig. 57) elicited a strong reaction from a critic in the *Art-Journal* about the morbidity of the ascetic life on which the young postulant has embarked:

> And Mr. Horsley's 'Novice' seems not to have forgotten altogether that external life from which she is about to separate, should resolution hold out the requisite term of probation. The dove she caresses so gently is, or may be accepted as, a messenger from the world beyond the convent walls, bringing her to, unlike the dove of Noah, thoughts that breathe . . . of the social enjoyments of her girlhood's home and its tenderest endearments; perhaps, thoughts of one dearer than all the world beside. The book of devotion is laid aside, the chaplet of flowers she is wearing from some holy rite has fallen from her hands, as the winged emblem of innocence flew into her bosom, breaking in upon her devotion and her labours. Those aged nuns, who have become habituated to the austerities of the community, regard her, as they saunter up the burial-ground of the sisterhood— recognized by the turf-mounds on the left—with looks of suspicion, as if they would connect the act with something sinful, or, at least savouring more of worldliness than is consistent with strict conventual life, which would shut out all the finer feelings of our nature and every source of pleasure God has bountifully placed within the reach of all.[9]

Unlike other interpretations of this subject in which the setting or accessories suggest a continental or Roman Catholic monastery, here the subject is quite contemporary, in topicality if not in other ways. The tone of censure in the last line is overt, and there is an irony evident in the "dovelike" female who pets a bird that has managed to surmount the convent walls to bring her a message, perhaps from an ex-beau, as the reviewer suggested.

The abnormality and near-imprisonment of the

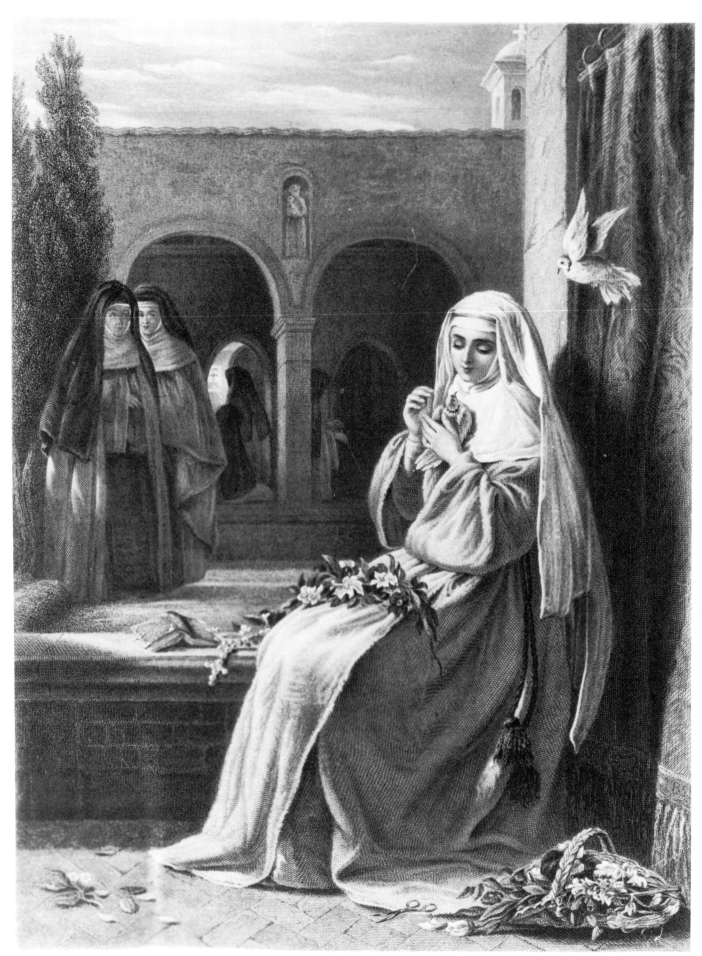

Fig. 57. John Calcott Horsley. *The Novice*. 1856. Engraving with etching from *The Art-Journal*, 1860.

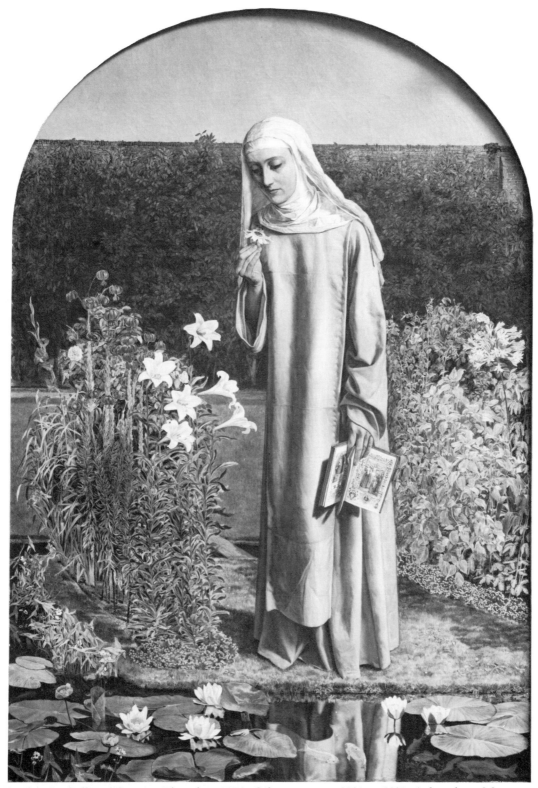

Fig. 58. Charles A. Collins. *Convent Thoughts*. 1851. Oil on canvas. 32½ × 22¼. Ashmolean Museum, Oxford.

convent and the high walls that sheltered it is per-
haps best expressed in yet another related treat-
ment of the cloistered inner sanctum of the
sisterhood—Charles Collins's *Convent Thoughts*
(Fig. 58) of 1851. This key picture is perhaps the
finest example of the pictorial cult of the nun. It
was accompanied when exhibited at the Royal

Academy with these lines from *A Midsummer
Night's Dream*—"Thrice blessed they, that master so
the blood, to undergo such a maiden pilgrimage,"
an allusion in the play to the choice of the female
character between actual death and life by entomb-
ment in a nunnery, a barren life of purity described
as "withering on the virgin thorn." "To undergo

such maiden pilgrimage" involves repudiating the material world and all previous emotional attachments, a conflict between the spirit and the flesh incorporated in other convent pictures of the period. The other lines accompanying the painting were from the Bible, Psalm 113:5, "I meditate on all thy works; I muse on the work of Thy hands." This excerpt suggests how the novice must now abjure all past remembrances and instead address herself solely to God and his works. Subsequent lines imply that the postulant is tormented by her love for Christ, for in her anguish the psalm reminds her: "My soul thirsteth after thee . . . Hear me speedily, O Lord: my spirit faileth . . . Teach me to do thy will . . . Quicken me, O Lord, for thy name's sake." The last few lines concerning "quickening" also evoke references to the holiness of the Virgin in her having conceived of Christ immaculately.

While Collins has chosen a real setting and flowers from the Clarendon Press Quadrangle in Oxford, he has also portrayed a contemporary figure, a postulant perhaps from a nearby convent.[10] The symbolic language is grounded in the stylistic verisimilitude of the things delineated but then moves beyond this to acquire additional layers of meaning. For example, this postulant is a modern Mary in a convent garden, yet she also functions as a contemporary figure in a *hortus conclusus* or enclosed garden of feminine virtue. Surrounded by tall white lilies symbolizing purity and the Virgin on an island within the monastery garden, she interrupts her scriptural reading to contemplate a passion flower, a common symbol of religious superstition.[11] The thorns growing on the nearby roses in this earthly garden contrast implicitly with the thornless Virgin and the Immaculate Conception, and the water lilies connote purity of heart. The laurel hedge behind also reinforces this notion of chastity, for the leaves of this plant never wilt and are sometimes emblematic of eternity. Moreover, the sober-looking postulant marks with her fingers two places in her missal: one is an illuminated illustration of the crucified Christ, the Holy Spouse to whom she has been promised, and the other contains an annunciation scene, alluding to the role of wife and mother which she has spurned. The starkness of her garments (provisional roles indicating her postulant status) and the austerity of her circumscribed life within these brick walls (reminiscent of Millais's archetypal *A Huguenot*) contrasts dramatically with the luxury, vitality, and lushness of the bountiful surroundings and nearby flora. Indeed, even the size and

numbers of the goldfish in the pond suggest that they have "multiplied and replenished" their species, unlike the self-proclaimed celibacy of the nun-to-be, yet another metaphorical flower of purity in the Christian garden of innocence.

John Ruskin originally viewed this as a Romanist or Anglo-Catholic painting, commenting that he had "no particular respect for Mr. Collins' lady in white, because her sympathies are limited by a dead wall. . . ."[12] A revised estimation reflected his firm disapproval of "maiden pilgrimages" and the reclusiveness of conventual life, Ruskin instead preferring "the old pilgrimage of Christiana and her children," a life of marriage and motherhood as depicted in Bunyan's *Pilgrim's Progress*. Furthermore, although Collins himself was a convert to Catholicism in the 1850s, his attitude remains at best ambivalent in *Convent Thoughts* about whether he intended merely to record the novelty of an Anglican convent or also to express some degree of latent censure about the "abnormality" of cloistered life for women.

The generally hostile response to the treatment of nuns in pictures, and Ruskin's specifically negative reading of walled virtue in *Convent Thoughts* help to explain why Millais's *The Vale of Rest* (Fig. 59) did not receive very enthusiastic reviews when it was exhibited at the Royal Academy in 1859. While the technique was praised by numerous critics, the gloomy topic was often singled out for denunciation. The *Athenaeum* spoke of the homeliness of the seated nun and the "air of ascetic meditation and self-immolation . . . sad and almost ghastly" that permeated the mood. This writer also remarked that the artist had expressed "with rare force, the rank growth of the burial ground grass, thick and dank from its horrible nurture, and the way the dying light is carried among the leaves of

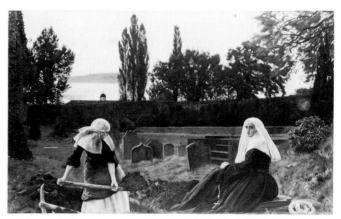

Fig. 59. John Everett Millais. *The Vale of Rest*. 1859. Oil on canvas, 40½ × 68. The Tate Gallery.

the bushes."[13] Indeed, in the sky coffin-shaped clouds hover ominously. To add to the moroseness, the young nun digging a grave may be a postulant, while her colleague grimly supervises her work and sits atop some tombstones marking the extinguished lives of other nuns. On the rosary beads hanging from the waist of this seated figure hangs a skull, which like the cloud formations may augur an early death for both women. The dropped floral wreath may also suggest earlier religious rituals (for example, a mock marriage ceremony at the time vows are taken) in the convent. The incongruity of this hard physical task being enacted by the "gentler sex" must have alarmed the public (as the *Athenaeum* reviewer perceived), as would the irony that the novice seems to be digging her own grave. Certainly the decision to join a sisterhood was often deemed burying oneself alive behind high, inaccessible walls. However, an Anglican, nonmonastic interpretation of *The Vale of Rest* can be found in the works of Edward Pusey, who wrote "As this hidden life is obtained by deadness to the world . . . so, by that deadness, is it to be cherished, maintained, perfected. Death to the world is life to God. . . . Seek only to be buried with Christ from this world and its vanities, hidden in his tomb, so that the show and pomps of this world may but flit around us as unreal things. . . ."[14] Thus, the vale of rest, subtitled, "Where the weary find repose," combines religious love or devotion with death, for as Pusey's lecture indicates, deadness to the secular world generated a paradoxical life of the spirit. Digging one's own grave as Millais depicted it may thus be a form of achieving union with Christ as well as spiritual resurrection.

Still other pictures transform the latent erotic and dramatic appeal of the comely novice in her isolation into what might be called the "rescued nun syndrome," as in Edmund Blair-Leighton's 1906 *Vows* (Fig. 60). Throughout the Victorian era literature and paintings often prescribed an ending in which the postulant was "saved" from the convent by a romantic male (as in Millais's 1861–62 illustrations for a novelette by Harriet Martineau entitled "Sister Anna's Probation"). Such images belie a kind of wishful thinking or fantasizing about the loss to the external world of this cloistered feminine virginity and beauty, and there was often a mingling of repugnancy and curiosity about what transpired behind the high convent perimeters of the modern madonna's enclosed garden. Moreover, the "rescued nun syndrome" revealed the

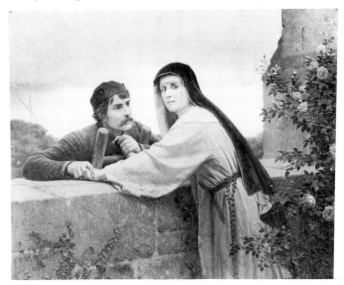

Fig. 60. Edmund Blair-Leighton. *Vows.* 1906. Oil on canvas. 31½ × 38½. Photo courtesy of Sotheby's London.

fantasy of male artists and viewers that if the woman did not renounce her decision, she might be forcibly rescued from the "unnatural" surroundings by a male deliverer and admirer. Here the "martyred innocent" presumably still has her vir-

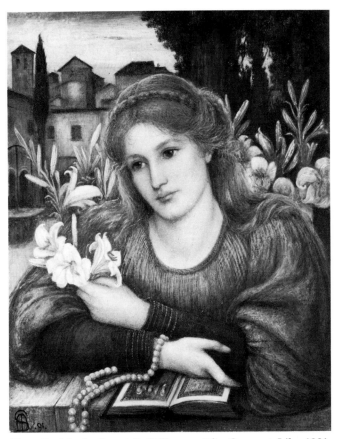

Fig. 61. Marie Spartali Stillman. *The Convent Lily.* 1891. Oil on canvas, 17½ × 13½. Ashmolean Museum, Oxford.

tue intact, and there is almost a fetishization of her unattainability, which "protects" her unconquered virginity with a suitably high and impervious convent wall. The nun's expression of excitement and anxiety at the sudden appearance of her conveniently materialized former suitor also conveys to modern viewers the protagonist's fear of an "attack" on her own sexuality (and her vaginal walls?).

Throughout the Victorian era the convent themes that proliferated changed rather little in content, being primarily vignettes of voyeurism, indictments of enclosure, or single figure portraits of otherworldly and remote beauties. A painting such as Marie Spartali Stillman's *The Convent Lily* (Fig. 61) of 1891 reveals how little the basic approach altered (and also how women artists also complied with this "formula"), for such an image manages both to adhere to the rather vacuous depictions of the nun in *Keepsake* publications and contemporary paintings at the same time it retains some affinity with the generally favored setting of a walled garden or *hortus conclusus* in its updated but nonetheless religious sense. Much as Collins's monumental canvas and *The Vale of Rest* both dramatized moments of contemplation about the transience of external things and the nature of feminine self-sacrifice, here there is an echo, albeit a rather saccharine one, of the elegiac mood of the solitary female along with the shared mystique of the walled-garden environment. Clutching a bouquet of madonna lilies and holding rosary beads and a Bible, the young postulant, not unlike her counterpart in *Convent Thoughts*, muses on some aspect of her fate. The low wall on which she leans is an understated reminder of the physical and spiritual perimeters to be imposed on her by conventual existence and vows. This tableau of girlish innocence with its look of unspoken anticipation (of a lover perhaps) and of solitary confinement is one that was modified and repeated countless times in secular settings too in works such as Deverell's *A Pet* and in the major strands of courtship imagery.

In all these "nun pictures," the choice of rejecting matrimony, sex, and the outside world was seen by artists as augmenting the nun's or novice's desirability, making her both paradoxically religious and sexy. As with other categories of femininity, however, such attitudes and images ultimately sentimentalized and trivialized the actual achievements of very real Victorian "sisters of charity"—women like Lydia Sellon, Harriet Monsell, and Marian Hughes—and their genuine religious vocations. And as with her secular sister in the parlor, this emblematic lily of spirituality and innocence was enshrined in a setting of inaccessibility and mystery that made her simultaneously repulsive and desirable in her *hortus conclusus* of feminine virtue.

6
Courtship and Marriage

Perhaps the most common of all the images of womanhood was that of the female role in courtship, for to the Victorians, the permutations of courtship were seemingly infinite, with every echelon of society susceptible to the ubiquitous malady of lovesickness. Painters seized on the slightest pretexts to depict amorous involvements—from railway carriages, to church pews, tearful farewells, theater balconies, and boating scenes. Neither children nor octogenarians were exempt from this mania, and "calf love" was immortalized along with vignettes of geriatric tête-à-têtes. Literary sources dominated a major classification of this genre, ranging from illustrations for execrable *Keepsake* verse to Shakespearean lines or texts from the Bible or, in contemporary terms, from Tennyson's poems. Predictably, the reigning magazines of the day indulged in romantic excesses, too, emblazoning their pages with a hard-sell sentimentalization of courtship in frothy short stories and doggerel aimed especially at female readers.

Obsessed with all phases of love, the Victorians matched their zeal with impressive statistics in the realm of fine art.[1] While in the 1820s a canvas with an amorous theme was likely to bear an allegorical title like "Venus with Cupid" or "Fidelity with Her Emblem," by the 1840s interest in courtship subjects per se had been sparked. By the 1870s until the close of the century the Royal Academy was virtually engulfed with images of courtship, with captive cupids and the like giving way to essen-

tially bourgeois or middle-class trysts. With each year the numbers of such depictions steadily mounted; the apex of this trend occurred in the late 1880s and 1890s, but the quality varied wildly from heart-rending masterpieces to mawkish or inane potboilers.

While it is impossible to verify how much guidebooks or etiquette actually influenced readers in their private lives, the compendium of rules and social rites outlined in such instructional or cautionary literature nonetheless helps to explicate the narrative details, customs, and cast of characters that appeared in scores of paintings of the period.[2] To the average middle-class suitor and his sweetheart, the very core of courtship etiquette was defined by decorum and respectability, essentially the assumption that the separation of the sexes was an obligatory safeguard against romantic excesses or injured innocence. The high degree of formality in the social rituals of courting was intended to protect young women from unseemly advances and to apprise both parties of their meticulously prescribed roles. The nearly total identification of manners with middle-class morality exaggerated the significance of outward respectability and made adherence to these regulations paramount, for an abrogation of the rules was punishable by ostracism and the inescapable taint of being quite outside the pale of acceptable society. From chaperonage, to the art of introductions at a dance, to the acknowledgment of an acquaintance on the

street, the elaborate system controlled and defended a woman's reputation. It was important for both parties to observe these rules, for a moment of indiscretion might be branded with the revealing and scandalous epithet of a "clandestine intercourse."[3]

It is interesting that numerous courtesy books sermonized that short of being reviled as a prostitute, the worst that a woman could lower herself to was a jilt or a flirt, for the "loose, over-gay conduct" of a "flaunting coquette" made her the equivalent of a male libertine. To toy mercilessly with a man's heart, or even to dance too frequently with a man to whom she was not engaged, attracted too much attention to a female and made her appear reckless, imprudent, and even rebellious.[4] Above all, a woman was never to yield to emotions or sexual promptings, lest she succumb to temptations which were viewed by some authors as downright satanic in their implications. Accordingly, ladies were never to be left alone with a man or to be subjected to any hint of conversational familiarity, and it was their role to monitor the range of suitable topics for discussion. They were moreover not to borrow items from a suitor, to allow him to buy tickets or expensive gifts, or to incur any form of indebtedness to him.

The most salient aspect of courtship was undoubtedly the suppression of real feelings on both sides, especially a woman's. A man was permitted to be foolish in love and to declare his affections, but a woman had always to impose a check on her emotions and to exercise self-control. As one courtesy-book author stipulated in an 1844 book:

> It will be her part to repress excess of ardour whether in her own case or in that of her lover. Nothing is more like to produce a diminution of respect than an undue familiarity. . . . It may be taken as a general rule that those who respect themselves will command the respect of others, and the safeguard and the impregnable bulwark which no daring can overcome, and no stratagem surprise, is self-respect.[5]

Ann Richelieu Lamb corroborated the affects of the virtual segregation of the sexes in a chapter on courtship in an 1844 book entitled *Can Woman Regenerate Society?*: "It is difficult, in the present degraded state of society, to speak of friendship between persons of opposite sexes. . . . Men are terrified from the presence and society of women, by the vision of an action for 'breach of promise,' or there rises before them the startling question of some prudent parent, or brother, as to intentions,

keeping them in a perpetual trepidation, rendering the intercourse between the sexes of the most restrained, artificial, and embarrassing description. This is much to be deplored, for how can young persons ever be the better for each other's society, when a formidable barrier is raised against it?"[6]

While the general subject of Victorian sexuality remains unresolved by twentieth-century research, it is nonetheless apparent that the rules of courtship nurtured feelings of guilt, secrecy, fear, and embarrassment about physical expressions of affection. Given all the strictures imposed upon them, it is difficult to imagine how couples always interpreted the complex clues of emotional concealment. How was a woman to differentiate between naturally retiring behavior, diffidence, polite conformity to the rules, and real feelings? And how might a man perceive from only fleeting, chaperoned meetings whether the blush, the fluttering hands, the half-smile, and the lowered eyelids and guarded gaze of a lady were the signs of shyness, well-bred social traits, or genuine preference?

It is apparent, then, that women in real life were in general encouraged to refrain from demonstrative outbursts and to act as ladylike ice maidens immured behind high walls of cold reserve. This legacy of shrinking delicacy in romance, of feminine passivity countered by tentative male aggressiveness, was also bequeathed to paintings of the period, and hundreds of depictions of middle-class lovers preserve exactly these postures and expressions of restraint.[7] Young love blossomed most often in a garden setting, and even courtship manuals sometimes extended the metaphor to make the woman herself a flower ripe for plucking

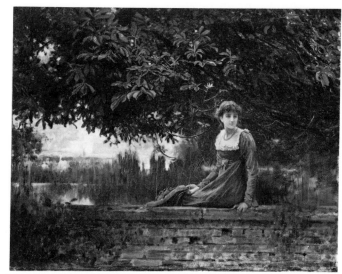

Fig. 62. Marcus Stone. *Waiting*. 1870s? Oil on canvas, 15 × 19½. Walker Art Gallery, Liverpool.

(much as she was a madonna lily in convent imagery). Often the young woman is shown hovering at a garden wall or threshold awaiting the arrival of her swain at their forbidden rendezvous, and indeed this emblem, as seen in a picture such as Marcus Stone's *Waiting* (Fig. 62) of the 1870s, became a standard icon of romantic expectation. At first examination this tableau of picturesque and girlish seclusion may not seem overtly imbued with romantic undertones, but it is with repetition that the motif gains its meaning, for there are dozens of representations that conform to this simple formula. Typically the woman waits at the edge of some architectural barrier, be it brick, rustic, or wooden, and she usually has a rather bland facial expression so as not to betray any emotion about the impending tryst. Love was firmly fixed in the sovereign domain or earthly paradise of the English middle-class garden or its rustic equivalent in nature, and thus the spate of females awaiting seen or unseen admirers at appointed trysting places or in flowery nooks. Such depictions and others in this chapter owed part of their iconographic debt to the visual tradition of the Virgin Mary, whose wall-bound *hortus conclusus* served as a general prototype for the secularization of feminine chastity. Like lovely and pure blossoms waiting to be metaphorically plucked, these flowers of femininity formed a pretty but often vapid collective hothouse of innocence for spectators to admire. The bequest of the medieval walled garden as an attribute of feminine purity, a sacred space where the modern madonna inhabited an insular sanctuary of artificially preserved maidenhood, was a critical one. It was in this sacred space that the Victorians staged their own, often contemporary, dramas of romantic pursuit and female resistance to male encroachment, a setting in which the phenomenon of the "courting wall" was born.

The seminal image in Victorian courtship pictures was Millais's *A Huguenot* (Fig. 63), an immensely important and popular work begun in 1851 and exhibited the next year at the Royal Academy. Hailed as a masterpiece throughout the artist's career, this painting also served as the archetypal Pre-Raphaelite composition for countless imitators and was the primary catalyst for the courting barrier motif, although there was also the more general heritage of the eighteenth-century rustic style, the biblical enclosed garden, and the medieval garden of love as sources.[8] Millais's basic compositional formula utilized the placement of two figures against an outside wall, typically that of a garden, with the emphasis on the intimate range, botany, and other insistent details of the encounter. Millais was deliberately trying to depict a "secret-looking garden wall," a subject with a purported "highest moral"[9] that he invented. The results challenged earlier stagnant courtship images, infusing a powerful amalgam of love and danger along with startling symbolic realism into the often banal sentimentality of the subject. While not a depiction of modern life, the painting unleashed scores of adaptations in Victorian attire and with contemporary personages. The theme actually derived from the opera by Giacomo Meyerbeer, which Millais had seen—a parting between the hero and heroine which united their imminent death and passion in a last embrace of *liebestod*.[10] *A Huguenot, on St. Bartholomew's Day, Refusing to Shield Himself From Danger By Wearing the Roman Catholic Badge* was accompanied by a quote purported to be the edict issued by the Duc de Guise: "When the clock of the Palais de Justice shall sound upon the great bell at daybreak, then each good Catholic must bind a strip of white linen round his arm and place a fair white cross in his cap." The "high moral" themes of conflicting religious faiths and love versus duty were a heady mixture that would recur in later works by this artist. Nonetheless, the passionate, locked embrace of the pair was nicknamed and cleverly retitled by *Punch* "Hug-or-not."

The major interpretation of *A Huguenot* was offered by Ruskin, who perceived that the various still life elements in the painting projected both literal and symbolic implications. The clinging ivy represented the fidelity of the couple even after death; moreover, an analogy might be made between the woman clinging to her lover and the plant to its brick wall. The yellow nasturtiums symbolized the sorrow of departure as well as the unfulfilled love of the pair, while the tolling bells that formed part of the border of the frame were emblematic warnings of the impending massacre and of the man's death.[11] Aside from the hyperrealism of its presence, the wall encompasses several levels of possible interpretation not mentioned by Ruskin. It may, for example, symbolize the implacable forces of fate which thwart the lovers, like the impenetrability and unchangeability that a stone wall by definition is. It may similarly allude to the solid resistance created by the confrontation between the two religions, which like a wedge forcibly separates the partners in life and may, as in the opera, reunite them in death. It is also a topos of the Protestant's unyielding stance of integrity and faith, for

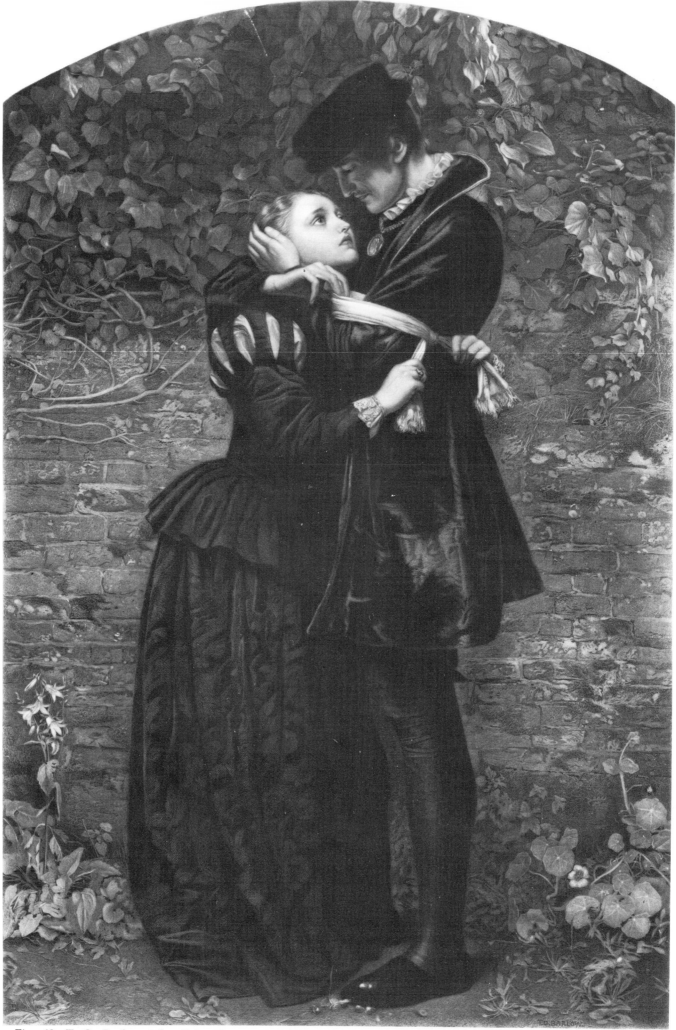

Fig. 63. T. O. Barlow, after John Everett Millais. *A Huguenot.* 1857 (after an 1852 painting). Mezzotint with etching, 29¼ × 20⅛ (with arched top). Yale Center for British Art, Paul Mellon Fund.

Fig. 64. Philip Calderon. *Broken Vows*. 1856. Oil on canvas, 36 × 26¾. The Tate Gallery.

he, like the wall behind him, remains impervious to attack or alteration. Above all, the barrier keeps their world and their rendezvous enclosed and private from external factors. Thus, Millais's wall is rather radical in concept—not a mere garden wall to be scaled, as his friend Holman Hunt had originally suggested to him, but instead a visual correlative to the tragic circumstances of the lovers. It is the presence of this powerful motif that deepens the meaning of the work and served as a model for the related courting wall barrier used so often by succeeding artists.

The rustic stile and wooden fence were interchangeable with the stone wall as barrier elements in the courtship rituals that melodramatically unfolded in Victorian paintings. One example is Philip Calderon's 1857 Royal Academy entry, *Broken Vows* (Fig. 64). This vignette of rivalry and betrayal by a suitor was accompanied by an excerpt from Henry Wadsworth Longfellow's 1843 poem "The Spanish Student": "More hearts are breaking in this world of ours,/ Than I could say. In distant villages/ And solitudes remote, where winds have wafted/ The barbed seeds of love, or birds of passage/ Scattered them in their flight, do they take root/ And grow in silence, and in silence perish./ Who hears the falling of the forest leaf?/ Or who takes note of every flower that dies?" Although Calderon may intend a visual reference to Millais's forerunner, he also transforms the wall into an active dramatic element in this tale of romantic trials and male infidelity. The artist posed his fiancée (Clara Storey, whom he later wed) as the figure in the foreground and tersely described this work in his notebook as a "girl fainting against garden wall, covered with ivy—in front of her . . . broken palings through which are seen her lover and another girl to whom he is giving a flower."[12] The swain's offer of an unfurling pink rosebud, symbolic of his confession of love, is in contrast to the fallen piece of jewelry on the ground, a previous love-token to the other woman. Here the wall is less a separating device than a listening aperture, with a hole that permits a mild amount of voyeurism by the spectator and the bereft female alike. In this "breach of promise" subject the ivy wilts, emblematic of the diminishing fidelity of the pair. Moreover, even the flowers in the left corner droop in sympathy with the swooning lady at right. In contrast to her blond pink-garbed rival, the dark-haired lady wears virginal blue, and on her wrist dangles a bracelet with a cross hanging from it, as if to suggest she is devout and pure. The initials

"MH" carved on the fencepost indicate the man's previous devotion to the dark-haired maiden, but now directly behind this inscription stands the fair-haired rival who causes another woman such pain. The betrayed female has a tear on one cheek, and her anguish is so grerat that she presses her hand against her side as if mortally wounded. Thus, in this ingenious adaptation of the motif, the separating wall allows one party to be an eavesdropper (although this is not a Pyramus and Thisbe type of chink in the wall) at the same time that it shields the flirting couple from the sight of the distraught and unseen rejected woman. Viewers are moreover seemingly placed on the jilted female's side of the barrier, thus seeing the situation from her point of view with symbolism pertinent to her state of despair.

The courting wall prop or backdrop was most often used in the representation of an innocuous meeting of the sexes, cordoning off a space exclusively as a domain for lovemaking and creating a hidden, self-contained environment with the kind of seclusion that would have made real-life chaperons shudder. Nothing truly amiss generally occurs within this spot, however, and usually the lovers are portrayed as respecting the literal barrier or "impregnable bulwark" which inanimately chaperons them and maintains their territorial boundaries. Although long gazes, hand-holding, and flirtatiousness are possible, real sexual contact is hindered by the courting wall, which frequently not only divides the pair but also separates their taboo genital areas from possible touching. Millais's (and then Calderon's) example triggered countless imitations that made the wall instead a completely separating device, and it even figured in popular marital imagery, as in an 1871 cartoon entitled "Over the Ring-Fence," in which a royal bride is being urged by her groom to leap over the wooden threshold. Millais re-used the motif as a divider in his 1877 canvas *Effie Deans* (Fig. 65) (illustrated here by a contemporary engraving), which at least one critic assessed as a masterpiece equal to the earlier canvas: "His 'Effie Deans' ranks in my mind, with the 'Huguenot.'"[13] The painting alludes to a scene from Sir Walter Scott's novel *The Heart of Midlothian* and its charming country heroine renowned for her beauty and guileless purity. Although later in the novel she is seduced by a young gentleman named Geordie Robertson and later bears his illegitimate child, the painting envisions a wall-dominated tryst at an earlier point in the narrative—namely, before Effie has lost her vir-

Fig. 65. T. O. Barlow, after John Everett Millais. *Effie Deans*. 1878 (after an 1877 painting). Mixed mezzotint. 41 × 30¼. Private collection.

ginity to her dissolute suitor. Yet sorrow and danger already seem to loom. He touches her arm imploringly and gazes at her intensely, but she leans on the stone wall and looks away from him. Her response is not the standard reflex of feminine blushing; instead it seems borne of a latent premonition of pending misfortune. Nor does the couple hold hands, a typical sign of marital implications. The omnipresent symbol of faithfulness in courtship or marriage, a dog, witnesses the scene and eyes his mistress as she makes her decision. But her fate is sealed, and as one critic noticed, "Her crown, her honour, are removed and lost, and in one hand droops the maiden snood."[14] And although she has not yet been seduced, her removal of the snood indicates her pending fall from chastity. (Proper young ladies, even rustic women, wore their hair primly restrained by a hairnet or snood, and the absence of this symbol of decorum suggests Effie Deans's moral lapse and sexual misconduct.) In her current innocence, however, she is weighing the merits of Robertson's words, and at this critical moment in her dilemma, the wall itself assumes a heightened role in the drama. In one sense, it is a class barrier as well as a physical obstacle or safeguard, for Robertson is of noble lineage and is accordingly not dressed in rustic garments. More importantly, the wall functions as a barrier suggestive of a power struggle between the sexes, for it is the suitor who urges her to yield to his flattery and to surrender to him sexually. The courting wall, like its counterpart in *A Huguenot,* is thus a sign of implacable fate; in addition, it is an inanimate chaperon, an architectural sentinel indicating the need for restraint. Had Effie Deans only heeded this symbol and "barricaded" her virtue, the future would not have held an out-of-wedlock pregnancy and a death sentence for her alleged crime of killing her baby. As in *A Huguenot* and in other instances, the wall serves as a taboo against sexual transgressions, here with multivalent implications that portend death as a consequence for the hapless female.

While Millais's *exemplum* generated scores of variations that ranged from mawkish to sensitive and pervaded the realm of popular culture in stereopticon views and post cards, the most bizarre and aberrant (yet riveting) example of this motif—and of courtship pictures in general—is Ford Madox Brown's *The Stages of Cruelty* (Fig. 66). Begun in 1856 and completed in 1890, this work spans the long years of the courting wall's greatest popularity and follows by a few years Millais's classic picture.

Compared to the mild overtures of love expressed in the majority of works, this painting is almost an allegory of sadomasochism, with heartlessness on the female's part replacing the usual blushing response, and clawing, frantic longing in lieu of the typical male signs of interest. Usually male passion or aggression did not exceed trying to snatch a kiss, hold the lady's hand, or reach her by scaling a wall—at least in the confines of art. Brown here shows the female protagonist as seated in an elevated position and looking down somewhat at her suitor from her side of the separating brick wall. In one hand she holds some embroidery that has been pierced through the center with a needle, much like a stabbed heart (the same detail appears in Hunt's *Awakening Conscience*—see Fig. 114). Below her (and out of sight to her swain) is a little girl, who tortures her dog with a whip made from a red foxtail branch, commonly called love-lies-bleeding, a flower that in name as in symbolism connotes fickleness and cruelty. The girl has similar features and blond curls and seems almost a flashback to the woman as a child.[15] Moreover, her infliction of pain on her pet is paralleled by the psychic injury the lady causes her languishing lover. Like the dog, the man has consigned himself to his mistress's care and is instead mistreated. Unlike that of his canine counterpart, however, the man's expression is both long-suffering and titillated—he seems to enjoy this callousness. Looking up at her with almost frenzied desire, he nearly claws at her arm; her reaction is a smile, for she relishes his misery. The results abound with perversity—his masochism in enjoying the power she sadistically commands. The devoted affection and tender, playful advances of a gentleman found in most courtship imagery are recast here in terms of male lust and female insensitivity. As Brown's painting implies, perhaps the most psychosexually charged of all the courtship configurations occurred when the wall was situated between the two partners and thwarted them.

Much of Victorian social life involved erecting barriers against strangers, improper actions, or sexual advances, so it is not surprising to find this safety gap or buffer zone in art as the personification of such restraint, a visual correlative to the "look but don't touch" shibboleth protecting feminine chastity. The barrier motif as a "mural" defense of purity had a remarkable longevity and consistency throughout the second half of the nineteenth century, changing its basic format very little. Whether an architectural "maidenhead" or a

Fig. 66. Ford Madox Brown. *The Stages of Cruelty.* Ca. 1856–90. Oil on canvas, 28¼ × 23. Manchester City Art Galleries.

prophylactic shield of sorts, it served as a demarcation for territoriality and restraint on both sides and as a buffer zone for both sexes. Moreover, a work such as *The Stages of Cruelty* with its Hogarthian implications (by its title) suggests that the divider could protect a man from the real or imagined threat of a *femme fatale,* for in Brown's portrayal the wall is a barrier the man partly hides behind as he beholds his sweetheart with a mixture of adoration, fear, and lascivious impulses.

Predictably enough, this persistent vigilance and enforced sequestering of maidenhood often served to heighten the romantic proclivities of the young charges and to intensify their determination to contact waiting lovers or outsmart their elders. Even *Punch* satirized these efforts in an 1856 cartoon entitled "Crinoline Convenient Sometimes: A Warning to Mothers," in which the beau hides behind his beloved's huge skirts. Love was thus an elaborate game of bypassing parental supervision, sneaking away to fetch a billet-doux, or arranging a clandestine tryst, and all of these situations were well-represented in Victorian art. Usually the accomplice in such romantic stratagems was the sister or female friend of a lovelorn lady—someone to share the vicarious danger as well as the excitement of these forbidden maneuvers. One of these "conspiratorial" images was William Gale's *The Confidante* (Fig. 67), which was exhibited at the 1857 Royal Academy with the line "Friendship's shrine is love's confessional." Like John Calcott Horsley's *The Secret Passage,* with its similar theme and composition, or even Arthur Hughes's *Silver and Gold* of 1864 (see fig. 104), this is an image of unmistakable female solidarity, of secrets and charades of love that women share in the "garden of love." As with Leighton's *Sisters* (see Fig. 17), there is a degree of physical proximity and affection that—while often present in images or descriptions of female friendships—is noticeably absent or constrained in male/female amorous exchanges.

The only time that a woman's emotions were

Fig. 67. William Gale. *The Confidante.* 1857. Oil on canvas, 9¾ × 6¾. The Tate Gallery.

Fig. 68. James J. Tissot. *The Return from Henley.* 1880s. Oil on canvas, 54 × 38. Private collection, Geneva.

revealed in art occurred in certain predictable permutations of the romantic triangle predicament. This focused particularly on the rivalry of two men competing for a lady's affections, as in James J. Tissot's *The Return from Henley* (Fig. 68). The triumphant pride of a double conquest acknowledged one of the few stages in courtship when the woman was basically in control of the outcome. (There were, of course, works like *Broken Vows* in which she was the victim, a tradition even female artists like Alice Walker continued in her 1861 *Wounded Feelings,* a ballroom scene of feminine rivalry.) In Tissot's canvas from the 1880s, a lady's pert figure is framed by two enamored sailors who have rowed her to her destination on the pier. Her expression is one of saucy impertinence and victory in lieu of the characteristic mask of coyness, and here the Victorian female is shown as overtly relishing her position of authority. Female coquetry and signs of teasing and tantalizing in the game of flirtation proved a popular subject in art, resulting in works with titles like *Two Strings to her Bow.* The phenomenon of the woman with two admirers gave the female a decided advantage, something not often granted to her in the world outside her garden. Such a moment of openly using her feminine wiles was a contrast to her life in general, particularly after marriage and the role of submissiveness she would assume. The passive femininity that earmarked most other images of women in courtship is modified here to reflect one of the few areas of power men ceded to her in the elusive game of love.

The pursuit of amorousness was occasionally fraught with peril and disappointment, and depictions of romantic tribulation—especially turbulent inner dramas of disillusionment and betrayal in love—were extremely common, if not epidemic, in Victorian art and literature. Typically the vulnerable female was shown bearing the burden of such pain, and the classic visual statement of the fragility of love is Arthur Hughes's *April Love* (Fig. 69) of 1856, which was accompanied by a passage from Tennyson's "The Miller's Daughter": "Love is hurt with jar and fret, Love is made a vague regret." The immediately preceding stanza expands and clarifies the notion of injured affections and questions whether lovers can forget the pain of disappointment or the thrill of rapturous affection. For Tennyson's persona, the memory of romantic pain was acute, and it was this combination of exquisite joy and misery, an oxymoron of sorts of both the gift and debt of love, which seemed to haunt the collec-

Fig. 69. Arthur Hughes. *April Love*. 1856. Oil on canvas, 35 × 19½. The Tate Gallery.

tive Victorian consciousness. In its overall meaning, the couple's relationship in *April Love* is endangered by the passage of time itself and the susceptibility of love to change and die with the successive seasons. The lady's averted face, typical of the downcast restraint of emotion, is nonetheless marred by a teardrop and a look of general uncertainty. The man presses his head to her as if in supplication, his ardor permissible both in real life and in art. The implied crisis in their relationship is amplified by other details such as the fallen rose petals on the ground, possible allusions to both the secrecy and the love of this tormented couple. Moreover, the aperture of this narrow,

gazebolike structure creates an over-the-wall situation reminiscent of *Broken Vows* and *A Huguenot*. Millais's composition is more specifically evoked by the cascading ivy keenly observed in the left foreground, but here the emblems of fidelity wither near the ground by the fallen petals.

The female was usually the victim of Cupid's manipulations, and the relatively mild effects of love's transience were proliferated in an endless string of paintings besides *April Love*. These usually represented the disappointed female in a slumped pose of despondency. This state of aggravated despair appeared in both bourgeois and rustic contexts, often reusing the courting wall motif as a reminder of a failed or thwarted tryst. As might be anticipated, *Keepsake* annuals could be counted on to exploit such themes of feminine sensibility, and scenarios of solitary females yielding to their heartbreak in the privacy of their rooms or a garden spot were legion. Instances of males brooding over rejection, however, were far less numerous, and indeed it was the female whom society tried to shield from false hopes in love by its elaborate code of behavior.

As the wall, fence, or stile was the site of amatory expectation, it was also the setting in art for lovers' tiffs and scenes of male or female rejection. In William Quiller Orchardson's *The Broken Tryst* of 1868, for example, a peasant lass waits forlornly by the tried-and-true rustic stile, partly propping herself up against it in order to brace herself for the prospect of being "stood up." In a general way, of course, the woman juxtaposed in this manner evokes the betrayal and rivalry in Calderon's *Broken Vows*. But the visual reference to *A Huguenot* was still tangible in some cases, as in Charles Lidderdale's 1876 *Rejected Addresses* (Fig. 70), in which the young lady hesitates before opening a garden door. Does she have the "key" to his heart or he to hers? Who is being spurned here? Is there also some allusion to the moral dilemma of conscience made so clear in a somewhat similar composition in Holman Hunt's celebrated *The Light of the World* of 1854, with its figure of Christ knocking on the door of the human soul? The brick wall with its ivy and foliage implies a definite romantic context, but there is a decided ambiguity about who has spurned whom or whether the lady has merely been disappointed by her unseen suitor and thus sadly closes the door on him and on their past love.

The worst effects of a tragic love affair could be mortal, causing the aggrieved lady to pine away and die. A middle-class lady too decorative and

Fig. 70. Charles Lidderdale. *Rejected Addresses*. 1876. Oil on canvas, 50½ × 34⅛. Bradford City Art Gallery.

delicate to survive an emotional upheaval was a stereotype in literature and art, and this story is enacted in William Windus's 1858 *Too Late* (Fig. 71). The work was accompanied by Tennyson's short poem recounting the saga of a woman's disillusionments in love—her disgust with her lover's weak, unfaithful heart and her desire that he "Come not, when I am dead." The poet's protagonist not only asks him to refrain from dropping "foolish tears" on her grave, but also says she is so "sick of Time" that she no longer cares whose fault the tragedy was or whether he weds another woman now that it is "too late" and she hovers near death.

In the modern-life pictorial subject Windus places the main characters in contemporary attire but has them enact an age-old tale. As Tennyson's poem vividly conveyed, it is the guilty errant lover who returns to repent and to discover that his irresponsibility has had a near-fatal impact on his beloved. She musters some strength to spurn him

Fig. 71. William Windus. *Too Late*. 1858. Oil on canvas, 37½ × 30. The Tate Gallery.

(an ending perhaps reminiscent of *La Traviata*) even though she leans on a cane weakly. Hollow-cheeked and emaciated, she has been made an invalid by her sorrows and now urges him to leave her, with a numbed indifference of tone and expression. Windus's friend and fellow artist Ford Madox Brown remarked that "the expression of the dying face is quite sufficient—no other explanation is needed,"[16] while other critics pointed out all the lady's ailments due to love. The *National Magazine* found the subject "most painful and indeed repulsive, but earnest and deep-feeling," noting that the woman's countenance was too hard to look at because it was a "most painful pathological study, with its burning hollows of the fallen cheeks, the gaunt eyes and sunken brows, the constrained and fevered mouth, and wasted figure."[17] At her feet are dead leaves and the outline of a tombstone, objects that amplify the mood of death, loss, or change in the poem. Behind the group—for the wronged woman is supported by a sympathetic friend or sister—stands an ivy-covered wall, a barrier which presumably once separated the couple in courtship but now reunites them in tragedy (this being a subtle reference, of course, to *A Huguenot*). The symbolism of the ivy and faithfulness is now an ironic reminder of the past. Although Ruskin criticized the work as too melancholy with its "puling and pining over deserted ladies,"[18] there is considerable emotional intensity captured in the gestures and faces of the four figures. As Brown commented, the returning lover has been "led by a little girl, when it was 'too late,'"[19] and she is perhaps an allusion to the girlish innocence and trust that the betrothed once had for her beau. The male is overcome with remorse or shame and shields himself from being watched, his raised arms mostly fending off the spectator of the picture. The only female who actually stares at him is the young girl, who fingers some foliage probably suggestive of broken vows. The distraught expression and the half-clinging, half-supportive pose of the female companion to the invalid underscore the vulnerability of the women. And the beloved with her deathly pallor seems about to expire in this garden, which evokes *A Huguenot, Convent Thoughts,* and similar pictures and their reverberations of meaning.

The goal and apex of courtship, the proposal, was depicted in various ways, often within the legendary garden of love itself. Costume pieces, cottage interiors, and middle-class settings all proved popular and enjoyed a particular vogue during the 1870s, 1880s, and 1890s. A consummate statement of this theme in the context of a garden or forest tryst is Arthur Hughes's *The Long Engagement* (Fig. 72), begun in 1853 as *Orlando in the Forest of Arden* but repainted and submitted under a revised title in the 1859 Royal Academy exhibition. The picture seems to complete an informal sequence of courtship vignettes left suspended in the artist's 1853–54 *Amy,* a canvas in which a young woman awaits an absent lover at their secluded rendezvous and primps at a tree on which her

Fig. 72. Arthur Hughes. *The Long Engagement.* 1859. Oil on canvas, 41½ × 20½. By courtesy of Birmingham Museums and Art Gallery.

name has been carved. *The Long Engagement* was accompanied by lines from Chaucer's *Troilus and Criseyde:* "For how myght sweetnesse have be known/ To hym that never tasted bitternesse?" Although the passage seemed cryptic to some contemporary reviewers, it may allude to the untasted sweetness of love, including the physical pleasures of intimacy, which this couple has little prospect of knowing. It also reiterates the adage that true contentment is not possible without suffering. The obvious pictorial inspiration for Hughes's composition was Millais's *A Huguenot* with its Pre-Raphaelite attention to meticulous natural and botanical details pressing in on the fated couple in an almost airless vacuum of space. Moreover, the sense of secret love compressed in a nook and of thwarted love overwhelmed, almost made claustrophobic, by the surroundings, also is reminiscent of Millais's painting. Here the lovers are surrounded by luxuriant flowers and foliage. The burgeoning fertility of nature, including perhaps that of the procreative squirrels in the trees and the faithful dog, is in contrast to the socially ordained chastity of the pair's relationship and thus heightens the pathos of their unfulfilled, potentially sterile, love. This was just the sort of "long, spiritless engagement" that many courtesy manual authors warned against, although Ruskin rather eccentrically advocated a seven-year period as an ideal term of engagement.[20] The gentleman in *The Long Engagement* is a cleric, and his expression signifies his realization that his meager salary and limited prospects will prevent him from marrying, for men were urged not to wed unless and until they could afford to provide for their wives at a level at least equal to what they had been accustomed to. In spite of the passage of time, the couple holds hands, a gesture symbolic of nuptial intentions. Moreover, the relentless march of time is suggested by the lady's subtle wrinkles (especially evident on her furrowed forehead) and the fact that her name, "Amy," is being covered over by the encroaching growth of foliage. Ivy creepers—emblematic of constancy and even of marriage—and moss (commonly associated with maternal love) ironically intertwine on the tree.

Another modern-life Victorian drama typical of the drawing-room setting so popular in bourgeois variations on this theme was Millais's 1871 *Yes or No?* (Fig. 73). The poignancy and intensity of emotion and the sense of romantic doom are much less evident than in Hughes's portrayals or in Millais's *A Huguenot*, but the canvas nonetheless serves as the

Fig. 73. John Everett Millais. *Yes or No?* 1871. Oil on canvas, 44 × 36. Yale University Art Gallery, Stephen Carleton Clark, B.A. 1903 Fund.

first part of a trilogy of paintings detailing a lady's quandary concerning an offer of marriage. The title reflects her wavering state of mind about how to respond to the letter of proposal on her desk, one means of properly broaching the matrimonial subject. A man might apply in person for his beloved's hand in marriage, but any matrimonial proposal, written or otherwise, was supposed to be referred directly to parents or a male relative to negotiate and, ultimately, to accept or to refuse. Indeed, courtesy manuals indicate that until late in the century a young woman was not permitted to register a deciding vote on this momentous question if she belonged to the upper classes. In Millais's painting, the scenario is in keeping with the type of advice dispensed by contemporary courtship literature. Reviews of *Yes or No?* postulated various interpretations: one author suggested the lady was holding a daguerreotype of a former lover while she contemplated a letter from a more eligible, but less cherished, beau. Another critic found her expression lacking any tenderness and called her a cold-hearted but "handsome harpy."[21] The dilemma was resolved in a sequel of 1875, *No!,* in which the female rejects the offer of matrimony

Fig. 74. Jessica Hayllar. *A Coming Event*. 1886. Oil on canvas, 22½ × 18½. The FORBES Magazine Collection, New York.

with a downcast expression. The denouement of this melodrama attests to the public's unwillingness to accept an unhappy ending, and *Yes!* of 1877 was created partly in response to lobbying by viewers for a blissful conclusion.[22] In this final scene the hitherto absent and rejected suitor, wearing a traveling coat and with a valise at his side, asks if his fiancée will "wait for his return."[23] The rose in her hair, the couple's intense gazes, and their clasped hands all imply that the resolution will be a joyous reunion and subsequent marriage.

Portrayals of courtship and engagements, often cloying and clichéd, glutted the *Keepsake* annuals and the art market, as was the case to a lesser extent with scenes of bridal preparations and weddings. The setting shifted from garden settings for rustic, bourgeois, and lower classes, and the architectural barrier à la Millais seemed to disappear. It is as if that prop or backdrop of the courting wall had relevance only to the period of courtship itself, when mutual reserve was mandatory and the separating device fulfilled the dual role of restraining apparatus and inanimate chaperon. With the wedding ceremony or day at hand, there was no need for such symbolism and the wall/fence/stile motif thus becomes conspicuously absent.

The cult of the bride and her attendants—practically the apotheosis of the Virgin to the Victorians—was reaffirmed by countless paintings. Nuptial imagery focused on the bride, her maidenly preparations, the ceremony, or the celebration, with middle-class vignettes generally outnumbering rusticized versions of this subject. One of the most captivating portrayals was produced by a woman artist, Jessica Hayllar, in *A Coming Event* (Fig. 74) of 1886. This is one of four canvases following the progress of the feminine stages of life and including other bridal imagery such as *Fresh from the Altar*. Although no contemporary critics seemed to have commented on it, *A Coming Event* was an unprecedented and iconoclastic image of courtship or nuptial subjects, which were usually rather saccharine closeups of demure ladies in their bridal finery or being prepared for their toilette. In Hayllar's haunting picture, the foreground still-life elements of the wedding paraphernalia—the lustrous gown, the flowers, the fan, and the empty slippers—all attest to the coming event. Yet unlike standard representations of the bride and her trappings, this painting focuses on the separate life of the lovely things themselves, which function as ghostly prefigurings of the new identity and life which the woman

would soon embrace. The bride may well be the female shown sitting at a window in the adjoining room (in actuality a part of the Hayllar residence, Castle Priory) and talking with a young man, perhaps her intended spouse. The fashionable white gown attests to current customs of wearing that color (the Victorian era "invented" many bridal traditions), while the basket of flowers may be a suggestion of fertility or abundance. Moreover, the empty satin slippers remind viewers of the ancient Anglo-Saxon practice of transferring "ownership" or custody of the woman from her father to her husband, by the handing over of a woman's shoe, a custom evoked by tying old shoes on the back of a carriage.[24]

The marriage ceremony itself could acquire an odd tone depending upon the intervention of fate, and the theme of the mismatched couple resulted. Millais, for example, produced several works treating the odd theme of rivalry and betrayal upon the marriage of a loved one to another person, as in his

Fig. 75. Edmund Blair-Leighton. *Until Death do us Part.* 1878–79. Oil on canvas, 59½ × 43½. The FORBES Magazine Collection, New York.

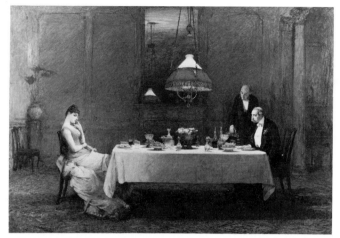

Fig. 76. William Quiller Orchardson. *Mariage de Convenance*. 1883. Oil on canvas, 40½ × 60¾. Glasgow Museums and Art Galleries.

1853 drawings entitled *Married for Money* and *Married for Rank,* or a related theme in his 1854 painting entitled *Wedding Cards: Jilted*. Similarly, Edmund Blair-Leighton's *Until Death Do Us Part* (Fig. 75) of 1879 treats what the *Magazine of Art* reviewer termed the "picturesque incidents of a modern wedding. . . . His bride walks down the aisle on the arm of her moneyed lord and master, whose prosperity and respectability are well expressed without caricature; while a former admirer stands up in his place in the church to reproach the faithless girl with a look."[25]

Although artists such as Marcus Stone painted cozy honeymoon subjects, the negative sides of married life infrequently intruded upon the endless placid visions of romantic bliss in contemporary paintings. Marriage was an anticlimax to the nostalgic and sentimental lure of courtship subjects. Unconsummated, perhaps plagued or even abortive, the theme of romance was stronger than any other in mid-to-late Victorian genre pictures, partly because of the alloy of mild titillation, wishful thinking, and innocent pleasure that could be projected into the narrative by viewers. Nonetheless, marital problems were the target of a few works by William Q. Orchardson, especially his serial *Mariage de Convenance* (Fig. 76) canvases of 1883 and 1886 (see the "before" scene). Taken together, this pair implies a discreet indictment, or at least a visual exposé, of the status quo among the upper classes, a system which pressured individuals to wed for reasons of money, not love. The first part of this scathing social drama was described by the *Art-Journal* critic as "a sermon—and a dismal tragedy. At one end of the richly appointed table sits the young wife—ambitious, disappointed, sullen, unutterably miserable. At the other end sits the husband—old, blasé, roué, bored too, and the more pitiable in that he has exhausted all his feelings and has only boredom left."[26] There are fruits and wine on the table suggesting fertility and bounty, while the long expanse of the table emphasizes the distance, both physical and emotional, between the two. The woman does not even pretend to be polite, but merely pulls back into a pose of self-reflection and pouting. The old man sits forward a bit to study his young wife, but his expression is also dolorous. At his side a butler witnesses this chilly encounter. In the 1886 sequel, the old man appears even more aged and sits alone in the same room in front of an unswept hearth, the cold ashes reminding the viewer that there is no woman here now to keep the "place of Peace" warm in spirit and otherwise. The husband is surrounded moreover by portraits on the wall, some of women, yet his own wife has ironically left him. The table is now set only for one, with the large carafe of wine perhaps alluding to future problems for the gentleman. Certainly his demeanor is forlorn, for he wears no slippers, his shirtfront buckles up awkwardly, and his empty hands hang on his lap; furthermore, his slumping posture conveys his state of loss and despair. As in the first part, the long narrow canvas and the wide interior spaces depicted seem to engulf the solitary figure and to personify the psychological isolation he is glumly experiencing. The *Athenaeum* reviewer also remarked about the "dreadful shadows and unhomelike furniture" and the bloodshot eyes of this "wicked, wretched, and abandoned husband," who broods about the past and yet was unable to "really care for the toy of his passion bought with his purse."[27] Thus Orchardson joins those artists who offer a glimpse into the affairs of the heart, whether they are scenes of tender poetry, abject misery, or, as here, an upper-class parlor redolent of disgrace and pitiable failure.

7
Women Workers

I. THE VICTORIAN LADY ARTIST

A TRUE LADY WAS NOT SUPPOSED TO WORK, ESPECIALLY for pay, and Victorian society obviously accorded respect to the inactivity and economic nonproductivity of middle- and upper-class women. Nonetheless, there were certainly many females who transcended a life of leisure and the level of mere ladylike accomplishments to make significant contributions in literature and art. Among the best-known female writers of this era were Charlotte and Anne Brontë, Elizabeth Barrett Browning, George Eliot, Anna Jameson, Christina Rossetti, Elizabeth Gaskell, and Mary Braddon, while in the art world Lady Elizabeth (Butler) Thompson, Henrietta Ward, Sophie Anderson, Rebecca Solomon, Joanna Boyce, Rosa Brett, and Jessica and Edith Hayllar exhibited canvases at the Royal Academy and similar institutions. For painters, however, there were numerous obstacles to overcome, for avenues for feminine creativity in the fine arts were impeded by prejudice and a lack of available training. Although two women (Angelica Kauffmann and Mary Moser) were among the founding members of the Academy in 1768, no other women attained membership (despite various unsuccessful efforts) until 1922, and the status of an elected Academician was not achieved by women until 1936. Although some sporadic attempts at formal education in this field were available in the Female School of Art (begun in 1851), this establishment, like the Society of Female Artists established in 1857 to stage its own exhibitions, could not really solve the problems faced by women artists. In 1860 a female student accidentally gained admission to the Royal Academy school because she had not given her first name on the application, but this oversight merely raised the vexing issue of whether women pupils should be allowed to work from the nude model. Indeed, most of the women artists already mentioned (as well as Mrs. W. H. Carpenter, Annie and Martha Mutrie, Mrs. Wild, and the sculptor Mary Thornycroft) gained their initial tutelage, or some protracted encouragement, from the men in their family—fathers, brothers, or husbands.

Although figures like John Ruskin could at times (albeit in a limited, biased way) encourage women painters (he was later to recant his belief that there could be no great woman painter), the image of the female artist was rather curiously a mixture of both ridicule and charm. *Punch* and other periodicals, for example, chose to treat the gifted female in a belittling manner, lampooning her as a simple dabbler in the arts as well as envying the male drawing master who taught pretty women students. *Punch* also often derided the female artist in cartoons as being homely, incompetent, and spinsterish (especially in the 1860s cartoons on Lavinia Brounjones), at best a creative type who might be handsome but who had an ephemeral dedication

Fig. 77. Octavius Oakley. *A Student of Beauty.* 1861. Watercolor, 30 × 21½. Collection of David Daniels.

to the arts in lieu of real talent.

In contrast, however, many paintings depicted women artists with far less undercutting sarcasm or editorializing tones. The talented female was still perceived as a "pretty young thing," but her expression was revealed as serious and diligent as she became involved in the creative process. Generally she is seen as isolated from others, absorbed in a mood of contemplation. *A Student of Beauty* (Fig. 77) of 1861 by Octavius Oakley, for example, raises some interesting sociological issues regarding the education of women in the fine arts in the nineteenth century. Since women were not permitted even in their own segregated academies to study the female nude, this lady in her elegant parlor must resort to a sculpture (probably of Clytie, a nymph whom Apollo turned into a sunflower) for her inspiration. The fashionable blue-and-white china and bric-a-brac in this fashionable, upper-class home remind the modern viewer that the decorative arts—teacup painting and other amateur realms—were often suggested as alternative fields for talented women artists. It was difficult for

women to exceed the boundaries of the accomplished amateur, and many were thus relegated to the relatively minor fields of still life and genre, often due to their lack of formal training. In Oakley's image, as in other renditions of this subject, the pensive beauty of the female is compared with that of a sculpted bust, providing viewers with a contrast of previous and contemporary standards of ideal feminine beauty. Moreover, the title of *A Student of Beauty* implies to a twentieth-century interpreter that a woman could only be a student, not a master, of painting.

John Ruskin wrote to one Victorian woman artist, Anna Blunden, that "as far as I know lady painters, they *always* let their feelings run away with them, and get to painting angels and mourners when they should be painting brickbats and stones."[1] Ruskin's comments are somewhat ironic given the fact that male artists produced the greatest number of melodramatic or sentimental genre and "modern life" pictures. One female painter who executed a telling vignette of the plight she and others faced in this regard was Emily Osborn. The *Art-Journal* critic paid her a backhanded compliment when he commented about *Nameless and Friendless* (Fig. 78) of 1857: "The subject is extremely well carried out; and, in execution and drawing it is much firmer than the works of ladies generally. . . . The incident is narrated with feeling and emphasis." This reviewer identified the subject as a "poor girl" who offers a work of hers for sale to a dealer, "who from the speaking expression of his features, is disposed to depreciate the work. It is a wet, dismal day, and she has walked far to dispose of it; and now awaits in trembling the decision of a man who is become rich by the labours of others. . . ."[2] (Interestingly, at one point in the twentieth century a male art historian interpreted the young boy as the artist, erroneously reasoning that women did not paint seriously.) But in truth it is the lad's sister who nervously twiddles with the string from her parcel as she attempts to market her wares. Given her sober attire, she is in mourning and has suddenly comprehended the harsh challenge of having to support herself and her brother. It is a tale movingly told by various glances, especially that of the downcast and unsure female, while that of her brother is more direct and beseeching as he watches the dealer assess the canvas she has removed from her portfolio. This is a male world of judgment, however, and this point is also subtly made by the biblical verse accompanying the painting: "The rich man's wealth is his strong city, etc." from Proverbs 10:15.) An assistant

Fig. 78. Emily Osborn. *Nameless and Friendless.* 1857. Oil on canvas, 34 × 44. Collection of Sir David Scott.

at right observes his employer's reaction; moreover, two top-hatted gentlemen (perhaps reckless dandies) at left seem to eye somewhat lasciviously the young lady, perhaps comparing her physique with that of the frivolous ballerina on the print they are examining. In contrast to the impoverished pair are a well-dressed young lady and boy who leave the shop with a purchase, a mild confrontation or contrast of the rich and the indigent in one small corner of London. No doubt the vicissitudes of self-employment, to say nothing of scorn or abuse, plagued Osborn herself, but here she has effectively sublimated such feelings into the context of poor orphans trying to cope in the city on their own. There were other, more sympathetic, images of women artists by artists such as Abraham Solomon in *A Sketch from Memory*, Samuel Baldwin in *Sketching Nature* of 1857, or Holman Hunt's *The School of Nature* of 1893, but this vignette of tribula-

tion and despair by a woman artist serves as compelling testimony to the plight of the talented female in art.

II. THE MISTRESS OF THE HOUSE AND THE DOMESTIC SERVANT

Some female artists had to support themselves or their families financially and were relatively successful at doing so, but they were anomalies and their exceptional status was often commented upon by critics who typically singled out a woman who could "paint as well as a man." Women painters like Rebecca Solomon and the Hayllar sisters received encouragement to pursue their aspirations from fathers or brothers who also painted, but in general the lot of the lady painter was limited to a very private audience and realm. The role a lady

was assumed instead to take upon herself was that of mistress of the house, a position as hearthside goddess which was extolled in paintings by Hicks and others. Isabella Beeton in her famous *Book of Household Management* urged the mistress of the house to act like the "commander of an army," marshaling all the human and other resources of the home and actively participating in every aspect of domestic management.[3] To Beeton, woman was not an ethereal intermediary of salvation: she was a formidable leader with a responsibility to teach, nurse, and above all to exemplify to her servants the proper degrees of morality, charity, cleanliness, frugality, and self-sacrifice. Thus, the Victorian lady was a paradox of idleness and industry, yet she was obviously very different from the female who had to toil to earn a living.

As one modern historian has insightfully remarked, "Victorian middle-class ideology about the nature of 'true womanhood' contained a fundamental contradiction: the sheltered lives that middle-class girls and women were supposed to lead depended directly on the labor of working-class girls and women, who through their services created the material conditions necessary to maintain the middle-class woman's style of life."[4] Of course, some females were conscious of their undeniable dependency as a class on an abundant and cheap supply of labor, but they frequently voiced more concern for "the welfare of such essentially marginal groups as seamstresses and prostitutes than . . . for the lot of ordinary domestic servants, who were the largest group among females engaged in service work. . . ."[5] As this statement implies, pity was perhaps more readily expressed for the fallen women, but the downtrodden employed women statistically comprised the majority of female workers in the English economy from the 1841 census

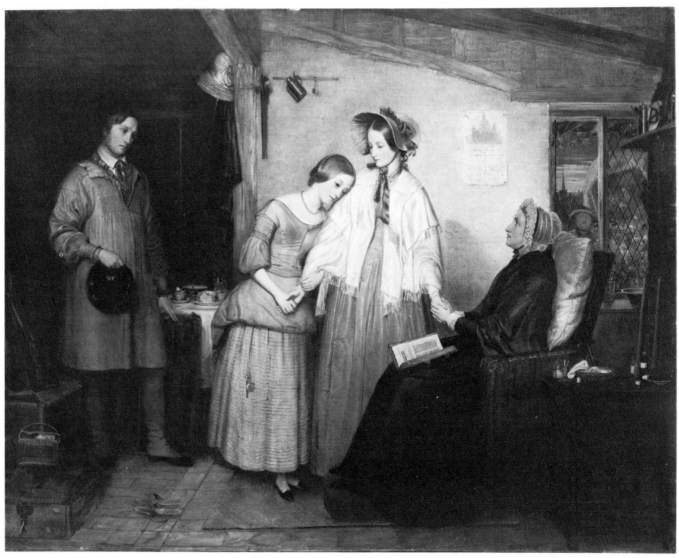

Fig. 79. Richard Redgrave. *Going into Service*. 1843. Oil on canvas, 31 × 39½. Private English collection.

until the turn of the century. During those decades nearly one out of four British females worked for a living, about three-quarters absorbed into the three dominating professions of domestic service, textile and dress manufacture, and agricultural labor.[6]

Domestic service was, in terms of statistical evidence, the largest source of occupation for working women throughout the Victorian era, and indeed female servants were ubiquitous background figures in both real life and art. Symbolically, of course, they were emblems of the English class structure and the households where they toiled were partly judged by the number of servants of which it could boast. A minimum annual income of about £300 was necessary to afford one servant, who became as critical a symbol of affluence as the changing fads of china pug dogs and Liberty fabrics.[7]

Unlike sempstresses or factory workers, for example, female servants were a suitable subject because they were perceived in general as submissive and obedient women confined to duties at home. Often they were the young, teen-aged daughters of impoverished country laborers and were therefore inexperienced in household responsibilities and other matters. Representations of the young female leaving home and "going into service" include Richard Redgrave's trenchant 1843 work (Fig. 79) of this title. Here the adolescent country lass is forced to seek a "place" in order to help support her invalid mother or grandmother, seated nearby with a Bible. Her sister has already taken in plain sewing to enlarge the family income, as the sewing apparatus hanging from her bodice and placed throughout the room suggest: perhaps these sewing materials may also be a harbinger of a future dire fate of being a sempstress, an even more afflicted creature. The man who assists is a drover or shepherd, as his long simple jacket attests, and he may be a sweetheart of the departing woman. Labels on the luggage indicate the destination to be "Lady Fashion's" in the West End of London, and more ominous details portend an unhappy fate. On the wall a notice reads "The True Ballad/ The Rogueish London Town" and has an illustration of St. Paul's Cathedral, a landmark found in many prostitute pictures. There are tears in the eyes of the old woman, whom the *Art-Union* imagined to be giving her daughter "excellent advice touching the temptations to which she is about to be exposed."[8] The uncertain destiny that awaits may be more than the glimpse of city spires evident through the window, for the Hogarthian cartload

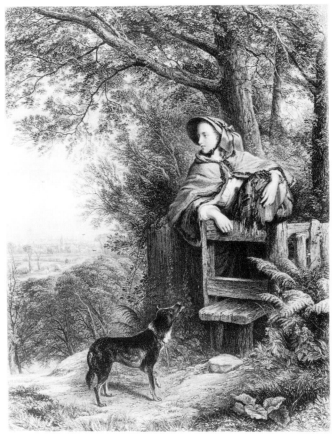

Fig. 80. William Powell Frith. *A Dream of the Future*. 1856. Etching and engraving, 6 × 8. Private collection.

of naïve young females seeking urban employment may allude to a fate of prostitution. If the young woman here is not fortunate enough to find a good mistress and place, she may be reduced to poverty or even worse circumstances. For this ingenious rendering of details *Going Into Service* was pronounced "perfect" by the *Art-Union*, for "every part of the canvas contains some allusion to the main incident, thrown in so judiciously as to appear in the proper place."[9]

A less pathetic scene is suggested in William Powell Frith's *A Dream of the Future* (Fig. 80) from the 1856 Royal Academy exhibition. At first glance, the subject has affinities with the "courting barrier" concept: the young woman is of peasant or lower-class origin and looks out over a stile to ponder dreamily her destiny, perhaps her marital or romantic fate, just as her upper-class counterparts might do. The picture's iconographic divisions follow the alternatives set up by this barrier as an emblem of crossing from one domain to another: from country to city, familiar to unfamiliar, past to future. The *Art-Journal* remarked that this canvas "might be an incident from some of our elder novelists or poets—Richardson, Fielding, or

Crabbe."[10] Although called "a dream," there is nothing somnolent, either in substance or allusion. It is a story of a country girl leaving her native village and about to seek employment in London, which appears in the distance, St. Paul's being always the notable sign of the great city. Another critic commented on the "Whittington-and-Highgate spirit" of the narrative and mentioned the dangerous lure of the city that beckons the young woman.[11] Traveling bag in hand, she may be on the verge of crossing the threshold in more than one sense, trading maidenhood for sexuality and destitution and the country life for the sinful one.

Once ensconced in her place of employment, the servant tended not to be an object of pity in art, perhaps because she was simply overlooked as an impersonal and invisibly omnipresent household "fixture." Augustus Egg's late 1850s *A Young Woman at Her Dressing Table with Her Maid* (Fig. 81) conveys the ambiguity of the employer/servant relationship. The painting also recalls seventeenth-century Dutch interiors of women at their mirrors with maids in attendance; this canvas is remarkably similar, for example, to one by Terborch entitled *A Lady at Her Toilet* of ca. 1657 that was known to be in England in the nineteenth century.[12] More importantly, the moralizing or didactic undertones of such Dutch pictures are implied here in the contrast between the vain lady of leisure and her diligent servant, embodiments of idleness and industry. Another contrast is of the fair and darkhaired women, the latter a silent and pensive sentinel to her blond employer's frivolous absorption in herself and her toilette. The table is littered with jewelry and flowers, and the lady's white dress, along with the chaplet of flowers and serpentine bracelet, may suggest a romantic (or even a marital) resolution to the narrative.

In spite of her inconspicuousness she was living proof of social status, but in some depictions she is shown as neglecting her duties or as being an eavesdropper. Her role as interloper in family affairs was, of course, inescapable, given the fact that the domestic servant invariably heard or saw a great deal in the home where she also lived, and this is why she was undoubtedly partly feared by her mistress. This mixture of neglecting her duties and gossiping is evident in John Finnie's 1864–65 *Maids of All Work* (Fig. 82), in which two female servants pause to exchange a few words. The woman at left has been engaged in household cleaning, as the broom handle on which she leans indicates, while her companion is better dressed (and wears a snood). The latter may be a young housekeeper or her assistant, for she holds the keys to the cupboards, an important responsibility in the hierarchy of the Victorian household. The two pose at a doorway to get some fresh air, but the brick wall behind them is part of the building's structural boundaries and not a portion of a lovely garden perimeter. This is a rare moment of leisure for these maids-of-all-work, who do not otherwise appear fatigued or downtrodden. Other paintings of the period depicted the female domestic as pretty and docile, even involved in romantic interludes with members of her own class (no lusty upper-class employees appear, as in novels), but often there is a rather condescending hint in such portrayals or an attempt to make the figures comic.

The darker side of domestic service rarely surfaced in art, but such an instance of reality intrudes in Frederick Hardy's *After the Party* (Fig. 83) of 1876. This is seen from a housemaid's point of view and thus affords a unique perspective on this subject. The *Illustrated London News* reviewer aptly described the scenario as "a little tired waiting-maid found by fellow servants at dawn seated fast asleep

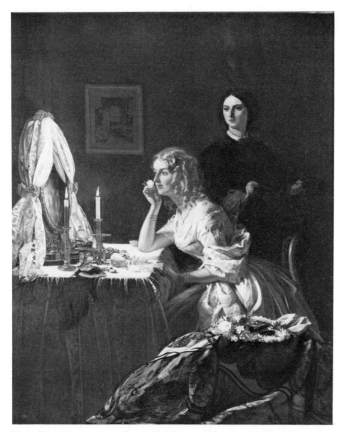

Fig. 81. Augustus Egg. *A Young Woman at Her Dressing Table with Her Maid*. Late 1850s. Oil on canvas, 23½ × 19½. The Suzanne and Edmund J. McCormick Collection.

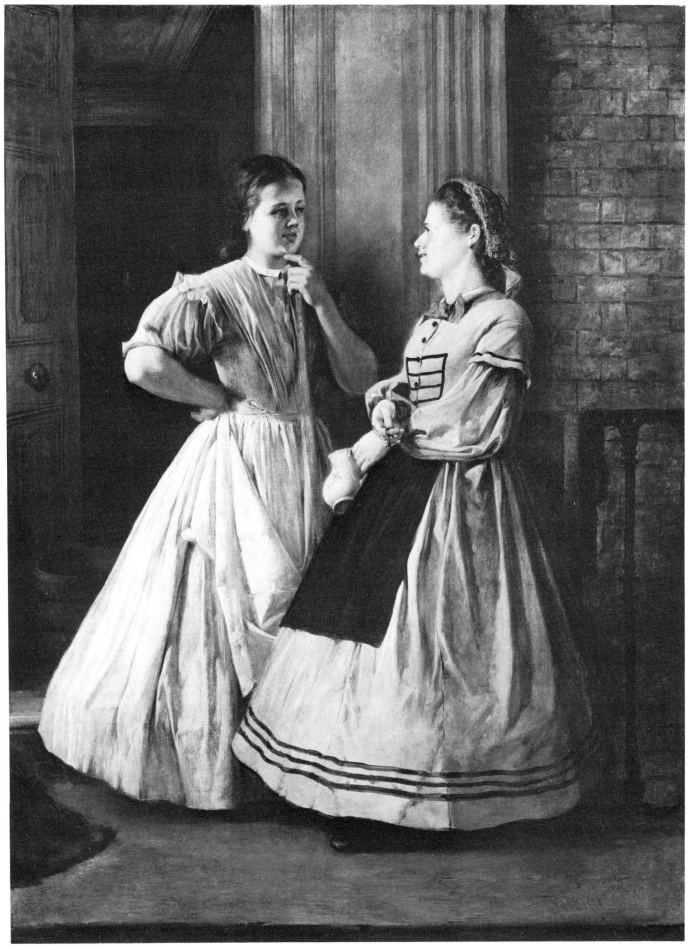

Fig. 82. John Finnie. *Maids of All Work*. 1864–65. Oil on canvas, 23½ × 17½. The Geffrye Museum, London.

Fig. 83. Frederick D. Hardy. *After the Party.* 1876. Oil on canvas, 25½ × 41½. The FORBES Magazine Collection, New York.

beside the wreck that strews the unremoved cloth." Moreover, the "artificial light of the guttering candles, in contrast with the glimpse of the morning at the door"[13] suggest the expiring light or youth of the young girl in service. Here the adolescent is far removed from the world of childhood and girlish dreams, having fallen asleep waiting for the party to end and her duties to commence again. The reflection of a male butler appears in a mirror, but it is another woman who rouses her and must, like her exhausted coworker, be burdened with cleaning up the mess of their employers' lavish entertaining.

While depictions of servants were not very popular in Victorian genre painting, countless contemporary cartoons in *Punch* treated this subject, generally ridiculing this unobtrusive witness of middle-class life. While the idealized servant is literally in the background in many paintings, she steps forward in more ways than one in *Punch* illustrations, especially in those drawn by John Leech. Frequently she is an object of ridicule, the victim of the nearly universal complaint among Victorian ladies about "the servant problem." Cooks, for example, were stereotyped as obese and uneducated, while housemaids could, depending on the circumstances, either be viewed as dumb and grotesque or as pretty young wenches. Numerous Leech depictions of "servantgalism" in the 1860s focused on the domestic's sauciness or impudence to her employer, and the affectations of dress, language, and reading material by which she aped her employers were also lampooned. At other times she is made to seem ludicrous and laughable for her impertinence, her self-important airs and ambitions hinting that she somehow did not really know her "place." Yet the growing short-

age of domestic servants beginning in the late 1880s caused these women in real life to be more assertive about the terms of their employment, and cartoons of this period accordingly depict a new figure who aggressively inquires about job conditions, wages, vacation, privileges, and the like. Interestingly, the image of the female domestic in advertisements at the end of the century became more idealized at the same time that her counterparts in *Punch* grew more assertive. In the *Graphic*, the *Illustrated London News,* and other periodicals the servant is stylized in ads as a uniformed, lovely creature who floats along with a tray of tea things to serve an unseen master or mistress, perhaps a symbol of wishful thinking about the "good old days" of the near-servitude of servants, not their mere grudging service to employers.[14]

III. THE SEMPSTRESS

One of the most tenacious images in the public imagination of the female worker was that of the needlewoman, whose overworked plight was chronicled in the reports of Parliament, the metropolitan police courts, the Children's Employment Commission of 1842–43, *Fraser's Magazine*, the *Pictorial Times*, and *Punch*. Thomas Hood's "The Song of the Shirt" appeared in *Punch* in 1843, and this rather simpleminded poem immediately ignited widespread interest and sympathy for the exploited sempstress.[15] The subject was perceived as an exclusively Victorian institution, even though oppressed needlewomen had toiled since the Industrial Revolution in England. Thus, there was no real iconological heritage for this subject, but Richard Redgrave single-handedly forged one with an 1844 Royal Academy entry that became the prototype for numerous later works by other artists.[16] His original version (now lost) of *The Sempstress* was, he said, "aimed at calling attention to the trials and struggles of the poor and the oppressed," a decided statement of his preference for depicting victims, particularly female ones.[17]

Like his 1845 *The Poor Teacher* (see Fig. 89), this canvas—as exemplified by Redgrave's 1846 version of *The Sempstress* (Fig. 84)—utilized a simple set of visual variables to achieve its effect; namely, a single figure with gaunt (perhaps once handsome) features, whose destitution and illness are the price of her sweated labors. Such a scenario was carefully orchestrated and manipulated, for in fact many needlewomen were obliged to share crowded quar-

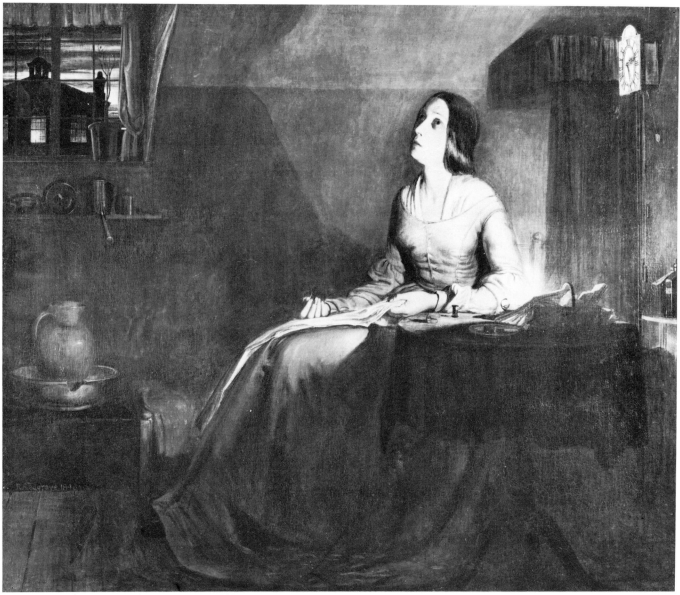

Fig. 84. Richard Redgrave. *The Sempstress*. 1846. Oil on canvas, 25 × 30. The FORBES Magazine Collection, New York.

ters. The final result was thus calculated to excite sympathy in the spectator and perhaps an awareness of the need to enact social reform of these deplorable conditions. Here the details echo such lines as these from Hood's poem: "With fingers weary and worn/ With eyelids heavy and red/ A woman sat, in unwomanly rage/ Plying her needle and thread./Stitch! stitch! stitch!/ In poverty, hunger, and dirt,/ And still with a voice of a dolorous pitch/ She sang the 'Song of the Shirt.' "[18] Most reviewers hailed the 1844 picture (of which this is a replica) as the *Art-Union* did: "The story is told in such a way as to approach the best feelings of the human heart: she is not a low-born drudge to proclaim her patient endurance to the vulgar world: her suffering is read only in the shrunken

cheek, and the eye made feverish and dim with watching."[19] Her situation was thus made all the more poignant because she was implied to be a "reduced gentleman's daughter" (the very title of the first of Redgrave's social themes in 1840), not a "low-born drudge." As the poem mentions, the worker's eyelids are reddened, an omen of blindness that often beset such creatures after a few years of this hard toil. The array of objects all bear witness to her state—from the vials of medicine on the table (marked "The Mixture" and "Middlesex Waters"), with their alleged curative powers, to the magnifying glass on a plate for use to ease her strained eyesight. On the window ledge a dying plant symbolizes the female's sickliness and alludes to a happier place and middle-class garden

which she was forced to leave. The withering plant also recalls the words of Hood's protagonist, "O! but to breathe the breath / Of the cowslip and primrose sweet—/ With the sky above my head, / And the grass beneath my feet, / For only one short hour / To feel as I used to feel; / Before I knew the woes of want / And the walk that costs a meal!"[20] Instead of rural grass and flowers, she sees a dying plant and crude attic chambers, not a blue sky, surrounding her. The passage of time and the thoughts of "only one short hour" are measured by the clock on the mantel, a last vestige of lost gentility, and the hands of the clock indicate a very early hour of the morning. One small candle illuminates the garret room, its state of near-extinguishment akin to the woman's wan and mortal condition. The chipped china beneath the pitcher also reinforces her derelict and disordered life and paltry possessions, as does the tragic absence of food to eat. William Thackeray, who otherwise criticized this painting for being too sentimental, nonetheless pointed out another telling detail, namely, the gray-streaked dawn rising over the house seen through the window, where "from a light which it has in its window, you may imagine that another pretty shirtmaker is toiling too."[21] The shirt itself becomes an emblem in the painting as in the poem, both a literal real thing and an omen foretelling the white shroud of death. Overly sentimental or not, this work inspired a string of imitations and variations, including those by George F. Watts in 1848, Anna Blunden in 1854, C. W. Cope in 1869, and Edward Radford in 1873, all of which utilize the same single-figure format and symbolism of suffering to make this figure a modern martyr looking to heaven for salvation from her fatigue, desolation, and abuse.

Punch also featured a number of contemporary cartoons on this subject in the 1840s and 1850s, and one entitled "The Needlewoman at Home and Abroad" of 1850 compared the sad fate of the English worker with the supposedly rosier one of her continental counterpart. Similarly, "an industrious needlewoman" is depicted as trapped under glass in another 1850 cartoon of "Specimens from Mr. Punch's Industrial Exhibitions," along with other wretched human examples of the state of British labor. There was also a poem that year entitled "The Needlewoman's Farewell," which related the desperate exile of a sempstress to find hope (and perhaps a spouse) across the seas by emigrating: "And so we strove with straining eyes, in squalid rooms and chill;/ The needle plied, until we died—

or worse. . . ."[22] The allusion to prostitution as a last resort in these lines was a reality in many cases, and Millais suggested this fate in an 1853 drawing entitled *Virtue and Vice* (Fig. 85). Here the thin and overworked needlewoman is besieged by personifications of the spirit and the flesh in a classic moment of choice about her future. Shall she, like the terrible vision that has materialized, also become a gaudily painted, raucous streetwalker? Or will she retain her virtue and perish in the sparse garret chamber which is the preordained place for her labors? The setting, as the city environment implied, reiterates Redgrave's (and Hood's) vocabulary of distress for the poor sempstress, adding a moral dilemma to that of mere survival. The objects in the room are also significant, from the package marked "shirts" (to become her shroud ultimately?), to the paper on the wall with the words "DISTRESSED NEEDLEWOMAN" (reminiscent of a *Punch* illustration title), to the theater program in the harlot's pocket emblazoned "HAYMARKET," the latter an allusion to the district in London were the streetwalkers thronged the pavement.

In a related vein, other *Punch* cartoons focused on the unjust dichotomy between the rich and the poor, stressing that the luxury of the wealthy

Fig. 85. John Everett Millais. *Virtue and Vice.* 1853. Pen and sepia ink, 8½ × 7. Private collection.

Fig. 86. John Leech. "Needle Money" and "Pin Money." 1849. Wood engravings from *Punch*, 1849.

woman virtually killed the female who sewed her clothing. This is the case, for example, in John Leech's 1849 "diptych" of "Needle Money" and "Pin Money" (Fig. 86). The same iconography of solitary despair is repeated for the sempstress in "Needle Money." Her garret room, rooftop view, shirt and lone candle, and gaunt expression make her a kindred spirit to Redgrave's protagonist, while the relationship between employer and servant in "Pin Money" suggests a counterpoint with Egg's *Young Woman at A Dressing Table with Her Maid*. Together, the connection between the idle and the industrious, the rich and the poor, is clearly forged. A much more grisly confrontation of the two classes of womanhood is depicted in John Tenniel's 1863 illustration for *Punch* entitled "The Haunted Lady, or 'The Ghost' in the Looking-Glass" (Fig. 87). While the intermediary character of the dressmaker reassures her customer that her dress will be ready in time "at any sacrifice," the lady herself sees in her mirror the reflection of an emaciated needlewoman who has died of overwork in order to finish the gown on schedule. This sempstress has not succumbed to prostitution, but she has paid the high price of her own life. Redgrave himself also referred to this conflict in his

Fashion's Slaves of 1846, in which a milliner's assistant is the point of contrast between the "upper" and "lower" nations of Englishwomen, for he dramatizes the tense encounter between a poor young creature meekly delivering an overdue article and an imperious lady lounging with her reading material on a divan.

THE HAUNTED LADY, OR "THE GHOST" IN THE LOOKING-GLASS.

Fig. 87. John Tenniel. "The Haunted Lady, or 'The Ghost' in the Looking Glass." 1863. Wood engraving from *Punch*, 1863.

Redgrave definitely touched the national conscience and consciousness with his pictures, which ultimately seem to serve at times both as literary illustrations (when applicable) and as poignant but melodramatic reconstructions or manipulations of reality. Yet reviewers, even while praising the aims of his art, criticized the unworthiness of such topics, preferring instead more elevated images of womanhood to Redgrave's stark, moralizing sermons. As the *Athenaeum* editorialized about *Fashion's Slaves*, "The end of Art is pleasure: and to dwell habitually on the dark side of humanity is to miss that end. . . ."[23]

IV. THE GOVERNESS

The governess was described by a contemporary woman as a "needy lady," a term which reflects the basic "status incongruence" of this female worker's plight.[24] Although often the equal of her employers in manners, education, and rank, she was nevertheless a displaced and suffering gentlewoman in economic straits. In 1865, for example, a clergyman inveighed against a system that produced so many tragic female "statistics" and offered as well a definition of this pathetic creature. "What must a governess be? The word 'lady' hardly expresses the accomplishments she must possess. It is a hard fate to be an angel of virtue, propriety, and piety, combining therewith a knowledge of almost everything, yet having no repugnance to mending stockings, and to be paid for the exhibition of this standing miracle with £20 per annum!"[25] Nonetheless, the governess was often the butt of jokes or the source of private amusement in homes, and even *Punch* usually made light of her situation by depicting both the comely and the homely teacher as exasperated by the demands of charges or their parents.

The ambivalence of her position—for she was not a guest, a servant, or a relative—amplified the potential conflict she could pose in a household. Such a situation is implied in Rebecca Solomon's 1854 *The Governess* (Fig. 88), in which the poor teacher, still in mourning attire, is both an "invisible" outsider and a pensive witness to the bliss (between husband and wife or the daughter of the house and her swain) that obliviously goes on around her in her new environment. When it was exhibited, the painting was accompanied by the lines "Ye too, the friendless, yet dependent, that find nor home nor lover, / Sad imprisoned hearts, captive to the net of

circumstance," an excerpt from a piece entitled "Of Neglect" by a clergyman and popular nineteenth-century writer named Martin Tupper in his *Proverbial Philosophy*. Tupper was not specifically referring to governesses, but he did fulminate in this poem against the ill treatment of the oppressed female: "Neglect? O libel on a world, where half that world is woman!" And in yet another passage he offered the promise of ultimate spiritual comfort for the long-suffering: "The daily martyrdom of patience shall not be wanting of rewards;/ Duty is a prickly shrub, but its flower will be happiness and glory."[26]

The *Art-Journal* perceived that *The Governess* actually told two stories, those of "a young lady and a youth . . . engaged in a flirtation at a piano, while a governess is plodding in weary sadness through a lesson with a very inattentive pupil."[27] The poor teacher, dressed in black possibly because she is in mourning, has dark hair and a beautiful face, and her seated image in dark beauty is implicitly contrasted with the (standing) blondness of the other woman (in pink garb) in the room, almost as if they were romantic rivals. Yet each female occupies her own psychological space, this leaving the governess "friendless, yet dependent." Although her heart is imprisoned with grief, a door or window at right opens onto a garden with white lilies symbolic of feminine virtue and replete with meanings of romance, another instance of the happy blossoming of womanhood to be denied this "captive of circumstance."

In 1851 there were roughly 25,000 governesses in England and about thirty times as many domestic servants, but neither type was a particularly popular subject in art, although both were living showpieces of a family's wealth and breeding. The governess, however, was a common literary subject and ranged in characterization from a downtrodden victim, to an evil ogress, to an opportunist, to a valued confidante in such novels as Harriet Martineau's *Deerbrook*, Anne Brontë's *Agnes Grey*, Mrs. Gaskell's *Wives and Daughters*, Elizabeth Sewell's *Amy Herbert*, William Thackeray's *Vanity Fair* and *The Newcomes*, Charlotte Brontë's *Jane Eyre* and *Villette*, and Wilkie Collins's *No Name*.[28] In real life she was the object of considerable concern, and in 1841 the Governesses Benevolent Institution was established for her benefit, as was Queen's College seven years later.[29] In contrast to literary and painted images, *Punch* often viewed this figure as a rather severe, spinsterish type, and occasionally as a burdened employee subject to the

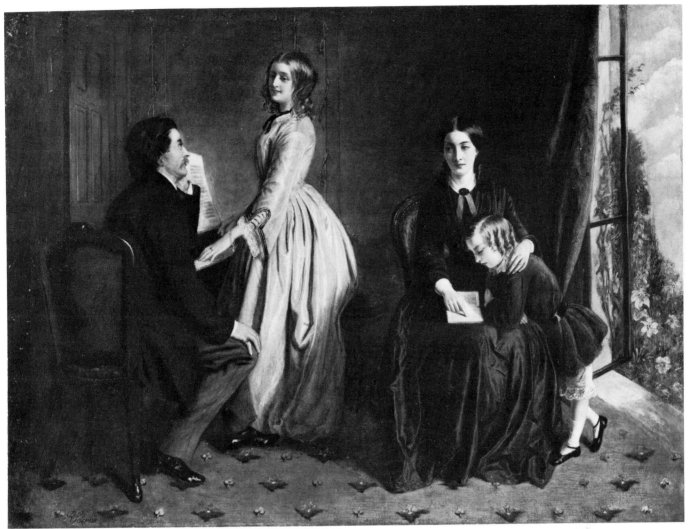

Fig. 88. Rebecca Solomon. *The Governess*. 1854. Oil on canvas, 26 × 34. The Suzanne and Edmund J. McCormick Collection.

caprices and demands of her charges and their parents. There were also a few instances in art of the poor teacher in rural schools, as in George Brownlow's 1864 *Straw Plaiting School in Essex* or Elizabeth Forbes's 1889 Newlynesque *School Is Out,* both of which interestingly feature more authoritative—or at least less pitiful—female instructors.

Although only a handful of canvases portray this subject, the theme was well known, once again due to the achievements of Redgrave. The subject may have been inspired by the artist's memories of his sister Jane, who had served as a governess, became homesick and consequently ill with typhus, and returned home only to die.[30] His first treatment of the theme, *The Poor Teacher* (Fig. 89) of 1843, established the basic format for later versions he produced: a single, forlorn figure, ostensibly orphaned, who contemplates her social and psychological isolation in a classroom. Redgrave

Fig. 89. C. Heath after Richard Redgrave. *The Poor Teacher*. 1845. Etching and engraving, 4½ × 5¼ to plate mark. Private collection.

made four versions of the painting, but since the 1844 version (Victoria and Albert Museum) was altered by the artist at the request of his patron, John Sheepshanks (who wanted Redgrave to "relieve the terrible loneliness of the forlorn governess in her empty schoolroom"[31] by adding other figures), it is preferable to examine this engraving after the original picture. Although a few reviewers complained that *The Poor Teacher* exaggerated the trials of the governess and therefore sentimentalized the subject, most critics praised the work, the *Illustrated London News* hailing it as having "no equal in the range of domestic art in Britain."[32] A second picture, *The Governess* of 1845, also captured the public imagination as "a painted sermon,"[33] and as in *The Sempstress*, Redgrave chose to repeat many of the same successful elements in orchestrating the narrative. The single figure in this engraving wears mourning attire and pauses to ponder the contents of a black-edged letter she is reading, a reminder of the recent death in her family. She may have just fainted, as the *Illustrated London News* suggests, at hearing this news, or may be tubercular, as the *Art-Union* insisted. At any rate, her frail health has not marred her delicate, madonnalike good looks. She is either so weak or so upset that she does not taste the bread and butter on the plate, although she has drunk the tea.[34] Among the schoolroom paraphernalia are books, an inkwell, French material, and yarn and embroidery material in a basket, items suggesting the subjects she teaches her female charges. The addition of a withering plant at the window (as in *The Sempstress*) adds to the poignancy of her attempts to survive on her own and outside of her natural home environment. Like the woman herself, the plant is restricted to the classroom, while outside the window a green garden, redolent with associations of middle-class security and romance, beckons, but not for her. Moreover, in the Victoria and Albert version there is a piano with sheet music entitled "Home, Sweet Home," a place the governess will never again know. All her worldly goods are confined to the schoolroom, while outside two girls blissfully play, unaware of her misery. Yet a seated dark-haired girl inside the portieres is solemn and watches her playmates pensively; perhaps she, like her teacher, is a symbolic outsider who is thinking about what would happen if she were a "reduced gentleman's daughter" and were forced to become a governess.

Redgrave was highly sensitive in his treatment of this theme, but it was another woman artist, Emily

Fig. 90. Emily Osborn. *Home Thoughts.* 1856. Oil on canvas, 27½ × 35½. Photo courtesy of Sotheby's London.

Osborn, who like Rebecca Solomon produced a kindred image of the suffering and vulnerable teacher in *Home Thoughts* (Fig. 90) of 1856. While a blonde girl is being prepared by a servant for a holiday trip home, a darker-haired classmate, like the somber dark-haired teacher on the opposite side of the room, muses dejectedly about her neglected and rather bereft state. Once again the contrast of the dark and fair haired maidens is significant, as is the subtitle, "one heart heavy, one heart light." *Home Thoughts* also includes various classes of contemporary femininity—from the wealth of the elegantly clad little girl and her escort (who eyes the teacher somewhat ruefully), to the female servant who prepares the child or, in the background, flirts with the groom or carriageman. On the window seat the dark-haired girl in black (like Redgrave's and Solomon's protagonists) copes with her private grief and almost hides herself and her emotions behind a large curtain. At the far right, in her own corner or "private world," is a bespectacled, not very attractive teacher, who is shown, like Redgrave's prettier counterpart, amid a pile of books and schoolroom equipment. Neither she nor the sad "orphaned" girl at left has any place to go and thus each remains isolated in her own psychological territory without otherwise interacting, each becoming orphaned outsiders who watch the preparations for another female's blissful return home. Behind the governess hangs a map of the world, a reference both to the curriculum she teaches and perhaps also to the prospect of emigration often urged on such "superfluous" women by

otherwise well-meaning peers. The capriciousness of fate in making some "worlds" dark and others sunny is also underscored by the verse that accompanied the painting: "One heart heavy, one heart light; / Half in Day and Half in Night / This globe forever goes, / One wave dark, another bright, / So life's river flows, / And who among us knows / Why in this stream, that cannot stop, / The Sun is on one water drop, / The Shadow on another?" The sunny destiny of some women, the "shadowy" fate of others is thus captured in this doggerel, and in Osborn's work and all the other depictions of the governess, the effect on the viewer might be complex. The cult of sentimentality made the "poor teacher" a victim, yet pointed no accusing finger at the middle-class viewer/employer, although it may have tugged at his or her conscience; to modern viewers the emotional power of such Victorian "soap operas" about the governess's status also underscores the failure of the whole system to provide for distressed gentlewomen.

V. FACTORY, MINE, AGRICULTURAL, AND OTHER LABORERS

Factory and mill work, particularly in the textile industries, constituted another major source of employment for English women. Female mill laborers were the subject of a great deal of attention and inquiry during the Victorian era and appeared as fictional characters in such novels as Charles Dickens's *Hard Times*, Disraeli's *Sybil*, and Mrs. Elizabeth Gaskell's *Mary Barton*, *Helen Fleetwood*, and *North and South*. Yet while the issue of female factory workers—their alleged lax morals, illiteracy, irreligious tendencies, and questionable maternal behavior—was under scrutiny, they were not very popular as heroines in the visual arts. This was undoubtedly because the subject was deemed ignoble and crude. While few images of female trials in this context survive from the 1850s and 1860s, there were a few from the early 1870s that treat this subject. For example, Eyre Crowe's *The Dinner Hour*

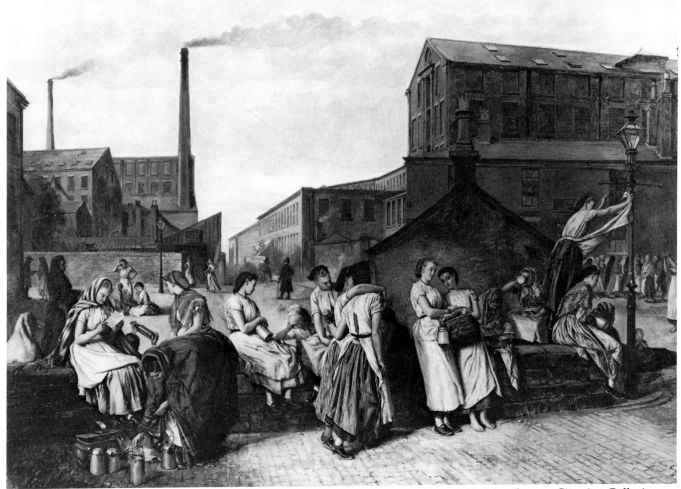

Fig. 91. Eyre Crowe. *The Dinner Hour at Wigan*. 1874. Oil on canvas, 30 × 42½. Manchester City Art Galleries.

at Wigan (Fig. 91) earned some measured praised from the *Art-Journal* critic when it was exhibited at the Royal Academy in 1874: "He is not afraid of reality, and does not shrink from scenes that less robust minds would consider vulgar. His method of interpretation is studious and faithful, observant of the truth without any temptation to display his mastery over facts by an emphasis on trivial incidents. His work lacks the highest inspiration which turns the forms of nature into forms of grace, and still keeps them true."[35] A wide range of typical activities is being enacted by the mill-hands who have just left the factory during their lunch hour. The topography of the brick mill and the street of this manufacturing town is carefully documented. As the *Athenaeum* categorized the action, "On the wall which divides one road from another, are gathered many damsels, chattering away an interval of labour; one, leaning against a lamp-post, throws apples to her neighbours; another squats on the pavement, and takes a meal from a service of tin, two gossip as they loiter."[36] However, although the stereoscopic effect was brilliant, once again the inappropriate subject matter was deplored: "notwithstanding the local interest of the subject . . ., it was a pity Mr. Crowe wasted his time on such unattractive materials."[37] In addition to the details already noted, there are others worth mentioning, such as the presence of a seated female at left who reads, a testimony to the literacy of these workers. Not all of the laborers appear to be of the same class, for a ragged group (of gypsies?) huddles in one corner while groups of other laborers—perhaps on another shift—prepare to reenter the factory. The barefoot state of some figures and the indecorous consumption of food from bowls and canisters would have been deemed gross, but the presence of only women reflects the fear of indiscriminately mixing the sexes and thus fostering an unhealthy familiarity and possible immoral effects. Furthermore, the presence of the baby at far rights suggests that his nearby working mother brings him to her place of employment. The impact on the rate of infant mortality when married women worked in cotton or other mills was a major concern among Victorian medical experts and journalists, especially after the passage of the Poor Laws in 1834, and in Lancashire and other counties numerous committees investigated the conflicting statistics.[38] While such efforts tried to prove that the mortality rate was much higher when mothers worked outside of the home, the data in time showed that the "sacrifice of infant life . . . was the price of the employment away from home, whether in factory or field."[39]

The artist's judgment about maternal care or neglect in this painting remains ambiguous, and the canvas seems a blend of the real with the fictional. The smokestacks belch pollution into the air, yet there is room enough for some exercise for the workers in this utterly industrial environment. Yet the brick-bound setting here is that of a city and a stark factory, a setting very different from the walled garden of middle-class vignettes of love and respectability. Ultimately this picture, as contemporaries recognized, was "not a mere romantic invention; it is a veracious statement, and in this quality alone it claims superiority over much of the work that surrounds it."[40]

Crowe's cheerful women laborers may have debatably mirrored the improved status of factory workers, but he was not alone in sentimentalizing their fate to some degree. Frederick Shields also contributed to this genre in a watercolor of 1875 entitled *Factory Girls, Old Knott Mill Fair, Manchester, 1875* (Fig. 92). The rosy-cheeked, shiny-faced laborers frolic rather like Rossettian maidens in a bower meadow, filled with vitality and happiness as they press onto the sidewalks to examine the merchandise offered by sidewalk peddlers.[41] The "girls" seem so pleased with their lot that they hug each other, and there is no trace—except in the background drabness of smoking factories—of depression in this image that originated in a wood engraving for the *Graphic* in 1870.

Just as the factory "girl" was a rarity on Royal Academy walls, so too was the nontextile worker.

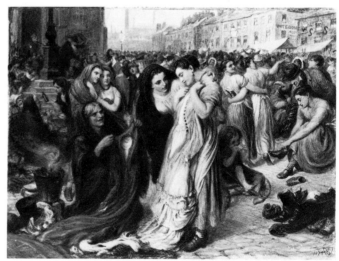

Fig. 92. Frederic Shields. *Factory Girls, Old Knott Mill Fair, Manchester.* 1875. Watercolor, 9⅜ × 5⅜. Manchester City Art Galleries.

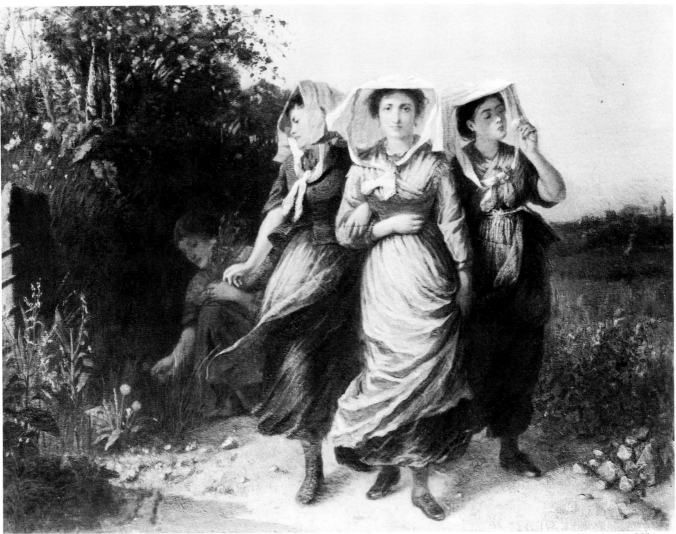

Fig. 93. Emily Osborn. *The Cornish Ball Maidens Going to Work in the Mines.* 1873. Oil on canvas, 27½ × 35½. National Museum of Wales, Cardiff.

Even though various public reports beginning in the 1850s publicized the unsanitary conditions and bad pay endured by those who toiled in the fields of glovemaking, lacefinishing, stocking knitting, mine or pit tasks, pin, nail, or screw fabrication, foundry and glass works, or button- and match-making, these women received scant attention from artists and novelists (although more from writers than painters). These industrial workers seemed to lack the sort of appeal with which middle-class readers or viewers could identify, for such creatures and their personal lives did not naturally hint—as did the governess or the sempstress, for example—of fallen gentility or of purity, beauty, refinement, or romance. Although it was mostly in the realm of reportage in contemporary periodicals like the *Graphic* that colliery "tip-girls" and the like were given more attention, one uncommon example from the 1873 exhibition at the Glasgow Insti-

tute of Fine Arts was Emily Osborn's *The Cornish Bal Maidens Going to Work in the Mines* (Fig. 93). The term was actually a designation for those who sorted ore, but the trio of 'workers' look more like girls who have gone a-maying or off to a ball. Except for their curious headgear and solid footwear, the three modern 'graces' are sprightly and idyllic, not deprived and unhealthy, creatures who stoop to pick up flowers instead of rocks along their path.[42]

In a kindred manner, the agricultural day laborer attracted less attention from artists than might have been expected. The exploitation of women day laborers was another topic of heated debate, and the low pay (women were paid less than men to hoe turnips and the like), overcrowding and sordid living arrangements that encouraged immorality, and the severity of the tasks themselves were all objected to by parliamentary commission reports. But

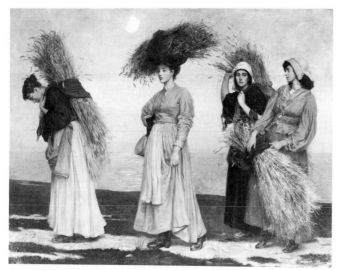

Fig. 94. Valentine Prinsep. *Home from Work (The Tired Gleaners)*. 1875. Oil on canvas, 47¼ × 62½. Photo courtesy of Christie's London.

the austerities of such a life rarely invaded art, with pretty milkmaids and gleaners portrayed by artists like Marcus Stone, Thomas Faed, and others distinctly idealized. Most of the women in this category seem to have stepped out of costume pieces,

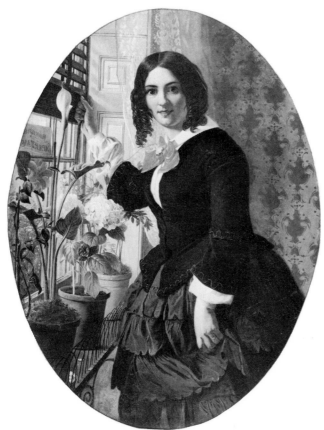

Fig. 95. James Collinson. *To Let*. 1857. Oil on canvas, 23 × 18. The FORBES Magazine Collection, New York.

not documentary history or genre scenes. In Valentine Prinsep's *Home from Work (The Tired Gleaners)* (Fig. 94) of 1878, for example, the moon adds an air of unreality to this somewhat friezelike arrangement of women. Exhibited at the Royal Academy in 1878, the painting was described by the *Art-Journal* as "soothing and suggestive," a far cry from sordid or realistic.[43] Gleaning was one of the last and worst parts of harvesting, and the women here in their stout shoes and work clothes appear subdued but not completely overwhelmed by their backbreaking toil. One female is bent over by drudgery and two who bring up the rear glance somewhat remorsefully at each other, yet a monumentality is conferred on the grouping, for as the *Art-Journal* remarked, there is also in this picture a "grace of untutored nature . . ., the stateliness which never fails to come to all women who are accustomed to carry burdens on their heads, whether they live by the Nile, the Tiber, or the Thames."[44]

In other nonfactory realms the female worker still persevered more as a vessel of feminine beauty and charm than as an object of pathos. As with this painting *At the Bazaar (the Empty Purse)* (Fig. 54) of 1857, James Collinson's *To Let* (Fig. 95) (subtitled "A Fine Prospect, Sir") of the same date includes a single female figure with *Keepsake* features and also utilizes an enigmatic title. One early twentieth-century reviewer conjectured that the two were pendants and that their subject was possibly a double-entendre concerning the excessively inviting gestures of the women and thus their "comparative iniquity."[45] Even contemporary spectators complained in the words of a writer in the *Art-Journal*, that "the point of the title is not very clear,"[46] although the sign in the window—"FURNISHED APARTMENTS"—suggests this neatly dressed female is only a landlady, not a procuress or a kept woman. In fact, the gold ring on her left hand may indicate she is married and not a "lady of the night" unaccustomed to pulling up the window shades to advertise to prospective customers. However, the potted flowers she is tending suggest another meaning to the narrative. At far right on the windowsill are bleeding hearts, which like the pale hydrangea connote heartlessness. The swelling calla lily on *calla aethiopica* is somewhat priapic and was symbolic of magnificent beauty, while the red camellia means "my heart bleeds for you." Both the camellia and the hydrangea were scentless, moreover, connoting external beauty or appeal without feeling, thus implying in general that the woman does not offer her affections permanently, but only

offers them "to let" on a temporary and fickle basis.[47] Thus, all these blossoms, including the lady herself, orchestrate a story that belies the innocence of the title or the innocuousness of this comfortable parlor or conservatory.

Considerably lower on the social scale was the waitress, the title of an 1859 painting (Fig. 96) by John A. Fitzgerald. She is a type in the tradition of the saucy serving wench, and although she is depicted alone, there are various allusions to the unseen gentleman (to whom the top hat and cane on the chair belong) to whom she serves her wares. She must tend to him behind the partition, and her expression at this prospect seems to mingle pleasure with slight trepidation, for the tray, with only one glass, is obviously for a single patron. Whether or not he will try to take liberties with this "lowborn" worker is up to the viewer to imagine, but this is a picture with a humorous rather than a semitragic tone.

A less respectable profession was that of the actress, who like the prostitute was marked as a woman of lax morals. She was a less popular figure in Victorian art, perhaps because she was perceived as less pathetic than risqué. These qualities ob-

viously intrigued G. F. Watts, who met a young and celebrated star of the theater, Ellen Terry, in 1862 and married her two years later when she was still a teenager and he was forty-seven years old. Their marriage was doomed to fail, in part because Watts, like Holman Hunt, wanted to educate and reform his "poor child" and charge, and the couple separated on the grounds of incompatibility within a year of their marriage.[48] Nonetheless, Watts depicted this adolescent beauty in *Choosing* of 1864 (Terry was later immortalized by John Singer Sargent in her role as Lady Macbeth in an 1889 painting). The closeup format of the solitary woman amid flowers recalls Rossetti's bower pictures, as does the artist's use of floral symbolism. There the golden-haired Terry smells, and almost caresses, luxuriant red camellias, which symbolized both unpretending excellence and vanity. The title derives from her preference for these scentless blossoms over the tiny sweet violets in her hand, associated with both modesty and faithfulness. Thus, it may be that the actress is choosing the empty vanity of a theatrical occupation over a more humble and quiet life.[49] Another interpretation of this subject is found in a less ide-

Fig. 96. J. Anster Fitzgerald. *The Waitress.* Ca. 1859. Oil on canvas (with arched top), 24 × 20. Christopher Wood Gallery.

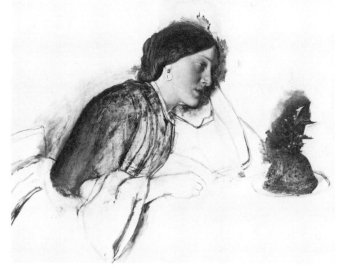

Fig. 97. Robert Martineau. *The Poor Actress's Christmas Dinner.* Ca. 1860. Oil on canvas (unfinished), 14½ × 18½. Ashmolean Museum, Oxford.

alized version in Robert Martineau's unfinished *The Poor Actress's Christmas Dinner* (Fig. 97) of ca. 1860. This female seems to be rather well-bred in her attire and demeanor, but she stares almost transfixed at the plum pudding with its sprig of holly that constitutes her entire yuletide celebration. In addition to it Christmas connotations, the holly

Fig. 98. Hubert von Herkomer. *On Strike (Out of Work)*. 1891. Oil on canvas, 89¾ × 49¾. The Royal Academy of Arts.

was also symbolic, in the language of the flowers, of foresight, a quality this woman may have lacked when she went onstage as an actress. Alone and depressed, she too is paying a high price for her decision to pursue a career that was beyond the pale of respectable society.

These female laborers, like such modern urban counterparts as the shop-girl and the clerk, were all noticeably underrepresented in Victorian art, this again owing to the fact that these subjects were not considered elevating or suitable enough. Nonetheless, contemporary periodicals often filled in the gaps with either sympathy or satire, at times poking fun at the new vocation of the typist, as in an 1897 issue of *Punch*, or commiserating with the fatal fatigue of the shop-girl in an 1893 illustration from the same magazine. Neither artist nor illustrator, however, really captured the worker in question; instead both generated half-truths or stereotypes that conformed with Victorian attitudes to these types of people.

A final image in this category, Hubert von Herkomer's diploma picture for the Royal Academy in 1891, reveals the oppressiveness of unemployment in *On Strike* (Fig. 98) (sometimes called *Out of Work*). Both the husband and the wife are brooding, the former with an almost desperate gleam in his eye. The wife is no cheerful worker, and indeed, she leans on him in such a way to suggest she is drained of any energy or hope.[50] The composition oddly evokes *A Huguenot*, yet this is a scene of bitter disappointment and not romance at a brick wall. Nor is it the vignette of wifely support seen in Hick's middle-class parlor in *Woman's Mission: Companion to Manhood* (Fig. 29) or her working-class counterpart in *The Sinews of Old England* (Fig. 30). At this point in English history a serious depression had been ongoing for nearly two decades, and Herkomer was known to have empathized with the plight of the poor. Each of the adults and two children is quite morose and drab, and they stand at the threshold not of romance or domestic harmony, but at a splintered and crumbling brick doorway in an industrial slum, surely a fitting conclusion to the realities of working class life in Victorian England.

8
The Widow and the Elderly Woman

LIKE THE SEMPSTRESS, THE GOVERNESS, AND OTHER downtrodden women, the widow was often delineated as a pathetic creature by Victorian artists. In spite of the fact that Queen Victoria was herself such an adamant public widow during her middle and old age, artists of the time seemed far more fascinated by the bereft wife who was young, attractive, and vulnerable, a potent formula to excite pathos.[1] A woman bore the brunt of society's mourning customs, and the complicated rituals and accessories could make a prolonged period of a woman's life an exercise in virtual colorlessness.[2] Desperate young and preferably pretty widows in art recur throughout Victoria's long reign, including the important work of 1841 by Charles W. Cope entitled *Poor Law Guardians—Board Day—Application for Bread*, in which a delicate and tidy widow with three children solicits the parish board for relief.

While Redgrave's 1846 *Throwing Off Her Weeds* (see Fig. 47) is an atypical example due to its somewhat sarcastic tone, Thomas Brooks's 1855 *Relenting* (Fig. 99) serves as a classic "problem picture" in this thematic category. It was accompanied at the Royal Academy that year with these lines from Shakespeare's *The Winter's Tale*: "The silence often of pure innocence persuades, where speaking fails." Brooks's painting somewhat parallels the situation in the play where the hapless infant Perdita, separated from her mother Queen Hermione by her father King Leontes, is about to be denounced, disowned, and deserted by him and then abandoned on the shores of Bohemia by his decree. In the Victorianized version of this narrative, a landlord and his agent prepare to evict a widow and her children from their attic chambers. The woman has struggled to preserve her husband's memory, retaining various mementos of him and their marriage. The portrait on the wall, the black-edged letter behind its frame, and the sword hanging nearby indicate that he was a soldier, perhaps killed in the Crimea, the most recent military campaign given the date of the canvas. His family now survives under considerable adversity: the room is sparsely furnished, the windows are curtainless, and the watchstand on the mantel is empty (the timepiece perhaps pawned). Like the garret setting in the city (seen through the window as a series of rooftops), the medicine bottles and the sickly plant evoke paintings such as *The Sempstress*. They also communicate the illness of the eldest child, a girl who sits propped among pillows as she helps her mother with piecework to earn support for the brood. Portentously, the mother is sewing a shirt, and perhaps her fate may meet as dire (or fatal) an end as that of the poor needlewoman. The virtuousness of the mother is attested to by the Bible on the windowsill, while her lost gentility is suggested by the bird cage that hangs from the window. She is no longer in the middle-class gilded

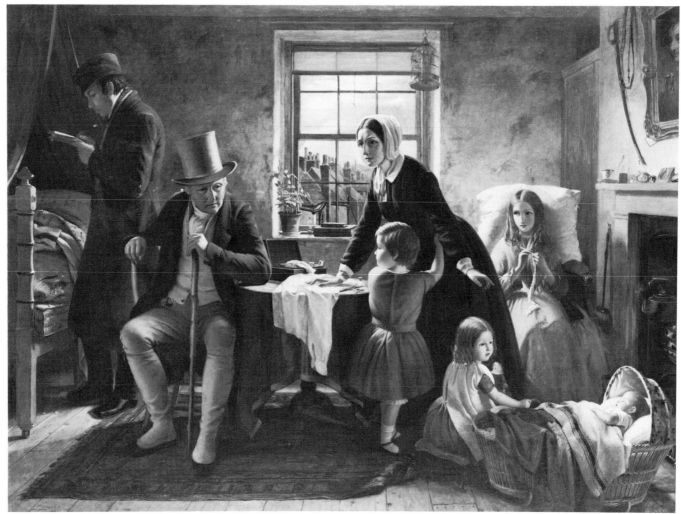

Fig. 99. Thomas Brooks. *Relenting*. 1855. Oil on canvas, 34 × 46. The Suzanne and Edmund J. McCormick Collection.

cage, but must cope with harsh reality in a totally alien environment. Like the cage, the oriental rug is one of the few vestiges of better days, but even these possessions may soon be confiscated or sold along with the ragged mattress and bed being inventoried by the clerk. At the left-hand portion of the canvas the male world of sternness reigns, while a more female one occupies the right side. In between these two domains the widow in black intervenes, a formidable opponent to the dour landlord in his top hat and spats. She anxiously points to the youngest child, a baby peacefully asleep by the fireside, a sight of innocence which may convince the stony-faced landlord to relent in his demands for immediate payment. The daughters repeat their mother's goodness, one by mending clothes and the younger with her doll by minding the baby and playing a "little mother" role. It is difficult to discern the sex of the child clinging to the widow (boys and girls were identi-

cally dressed until about the age of four in Victorian times), but the drama of gestures and glances is nonetheless bittersweet.

An unintended sequel of sorts is found later in the century in Thomas B. Kennington's 1888 Royal Academy entry, *Widowed and Fatherless* (Fig. 100), the very title underscoring the pathos of Brooks's canvas. Here too the drama is being played out in a garret chamber (with undertones of the tragedy of Henry Wallis's *Death of Chatterton*, for example, or of Octave Tassaert's canvases in France), but this is the penultimate act before "the curtain comes down," so to speak. There are even fewer belongings in this chamber, which has shrunk from a middle-class parlor to a seedy attic with sparse furnishings. The woman in black at the table has a strained expression, and there is not even any more tallow in the candleholder to enable her to sew in the dark. Like Brooks's widow forced to do piecework, she holds a shroudlike garment evo-

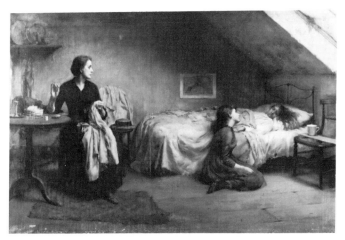

Fig. 100. Thomas B. Kennington. *Widowed and Fatherless.* 1888. Oil on canvas, 48 × 71½. Photo courtesy of Christie's London.

cative of Thomas Hood's bathetic "Song of the Shirt." This is a veritable female microcosm of misery, for on the other side of the room are her daughters. The elder has tried to feed her bedridden sister some gruel or soup from a cup, but the poor creature in the bed looks so ill as to be on the verge of death.

While the sadder stages of life may be implied in Kennington's work, the gamut of feminine existence from youth to old age—including that of premature widowhood—is more overtly reflected in a work such as James Archer's *In Time of War* (Fig. 101), exhibited in 1858 and illustrated here in engraved form. The poetic feeling imbued by the artist was highly praised, as was the subject of the quintessential war widow keeping the home fires burning. One reviewer gave the picture its most likely reading—that an old woman has received news of her soldier son's death and now must impart these sad tidings to her daughter-in-law and grandchild. "With faltering steps she has come down the long garden-paths, through the gathering gloom of the evening,—gloom darkly in unison with her fellings,—to the arbour where are the young wife and child of him whose misfortune has to be made known; a misfortune greater perhaps to them than to him. The child neglects its toys to ask about that distant parent, whose portrait the mother holds in her hand. They appear unconscious of the approach of the beloved messenger of evil, her steps falling lightly on the path,—more lightly than will the sorrow fall upon their hearts."[3] In the lush garden setting once reserved for courtship, tragedy has entered, and the woman communicates not with her lover but with her prescient child. Even the natural details reinforce the

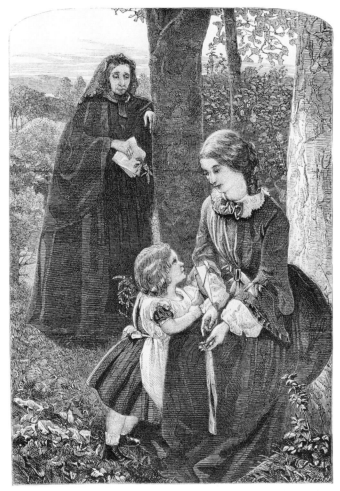

Fig. 101. H. Linton, after James Archer. *In Time of War.* 1858. Wood engraving from *The National Magazine*, 1858.

lugubrious tone, partly by the melancholy luster of twilight which heightens the sorrow and "suggests the pathos of the subject."[4] In addition, autumn leaves have fallen and withered, suggesting death and a change in the seasons of life. As a critic noted too, "the flaky bark of the pine breaks from its hold, and the lustrous white birch-stem seems half ghastly in the evening light; behind, the heavy masses of foliage swing sadly in the wind."[5] To heighten this meaning, the artist has included a pine tree to connote "hope in adversity" and a birch to signify the women's meekness in accepting their lot. Such is the garden of womanhood, a place both for joy and tears, and here as well the common device of contrasting childhood or youthful beauty with old age is employed. The sentimentalization of roles is typical, with the wife as fresh and fair as her old mother-in-law is wrinkled and infirm. The prettiness and confidence of the child also adds to these meanings.

A denouement to this recitation of woes is provided in George Smith's 1876 Royal Academy en-

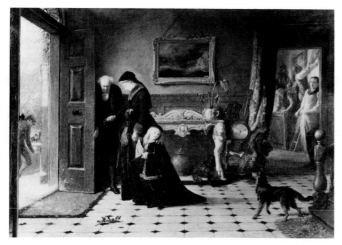

Fig. 102. George Smith. *Into the Cold World.* 1876. Oil on canvas, 24 × 20. Private collection.

try, *Into the Cold World* (Fig. 102), which somewhat paraphrases Martineau's *The Last Day in the Old Home* at the same time that it suggests a narrative moment just before that depicted in Brooks's *Relenting.* A beautiful young widow, head and posture downcast, has no recourse but to leave her home. Her equally exquisite son, still young enough to sport long Fauntleroy-ish curls, looks back at his faithful dog, but the latter hesitates about following his master into the cold world. The mother and child cast a long shadow on the hall floor; a sprig of holly fallen there not only indicates the season—and the cruel fate of being turned out at yuletide—but also is an ironic floral allusion to foresight (which the widow's spouse apparently lacked in planning his estate). Unprotected by any male, the woman is now emotionally and financially at sea, and a remaining painting on the foyer wall thus aptly represents (as in Egg's *Past and Present* trilogy) a dismasted boat in turbulent waters. This detail makes the boy's plaything all the more poignant, for his toy boat—an irrational choice given the wintry season—clearly allies the pair's destiny with that of the stormed-tossed vessel in the picture. As men in the next room dismantle belongings, a plant on the hall mantel withers. An older man, perhaps a family steward or butler, averts his eyes from meeting the woman's and stands at the door holding the keys to the house. The inside/outside dichotomy of the safe, warm haven and cold, cruel world reminds viewers that the lady must exchange the hermetic comforts of home for the chilly reception that awaits in the unknown realm beyond the threshold. Perhaps the snow on the doorstep, like that in Redgrave's 1851 diploma piece of that title, was meant to make the

woman an outcast or to suggest the dire straits of the woman who perishes in a snowstorm in Frederick Walker's 1863 Royal Academy picture *The Lost Path* and in Edward H. Corbould's 1869 watercolor entitled *Cold.*

The widow was usually an emblem of feminine helplessness, for she was viewed as without benefit of money or protective male relatives, and much the same could be said about the attitude toward elderly women. If she survived numerous childbirths, poor diet and hygiene, and in the case of the working classes, horrible employment conditions, a Victorian woman might reach old age, but then as now there were many stereotypes of that stage in life which often dehumanized or reduced the elderly female to a stock type. Sometimes she was viewed as an invalid, sad and waiting to die; frequently, if not almost categorically, she was contrasted with the young and handsome. Generally the old woman in Victorian art was a benign and grandmotherly sort who quite faded into the background of a painting or symbolized the penultimate phase of the feminine life cycle. One of the more active roles older women were assigned in art was occasionally that of dame teacher, her wizened

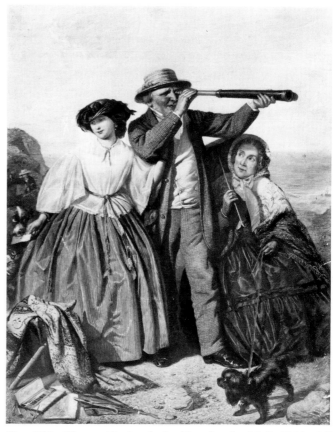

Fig. 103. Henry Garland. *Looking for the Mail.* 1861. Oil on canvas. 20½ × 16½. York City Art Gallery.

age presumably an index of her wisdom compared with callow youth. In addition, the function of chaperon or old-fashioned duenna, especially in middle-class households, was quite important.[6] Such themes were popular in eighteenth-century prototypes in the art of Francis Wheatley and others, typically with a rural cottage interior with an old woman supervising or interrupting romantic assignations. This category of painting typically portrayed an elderly woman halting a couple before any transgression occurred, and as such her presence made her a pictorial conscience of sorts, matronly yet reproving.[7] Sometimes she played this role in utterly contemporary garb, as in Henry Garland's rather humorous *Looking for the Mail* (Fig. 103) of 1861. While the patriarch of the family looks through a telescope at the seaside scenery, the mother or chaperon casts her eye on a closer view. The pretty young lady who has just been painting (as the box of watercolors and folding stool in the left corner confirm) is now trying to deliver a billet-doux or other message, perhaps to the gentleman visible in the distant rocks at left. She furtively sends her missive via a seemingly sympathetic large dog at left, and this subterfuge has been noted both by the older lady and by her leashed dog, who stiffens at the sight of another animal. The very title may be a pun, for here the elderly woman serves both as a guardian and as an accomplice (or lookout) to the love-struck maiden.

More often, however, the chaperon enacted her functions in Victorian art in the costume of another era. A consummate example of this is Arthur Hughes's 1864 *Silver and Gold* (Fig. 104). Although a costume piece, this painting and similar ones thinly disguised the preoccupations of Victorian viewers on the subject of safeguarding female chastity. Here the standard ploy of contrasting withered age and silver hair with vibrant youth and golden locks is beautifully stated. Like the walled garden in *A Pet*, the natural setting here perhaps unconsciously reflects and recycles that of the *hortus conclusus* itself. The old woman and her *protégée* perambulate the interior of this fortress of virtue, the latter, judging from her dreamy expression, probably ruminating about love while her caretaker harbors protective instincts. There is the ivy of constancy also growing in these verdant surroundings, and the heart-shaped leaves of some of the foliage are echoed by the lady's locket (with a memento from her beloved?) and the motif on the statuary. The blooming lilac tree also signifies the first emotions of love, this youthful affection contrasted with the duenna and the fallen petals elsewhere in the composition. The statuary contains a sundial that marks the passage of time for both women as well as signals the appointed hour for a clandestine rendezvous; the handle of a scythe nearby, however, may suggest a sadder ending. Moreover, the peacock perched in the garden with its brilliant fan of feathers may allude to the Christian symbolism of immortality, or perhaps to different connotations of worldly pride and vanity. Whichever meaning was intended, the mood of precious insularity and reverie is preserved in this enclosed environment.

In contrast to Hughes's rather lyrical conception of the chaperon was the attitude of cartoonists in periodicals like *Punch*. These illustrators were not always very generous in their assessments of this creature, and many quite misogynistic images can be found in the magazine's pages between about 1850 and 1870. *Punch's* version of the chaperon is often fat, rather obtuse, and deluded about her charms, and other older women are represented as physically ungainly. Their behavior is often made to seem unattractive or even ridiculous, too, as when they try to be coquettish, affect fashions or cosmetics intended for more youthful wearers, or get involved in awkward situations at the beach or in a cab. Sometimes the figure of the old woman was mocked as domineering as well, and in general she received more hostile interpretations in *Punch* than her counterpart did in paintings of the period.

While young, often nubile, widows outnumbered other types in art, elderly mourners recurred as weeping attendants or pious, loyal survivors in such works as Charles Perugini's 1880s *Faithful* (Fig. 105). Here a widow has brought a basket of flowers, once a token of courtship affection and now one of remembrance, to her husband's grave, and among the blossoms are those symbolizing her enduring love and her painful separation from him. She is seated and enveloped in black from head to toe, but it is her simple gesture of praying, and her lined face and seemingly toothless mouth set in an expression of resignation, that are meant to serve as touching details. In the landscape in the distance there are houses and other signs of life continuing, but the figure sits alone in a corner of the cemetery with an oak tree—a Christian emblem of faith and virtue—shading this spot and ensuring that her bereavement is private. Her shabby shoes and clothing suggest she is impoverished but still struggles to retain her dignity amid adversity. The widow sits on a low wall in this

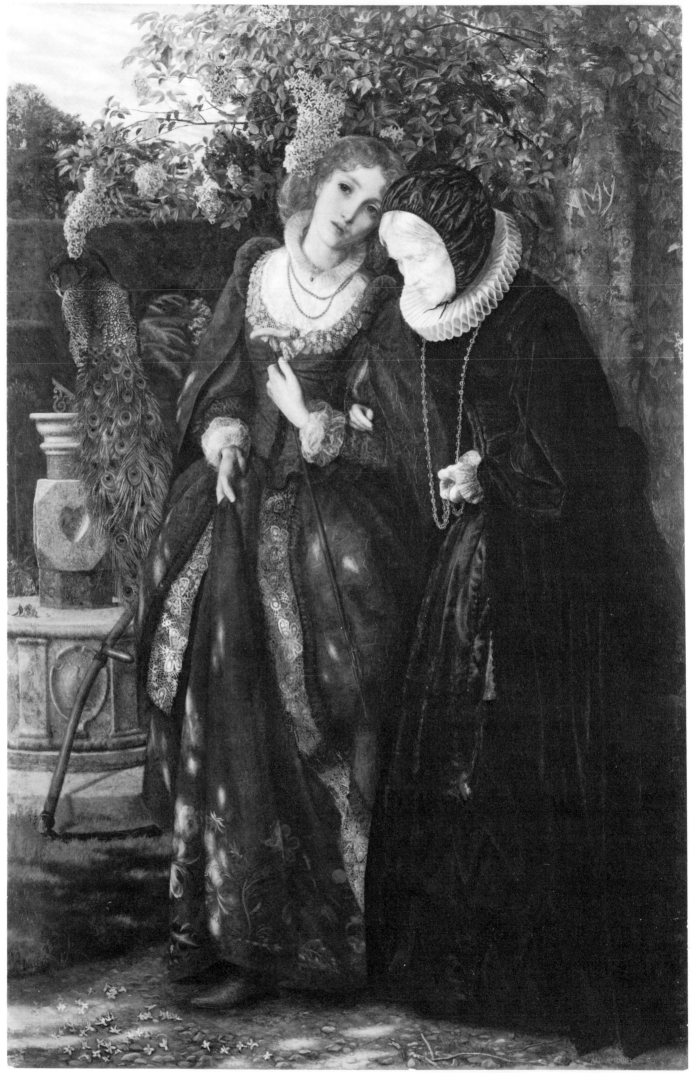

Fig. 104. Arthur Hughes. *Silver and Gold*. 1964. Oil on canvas, 39 × 26. Pre-Raphaelite Inc.

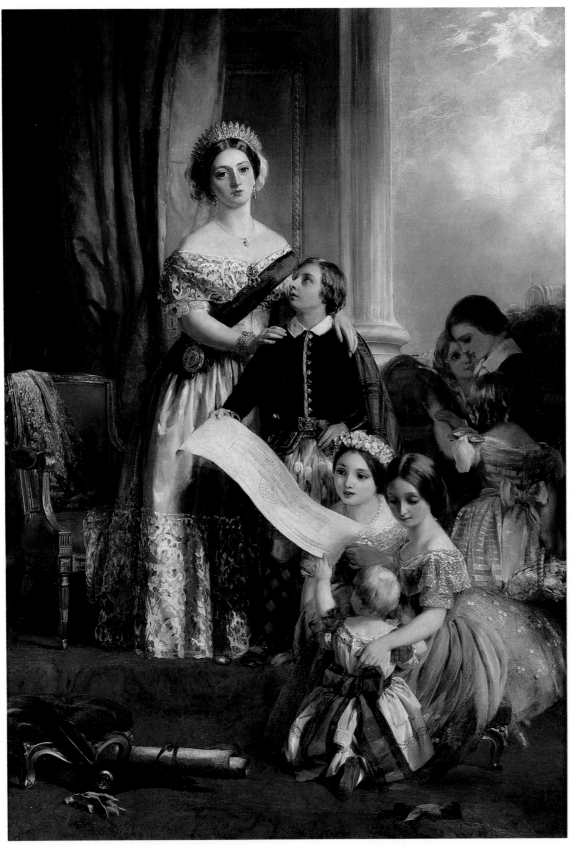

John Calcott Horsley. A Portrait Group of Queen Victoria with Her Children. *Ca. 1865. Oil on canvas, 47 × 35. The* Forbes *Magazine Collection.*

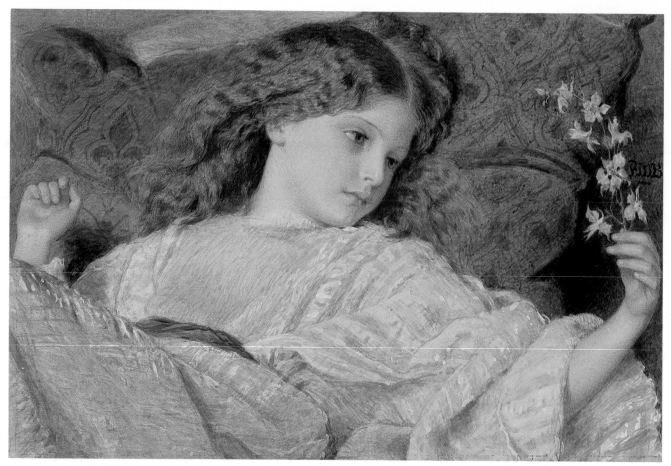

Frederick W. Burton. Dreams. 1861. Watercolor and bodycolor over pencil with gum arabic, 8⅛ × 12. Yale Center for British Art.

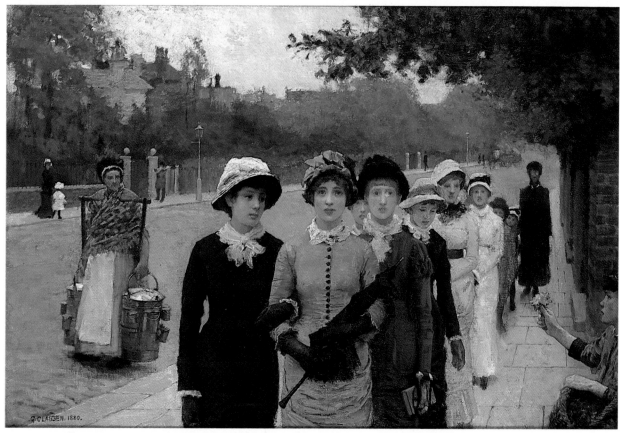

George Clausen. Schoolgirls. 1880. Oil on canvas, 20½ × 30⅜. Yale Center for British Art.

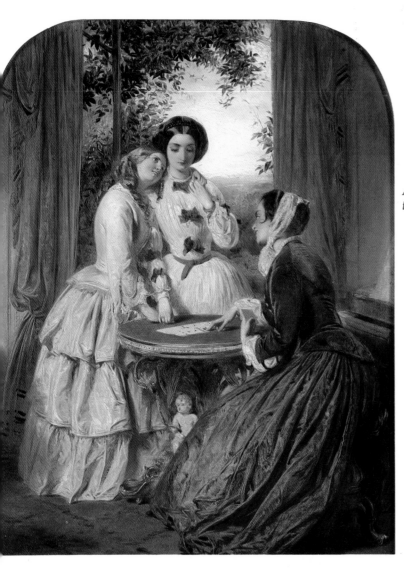

Abraham Solomon. Doubtful Fortune. 1856. Oil on panel (with arched top), 15½ × 12. The Suzanne and Edmund J. McCormick Collection.

Jessica Hayllar. A Coming Event. 1886. Oil on canvas, 22½ × 18½. The Forbes Magazine Collection.

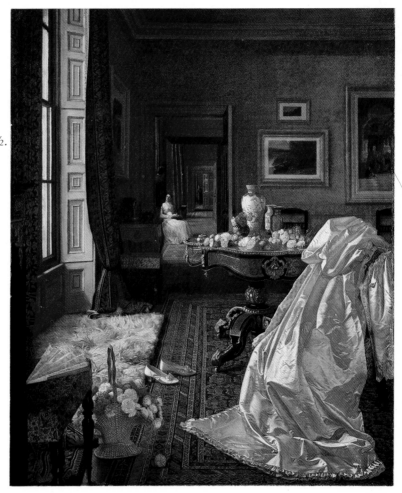

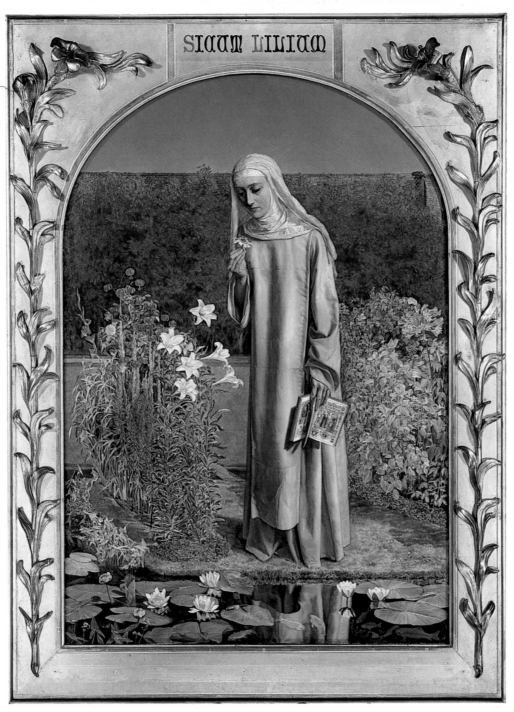

Charles A. Collins. Convent Thoughts. 1851. Oil on canvas, 32½ × 22¼. Ashmolean Museum.

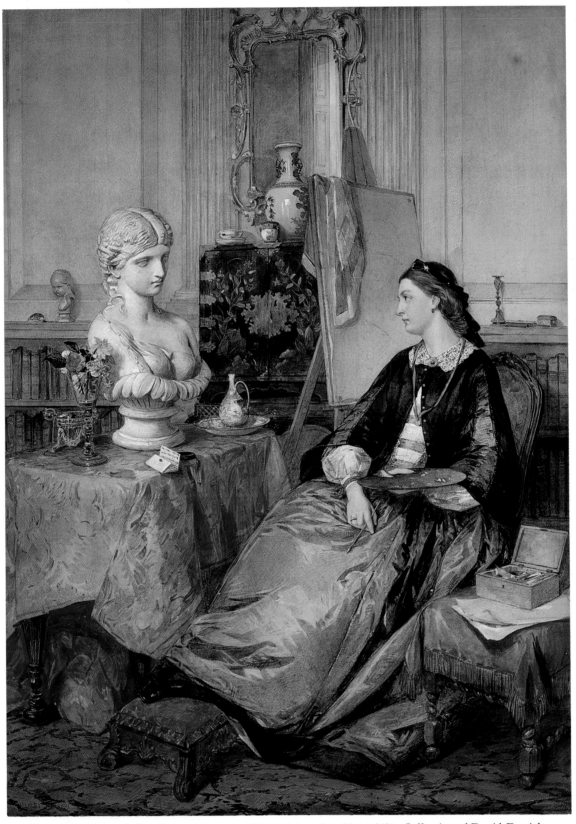

Octavius Oakley. A Student of Beauty. *1861. Watercolor, 30 × 21½. Collection of David Daniels.*

Augustus Egg. A Young Woman at Her Dressing Table with Her Maid. *Late 1850s. Oil on canvas, 23½ × 19½. The Suzanne and Edmund J. McCormick Collection.*

Richard Redgrave. The Sempstress. *1846. Oil on canvas, 25 × 30. The* Forbes *Magazine Collection.*

Rebecca Solomon. The Governess. *1854. Oil on canvas, 26 × 34. The Suzanne and Edmund J. McCormick Collection.*

Thomas Brooks. Relenting. *1855. Oil on canvas, 34 × 46. The Suzanne and Edmund J. McCormick Collection.*

Albert Morrow. The New Woman. *1897. Mixed media poster, 12 × 16. Private collection.*

Fig. 105. Charles Perugini. *Faithful*. Oil on canvas, 48 × 38. Walker Art Gallery, Liverpool.

cemetery garden, a setting far removed from the middle-class context, the convent perimeters, or the courting wall atmosphere evident in previous works. Instead these are the boundaries of a place of death, to which she continually returns to visit her husband's grave and eventually to be reunited with him. Unless an older woman could rely on middle- or upper-class security in her dotage or on her family for support, she might face the penniless destiny portrayed in numerous pictures of derelict street people selling flowers or other wares, subsisting in lodging houses, or ending up in Salvation Army shelters. As a dependent creature she might become so decrepit and incapacitated as to require constant care, a scenario depicted in George Smith's 1861 *With the Burden of Many Years*. In that work the title describes the state of illness and uselessness that the old woman has reached, but she has kneeling at her side an angelic and eager daughter or granddaughter to read to her from the Bible and to minister to her needs.

Worse yet was the dreaded fear of the "union workhouse" and a pauper's grave, the former subject being a hotly contested issue in Victorian so-

ciety and in Parliament after the Poor Laws were enacted in the 1830s. However, the "bastille" or "union" was rarely treated by artists because of its extreme and sordid nature. Inmates in literature were the object of sympathy in Dicken's *Oliver Twist* and Frances Trollope's 1844 *Jessie Phillips,* but in spite of the opposition to this drastic 'remedy' to pauperism which such novels generated, these institutions increased in number. The aged were the most numerous "unfortunates," with fallen women comprising the second largest group of occupants. Hubert von Herkomer depicted the distressed elderly women in these circumstances both in numerous illustrations for *The Graphic* in the 1870s (when England was in the throes of a serious economic depression) and in his gripping canvas of 1878 entitled *Eventide, Scene in the Westminster Union* (Fig. 106). Conditions did improve in some workhouses late in the century, but they were generally very demoralizing places—with poor diet, segregation of the sexes (even for most married couples), overcrowding, depressing routines, and a patronizing attitude toward the geriatric inmates all in evidence. Inhabitants were required to pick oakum or peel potatoes for long hours yet subsisted on very meager diets. Such unpleasant, nearly unlivable conditions were believed to motivate the poor to become productive and independent, but instead, many among the poverty-stricken ranks wound up suicides in the Thames rather than seek admission or return to the workhouse.[9] Here Herkomer has selected a barnlike ward of the Westminster Workhouse in London, which he visited and observed in order to create this painting. He focuses on clusters of rather dour, toothless old women perched on uncomfortable backless chairs, for the needy on public assistance were not to be too comfortable, only very grateful. The inmates are mostly dressed in bleak uniforms and mobcaps, hallmarks of institutional regimentation. Various small groups hover along the background walls, which have been lined with prints or engravings, presumably an effort to improve conditions by bringing art into their lives. A young woman helps an older one at a table, the former's youth in obvious contrast with the surrounding, almost grotesque, signs of old age. Some of the women appear morose and isolated, while others seem to enjoy the teacups and the bouquet on the table. Even the sparse allotment of tea and sugar they are being given represented in reality an arduous campaign that had been waged for several years by numerous reformers. In spite of the relative senti-

Fig. 106. Hubert von Herkomer. *Eventide, Scene in the Westminster Union.* 1878. Oil on canvas, 42 × 78. Walker Art Gallery, Liverpool.

mentality of treatment, there is a gripping desolation and sense of alienation in this image, in part conveyed by the deep space that projects into a tunnel-like void filled with anonymous and huddled creatures. Some reviews, especially that in the *Athenaeum*, found Herkomer's canvas to be powerful and moving, while others like the *Spectator* and the *Illustrated London News* were offended by the allegedly coarse and rough subject matter. Whatever the judgment on this issue, there was little apparent relief to being old and poor, and society often opted to forget or neglect such lost souls both in real life and in art.

9
The Wayward and the Fallen Woman

THERE WERE OTHER KINDS OF FEMININE CASUALTIES BE-sides the old, the indigent, and the oppressed in Victorian society, and on the opposite end of the pole of respectability and innocence was the alternative (or "profession") of prostitution, a cultural sign of the Victorian era's avid fascination with the harlot.[1] In an age that was paradoxically obsessed with both virginity and sexual promiscuity, the two extremes were related, one almost at the cost of the other, because of the inordinately high value placed on feminine purity. The stability and sanctity of the home and of the family itself rested to a considerable degree on the existence of prostitutes, to whom gentlemen might resort because of the taboos of gentility and the idealized, nearly sexless purity ascribed to the "angel in the house." The double standard thus dictated that the harlot would serve as a safety valve to the institution of marriage. At least a few Victorian writers understood this integral connection between "the great social evil" and respectability, and one commented in the *Westminster Review* in 1868 that "Prostitution is as inseparable from our present marriage customs as the shadow from the substance. They are two sides of the same shield."[2] Another commentator declared of the whore: "herself the supreme type of vice, she is ultimately the most efficient guardian of virtue. But for her, the unchallenged purity of countless happy hopes would be polluted."[3] Thus, in order to keep the womanly woman on her pedestal and to sustain the requisite propriety of courtship, it was inevitable that the harlot would serve as both the foe and ally of the Victorian lady. In some senses she both deflected the dangers of seduction from daughters and protected wives from the possibly full-blooded sexual appetites or demands of their spouses. Like a shadow on the edge of decorous society, the reality of prostitution become more and more intrusive, perpetuating a vicious cycle of lost innocence often to preserve the hallowed state of other (middle- and upper-class) women.

Exact numbers of women around midcentury who committed this "greatest sin of all,"[4] as W. R. Greg called it, are impossible to gauge, but the most persistent total cited after 1838 was Henry Mayhew's reckoning of about eighty thousand fallen women, in his authoritative *London Labour and the London Poor* (1861–62). This alarming figure, accurate or not, stimulated a deluge of debate and journalistic attention, and from about 1839 a spate of books on the subject by doctors, social workers, poets, and novelists brought notice of this vice to the constant, if somewhat prurient, attention of the public.[5] William Tait's 1840 book entitled *Magdalenism*, Ralph Wardlaw's 1842 *Lectures on the Female Prostitute*, William Logan's 1843 *Exposure . . . of Female Prostitution*, and James B. Talbot's 1844 *The Miseries of Prostitution* are only a few of the myriad publications which appeared on the market in the

1840s ostensibly to apprise and warn the public of this "hazard." Moreover, it was precisely during this decade that the depiction of prostitutes on Royal Academy walls began to increase, gaining momentum in the 1850s and 1860s and remaining a viable subject until the turn of the century. W. R. Greg's call in the *Westminster Review* of 1850 for sympathy for this creature, who was besieged by disease, violence, poverty, malnutrition, and alcoholism, set the tone for the entire period's double-edged and rather equivocal attitude toward the prostitute: loathing for her foul career mixed with pity for her destitution. The sentimentalization of martyred innocence—of virginity gone astray—occurred in innumerable literary sources and illustrations. For example, among the literary treatments of this topic were William Bell Scott's poem "Rosabell," J. A. Froude's *The Lieutenant's Daughter* of 1846, Mrs. Gaskell's *Ruth* of 1853 and *Mary Barton* of 1848, Dante Gabriel Rossetti's poem "Jenny," Wilkie Collins's *The Fallen Leaves* of 1886, and H. G. Jebbs's 1859 *Out of the Depths*. A minor poem entitled "Within and Without" from the 1845 *Illustrated Family Journal* establishes the outsider status of this being: "She who is slain neath the winter weather / Ah, she once had a virgin fame . . . The harlot's fare was her doom to-day,/ Disdain, despair; by tomorrow's light/ The ragged boards, and the pauper's pall;/ And so he'll be given to dusky night . . . / Let her in calm oblivion lie,/ While the world runs merry as heretofore."[6] Her male seducer is described as being a liar "within" the bosom of society, yet one who was free from the social consequences of their illicit sexual behavior. (In terms of criminal law, prostitution itself was not a legal offense, although a "nightwalker" could be punished for creating a disturbance; her customer, however, was not punished at all, unless he seduced a child under the age of twelve or kidnapped a propertied heiress.) Literature and courtship manuals alike decried this individual as a dissolute scoundrel whose villainy was nonetheless construed as an object lesson for all young women. With several exceptions—as in a male's presence in E. C. Barnes's *The Seducer*, D. G. Rossetti's *Found*, Hunt's *The Awakening Conscience*, Brown's *Take Your Son, Sir!*, and a few other paintings—the woman was generally shown alone bearing the brunt of their shared sexual transgressions, thrown adrift in the uncaring city, "where the world runs merry as heretofore."

One of the major stimuli for this strand of urban imagery of the woman gone astray was the 1844 publication of Thomas Hood's poem "The Bridge of Sighs," which rapidly became a classic Victorian stereotype of the solitary harlot and her brutalized existence of penury, ignominy, and death. Some lines from Hood's doggerel verse reinforce the characteristic Victorian alloy of compassion for the whore but do not show the way to extirpate the social roots of the problem: "Alas! for the rarity/ Of Christian charity/ under the sun!/ Oh! it was pitiful! Near a whole city full, Home she had none . . . / Where the lamps quiver,/ So far in the river,/ With many a light/ From window and casement,/ From garret to basement,/ She stood with amazement/ Houseless by night./ The bleak wind of March/ Made her tremble and shiver;/ But not the dark arch,/ Or the black flowing river:/ Mad from life's history, Glad to death's mystery,/ Swift to be hurl'd— Anywhere, anywhere/ Out of the world!"[7] Various artists, including G. FitzGerald, Gustave Doré, and Millais, illustrated this poem, usually selecting the instant just before or after the woman committed suicide by jumping off a bridge. Both FitzGerald and Millais contributed illustrations to the Junior Etching Club's 1858 edition of *Passages from the Poetry of Thomas Hood*, FitzGerald depicting a horrible scene of men dragging the river for the woman's body with boathooks. Although his drawing included a crowd of males of all ages watching this grisly event and the lantern being shined on the deceased women, Millais chose to concentrate on the woman as she contemplates doing the rash deed. The silhouette of St. Paul's distinctive dome is visible in the fog and only a few lights illuminate the foreboding bridge on this gloomy night. Other artists like Doré and George Cruikshank (in his 1848 *The Drunkard's Children* illustration) emphasized the woman's long plunge to the waters below, but Millais instead focused on a solitary female (Fig. 107) frantically clutching her thin shawl and wandering toward the river's edge with a wild-eyed look on her face. Such a watery death also appeared in contemporary novels, notably in Dickens's *David Copperfield*; Phiz's illustration for the first edition in 1849, for example, showed the character Martha Endell, a prostitute, hesitating on the brink of self-destruction and identifying with the scum of the river Thames. Endell's remarks repeat the terror that drives Hood's protagonist to suicide: "Oh, the river! . . . I know it's like me. . . . It comes from country places, where there was once no harm in it—and it creeps through the dismal streets, defiled and miserable—and it goes away, like my life, to a great sea, that is always troubled—

Fig. 107. John Everett Millais. "The Bridge of Sighs." 1858. Etching and engraving from *Passages from the Poems of Thomas Hood*. 1858. Trustees of The British Museum.

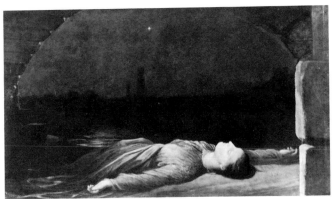

Fig. 108. George Frederick Watts. *Found Drowned*. 1848–50. Oil on canvas, 57 × 84. Trustees of the Watts Gallery, Compton.

and I feel that I must go with it!"[8]

In paintings the harlot who had reached the nadir of hope or degradation conformed with William Acton's description in his 1870 book entitled *Prostitution*: "ill-fed, ill-clothed, uncared for, from whose misery the eye recoils, cowering under dark arches and among bye-lanes."[9] She is just such a pathetic embodiment, for example, in

George F. Watts's *Found Drowned* (Fig. 108) of 1848–50 or his similar painting of the same period, *Under A Dry Arch*. Both paintings were supposedly transcribed from real life, and a contemporary critic hypothesized that the reason *Found Drowned* was not included in the artist's 1882 retrospective was because it depicted a fallen woman who chose suicide rather than bear a fatherless child. With unstinting realism this composition brings all the horror of death to this subgenre, exceeding the limits of propriety in art with results that are undeniably grim. A woman lies supine on the strand under Waterloo Bridge, with the shot tower and a silhouette of Westminster Buildings also legible (these landmarks, along with St. Paul's cathedral, were often depicted in prostitute pictures). As another critic wrote of this work in 1884, "On the mud which has been left dry by the receding tide lies a suicide. The subject is identical with that of Hood's poem, but was not taken from it, but suggested by an incident seen by the artist."[11] Watts makes the female's face and pose shockingly realistic, positing her as an outstretched corpse on a stony "morgue slab" awaiting inspection by the spectator. In her left hand are two identically shaped yellow and red objects, possibly pawn tokens for the last articles she relinquished for sale.

The scenario of the outcast woman rejected by society and thrown against a wall of unyielding pain, desolation, and punishment—as in Hogarth's prison scene at Bridewell in Plate IV of *The Harlot's Progress* of 1731 or George Morland's "fair penitent" episode in the six-part moral thriller entitled *Laetitia* of 1786—foreshadowed the cowering physical and mental posture of the defiled woman in Dante Gabriel Rossetti's *Found*, begun in 1853 as the artist's modern-life equivalent to the magdalen theme. The oil version of this subject remained unfinished by Rossetti, so a preliminary drawing for *Found* (Fig. 109) of 1853 provides a more useful index of the artist's original intentions for the composition. Here a drover or shepherd, as his oversized smock suggests (as in Redgrave's *Going into Service*), comes across his former sweetheart and fiancée in the city. (It is unclear whether he has been searching for her or finds her accidentally.) In his hat is a sprig of jasmine, commonly associated with the Virgin Mary and also connoting separation. The biblical passage inscribed on the drawing reveals that the couple was once betrothed: "I remember thee: the kindness of thy youth, the love of thy betrothal," from Jeremiah 2:2. Now, however, the once chaste country lass leads a wayward

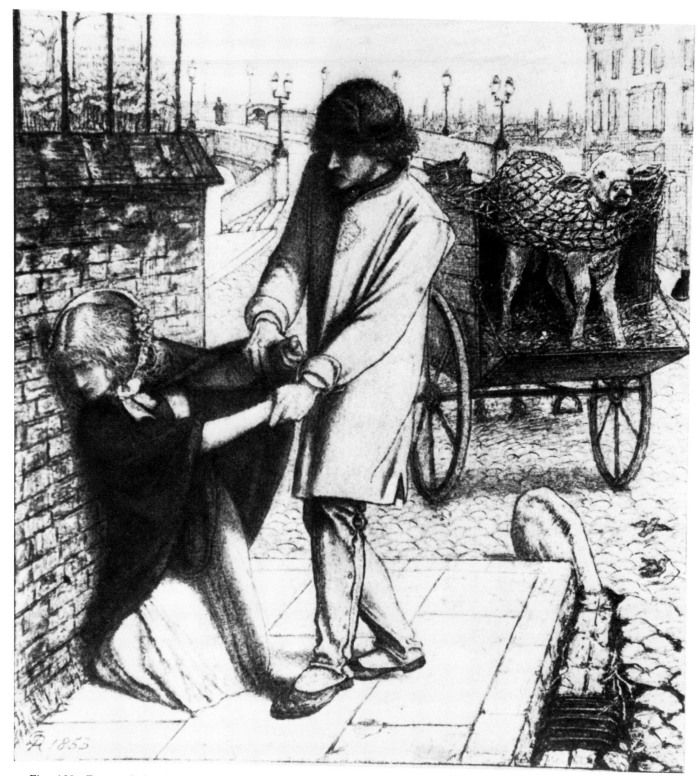

Fig. 109. Dante Gabriel Rossetti. *Found*. 1853. Pen and brown ink and brown wash and some India ink, and touched with white, 8¼ × 7¼. Trustees of The British Museum.

life in the city, her head aligned with the forces of death and placed directly up against the outer brick wall of a cemetery. Her plight echoes that of a whore described, for example, in James B. Talbot's 1844 *Miseries of Prostitution:* "soon the poor victim, who has yielded to temptation, comes to know . . . the tendency downward. Whether seduced in private, or beguiled into one of the superior receptables of infamy, it is seldom long ere satiety and the passion for change throws her off. She is turned

mercilessly adrift . . . It is all down—down—rapidly down,—down from stage to stage, till it terminates in some scene of wretched squalidness." Moreover, her positioning near a cemetery reiterates Talbot's warning that this cast-off creature was "the prey of hopeless misery . . . [who] drags on for a few years, and then sinks down to her grave."

The tombstones behind the prison-like bars have a partially legible inscription: "There is joy . . . the angels in he . . . one sinner that . . ." and Frederick G. Stephens, a colleague and friend of the artist, explicated these cues as follows: "Among these are that the girl crouches against a wall of a church yard—'where the wicked cease from troubling, and the weary are at rest.' "[13] In some senses this may be a prophecy of the woman's own death and tombstone, for she is "one sinner" headed for such an end unless she repents. In addition, the brick wall evokes the courting wall of a more innocent relationship as well as separates the living from the dead while pointing up analogies between the two states of being.

This chillingly foreboding quality pervades other visual symbols: for example, the windows of the deserted warehouse are all shuttered, closed against receiving this female. The broken-down warehouse also suggests she too is a commercial commodity, one that has been bought and sold and now lies in ruin and waste. The nearby river is polluted and the bridge over it (Blackfriars) unavoidably connotes the sites of suicide of other desperate women. The lone figure on the bridge may be another prostitute on the brink of another "Bridge of Sighs." The string of gaslights on the bridge evokes lines from Rossetti's 1840s poem about another "soiled dove" named "Jenny," for in that poem too there are "cold, ghostlike" lamps that wind around the streets to create the pattern of "a fiery serpent for your heart."[14] The perversity of the city in this drawing is evident as well in the wilted posy on the grate, which is on the verge of falling into the sewer much as the harlot herself has fallen into dissolute surroundings and habits. Moreover, this limp nosegay recalls some lines from an early draft of "Jenny" that have been plucked and trampled on and are now "stemless, scentless, strengthless, gone . . ."[15]

The ensnared calf is a sacrificial image of entrapment, a country thing imprisoned by the city which parallels the woman victimized by circumstances and unable to escape the "tendency downward." As Stephens analyzed this topos, "the calf trammeled in the net . . ., helpless, carried in the cart to its death, points to the past and present life of the girl."[16] Fluttering by the phallic bollard on the curb is a pair of sparrows, birds which in Christian iconography often connoted lowliness, since they were among the least exalted of God's creations. As such they may refer to the fallen woman's low status in society and her need for divine protection or deliverance. Once again some of the imagery found in "Jenny" recurs, for both include "London sparrows" that suddenly come together and compare these with Jenny, a caged bird who now must face the truth as dawn breaks.[17] In Rossetti's drawing, the London sparrows carry bits of straw from the cart; but unlike the harlot and her ex-lover, they will go off and mate and build a nest to share. Neither the fallen woman nor the city birds are captives of a gilded cage any longer, and they must face the harshness of city life and survival.

In the sonnet which Rossetti wrote many years later (in 1880) as a literary complement to *Found*, various visual details of the drawing are telescoped and some lines evoke, for example, the coming daybreak: "In London's smokeless-resurrection light,/ Dark breaks to dawn . . ."[18] Stephens hypothesized that the brightening dawn symbolized peace and forgiveness,[19] but the tone of the poem is pessimistic and makes the possibility of salvation unfulfilled and uncertain. The sonnet also mentions "the deadly blight of love deflowered," a detail which in the final painting is more explicit in the streetwalker's garb. Her plain attire in the drawing is transformed into the showy if bedraggled garments of a harlot—a symbolically rose-sprigged dress with plucked flowers (connoting her defloration), a gaudy plumed hat, plus roughed lips and pierced earrings. Such attire reflected the tattered but ostentatious attire of "gay women" in real life.[20]

The Victorian melodrama of the defiled woman was invariably staged in the city, the almost canonical location of female prostitution, as the majority of such paintings attest. The artlessness of the country girl and the sexual consequences of her naïveté in the city had been a subject of interest even in the eighteenth century, as in Hogarth's 1731 series *The Harlot's Progress* as well as in works by George Morland and Francis Wheatley. But the Victorians exploited this notion even more, using the pernicious contrast of the sinful city with the tranquil countryside by focusing on the ruined maiden. In addition to *Found*, Rossetti's 1857 watercolor *The Gate of Memory* explored this theme of a

country girl succumbing to an upperclass admirer from town who destroys her reputation and honor. Rossetti selected some lines from William Bell Scott's earlier poem entitled "Rosabell" (which Rossetti suggested be renamed "Maryanne") as his source. The poet followed the fate of his outcast from the age of eight to twenty-five, even speculating at the end that she would commit suicide by drowning like her predecessor in Thomas Hood's poem. In the penultimate stage the prostitute finds herself embittered and impoverished in a bleak urban setting. She hovers in the darkness and leans against a brick wall, reminiscent of the abandoned woman next to the cemetery wall in *Found*, as well as prophetic of Egg's adulteress in the last phase of *Past and Present* of 1858. "She leaned herself against the wall, And longed for drink to slake her thirst and memory at once."[21] In a deadened emotional state she watches girls play nearby and hates them for their beauty. Their childish rhyming prattle about purity also causes her to recall the irretrievability of her own innocence and simple pleasures of the past.

The pain of memory and of self-loathing are also conveyed in another painting of a "poor unfortunate" contemplating her past in a moment of apparent realization of her tragedy. This unfolds in Spencer Stanhope's 1859 *Thoughts of the Past* (Fig. 110), for which the artist seems to have used one of Rossetti's favorite models, Fanny Cornforth, who also posed for *Found*.[22] Dressed in a nightgown and robe, the fallen woman is immobilized and grasps her hair in a way that suggests some intense emotion has overcome her. On the table are a few worthless baubles, five coins (perhaps compensation from her paramour) and a letter—maybe with bad news—tucked into the mirror's edge. As in Egg's initial part of *Past and Present* (Fig. 40), a man's walking stick or umbrella handle are evident in the foreground, and the dropped glove is reminiscent of the same article in Hunt's 1853 *Awakening Conscience*. The flower-sprigged curtain recalls the female's deflowered virginity, and the fabric itself is ripped. Similarly, the dresser drawer is disfigured by peeling veneer, and the plants and flowers are dying, all symbols reinforcing the derelict and disordered state of this lugubrious creature. The wilted violets on the floor connote faithlessness and the primrose posy may refer to her youth. These details, like that of her streaming hair (for proper young women wore their hair up) indicate she is a modern magdalen, not a lady. Furthermore, the wharfside chambers overlook the grimy

east end of London, a setting reminiscent of Hood's poem and of *Found*, as well as a possible prefiguring of the suicidal plunge of the female from the bridge drawn in the distance.

Not surprisingly, Augustus Egg's finale of *Past and Present* (Fig. 111) with the errant wife is set in a related melodramatic setting in London. These dank, dry arches were described by the *Athenaeum* as "the last refuge of the homeless sin, vice, and beggary of London."[23] Under the "dark grave-vault shadow of an Adelphi arch," the adulteress with her bastard child gazes at the moon (seen in part two as shimmering elsewhere in the city and viewed by her two "good" daughters from their bedroom chamber).[24] Among the significant details are an overturned basket, like the woman a castoff,

Fig. 110. Spencer Stanhope. *Thoughts of the Past*. 1859. Oil on canvas, 24 × 30. The Tate Gallery.

Fig. 111. Augustus Egg. *Past and Present, No. 3.* 1858. Oil on canvas, 25 × 30. The Tate Gallery.

and the decaying boat reminiscent of the storm-tossed ship painting above the man in the first scene. Posters on the brick wall accentuate both the past and present, advertising, for example, "Haymarket," both an actual theater and the name of a notorious theater district of London which was crowded with "gay" women. One sign is emblazoned "An Original Comedy/ Tom Taylor/ Victims . . . A Cure for Love," cues which refer both to the woman's victimization by love and to two actual plays of the period about misfired romances, jilted love, faithless lovers, and grieving partners. One of them, Tom Parry's *A Cure for Love,* incorporates the idea of the incriminating letter and also that of suicide by a river. Other notices announce trips via the Brighton railway—"Pleasure Excursions / To

Parris / Every Tuesday / London Bridge . . . For Seven Days with Room and Board Included." Ironically, this sort of clandestine pleasure trip may have been the initial step in the woman's downfall, for it was her straying from marriage for the sake of personal pleasure that caused her present doom. Instead of leaving on a holiday from London Bridge, as she might previously have done with her husband, she is now housed under such a structure, ironically now lacking even the most rudimentary form of "room and board." Farther in the shadows the word *Return* is prominent and suggests possible salvation or repentance; one critic suggested that the foulness of the slimy setting, the woman, and her diseased child were all counterbalanced by the "calm and holy moon [that] shines

Fig. 112. E. C. Barnes. *The Seducer.* Ca. 1860? Oil on canvas, 36 × 28. Pre-Raphaelite Inc.

steadfastly like a promise of peace."[25] However, the word *Bridge* also recurs, thus emphasizing the possibility of a tragic ending in the tainted waters à la Bridge of Sighs.

Thus, one of the most dramatic uses of the wall motif as popularized by Millais is found in the imagery of prostitution, a usage which unconsciously confirms the psychosexual meanings latent in the hieroglyph. It is as if once the commanding perimeters of the garden or courting barrier were violated or trespassed, the wall became a powerful symbol of the loss of virginity of the woman and of "paradise lost" through sexual transgressions. Accordingly, the setting shifts from the idyllic countryside or the bourgeois confines of the home to the corrupt city, a reflection of the woman's unchaste condition. In Rossetti's images and Egg's, the ruined female was thus both literally and metaphorically placed near an unyielding urban wall, an allusion to the innocence of past dalliances and to the inflexible laws of restraint which had been broken. Instead of being a courting wall, the brick backdrop in many of these prostitute pictures functions as a totem of her urban isolation, a shadowy place in the anonymous city where she could hide and be forgotten.

Perhaps the most interesting inversion of the courting wall motif is found in a related image of prostitution. Once again the setting moves from the bucolic, or at least the natural, landscape to that of the city with all its reverberations of moral dirtiness, danger, and downfall. This riveting perversion of Millais's *A Huguenot* is E. C. Barnes's *The Seducer* (Fig. 112), which probably dates from the late 1850s or 1860s. Little is known about the artist, but the symbolism utilized nonetheless generates a great deal of meaning. *The Seducer* repeats the arched format of *A Huguenot* and also the pose of a standing couple against a brick backdrop, the woman on the left and the man on the right. But in lieu of a tender or noble embrace or a struggle between love and duty, there is a gap and an underlying tension that communicate psychic distance and uneasiness. Millais's lovers stare wistfully at one another, but Barnes's female protagonist averts the intense, almost rude, gaze of the man, who boldly attempts to touch her hand or to carry her hatbox. Such gestures or overtures on a street would have been deemed most improper, for a lady was not to acknowledge a gentleman in these circumstances unless he were a relative or a very close acquaintance. As if to reinforce his less-than-honorable intentions, the man wears his top

Fig. 113. Artist unknown. "And how long have you been gay, Fanny?" 1857. Wood engraving from *Punch*, 1857.

hat in the female's presence, a sign of his lack of manners and of his deficient deference to her femininity. Even his body language suggests encroachment as he steps closer to her apparently without a signal of permission. In addition, the signs above the hesitant, even intimidated, female advertise "TRAVIATA. A DRAMA. ACT I, ACT II," an allusion to the opera that chronicled the saga of a woman gone astray. This mention of LA TRAVIATA had also appeared in an 1857 *Punch* cartoon entitled "The Great Social Evil" (Fig. 113), in which one prostitute at midnight asks another, ("Ah! Fanny! How long have you been *gay?*") (the last word a colloquial Victorian epithet for a whore). As with Egg's *Past and Present* finale, the word *lost* appears on the wall in Barnes's painting; moreover, "policeman," "Rev. A. Mursell," and "conscience" appear, all alluding to the immorality of the im-

pending misconduct in the eyes of the law and the church and perhaps also suggesting the key word in Hunt's well-known canvas of a kept woman. There may also be a connection with images of sempstresses, since the woman carrying the hat-box may be a milliner or milliner's assistant (as in Redgrave's 1847 *Fashion's Slaves*) and therefore quite vulnerable by dint of her class and economic circumstances to succumb to a seduction.[26]

Whatever the occupation of the female, it is clear that the man's intentions are impure. The boutonniere in his lapel consists of lilies of the valley, an ironic symbol signifying the "return of happiness" in the language of the flowers and the Virgin Mary, especially her Immaculate Conception, in Christian iconography. In a sense, this cad wears the woman's virginity rather casually, and there are more menacing clues in the picture which point to his malevolence. For example, a skull, a harbinger of death and evil, forms the jeweled head of his cravat pin. Another symbol of evil and the loss of innocence is suggested by the serpent design that coils around the man's walking stick; this phallic symbol is also a reminder of the original sin of Adam and Eve and their fall through sexual temptation. As if to heighten the charged meaning and the sense of peril, broken glass lines the top of the erstwhile neutral brick wall. This cutting detail confirms that this is not an innocent tryst but instead a scene of broken and jagged intentions in an urban setting that might well be called by its derogatory popular name, "Damnation Alley."[27]

While Rossetti and most artists chose to depict the damned world of the streetwalker, there were a few representations of the kept woman or mistress in her apartment. As Ruskin remarked of such modern subjects, "it would have been impossible for men of such eyes and hearts as Millais and Hunt to walk the streets of London . . . and not to discover what was also in them. . . ."[28] Hunt's *The Awakening Conscience* (Fig. 114) of 1854 is a remarkable and somewhat voyeuristic look into the love nest of a gentleman and his mistress. (The composition may be indebted to the *Before* portion of Hogarth's *Before* and *After* pendants of 1732–33, both in the woman rising and struggling to remain decorous and in her "protector's" arm reaching out to keep her with him.) Ruskin's meticulous reading of the picture in *The Times* in 1854 remains a classic, truly revealing, analysis of a Victorian painting, for as he stated, "There is not a single object in all that room—common, modern, vulgar, but it becomes tragical, if rightly read." The rosewood furniture,

for example, has a "terrible lustre" due to its "fatal newness," for there is nothing in this room "that has the old thoughts of home upon it, or that is ever to become part of a home."[29] The embossed books, including one entitled "The Origin and Progress of the Art of Writing," are "vain and useless" attempts at self-improvement that remain unread by the occupant. On the wall the paper is patterned with birds eating ripe corn, fertility symbols, in a kind of symbolic rape of the woman's fertility. Hunt wrote for an 1865 pamphlet on this canvas that the sleeping cupids on the clock (which tolls the ominous eleventh hour) have left the corn and vine unguarded, and this detail "might lead the spectator's mind to reflections beyond those suggested by the incidents connected with the scene portrayed."[30] Underlying allusions to chastity recur in the embroidery she has been working on, which contains a rose pricked through with a needle, a sign of deflowering and of the sudden pain she experiences at this moment of epiphany. Moreover, her pose as she arises while her companion sings on nonchalantly, are echoed by that of the "Woman taken in Adultery" print from the Bible that hangs over the piano. Indeed, the words the pair has been singing are from "Oft in the Stilly Night" and includes such lines as these: "Sad Memory brings the light / Of other days around me."[31] In the original version of the woman's face, she wore an expression of horror of which one writer declared that "The author of the 'Bridge of Sighs' could not have conceived a more painful looking face," yet another reference to Hood's poem and a fatal finale.[32] As with *A Huguenot*, the frame is significant, for there are chiming bells on the border tolling warning, and marigolds symbolizing sorrow. The work gains autobiographical meaning because the model was Annie Miller, Hunt's fiancée at the time, a rather willful but beautiful young lower-class woman with decidedly lax morals. Hunt was trying to reform Annie Miller into a lady and to educate her in his own version of a Pygmalion experiment, but the effort failed and Miller disappointed the artist by her rather loose behavior with Rossetti and others whom Hunt knew. While Hunt's relationship with her during this time seems to have remained pure, Miller was enacting her own notion of the fallen woman with Rossetti, for example. Hunt later wrote that he had wanted the mistress in this painting to consider "breaking away from her gilded cage with a startled holy resolve."[33] The motif of genteel captivity in a middle-class context is inverted here, for on the floor a

Fig. 114. William Holman Hunt. *The Awakening Conscience*. 1854. Oil on canvas (with arched top), 29¼ × 21⅝. The Tate Gallery.

bird has been yanked from its cage and now lies dying, a victim of the cat's rapaciousness. As the fleeing bird in Dutch seventeenth-century art was often a symbol of surrendered virginity, the cat was also a symbol of sensual, and often cruel, love. Thought to be the lascivious consort of whores, cats were depicted in earlier art as dangerous to play with, so that being toyed with by a cat connoted sexual peril and even pregnancy.[34] Hunt's courtesan in her loose morning dress is in no less deadly a situation as a victim of a predatory male, whose selfishness and lust have entrapped her. Significantly, she is wearing a nightgown and her hair is undone like that of a modern magdalen, and she has a ring on every finger except her "wedding" finger.

The Awakening Conscience was the secular pendant to *The Light of the World,* Hunt's vision of Christ knocking on the door of the human soul, symbolizing "the appeal of the spirit of heavenly love [that] calls a soul to abandon a lower life."[35] The door of this soul, however, is overgrown with weeds of neglect and tendrils of ivy and this spiritual counterpart wears a white robe of prophet, priest, and king that is nonetheless a parallel to the lady's white nightgown, an emblem of her carnal nature. The action is set in a garden replete with what Hunt later termed "the delectable fruit for the dainty feast of the soul."[36] Inscribed on the frame was the following excerpt from Revelation 3:20: "Behold, I stand at the door, and knock; if any man hear my voice, and open the door, I will come in to him," but whether or not the woman or her seducer will accept this opportunity to repent is left ambiguous. Like its pendant, *The Awakening Conscience* is inscribed with biblical verse, one citation being from Ecclesiastes 14:18: "As of the green leaves on a thick tree some fall and some grow; so is the generation of flesh and blood." While the reflected tree in the garden (which is visible in the mirror behind the woman) is in verdant bloom, the mistress, like one of the leaves, has fallen from the branches of virtue as one who has succumbed to the needs of the flesh. Another passage from Isaiah is included by Hunt: "Strengthen ye the feeble hands and confirm ye the tottering knees; say to the faint-hearted: be ye strong; fear ye not, behold your god," and the woman is summoning that strength in this vignette. The last scriptural reference—from Proverbs, "As he that taketh away a garment in cold weather, so is he that singeth songs to a heavy heart"—was later explicated by Hunt as referring to the shallow male companion, who has

unconsciously ignited the woman's memories with his idle song and still continues unaware of what he has triggered in her.[37] Moreover, on the floor another sheet of music adds to the narrative. This furled sheaf is "Tears, Idle Tears," a song by Thomas Moore adapted from Tennyson's poem with its themes of lost love and desolation. This song, like the courtesan's epiphany, involves tumultuous emotions of regret, sorrow, and transience, and like "Oft in the Stilly Night" reinforces the primary themes of the painting. Perhaps the "glimmering square" of light mentioned in Tennyson's verse is that which the woman sees in the mirror, both a physical manifestation of sunlight reflected and a metaphorical light that dawns, an inward experience mirroring the transformation from night into day of her recalcitrant soul. Thus, Christ in *The Light of the World* may have successfully conquered the darkness of sin by opening the door of the soul and redeeming it with the light of his resurrection and sovereignty, emanations made concrete by the light of conscience and salvation Hunt intended viewers to perceive.

The wayward woman, as these pictures convey, rarely met with a happy ending, and many depictions of the "East End" type of harlot pivoted on the literally fallen and shameful posture of the outcast, as in *Found.* Vilification by family and society was the usual outcome, at least in art, and few scenes of reconciliation with the penitent daughter exist. A typical woeful conclusion to the tale of the prostitute or courtesan in art (but not necessarily in real life, where she may have subsequently wed and prospered) is seen in Richard Redgrave's 1851 *The Outcast* (Fig. 115). A patriarch sternly exiles his errant daughter with her baby on a wintry night

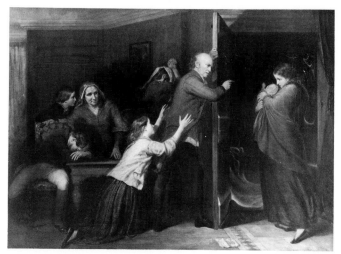

Fig. 115. Richard Redgrave. *The Outcast.* 1851. Oil on canvas, 31 × 41. The Royal Academy of Arts.

Fig. 116. Abraham Solomon. *Drowned! Drowned!* 1860. Wood engraving from *The Art-Journal*, 1860.

(akin to the chilly fate of Smith's unprotected female in *Into the Cold World*). Snowdrifts accumulate by the threshold of home and all it symbolizes, and inside the warm house another daughter beseeches her father to reconsider his harsh decision, while a brother and others also react dramatically. Redgrave prefigured both Hunt and Egg in his use here of certain emblematic objects in the narrative—for example, the fallen and incriminating missive and the meaningful pictures on the wall. Abraham is shown casting out Ishmael and Hagar, a biblical scene of expulsion that parallels the state of this female exile. On the brink of disaster in her life, the errant woman turns around for one last look, but whether or not she will return as a prodigal daughter or will perish is left open-ended by the artist. Perhaps the ostracized mother and her bastard offspring will face the moment of crisis depicted in F. B. Barwell's *Adopting A Child* of 1857, in which an affluent older couple reaches out for the thin, raggedy girl who still clutches at her mother's skirt. This haggard mother is torn between her maternal affections and giving her child a new start on her life, for a portrait on the library wall suggests that this girl is a "replacement" for one who has died.

A final entry in the string of often Ophelia-like tragic finales is Abraham Solomon's lost *Drowned! Drowned!* (Fig. 116, illustrated here from an engraving) of the 1860 Royal Academy, the very title of which forms the preface in Hood's poem "The Bridge of Sighs" and derives from a passage describing Ophelia's demise in *Hamlet*. The *Athe-*

naeum critic of that year meticulously analyzed this work, noting that "A masquerader, accompanied by a female of unquestionable character, is returning from a revel at early dawn."[38] They traverse Waterloo Bridge, the canonical site of death, and find a waterman who has just rescued a drowned woman from the Thames. Another woman cradles this victim, while a policeman shines a lantern onto her pallid face and the waterman, boathook in hand, tells a companion where and how the body was located. As Victorians viewers no doubt understood, "the masquerader looks horror-stricken at the sight before him, which we are to suppose is his own handiwork; he strives instinctively to check his female companion, who is advancing unconscious of the event, and full of feverish life."[39] In spite of the man's behavior which caused the prostitute's downfall, this is essentially a drama about the reactions of the various females in the work: from one of the female revelers flirting with a man (and perhaps repeating the initial steps toward the tragedy of the drowned woman), to the compassionate female holding the body, to the flower-girl at right standing as a symbol of urban life. (It was also a composition that inspired Frank Holl's 1874 *Deserted—A Foundling*, another dock scene in which a deserted baby is found by a policeman; there, however, the anguished mother hides behind a column with a man, presumably the father of the child.) As with *Found* and a number of other pictures, the bridge figures prominently in the narrative, for the lights on it "stretch in a line [and] struggle smokily with the coming day."[40] While the corpse of Watts's harlot in *Found Drowned* is already stiffened by rigor mortis, the scene here is not quite as brutally true-to-life, but it is still the overriding presence of the water-logged body that overwhelms all the other pictorial symbols and once again imprints this powerful image of errant destitution on the viewer's consciousness. Indeed, in all the pictures in this chapter, the mythology of the fallen woman centered on her lost innocence and on an assumption of male lust, and guilt for female sexuality.[41] If women were thus made victims of male passion, then the underlying issues of economic conditions and societal biases could be deflected, and artists could appeal primarily to the spectator's sympathy for these "soiled doves."

10
Later Feminine Alternatives

I. THE NEW WOMAN

THE PROSTITUTE WAS A SOCIAL OUTCAST, AND IN A DIF-ferent respect so too was the "New Woman," an unconventional persona who made her appearance toward the close of the century in England (and also in America). The offensive brazenness implicit in both creatures is evident, for example, in John Collier's *The Prodigal Daughter* (Fig. 117) of the 1903 Royal Academy exhibition. This protagonist is not a ruined, hapless female; instead the fancifully costumed woman displays herself as she now is—an ostentatiously dressed and expensive courtesan. Neither impoverished, victimized, nor contrite, she confronts her aged parents with the fact of her immorality and smiles rather smugly and cruelly to watch their reactions. The interplay of looming shadows cast by the mother and daughter suggest just how much of a secretive, night-time encounter this eerie confrontation seems to be, and the father reading his Bible remains rooted to his chair at the sight of his bold offspring. Similarly, the "New Woman" of this period was also a "prodigal daughter," one who flaunted convention, ruined her honor and upset her family, and often refused to repent for alleged sins. This real-life female, however, was in many respects the natural evolutionary offspring of advances in higher education and hygiene, opportunities for athletic prowess, legislative reforms in marriage and divorce laws, and agitation for female suffrage, although she was not exclusively the by-product of any one of these forces.[1]

The image of this new and anomalous creature was most vividly forged in the literature of the period, and an entire subcult of "New Woman" novels arose and communicated a mixture of complicated and sometimes contradictory ideas about contemporary womanhood. Grant Allen, Thomas Hardy, and George Gissing all wrote about this provocative character in the late 1880s and 1890s, placing their daring feminist heroine in direct conflict with the traditional values and feminine ideals of conservative Victorian society. The antecedent of this new being was, of course, to be found in John Stuart Mill's *The Subjection of Women* of 1869 (as in the landmark ancestor of 1792 by Mary Wollstonecraft), but the Victorian amazon was far more blatant and defiant than any forerunners. In several of Gissing's novels of the 1890s (for example, *The Emancipation, The Odd Women,* and *Eve's Ranson*), as in Allen's *The Woman Who Did,* W. Barry's *The New Antigone,* Emma Brooke's *A Superfluous Woman,* and M. Muriel Dowie's *Gallia,* "the woman question" is addressed, often by using heroines who challenged the status quo on principle and even supported the shocking tenets of "free love." Such rebelliousness naturally unnerved (and occasionally amused) critics, and Eliza Lynn Linton maligned the "Wild Woman" as a member of the "Shrieking Sisterhood," one whose reckless and

Fig. 117. John Collier. *The Prodigal Daughter.* 1903. Oil on canvas, 65⅜ × 81¾. Lincolnshire City Council Recreational Services, Usher Gallery, Lincoln.

above all willful behavior allied her more with wicked women (i.e., prostitutes) than with virtuous ones.[2] To others, this radical creature committed the cardinal sin of "unsexing" herself by personally or ideologically rejecting marriage and sacred motherhood. Whether she was called the "New Woman," the "Odd Woman," or the "Half Woman," she was blamed by many as the cause of the demise of various institutions in England. Even her attire could be threatening, for although bloomers had appeared in the late 1840s and 1850s (and had even then been asssociated with dangerously mannish behavior in numerous articles and cartoons), women wearing bloomers, trousered ensembles, "rational" costumes, or even artistic garb were often stereotyped by contemporary novels and *Punch* as "strong-minded" and unladylike. While the literature that treated this subject ex-

plored the motives as well as the specific emancipated actions and credo of the bold New Woman (often ending with exaggerated penalties like death, disease, or insanity for her iconoclastic behavior), visual forms of art necessarily had to schematacize these elements into an iconological shorthand of sorts. Once again it was the journals of the period, especially *Punch*, that took the lead both in documenting and lampooning this subject.[3] The New Woman had many faces and was not always specifically identified as such in the pages of *Punch*, but she was clearly depicted as simultaneously well-educated (for example, shown in academic robes or as a "Girton Girl"), a bicycling fiend or accomplished athlete, an advocate of female clubs, a serious intellectual (for example, reading Greek), a daring decadent, and a physically menacing amazon. Some cartoons were even

WHAT THE NEW WOMAN WILL MAKE OF THE NEW MAN!

"IF YOU WANT ME TO KEEP THE NEXT DANCE FOR YOU, YOU MUST WAIT UNDER THIS DOOR. I CAN'T GO RUSHING ALL OVER THE ROOM TO *LOOK* FOR YOU, YOU KNOW!"

Fig. 118. George Du Maurier. "What the New Woman will make of the New Man." 1895. Wood engraving from *Punch*, 1895.

captioned "The New Woman," a sobriquet that could connote either statuesque size or able mind, mannish garb or demeanor, or modern ideas. In George Du Maurier's 1895 cartoon "What the New Woman Will Make of the New Man!" (Fig. 118), for example, the ballroom of the past is shown in a different light: instead of a passive female awaiting a bid for a dance from a male partner, the lady announces to her escort, "If you want me to keep the next dance for you, you must wait under this door. I can't go rushing all over the room to *look* for you, you know!" Even more assertive was the creature illustrated in *A New Woman* (Fig. 119) of 1894 in a conversational exchange with a vicar's wife. The latter inquires, "And have you had good sport, Miss Goldenberg?" to which the huntress replies, "Oh, rippin'! I only shot one rabbit, but I managed to injure quite a dozen more!" Miss Goldenberg's statement speaks of a new breed of female who would openly brag about her hunting prowess— here a deadly skill—without any trace of the hyper-delicacy and squeamishness of her frail, largely housebound predecessors. In these and similar

cartoons the "New Woman" is portrayed as quite comely, but her fictional counterpart was more typically described as sensual, perhaps even dignified, but decidedly homely. The novelist with the pseudonym "Ouida," for example, complained in 1894 that this type of female lacked womanly graces and was downright ugly in features and demeanor.

In paintings the New Woman is remarkably rare, if not conspicuous by her absence. An unconventional forerunner is found in William Powell Frith's 1869 *At Homburg* (Fig. 120), but here she is significantly a Continental, not an English, woman. The artist had visited Homburg and its gambling dens (immortalized in his huge *Salon d' Or*) and actually saw such a woman daring to smoke in public. In spite of the fact that the foreign nationality of the subject made it easier to depict a pretty coquette engaged in this audacious act in public, Frith was censured. He wrote in his memoirs about this painting, "Homburg was the innocent, or wicked, cause of another small artistic effort of mine. It was not very uncommon to see ladies sitting amongst the orange-trees smoking cigarettes. I was attracted

A "NEW WOMAN."

The Vicar's Wife. "AND HAVE YOU HAD GOOD SPORT, MISS GOLDENBERG?"
Miss G. "OH, RIPPIN'! I ONLY SHOT ONE RABBIT, BUT I MANAGED TO INJURE QUITE A DOZEN MORE!"

Fig. 119. George Du Maurier. "A New Woman." 1894. Wood engraving from *Punch*, 1894.

with a cigar, but while his actions are commonplace, hers were totally unacceptable to an English audience.

The New Woman of the 1890s was equally evasive in fine art. William Rothenstein alludes to her in his 1899 canvas entitled *The Doll's House* (Fig. 121). The first production of this play in London was staged ten years earlier and had been attacked by *Punch* for its "Ibscenity," in particular its mention of taboo subjects like venereal disease and feminine dissatisfaction with the institution of marriage. George Bernard Shaw had introduced the artist to Janet Achurch, who had played Nora, but here the artist portrays his wife Alice in the role of Mrs. Linden and his friend and fellow artist Augustus John as Krogstad, in the third act of this drama about tension between the sexes.[5] Various critics have pronounced this work an enigma, for Mrs. Linden huddles on an odd, directionless staircase as if to hide. The man is dressed in black and she in black and white; the woman's shadow looms large behind her like an independent spirit, the dark shape it casts enveloping the two figures almost totally. This was in some ways a strange painting to have been produced during the artist's

to one—a very pretty one—whose efforts to light her cigarette, being unavailing, called to a waiter for a light. A candle was brought, and as the fair smoker stooped to it she presented such a pretty figure, and altogether so paintable in appearance, that I could not resist a momentary sketch, afterwards elaborated into a small picture. I think Hogarth would have made a picture of such an incident, with the addition, perhaps, of matter unpresentable to the present age. It might have adorned our National Gallery, whilst I was mercilessly attacked for painting such a subject at all."[4] In this slice of modern life, Frith contrasts this handsome woman engaged in an outrageous act with five ladies in the background, whose deportment is quite decorous in this public garden. Ironically, a German male stands in the background

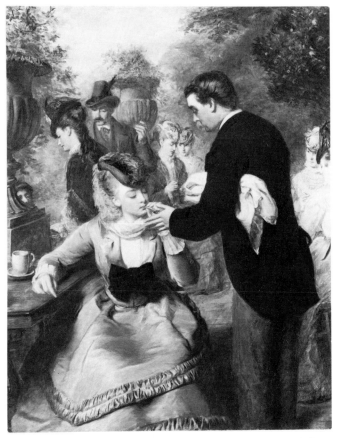

Fig. 120. William Powell Frith. *At Homburg*. 1870. Oil on canvas, 23½ × 19½. Photo courtesy of Christie's London.

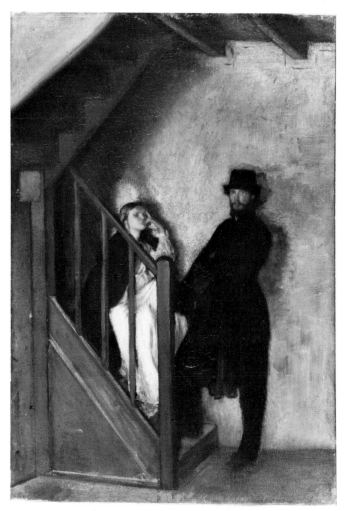

Fig. 121. William Rothenstein. *The Doll's House.* 1899. Oil on canvas, 35 × 24. The Tate Gallery.

honeymoon, and one modern writer has aptly remarked that "this man and this woman, though they are so nearly touching, are each alone in the prison of their own thoughts."[6] The fatalism of mood, along with the sinister shadows, creates an introspective female who is quite different from the flighty, or even the melancholic, maidens of earlier Victorian painting. And she is also very different from the cartoon of a domineering wife entitled "Ibsen in Brixton" in *Punch* of 1891, in which a massive, aggressive wife says to her puny and rather startled spouse, "Yes, William, I've thought a deal about it, and I find I'm nothing but your doll and dickey-bird, and so I'm going!"

Another entry in this category, albeit from the more peripheral realms of fine art, is Albert Morrow's 1897 poster (Fig. 122) for Sydney Grundy's 1897 play *The New Woman.* Once again the cigarette with its unfurling smoke (here in the border) is a symbol of the feminist woman's decadence and

radical ways. An assertive, bespectacled woman, who seems modeled after the Victorian author George Egerton (the pseudonym for Mary C. Brights), is surrounded by a litter of books confirming her intellectual bent.[7] This bluestocking does not even sit properly or primly as a lady, but instead strains forward in an ungainly posture like some absent-minded scholar intent on hearing or saying something. Strenuous mental labors were thought to result in nervous disabilities, hysteria, a host of maladies, and even death, and the ungraceful pose and pince-nez are harbingers of possible future problems. Such women were also denounced as irreligious, and in lieu of a Bible in the pile of books depicted is one entitled *Man the Betrayer.* This work was also mentioned in the play, which queries feminine roles and responsibilities in Victorian society by focusing especially on the issue of marriage and the opinions of various dramatis personae on this subject. In addition, the artist has added above the dado on the wall a latchkey, this possibly a pun on Egerton's well-known publication of 1893, *Keynotes.* The key also represents a central issue in the play about a woman's desire and right to come and go as she pleases and thus symbolizes the protagonist's wish for personal independence. Many Victorians deemed this goal an illusory one, for "deserting" the home ultimately destroyed both the family and, at least in contemporary fiction, often brought misery to the heroine herself.

A slightly later example of this independent type, dating from the early twentieth century, also falls into the category of the "strong-minded" woman. It is called, aptly enough, *Surprised!* (Fig. 123) and was painted by Frank Craig. Here the iconoclastic female has bobbed here tresses and also wears trousered attire, both dangerous evidences of her blasphemous tendencies. She flaunts these aspects of herself and openly confronts her stunned male visitor, perhaps a former suitor, with her feminist principles on the banner she holds. The "New Woman" in literature was often viewed as an imperious, vampirish type who tormented the men who had the misfortune to love her, and this may be the case here. Ironically, on the wall above the man (who is in military uniform and may be home on leave to see his ex-sweetheart) is a telling picture, and its placement seems to align him with more traditional beliefs about womanhood. The painting is a roundel representing a trecento-like Virgin and Child, a Renaissance image of sacred motherhood in obvious contrast to

Fig. 122. Albert Morrow. "The New Woman." 1897. Mixed media poster, 12 × 16. Private collection.

Fig. 123. Frank Craig. *Surprised!* Ca. 1905. Watercolor, 14 × 14. Photo courtesy of Sotheby's London.

this modern, avant-garde female, who does not pretend to be a secular saint, a dutiful daughter, or a maternal vessel of purity.

Both a real social "problem" and a fantasized artistic expression of deep-seated anxieties and wishes, the New Woman was accorded a much more prominent place in contemporary literature than she was in art, the latter relegating her mostly to the pens of cartoonists in the popular press. Nonetheless, in the few paintings in which she does appear this creature personifies the shame with which she was regarded as an "unnatural" woman as well as the alleged shamelessness of her behavior and dress. While in the 1850s and 1860s especially images of women within the enclosure or confinement of home and garden prevailed, by

the close of the century this narrowing universe had widened, and the female of the 1890s was thus often liberated to lead an active life in every respect.

II. THE ATHLETIC FEMALE

One change that the New Woman heralded was her athleticism, a development that had evolved throughout the Victorian era. For much of the nineteenth centery, however, the ideal woman was conceived of as aphysical, a paragon of fragility. If a female "unbalanced" her constitution by too much exercise or too much intellectual stimulation, the results could be dire and range from nausea or nervous disabilities to fatal brain fever. Such prejudices made the female an embodiment of almost hopeless frailty, so much so that feminine passivity could at times be equated with invalidism.[8] The convalescent woman, like that of the sick little girl, was a frequent subject in art, for even the middle-class lady was not immune from the tragedies of consumption or postpueperal complications. James Tissot, for example, had treated the theme of the beautifully expiring lady in such work as his *La Soirée d'Eté* (Fig. 26) of 1881, only one of myriad depictions of wilting, if not truly expiring, flowers of femininity.

In actuality, during the first half of the century the nature of physical exertion for middle-class females was quite limited—for example, to tossing a ball, rolling hoops, or just blowing bubbles. (There was, of course, a class difference obvious in that female laborers in the fields and in the factories were denigrated for the very strength they needed to survive.) But great strides were made in women's athletic endeavors between 1850 and 1900, with numerous factors—from increased leisure, to the higher education of women, to a heightened awareness of the interrelationship between exercise and good health—contributing to alter the basically sedentary female existence.

The pages of *Punch* perhaps best chronicled these changes in England, and there were relatively few paintings of women engaged in sports. Prior to about 1870 females were depicted, in both periodicals and paintings, in activities that were more recreational than physically exacting—noncompetitive pursuits like horseback riding, boating, and bathing. Even in the 1860s the fad for croquet was not terribly rigorous and could, like golf and archery, be played in regular clothing. The model of idleness was challenged in the 1870s, however, by much more active pursuits and players. *Punch* published many images of women (still in nonspecialized attire) rowing, ice or roller skating, playing lawn tennis, and performing gymnastics, frequently in the company of men and thus with a certain playfully competitive edge suggested by this mixed society. In the last two decades of the nineteenth century, however, team sports for women emerged—particularly cricket and field hockey—which were vigorous all-female enterprises, not gentle social games.[9] The evolution of these transformations is chronicled in an 1891 cartoon from *Punch* entitled *Past and Present* (Fig. 124), not a permutation of Egg's trilogy but a documentation of the changing styles of female athletic exercise. By the 1890s the bicycle came into vogue, arguably causing the greatest impact of all sports on the life of the middle-class Victorian lady. Costumes were modified to accommodate this novelty, even though earlier attempts at dress reform had occurred in 1850 with Amelia Bloomer's sartorial innovation. The 1890s alteration in dress for bicycling was primarily sports-oriented, although the divided-skirt style, like Amelia's bloomers, was perceived partly as a political issue.

More than a mere toy of fashion, the bicycle helped to promote the New Woman by the very increase in physical freedom (including a possible temporary escape from chaperonage) it enabled female riders to enjoy.[10] There were countless cartoons in *Punch* of bicycling fiends, and the aged and acid-tongued Mrs. Linton in this decade singled out the cyclist as an ominous manifestation of the New Woman, attacking her for smoking, reading dubious novels, and showing a lack of respect for her home or parents. In "Fashion à la Shakespeare" (Fig. 125) of 1897, for example, the illustrator Linley Sambourne shows a female who almost defiantly confronts a bespectacled man. He looks quizzically at this new specimen of womanhood that goes out "driving" alone, wears a trousered costume, and perhaps even agitates for the vote.

Aside from wild women cyclists, *Punch* showed the New (athletic) Woman as often dominating men and exhibiting a streak of independence. Some cartoons portrayed this creature with a decided air of self-assurance (she was certainly not passive) as she repaired bicycles, made romantic overtures to a man, and petitioned to gain the vote because of her newly discovered physical and psychological stamina. The political nuances of this

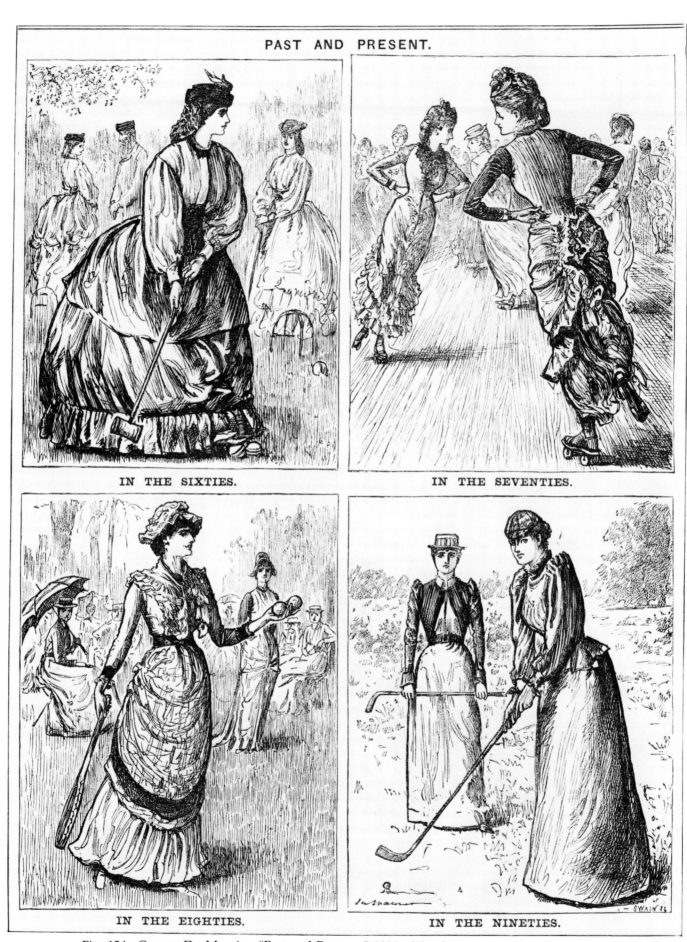

Fig. 124. George Du Maurier. "Past and Present." 1891. Wood engraving from *Punch*, 1891.

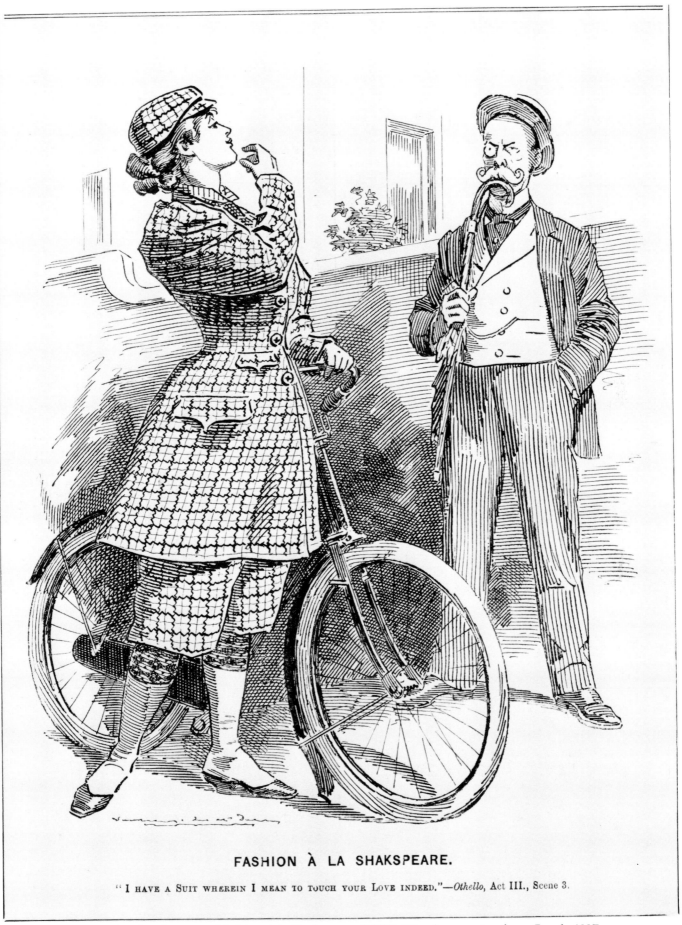

FASHION À LA SHAKSPEARE.

" I HAVE A SUIT WHEREIN I MEAN TO TOUCH YOUR LOVE INDEED."—*Othello*, Act III., Scene 3.

Fig. 125. Linley Sambourne. "Fashion à la Shakspeare." 1897. Wood engraving from *Punch*, 1897.

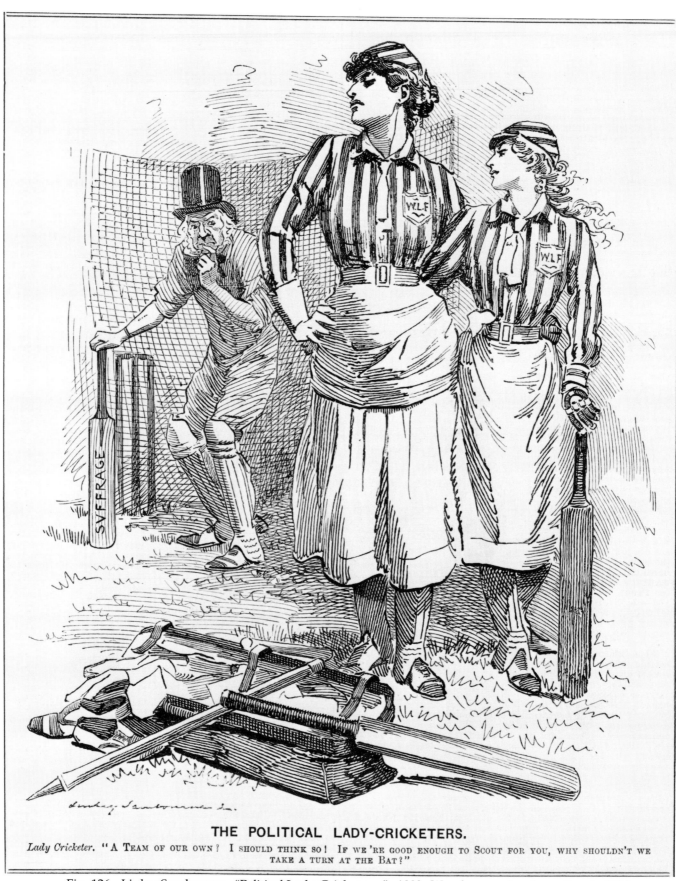

THE POLITICAL LADY-CRICKETERS.

Lady Cricketer. "A TEAM OF OUR OWN? I SHOULD THINK SO! IF WE'RE GOOD ENOUGH TO SCOUT FOR YOU, WHY SHOULDN'T WE TAKE A TURN AT THE BAT?"

Fig. 126. Linley Sambourne. "Political Lady-Cricketers." 1892. Wood engraving from *Punch,* 1892.

type of cartoon are evident in Sambourne's 1892 drawing "The Political Lady-Cricketers" (Fig. 126), in which the rather wimpy man in the background can be identified as Prime Minister William Ewart Gladstone. The comic conversation among spectators of the match in the accompanying text was preceded by a reminder that in 1890 yet another resolution had been passed, theoretically in support of the enfranchisement of women. Thus, one of the lady players in this uniformed amazon duo says, "A team of our own! I should think so! If we're good enough to scout for you, why shouldn't we take a turn at the bat?" This was perilously close to an overt demand for the vote, for the woman was no longer hiding behind her own skirts or her alleged influence over the males in her family. The shortened skirt and trousered ensemble were other indications of the altered perception of the late-

century female. Ultimately, her increasing athleticism in the last quarter of the century, along with political factors, made the Victorian woman grow in size and menacing stature in the pages of *Punch*. As some of the previous examples have suggested, *Punch* viewed such a being as an overwhelming amazon who made her male companions seem puny indeed. In "The Weaker Sex" (Fig. 127) of 1901, for example, she is both robust and huge and is described in the text as a "stalwart damsel." The tall female with her stick says to the slight man with his walking cane, "You haven't joined our club, Mr. Sleaford?" to which he (at a weight of only seven stones, six pounds) replies, "No. Fact is I think mixed hockey frightfully dangerous." She retorts, "Indeed!—do you mean for the men?" Such an encounter, both humorous and acerbic, was unthinkable even a decade or so earlier, and there had at no time been anything like it in Victorian paintings.

There were some representations of the athletic female in art of this period, but they tended to be mild types indeed, far removed from *Punch*'s robust practitioners or Linton's "wild women." Croquet, tennis, and archery were all fashionable themes, one rather innocuous example in this category being W. P. Frith's 1872 *The Fair Toxophilites* (Fig. 128). Subtitled *English Archers, Nineteenth Century*, the work was inspired by the artist's observation of some lady archers at a seaside resort. His three daughters served as the models, and both Frith and the critics of this 1873 Royal Academy entry both realized that this was less an anecdotal painting than "a record of the female habiliments of the time."[11] Interestingly, the women are gorgeously arrayed, but not in any special attire designed for the sport at hand: in their fancy hats and dresses they could as readily be going shopping or paying a call as practicing archery. This sport enjoyed considerable popularity among women because it afforded them exercise without great exertion, and it was also thought graceful to behold, both in gesture and in the way the carefully tailored costumes supposedly enhanced the female figure. There was even a connection made between the fair toxophilites' arrows and the amorous darts of Eros. The lines accompanying this painting at the Royal Academy underscored this somewhat ambiguous romantic implication: "The bow is bent, and drawn, make from the shaft." As Thackeray asked in *Vanity Fair* of 1848, "What causes young people . . . to wear Lincoln green toxophilite hats and feathers, but that they may bring down some

THE WEAKER SEX.

She (a stalwart damsel). "You haven't joined our club, Mr. Sleaford?"

He (7 st. 6 lb.). "No. Fact is, I think mixed hockey frightfully dangerous."

She. "Indeed!—do you mean for the men?"

Fig. 127. Artist unknown. "The Weaker Sex." 1901. Wood engraving from *Punch*, 1901.

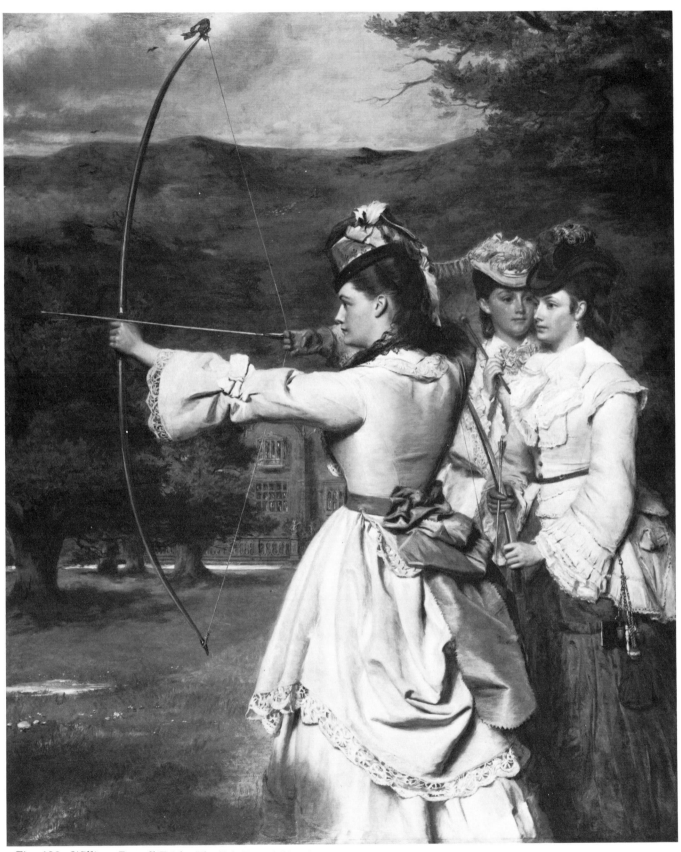

Fig. 128. William Powell Frith. *The Fair Toxophilites (English Archers, Nineteenth Century)*. 1872. Oil on canvas, 38¾ × 32. The Royal Albert Memorial Museum and Art Gallery, Exeter.

'desirable' young man with those killing bows and arrows of theirs?"[12] And in George Eliot's 1876 novel *Daniel Deronda*, the beautiful protagonist Gwendolyn at first attracted the attention of her future spouse at an archery meet. With such amorous meanings looming, it is difficult to view Frith's canvas as an essay in athletic prowess.

A kindred mood of decorativeness, in addition to languor, reigns in James J. Tissot's 1878 *Croquet* (Fig. 129), both an etching and a painting (the latter exhibited at the Grosvenor Gallery in 1878). Croquet did not, like archery, require strenuous physical exertion, and this mania was viewed in the 1870s as "the only game that brings gentlemen and ladies together in the open air. . . . Whether for flirtation or hard play, croquet has unquestionably achieved this result and every other pastime failed."[13] The *Illustrated London News* remarked of the painting that it had "a delightful sunlight effect, with a juvenile *croqueteuse* in short skirts, and the well-known 'polished ebony pianoforte legs' which Mr. Du Maurier has made so fashionable."[14] Set in the artist's St. John's Wood garden, the image seems less about activity than about relaxation. Indeed the scene itself is a sort of *hortus conclusus*, replete with splashing fountain, lush vegetation, and virginal maidens. The two girls lounging in the midground on the grass suggest that they are content to remain idle and not exert the effort to play on this warm summer day. As one twentieth-century commentator has described this earthly paradise, "It is a lazy, intimate and rather delectable secret garden into which we are invited, and at the same time prevented from entering. There is a suggestion of a threshold to be crossed, and we are further hindered by various objects at our feet—a croquet ball, a small dog, flower pots and a watering can. A girl with a croquet mallet bars our way and seems almost to challenge us as intruders into a private and ideal world."[15]

Another contemporary image was Edith Hayllar's 1883 *A Summer Shower* (Fig. 130). This artist seems to have had a penchant for painting subjects involving sports—boating, punting, and shooting subjects.[16] Here she concentrates on lawn tennis, which had been introduced into England in the 1870s and became almost immediately fashionable (by 1884, for example, a woman's championship had already been established at Wimbledon). Paintings of women actively engaged in sports were not common, and as in *The Fair Toxophilites* the females often seem merely posed in pretty garments with the proper equipment. (*Punch*, however, published myriad cartoons of women vigorously playing tennis with other females or in mixed doubles.) Here a casual note is struck by the clothing and postures of the foreground figures, and the young lady with her wooden racquet wears a dainty but protective apron over her afternoon frock. *A Summer Shower* also reflects the fact that men and women played mixed games of tennis in the 1880s, although this match has been temporarily interrupted by rain and further postponed by an informal recess for refreshments and conversation. Once again the hint of possible romance lingers, for in such pictures females often functioned more as fashion plates volleying in the game of love, not *dévouées* devoted to a sport for their physical development.

Fig. 129. James J. Tissot. *Le Croquet (Croquet)*. 1878. Etching and drypoint on laid paper, 12 × 17½. Yale University Art Gallery, Gift of G. Allen Smith.

Fig. 130. Edith Hayllar. *A Summer Shower.* 1883. Oil on board, 20 × 16¾. The FORBES Magazine Collection, New York.

Fig. 131. John Lavery. *A Rally.* 1885. Watercolor, 26 × 25. Glasgow Museums & Art Galleries.

One of the few exceptions to this paradoxically nonphysical female athlete appears in John Lavery's 1885 canvas *A Rally* (Fig. 131). Here the forward thrust of the lady's body as she rallies is quite violent, making her white tennis attire swirl about her like a whirlpool. The light tones of the woman's dress, like those of the landscape, make the atmosphere seem sun-drenched, on a day so hot that another lady must put up a parasol for protection. *A Rally* suggests both a new depiction of the female involved in sports and a different style of painting, for Lavery had been inspired by contemporary French artists like Bastien-Lepage to work out-of-doors and to employ a fresh, light palette. Lavery's preoccupation with recording movement is also apparent here, for he has captured a split-second of action with considerable spontaneity and immediacy.

Thus, sports did not cause a complete revolution in femininity, but they did significantly alter the image of Victorian women in real life in their enlarged sphere of options for physical exercise. By contrast, however, the lovely, frail, and often corseted female type of the past continued to reign in the majority of pictures, thus making the sporting life of her modern counterpart more evident in real life than in art.

III. THE FEMININE AESTHETE

The cult of the aesthetic female especially in the 1870s and 1880s embraced a number of diverse aspects of contemporary womanhood, from fashion, to artistic taste in interior decoration, to posture, to attitudes, to physical attributes. In decided contrast to the robustness and sturdiness of the athletic woman was the cultivated languor of her artistic "sister," the aesthete. The two types coexisted, but the aesthetic lady's life span was shorter in art and in the pages of *Punch,* concentrated in the years between the late 1870s and about 1882. The Aesthetic Movement had its roots in earlier decades and had emerged by 1880 without either a formal manifesto or a particular institution or artist to represent it. However, the hedonistic Oscar Wilde was in many ways an informal spokesman for the more salient aspects of the movement, which included a reverence for the poetry of Keats and Rossetti, an appreciation of the Pre-Raphaelites and their revolt against false sentiment and frothy subjects in art, and an enthusiasm for *japonisme* as well as for the craftmanship of William Morris and Company.[17] The Aesthetic Movement was susceptible to a considerable amount of ridicule and censure, and one of the most continually mocked subjects was that of the feminine aesthete, who even more than her male counterpart seemed to obsess poets, painters, and the press. It is the legacy of this creature, coupled with the impact of poems by Algernon Swinburne and both poetic and painterly works by Rossetti, that influenced succeeding representations of the languid lady in late-nineteenth-century art.

The cult of beauty and taste cherished by aesthetes of both sexes appealed strongly to contemporary artists, poets, playwrights, and intellectuals, and a feminine ideal evolved which Walter Hamilton described in his 1882 *The Aesthetic Movement in England* as "a pale distraught lady with matted dark auburn hair falling in masses over the brow, and shading eyes full of love-lorn languor, or feverish despair . . . long crane neck, flat breasts, and long thin nervous hands."[18] In the realm of painting, author Mary Haweis pointed to artists such as Rossetti, Edward Burne-Jones, and Albert Moore for having introduced a new feminine type that encompassed women who had hitherto been dismissed as rather unattractive: "those dear and

Fig. 132. Dante Gabriel Rossetti. *Perlascura*. 1871. Pastel on pale green paper, 22 × 17¼. Ashmolean Museum, Oxford.

much abused painters . . . are the plain girl's best friends. They have taken all the neglected ones by hand. . . . All the ugly flowers, all the ugly buildings, all the ugly faces they have shown us have a certain beauty of their own. . . . Red hair—once . . . a . . . social assassination . . . is the rage. A pallid face with a protruding upper lip is highly esteemed—only dress after the pre-Raphaelite style and you will be astonished to find that so far from being an 'ugly duck' you are a fully fledged swan."[19] The Pre-Raphaelites and their adherents were singled out not only for having forged a new ideal of beauty, but also for having stimulated a change in apparel—for example, a preference for the loosely flowing, vaguely medievalizing, and apparently noncorseted robes that Jane Burden Morris was often shown as wearing.

Fig. 133. George Du Maurier. "The Six-Mark Teapot." 1880. Wood engraving from *Punch*, 1880.

ÆSTHETIC LOVE IN A COTTAGE.

Miss Bilderbogie. "YES, DEAREST JOCONDA! I AM GOING TO MARRY YOUNG PETER PILCOX! WE SHALL BE VERY, *VERY* POOR! INDEED HOW WE ARE GOING TO *LIVE*, I CANNOT TELL!"

Mrs. Cimabue Brown. "OH, MY BEAUTIFUL MARIANA, HOW *NOBLE* OF YOU BOTH! NEVER MIND *HOW*, BUT *WHERE* ARE YOU GOING TO LIVE?"

Miss Bilderbogie. "OH, IN DEAR OLD KENSINGTON, I SUPPOSE—EVERYTHING IS SO CHEAP THERE, YOU KNOW!—PEACOCK FEATHERS ONLY A *PENNY A-PIECE*!"

Fig. 134. Artist unknown. "The Two Ideals." 1879. Wood engraving from *Punch*, 1879.

As such descriptions attest, Jane Burden Morris's features—especially her columnar neck, thick, sensuous lips, heavy mantle of hair, well-defined brow and jawline, and slouching, "boneless" posture all epitomized this new standard of femininity, and some of these facial traits are evident in Rossetti's 1871 drawing entitled *Perlascura* (Fig. 132). This "dark pearl," nicknamed "Janey," also happened to be the wife of Rossetti's colleague William Morris, and Rossetti's relationship with her remains shadowy, although he seems to have loved her. The qualities of her face and physique became elements which reappeared in Rossetti's poems and art of the 1870s, and they also serve as the apparent prototype for numerous *Punch* cartoons by George Du Maurier lampooning aestheticism.[20] Du Maurier's classic statement on aesthetic excesses is perhaps "The Six-Mark Tea-Pot" (Fig. 133) of 1880, which seemingly caricatures both aesthetic courtships and Jane Morris's face in the person of a drooping, haggard Pre-Raphaelite "stunner." Amid their personal paradise of Japanese screens, blue and white china, and ebonized furniture, this Janey clone speaks the following dialogue with her

oddly Oscar Wilde-like groom. He says, "It is quite consummate, is it not?" (perhaps a newlywed's bad pun as well as a comment on their newest acquisition), and his "intense bride" replies, "It is, indeed! Oh, Algernon, let us live up to it!"

This revised notion of beauty, in the light of previous standards almost constituting a cult of ugliness, was often derided by critics for the female characteristics of a sallow brow, parboiled, hollow eyes, Greek poses or affectations, a sodden, pasty cheek, and dresses of "stew-sage green." The duality, if not at times the schizophrenia, in upper-class circles of Victorian womanhood was reflected in numerous Du Maurier cartoons as well as in an 1879 poem and illustration entitled "The Two Ideals" (Fig. 134). This statement rejects the "moon-eyed, and mild, and pulpy-mouthed" ideal of the past along with the Aesthetic "moon-eyed maid of melancholic mien."[21] The disdain evinced for the unhealthy languor, oddly hued garments, and temptresslike intensity and passion are conveyed in these few stanzas of doggerel: "She stood as one from whom each garment slips, / Limp, . . . drooping with pendulous lids and lips. / Her eyes were hollow, dusk, like fires outburned, / And to the earth in hopeless languour turned, / As they for restful death and darkness yearned. / Forlorn, and faint, and fatefully foredone, / Satiated of all delight beneath the sun, / As sick of passion, as unfit for fun."[22] Thus, the caricatures in the popular press portrayed the female aesthete as lugubrious, morbid, listless, and often sirenlike and with a sense of terminal ennui akin to the mood of malady projected by contemporary images of goddesses, mythological personifications, and *femmes fatales*.

In painting, however, this aesthetic being was usually depicted rather innocuously and without the sarcastic editorial tone of *Punch*. Often such a female is shown as surrounded by the accoutrements of the Movement, for example, with some unstated but intense relationship with the peacock feathers, flowers, or blue-and-white china she has chosen to decorate her "cultured" environment. In this category are works such as Thomas Armstrong's 1876 *Woman with Lilies,* Valentine Prinsep's 1878 *Portrait of Leonora di Mantua*, or Frank Potter's *Girl Resting at A Piano* (Fig. 135) or any of his similar single-figure paintings of the 1880s. In all, the overriding aestheticism of the interior gives the works an oddly exotic tone. The wan female inhabitants seem to strike poses; here the young lady is too weary to do anything but lounge and withdraw into dreamy or pensive isolation. Some-

Fig. 135. Frank Potter. *Girl Resting at a Piano.* 1880s. Oil on canvas, 20¼ × 28⅛. The Tate Gallery.

times the presence of a beautiful object, like that of the iridescent peacock fan, seems to suggest an aesthetic allegory of sorts: that by being surrounded by things of exquisite beauty, one can be both enlightened and ennobled by art. Such paintings make the Victorian lady even more of a languid denizen of the drawing room than usual. The woman as a decorative object with fashionable apparel or accessories to complement avant-garde interiors was not a new idea, of course, but it was quite persistent in the image of the aesthete. In real life, the characteristic slouch, the oddly hued clothing, and the accoutrements also appeared. For example, the costume of aesthetic dress proponents was often rather eccentric in hue—peacock blues, amber yellows, and dull greens all comprising what one author complained was "a chromatic misery, the green and yellow melancholy which is supposed to distinguish the Aesthetic habit."²³ Photographs of Jane Morris by Rossetti and others showed her in such attire, her high-waisted flowing gowns intended both for comfort and to harmonize with aesthetic furnishings, screens, ornamentation, and Morris wallpaper.

A rather peculiar offshoot of the female aesthete was the artistic focus given to her daughter, both in the fine arts in and in Du Maurier's cartoons about the Cimabue Brown family. This is apparent even in an early example such as Thomas Armstrong's *The Test* (Fig. 136) of 1865, in which a mother, amid the exotic clutter of skin rugs, blue-and-white china, and peacock feathers, attempts to instruct her daughter. The fashionably clad mother is imperious and even remote as she holds a book aloft, while the little girl is crestfallen and has abandoned

her jumprope activities to be drilled by her parent on some subject. The situation seems oddly akin to that satirized in a modern ballad of 1882 by Josephine Ballard entitled *The Decorative Sisters*, a tale of how two ordinary, jolly young females are transformed into sallow, sickly, and chic adherents of the Aesthetic Movement. Instead of spending their time in normal and healthy pursuits, they prefer to contemplate lilies and sunflowers (hallmarks of the Movement), to strike slouching poses, and to practice their expressions of aesthetic "intensity." Perhaps this rejection of athletic activities is what the mother is, by her example or tutelage, encouraging her daughter to do here. At any rate, the Victorian girl later figured in many depictions of the aesthetic female, typically embedded in the same kind of decorative trappings. In Mary Gow's 1880 canvas *Fairy Tales,* for example, the solitary girl reads a Walter Crane storybook, and the underlying meaning may reiterate that of her older counterpart—namely, that even a child's life can be enhanced by exposure to exquisite things.

James McNeill Whistler also contributed to these canons and the representation of the female in this regard, for example in his early manifestation of aesthetic ideas in *Purple and Rose: Lange Lijzen of the Six Marks* (Fig. 137) of 1864. This work portends the concerns of the movement of which Whistler himself was a pioneer, and is moreover one among several canvases of the 1860s—the most famous being *The White Girl: Symphony in White No. 1* of 1862—depicting a solitary, hauntingly handsome young woman in a detached and moody world of her own. This painting is among Whistler's early orientalizing works, yet the subject is distinctly occidental in character, being above all a picture of art about art as well as a quintessentially Victorian representation of a finely clad lady in a cluttered domestic interior. The western model was the artist's mistress, Joanna Hiffernan, who is dressed in eastern garb and is shown decorating an "aesthetic object," a Chinese porcelain, with *"lange lijzen"* or attenuated female figures. The porcelain with the six marks or potter's seals, along with the rug and other oriental objects, were all part of Whistler's own collection of exotic paraphernalia and Japanese prints.²⁴

Thus, contemporary artists took a less radical and more mellow view of aestheticism, using it as a pretext for placing women in beautiful surroundings instead of shrilly criticizing their "idiotic mien" and dangerous languor as *Punch* and others did. Such creatures amid expensive and exotic objects

Fig. 136. Thomas Armstrong. *The Test*. 1865. Oil on canvas, 31 × 23. The Wadsworth Atheneum, Hartford. The Ella Gallup Sumner and Mary Catlin Sumner Collection. Photograph by Joseph Szaszfai.

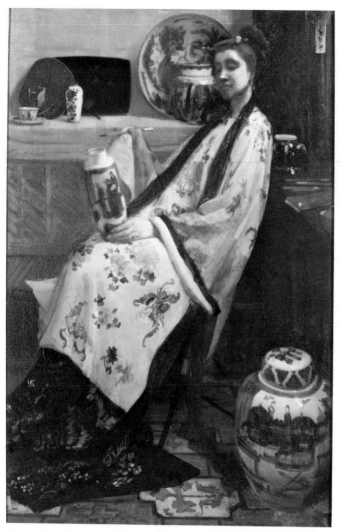

Fig. 137. James McNeill Whistler. *Purple and Rose, Lange Lijzen of the Six Marks*. 1863–64. Oil on canvas, 35 × 24½. The Philadelphia Museum of Art, John G. Johnson Collection.

ultimately constitute a statement about the position of the middle-class woman as both consumer and the one consumed by the enforced leisure dictated by her superior social standing. Yet while the insularity or hermetic quality of these settings is evident, the paintings were also often intended—especially in Whistler's case, to be appreciated as beautiful images created for their own sake, as the credo of *l'art pour l'art* demanded. Moreover, the melancholy and ennui of these figures allies them with several pictorial traditions, including that of Rossetti's own dream of beauty in his indolent and mesmerized *femmes fatales* of the 1860s and 1870s. The aesthetic female in her setting and attributes also bore some kinship to the hothouse "flowers of femininity" imprisoned in their lush gardens or parlor as well as to the alleged narcissism of the far more rebellious New Woman. An embodiment especially of aesthetic notions of feminine refinement, beauty, and fragility, the female aesthete in many ways personified the different, even superior, emotional and spiritual powers—and even the creative introspection or imagination—that women were often alleged to have. As a captive in the drawing room, the aesthetic female was a perfect candidate for the role of dreamer and vessel of intuition and decorative appeal, and she usually resided in an equally handsome or exotic interior. However, ultimately the Modern Woman, the athlete, and the aesthete all fell short of the popularity of less controversial types of femininity, foremost among them the Victorian lady herself.

11
Conclusion:
The End of the Century
and Conflicting Fantasies of
Femininity

I. SOME COMPETITION FROM FEMMES FATALES
AND GODDESSES

THERE WERE ULTIMATELY TWO DEVELOPMENTS THAT AP-preciably altered the basically placid course of the imagery of women toward the end of the nineteenth century. One was the social revolution affecting womanhood that had fermented since the 1850s and peaked in the 1890s, the undisputed heyday of the New Woman. In bloomers and on bicycles, this new creature arrived, exhibiting much of the "unwomanly" deportment—aggressiveness and athletic ability as well as an intellectual bent—that was deplored as unfit, offensive, and "fast" by writers like the reactionary Mrs. Linton:

> Of late we have changed the pattern, and have given the world a race of women as utterly unlike the old insular ideal as if we had created another nation altogether. . . . What the *demi-monde* does in its frantic efforts to excite attention, she also does in imitation. . . . Love in a cottage—that seductive dream which used to vex the heart . . . of the prudent mother—is now a myth of past ages. . . . But the Girl of the Period does not please men. . . . All men whose opinion is worth having prefer the simple and genuine girl of the past, with her tender little ways and pretty bashful modesties, to this loud and rampant modernization, with her

false red hair and painted skin, talking slang as glibly as a man, and by preference leading the conversation to doubtful subjects. . . .[1]

An upheaval in the conduct of the hitherto compliant and ultrarespectable middle-class lady was thus occurring in some quarters from the 1870s onward, for as the stepped out of her protective chrysalis she challenged (and in Linton's view perverted) the prevailing "natural" order of femininity.

The other development was in some respects a "counterdevelopment" that created a rather schizophrenic situation in society and in the art produced in the last twenty-five years of Victoria's reign. At the same time that middle-class codes of morality were generally being liberalized for women (in the realm of courtship, education, physical freedoms, etc.), there was also a strong reform crusade that battled in the 1870s and 1880s against public immorality. An outgrowth of Josephine Butler's efforts (and those of others) to repeal the Contagious Diseases Act, this feminist-inspired phenomenon urged not only female chastity, but also male purity. Thus, the daring New Woman, the sensuous female aesthete, and the decadent tendencies in general of either sex posed a threat to both middle-class ideologies and this new spirit of reform. As a result, in the 1880s in particular legislation was enacted that began to restructure sexual

policies that affected Victorian society—for example, the age of consent for females to marry was raised to age sixteen and new laws monitoring brothels and homosexuality were also debated. Given this situation, it is not surprising that a few different types of females prevailed in art, the foremost in popularity being Eliza Lynn Linton's retiring, "simple and genuine girl of the past." The frankly "safe" appeal of this creature was explained by the *Art-Journal* in 1895 in a discussion of Marcus Stone's penchant for this romantic and *retardataire* heroine:

> Nothing of nature's literalness is allowed to obtrude within the precincts of the enchanted garden wherein the beings he represents pass their quiet lives. . . . The artificiality of this ideal world is not apparent because the entire creation is a consistent one. It is generally acceptable because it recalls to so many people the rare moments when they have found themselves untroubled by cares, when the world has veiled the hard outlines of modern life. . . . Their lovers' quarrels and reconciliations, their partings and welcomes, and all the other small events of their placid lives are presented with a gentle suggestion of properly ordered passion which recognizes the importance of obeying the laws of self-repression laid down by good society. . . . They behave not only as they should, but also as every lover of good manners would have them behave.[2]

In opposition (although not necessarily so in real life) to this female was the more progressive, even avant-garde, woman who appeared especially in the pages of *Punch* as an intellectual, a sallow advocate of aestheticism, or a vigorous athlete.

In contrast to these types was another major factor that transformed the imagery of women during this period, namely, the appearance of the *femme fatale*—a daring Venus who seemed both to threaten and mesmerize the public imagination—from about the 1870s onward. Similarly, toward the end of the century a legendary, colossal, and sometimes monstrous feminine counterpart joined the ranks and literally loomed large in art. Thus far this book has examined almost exclusively images of contemporary Victorian womanhood, studying both the fictionalized nature of this iconology and relevant analogies in courtship or other circumstances to real life. But the "angel in the house" faced competition from goddesses or enigmatic female personifications in the latter portion of Victoria's reign, and the results might be considered a collective artistic fantasy of feminine mystery, power, and lethargy. While an entire book might be devoted just to exploring these visual fantasies, here only the major strands that expand and relate to the imagery of the preceding chapters will be invoked. For in these final pages a juxtaposition of some of the most common fantasies with more "realistic/sentimental" images of womanhood perhaps offers the truest index of the Victorian culture's underlying attitudes toward females. Freudian psychoanalysis had not yet liberated human psychology, but examination of certain persistent icons during this period proves to be a very revealing retrospective probe of the psyche of this era.

The imagery of the wayward woman and the less reviled New Woman found a formidable competitor in the *femme fatale*, still another shadow side of Victorian femininity. The fascination in art with malevolent females and enchantresses was longstanding, of course, and in the nineteenth century had literary origins in works by Keats, Baudelaire, Gautier, and Swinburne. The evil woman of imaginary but colossal deeds of depravity (not of mere behavioral transgressions of society's rules) also interested some of the Pre-Raphaelites (mostly Rossetti), and on the continent decadent and Symbolist writers and artists were even more intrigued by her. Baudelaire's cruel and aloof female, one whom men approached with a mingling of fear, disgust, awe, and desire, materialized into a late-century creature who reveled in deceiving, enticing, and destroying males in literature or art. In real life, such individuals as Lily Langtry, Cora Pearl, and perhaps even Sarah Bernhardt at times fulfilled this role, but they were no match for the countless menacing, sometimes almost lurid, permutations of the *femme fatale* that riveted the attention of contemporary painters and authors.

In England the origins of this type are to be discovered primarily in the works of Rossetti, who was perhaps the most prolific purveyor of sirens awaiting men at balconies or in boudoirs. Rossetti rewove the strands of superficial *Keepsake* images of this sort into a haunting private icon of alluring womanhood, and the theme of the enshrined or embowered female recurred in his poetry, as in an 1860 poem entitled "The Song of the Bower."[4] The visual corollary to this notion found expression in numerous canvases of the 1860s, the first appearance of this new temptress in his *oeuvre* occurring with *Bocca Baciata* (Fig. 138) of 1859 (of which this is an 1868 replica). The original was branded coarse and sensual, and on the back lines in Italian from a sonnet by Boccaccio were, in translation,

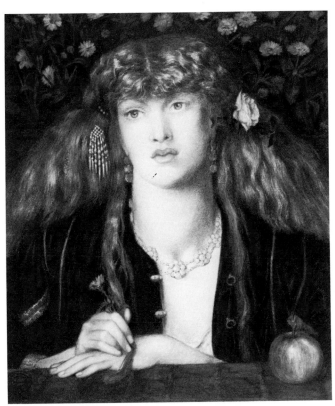

Fig. 138. Dante Gabriel Rossetti. *La Bionda del Balcone.* 1868 (replica of *Bocca Baciata*). Watercolor on board, 17¾ × 14⅞. The Memorial Art Gallery of the University of Rochester, Marion Stratton Gould Fund.

"The mouth that has been kissed loses not its freshness, but renews itself even as does the moon."[5] Fanny Cornforth of *Found* modeled for the 1859 version, but here, as he often did, the artist seems to have conflated the facial and physical characteristics of several women he knew. The dreamy figure is posed against a backdrop of marigolds, which may symbolize cruelty or despair. Furthermore, her paradoxical combination of innocence and temptation is alluded to in the pure white rose in her hair with the snakelike decorations on her sleeve and the apple (suggesting Eve's sin) on the ledge. Like later examples, this precursor of the *femme fatale* gazes inscrutably at an unseen lover from a richly patterned background niche. *Bocca Baciata* also established the basic format of subsequent pictures, placing a voluptuous, mesmerizing female with her symbolic accessories against an elaborate background, one which seems to press against the picture plane and thus heighten the lady's erotic appeal to her suitor and the spectator as well.

Another work in this category is Rossetti's *Regina Cordium* (Fig. 139) of 1866, a rephrasing of the closeup, phlegmatically sexy woman holding a floral attribute and dreamily staring out at the viewer. Like *Bocca Baciata,* she is separated from the audience by a low barrier and occupies a rather narrow space with flowers (the full-blown roses and other blossoms signifying her sensuality) and other props that presses her uncomfortably between a suffocating backdrop and a formidable frontal obstacle. The duality of this female—her powerlessness because she is restrained and yet her omnipotent control of men through love and libido—is an important undercurrent in Rossetti's poetry as well. In these selected examples by this artist and myriad others, one quintessential type emerges from the different personalities and personifications: a larger than life, full-lipped, and voluptuous woman (typically with magnificent tresses), who is both indolent and withdrawn in private reverie (yet in a way quite distinct from that of the innocuous aesthetic female). Rossetti's females are rarely openly "come-hither" in their behavior but nonetheless communicate, with their mystical silence, half-closed eyes, sensuous mouths, and mesmerized stares, a sense of magnetism, expectancy (more charged than that found in innocent courtship images), and even potential danger. However, this alluring woman is ultimately unattainable, for the wall, bower, or toilette table that often literally holds her back reinforces the strange paradox of her being both sexy and yet soulful, desirable, and inaccessible. These women are being held back from perhaps unleashing a fearful sexuality, an implication more subtly conveyed in Brown's *The Stages of Cruelty,* which uses a more classic version of the courting barrier. Yet Rossetti's women ultimately seem to qualify more as tantalizing cult objects and as devotional icons than as courtship images or anything else, fusing the enchantress simultaneously into a very private metaphor for the artist (who know and loved many of the women he painted) and a public, recognizable fantasy of feminine sexuality.

Rossetti also painted a string of destructive women like Lucrezia Borgia, La Belle Dame sans Merci, and Astarte Syriaca, and his obsession with such types influenced the images of his friend Frederick Sandys, for example, in his ca. 1875 drawing *Medusa* (Fig. 140). As abundant tresses were synonymous with the beguiling and damnation of innocent men, and, in religious belief at least, the serpent was the cause of woman's fall from grace, it follows that a hybrid imagery of demonic woman and snake developed in literature and art. Turning from the classical fatal lady to the

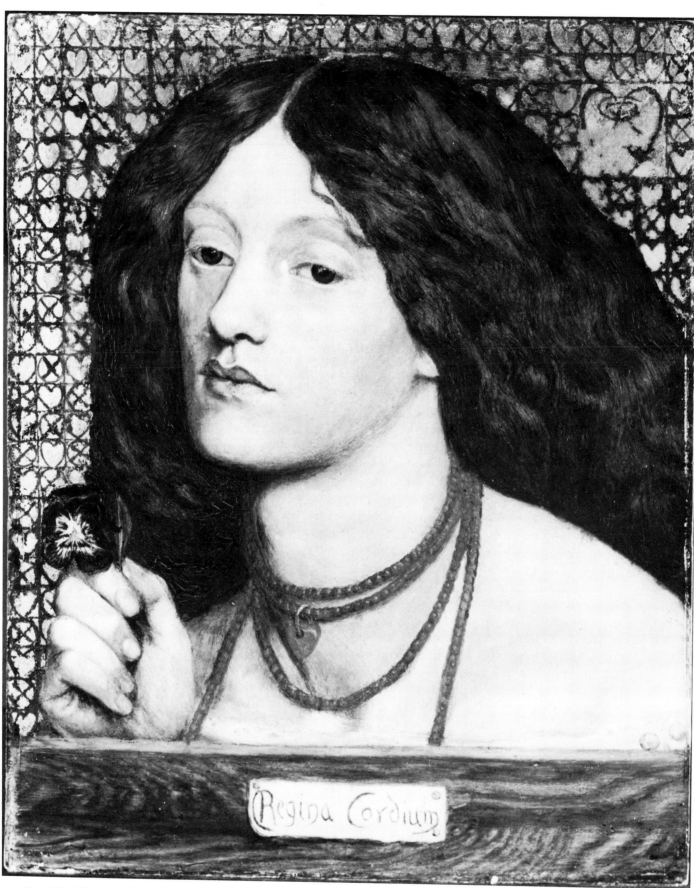

Fig. 139. Dante Gabriel Rossetti. *Regina Cordium*. 1860. Oil and gold on panel, 10 × 8. Johannesburg Art Gallery.

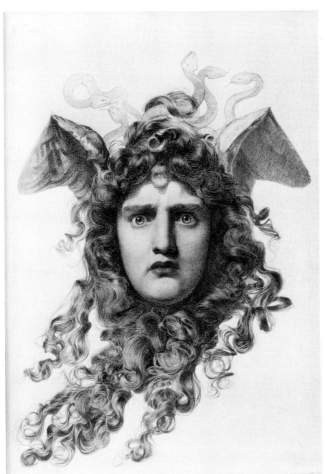

Fig. 140. Frederick Sandys. *Medusa*. Ca. 1875. Chalk, 28⅝ × 21½. By courtesy of the Board of Trustees of the Victoria and Albert Museum.

real-life vamp, Algernon Swinburne, in a poem appended to an 1865 drawing of Jane Burden Morris by Rossetti, drew a parallel between the wavy-haired wife of his colleague and a serpent: "O lip coiled to strike like a cobra/ O consummate tangle of hair/ Is this love or some destiny sob'rer/ Is thy temple thy tomb or thy lair?"[6] That the Medusa theme provided the perfect opportunity to dramatize this fatal mix of womanly beauty, coiling ringlets, and awesome female power is evident from the numbers of artists and writers who took up this subject. Yet like his Victorian brethren Burne-Jones and G. F. Watts (and like the Belgian Ferdinand Knopf, who admired Pre-Raphaelite art), Sandys chose to represent not the horrifying, petrifying Medusa, but one whom he found terrifyingly beautiful. The long curls and wings of the Medusa surround her like an aureole, making her an angelic stunner akin to Rossetti's enshrined creatures. Juxtaposed with these qualities are her red, wildly staring eyes and the snakes ribboning through her ringlets, thereby revealing her satanic side as a *femme fatale*.

Fig. 141. Edward Burne-Jones. *Laus Veneris*. 1873–75, not finished until 1878. Oil on canvas, 48 × 72. Tyne and Wear County Council Museums, Laing Art Gallery.

Burne-Jones also preferred to treat the legendary rather than the contemporary female, extending Rossetti's mood of fatal indolence into the realm of the mythological in a work such as *Laus Veneris* (Fig. 141), finished in 1878. One critic deemed the subject of Venus with her attendants to be oppressively morbid, describing the central figure as "stricken with a disease of the soul . . . eaten up and gnawed away with disappointment and desire."[7] Similarly, the novelist Henry James in a review of this picture concluded that Venus possessed "the aspect of a person who has what the French call an 'intimate acquaintance' with life" and that she and her languid, rather vacant-looking companions were all disarminly "pale, sickly, and wan."[8] Such a reaction not only allies Burne-Jones's creatures with prostitutes and wanton females; it also conjures up the sort of criticism that had been leveled against the female aesthete for her cult of wanness and ennui. The theme itself was derived both from the medieval legend of Tannhäuser and from contemporary fascination with the subject in works by Swinburne, William Morris, and Richard Wagner. Swinburne's poem entitled "Laus Veneris" (published in 1866) in fact describes in smoldering detail the goddess's deep and dangerous sleep as well as how her beautiful mouth and hair could sear a lover's flesh. Suspended in a state of exquisite languor, she inflicts both pleasure and pain on her admirers and seems nearly consumed by her own sexual passions: "Her gateways smoke with fume of flowers and fires,/ With loves burnt out and unassuaged desires."[9] Burne-Jones knew Swinburne well and may have intentionally alluded to his friend's earlier interpretation of this subject. Certainly the artist reiterates here the theme of seduction and places the recumbent

Fig. 142. Aubrey Beardsley. *A Christmas Card*. Ca. 1896. Pen and ink over pencil, 9⅝ × 6⅛. The Yale Center for British Art.

Venus in a densely packed Rossettian niche, Swinburne's "Horsel" or claustrophobic chamber of love. In the background is a tapestry with Cupid present and a scene depicting knights about to be snared as amorous victims by waiting sirens. The viewer too functions somewhat as an intended victim and voyeur, but *Laus Veneris* projects torpid seduction and not innocent courtship.

Enchantresses and sorceresses were among the inversions of femininity which appeared in the art of the last quarter of the century, and the evil idol of perversion was commonly found, for example, in the work of continental artists like Jan Delville, Edvard Munch, Felicien Rops, and Gustave Moreau. In England this perverse feminine transformation surfaced in the sometimes pornographic and often bizarre drawings of Aubrey Beardsley. His ca. 1896 drawing for *A Christmas Card* (Fig. 142), for example, an illustration for the *Savoy* magazine, qualifies—in spite of its title—as a sinister variation

of the traditionally beatific and benign Christian image. The "Virgin" and child wear more or less modern clothing, the Virgin being more of a "darkling Venus" than a revered saint. The writhing fur trim on her robe, like the serpentine curls and spiky "thorns" that mimic an aureole, all mark her as alien and apart from typical Mary figures. The blending of the traits of the Madonna with those of the *femme fatale* recalls Walter Pater's famous comment about the Mona Lisa as a woman who embodied both religious and irreligious qualities simultaneously. Furthermore, there are plucked flowers on her gown signifying defloration, a detail reminiscent of that on the garb of the fallen woman in Rossetti's painting *Found*. Traditionally, the *hortus conclusus* in art was also known as the "Mary Garden" because of the purity of its inhabitant, but here the atmosphere reverses that notion and is literally black in this dark garden of evil. The somewhat malevolent expression of the figure even recalls that of Madox Brown's mistress in *Take Your*

Fig. 143. Aubrey Beardsley. *The Climax*. 1894. Line block, 6 × 8¼. Plate X from *Salome—A Tragedy in One Act; Translated from the French of Oscar Wilde: Pictured by Aubrey Beardsley*, 1894.

Son, Sir!, which also deliberately recast the madonna-and-child subject in a rather startling way.

While images of women as hybrid monsters or vampires are rare in Victorian art, the bestial cruelty of the *femme fatale* was a frequent theme, especially in numerous designs by Beardsley (who was himself notoriously odd in matters relating to sex). The occupants of his boudoirs were often mysterious and dangerous, and it was not only his brilliant used of line and black-and-white graphics that shocked audiences. Equally fascinating was his creation of figures that were simultaneously heterosexual and androgynous, promiscuous and celibate, alluring and repulsive, malignant and innocent. Among his most famous images is *The Climax* (Fig. 143), which originally appeared as an independent drawing in 1893 and was among the illustrations for Oscar Wilde's play *Salomé*. The "sinful" subject, expressed in crisp and sinuous line, perfectly embodied the *art nouveau* style. It also typified the *fin de siècle* obsession with the voracious *femme fatale* who tortured men. Here Salome floats in an almost orgasmic encounter with Ioakanaan, the title of the drawing a sexual allusion to this moment. Salome is portrayed as rather triumphantly caressing the severed and bleeding head of John the Baptist, holding it aloft like some sort of trophy, her heartlessness a quantum leap from the demure conduct of courtship pictures. As in *A Christmas Card* and Sandys's *Medusa*, the woman's hair is snakelike, making her part animal and carnal in her lust for her victim.

This necessary digression has revealed some of the strands of imagery that competed with more conventional subjects of femininity. Rossetti's haunting paeans to embowered womanhood had forged the old formulas of female charm into a new and more blatant context of paradoxical soulfulness and sexiness, while other artists like Sandys and Beardsley chose to depict far more malevolent embodiments. But there was another pictorial rival to contend with, a category of enigmatic female personifications endowed with a deliberate sense of abstraction and removal from everyday life. Frederic Leighton, George F. Watts, Lawrence Alma-Tadema, and Albert Moore all arrived at their own resolutions of this subject, in general creating remote, monolithic, often rather frigid feminine types that represent universal concepts or mythological legend. There is rarely any evil lurking in the works of these artists—nor are their female protagonists necessarily mortal (although many appear to be Victorian ladies in costumes, particularly in the case of Alma-Tadema). Instead they seem to live in a static world of beauty where passion, rage, and sensuality do not enter, as is the case in Leighton's *The Garden of the Hesperides* (Fig. 144) of 1892. This is one of the artist's most perfect statements about the immortality of beauty and the role of females as decorative embodiments in an ideal world of aesthetic transformations. The ancient legend here concerns the island of the Hesperides, where the daughters of Hesperus preside; their song enchants the serpent guarding the tree with the golden apples (and later Hercules undertakes to steal these fruits as one of his labors). As a modern critic has pointed out, this picture "depicts a golden age which we know to be doomed, a garden of Eden forever closed. The myth has profound symbolic implications, and Leighton's painting is an attempt to express this deeper meaning through the forms themselves. The nearest parallel can be found in music, and the picture is an equivalent to the song which the Hesperides are singing, a song of sleep and suspended existence."[10] The symbolism of slumber and of enclosure is created by the repetition of curving forms, from the shape of the canvas itself to the coiled dragon/snake, the maidens encircling the tree, and the movement of the figures' drapery. Even the lush vegetation of the apples echoes this shape, and the balance of forms is nearly perfect in this paradise. Furthermore, the erotic appeal of the three females in their semidiaphanous, variegated robes was apparent even to the late Victorian critic, and the *Art-Journal* described the women sleeping in half-shadow "while down the tree creeps the great guardian python, amorously enlacing in its huge folds the nymph who occupies the centre of the group."[11] This is no bourgeois garden setting, but one that belongs to the gods and to legend, and the conduct of the mesmerized occupants need not comply with the dictates of reality.

The somnolent state in this 1892 painting was repeated in other late-century canvases by Leighton and his colleagues and resulted in a pictorial preoccupation with the hypnotic and sensuous appeal of female dreamers. This erotic and languid suspension of time recurs in *Flaming June* (Fig. 145) of 1895, in which the sleeping figure coils upon a bench of white marble in a pose reminiscent of an antique frieze. The sumptuous figure of the sleeper transcends her semiconscious state and becomes an emblem of indolence and sensuality, an effect aided by the rich saffron and fervid coloration that dominate "with a splendour which is al-

Fig. 144. Frederic Leighton. *The Garden of the Hesperides*. Ca. 1892. Oil on canvas, 66 diameter. Merseyside County Council, Lady Lever Art Gallery.

most imperial,"[12] as the *Art-Journal* remarked. The saturating silence and heat of a summer noon are evoked both by the use of color and by the self-absorption of the woman's circular, curling pose. The cheeks of this beautifully passive creature (who in spite of her exalted title has a decidedly contemporary air about her) have been aptly described by an Edwardian critic as "flushed with the impulse of

youthful love. Her bosom is pulsating; her arms and feet are bathed in gracious sensibility."[13] She too is an inhabitant of a charmed environment, a mythological garden or bower of bliss rather than a middle-class domestic setting. Her drowsy demeanor and rather limp pose also align her with the period's real-life female aesthetes, although Leighton's creation is a monumental goddess and

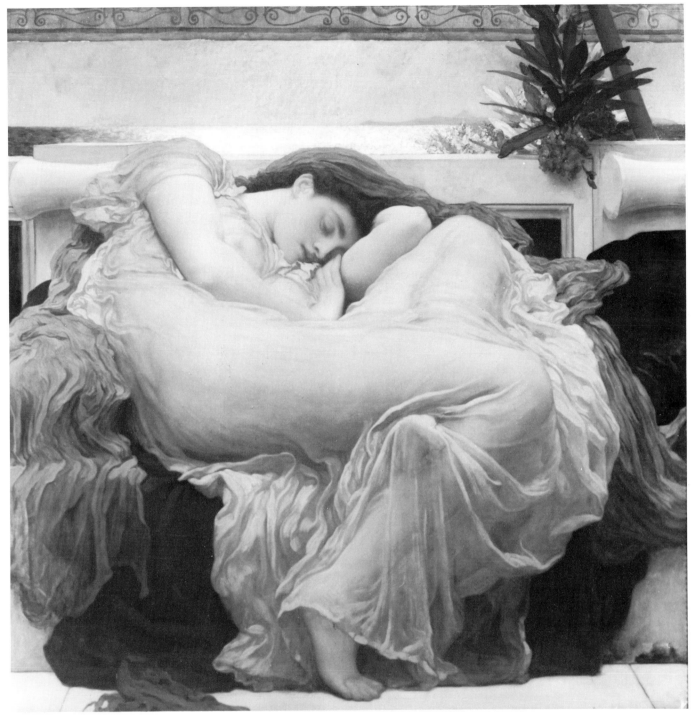

Fig. 145. Frederic Leighton. *Flaming June*. Ca. 1895. Oil on canvas, 47½ × 47½. Museo de Arte de Ponce, Puerto Rico, The Luis A. Ferre Foundation.

not a self-conscious follower of fads.

While the New Woman in real life and art was perceived as amazonian in many ways, her counterpart in late-century art was equally statuesque or imposing but eminently more classicizing. Often she reigns in an immobile world of myth and represents some ponderous literary, historical, or aesthetic idea. Two examples suggest this aggrandizing effect, one being Leighton's nearly

life-size *Lachrymae* (Fig. 146) of ca. 1895. The Latin title transforms the popular Victorian saga of a female grieving over lost love into a neoclassical tableau. A stately Hellenic maiden stands in an attitude of dignity and sorrow near a funereal urn that stands atop a Greek pillar. This lachrymose maiden is surrounded by floral symbolism: a fallen laurel wreath evokes the past glories of the deceased, the cypress trees in the background con-

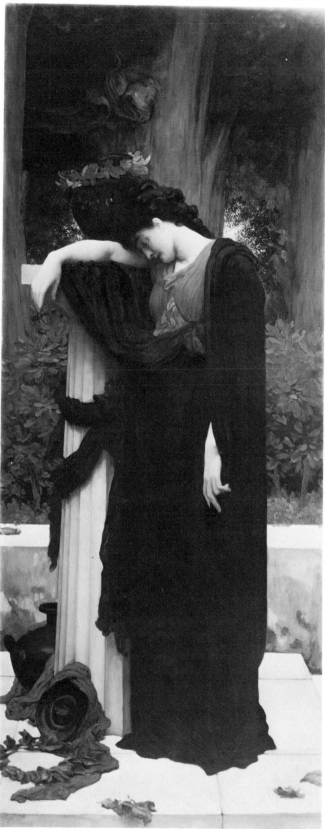

Fig. 146. Frederic Leighton. *Lachrymae*. Ca. 1895. Oil on canvas, 62 × 24¾. The Metropolitan Museum of Art.

note death, and the garland of ivy adorning the urn evokes the fidelity of the pair. As the *Athenaeum* reviewer commented when the painting was exhibited in 1895, the "sad blues and black pervade the design, and the softening shadows of the vault seem about to close upon the almost statuesque figure of the mourner."[14] Amid the gloomy foliage behind her is a glimpse of ashen clouds of sunset, every motif and even the coloration serving to complement the lugubrious mood. While narrative details like the floral imagery evoke paintings as diverse as *A Huguenot* and *The Vale of Rest*, the work is quite different in its effect. And while the columnar posture of the solitary female may remind a viewer of a domestic counterpart in Hick's *Woman's Mission*, this late-century creature is light years apart from such anecdotal interpretations.

Even more so with Albert Moore, the aesthetic and decorative qualities of the figure and the entire composition are paramount, not narrative incident, as in the majority of genre paintings. Moore's immobile, classicizing world of myth complements Leighton's in some ways, but Moore was concerned with other pictorial issues. For him the repetition of motif, whether of the female form or not, was merely a vehicle for his stylistic aims. In pictures like *Beads* (Fig. 147) of 1875, for example, there is a sense of the entire composition being ultimately subjectless, suspended in an arcadian timelessness. The *Athenaeum* reviewer perceived these qualities when the work was exhibited in 1876 and accordingly wrote, "'Beads' is one of those little things which, like those epigrams, or '—jewels, five words long / That on the stretched forefinger of all time sparkle for ever, '—keep their place in our memory, and we remember a string, so to say, of these 'beads,' each more exquisitely beautiful than its forerunner, and though specimens of the same gems, very different from each other, and varied greatly in tint, lustre, and water."[15] In addition to their beauty, these females embedded in a bas-relief of delicate color harmonies—like their counterparts by Rossetti and like *Flaming June*—convey a torpor and languor which project far more sensuality than mere middle-class idleness in a parlor or boudoir. For example, the females in Augustus Egg's *The Travelling Companions* (Fig. 18) are slightly eroticized but nonetheless basically prim, introspective paragons of middle-class femininity. However, Moore's restatement of this theme in *Beads* (and his similar compositional device of creating a private chamber of slumber into which spectators peer) is very different and as much a product of the

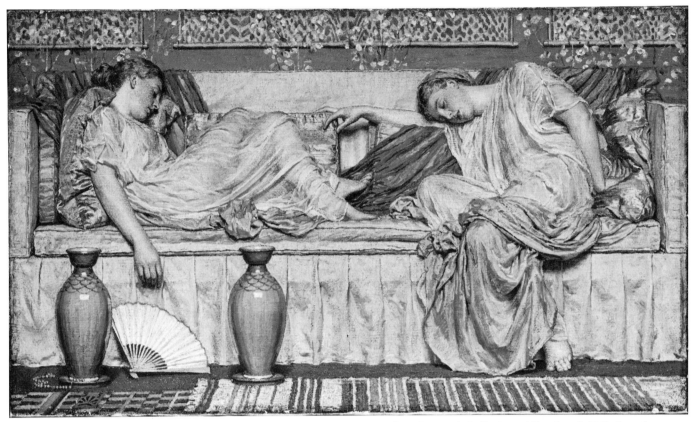

Fig. 147. Albert Moore. *Beads*. 1875. Oil on canvas, 11¼ × 19¾. National Galleries of Scotland, Edinburgh.

late Victorian era as Egg's canvas was of the 1850s and 1860s. One of several variations on the same formal elements, *Beads* also restates in a new way the legacy of Rossetti's somnambulist goddesses enshrined in patterned and hermetic niches. The exquisite objects in *Beads*—the jewelry, fans, vases, and fabrics—all convey what Algernon Swinburne described as "the faultless and secure expression of an exclusive worship of things formally beautiful. . . . The melody of colour, the symphony of form is complete: one more beautiful thing is achieved, one more delight is born into the world; and its meaning is beauty, and its reason for being is to be."[16]

II. ON "A DREAM OF FAIR WOMEN"

The title of Tennyson's celebrated poem "A Dream of Fair Women" serves in these concluding remarks as one way of briefly recapitulating what has been suggested in the previous chapters. In general, the conventional middle-class lady was the undisputed angel of the drawing room, and images abound of her as a helpmate, a paragon of submissiveness, and a spiritualized heroine. The

home, revered by Ruskin as a "place of Peace," served both as a lady's sanctuary and her prison, and her daughters too were sequestered and incarcerated within this *hortus conclusus* of feminine virtue and influence. While representations on canvas of her leisure pursuits, accomplishments, fashions, idleness, and social preoccupations often seemed to monopolize artistic interest, it was as the model of contemporary domesticity that she garnered real attention. This goddess of the hearth presided over a wide spectrum of feminine victims, ranging from the impoverished laborer, to the genteel governess, to the "soiled dove." Her young female offspring emulated her actions and also frequently appeared as redemptive figures in art, symbols of delicate purity tinged, however, with latent sexuality as well.

Saccharine vignettes of charitable female activity extended the feminine moralizing and uplifting province of the home, although genuine religious commitment in the form of entering a sisterhood was usually portrayed as an abnormality (interestingly, the celibate spinster was often also hostilely criticized or caricatured). Once again, however, the inner sanctum of the woman, in this case of a postulant or nun, sheltered her uncorrupt

nature, yet it was also replete with repressed sexual meanings. The comely young novice, like her secular counterpart in the parlor, was enshrined by artists in an enclosed garden that made her both chaste and inaccessible, a beguiling combination.

The Royal Academy was inundated with portrayals of middle-class courtship from the 1850s onward, and these depictions often reveal a great deal especially about the female partners in love. The shibboleth of Victorian courtesy books was basically a "look, but do not touch" approach, and such prescriptive advice found a visual corollary in the "courting wall" motif in myriad pictures. This barrier typically thwarted lovers in a broad range of amorous situations, thus serving as a surrogate chaperon as well as guaranteeing mutual restraint and, above all, vouchsafing female virginity. In countless images each partner is thus depicted as exhibiting the proper social behavior, with the male making timid overtures and the woman passively and even defensively accepting them from her side of a symbolic architectural impediment. In other romantic circumstances, a woman remained vacantly unexpressive, except in the case when more than one suitor vied for her affections: in this rare instance her face reveals a trace of triumphant pride and even insouciance. Far more numerous were the tableaux of dejected and drooping women who had been misled or doomed in romance by faithless swains. But while courtship in bourgeois, rural, classicizing, fancy dress, and other contexts persisted, images of married life (especially any criticism of the status quo) were much less common, perhaps because marriage was an anticlimax to the pictorial titillations of frustrated expectancy and sexual yearning in trysts and amorous tribulations.

In the realm of the working woman, the sempstress and the governess were viewed as objects of sympathy and also victims of unjust conditions, but their picturesque appeal centered on their lost beauty or stature, not on the real social causes of their misery. Redgrave was a particular innovator in this category, and his depictions of the oppressed teacher and needlewoman popularized the format of a suffering single figure in abject penury. Other sorts of laboring women—from the factories, to the fields, to the stage—proved less appealing subjects, but even images of them are generally colored in rosy tones.

The "martyred" female worker was complemented by the image of elderly helplessness, with various stereotypes of the aged mitigated only by the depiction of the widow as preferably youthful, comely, and vulnerable. The final female casualty was the prostitute, a fallen angel or Ruskin's "feeble floret," who was a shadow on the edge of decorous society that nonetheless was the focus of considerable pictorial attention. The city was the preordained location selected by Victorian artists for the loss of innocence, and images of solitary and pitiable harlots outnumbered those of reconciliation with the prodigal daughter. As with the governess and the sempstress, the attitude toward this destitute creature was mostly one of compassion, although the male artists who invariably produced such representations also seemed to inject a subsconscious note of the outcast's covert sexual appeal in spite of her ruin and desolation.

Another unconventional or deviant female in English society was the New Woman, whose appearance was infrequent in paintings, though less so in the pages of *Punch*. As with the athletic woman of the 1890s who often shared this epithet, the New Woman proved a virtual nonentity in paintings, perhaps since her mild-mannered "sister" of the parlor seemed to be vastly preferred by the majority of viewers, both male and female. This phenomenal and strident iconoclast was also seen as responsible for her own life and future (whether that proved happy or not), for she had willfully endorsed the new "modern" creeds and was thus not a fragile victim like the "dark angel" of the prostitute.

Contradictions abound in the degree of reality ultimately projected by the examples in this book, for while some works appear to be historical documents in part (like *The Last of England*), others merely treat topical subjects, dispense a stylistically literal but rather frivolous anecdotalism, or penetrate to a more profound level. In still other instances, the final effect is primarily one of totemic significance, as with the garden and courting wall motifs and their accumulations of multivalent meaning through repetition. In addition, there were clearcut male fantasies, whether of airy sprites, allegorical amazons, monstrously heartless *femmes fatales*, or cool goddesses. From this heterogeneity a cohesive cultural mythology about femininity seems to crystallize, invariably overblown, but fascinating nonetheless. It is a fallacy, of course, to scrutinize Victorian paintings and novels as the only commentaries on historical or social realities, since in doing so the actual women of the period are overlooked. Whether Florence Nightingale, a pioneering social reformer, one of the first

sisters of charity, a college graduate, or an ordinary lady or laborer, the Victorian female was often lost or embedded in a superstructure of categories and prejudices, telescoped and often trivialized into restrictive sentimental stereotypes.

Yet perhaps there are some latent interconnections between the high-minded housewife in Hicks's painting *Woman's Mission* and Leighton's somnolent personification *Flaming June,* for each corresponds to a different decade's notion of female sexuality and each is an image created for middle-class consumption. The virginity, respectability, and productivity of Hick's lady can be understood as a "code" for her virtue, and in this respect she might be construed as a symbolic statement of English stability and national pride at mid-century. On the other hand, the idleness of Leighton's sleeper has connotations of vice and licentiousness. This indolent creature is a by-product of Aestheticism, the New Woman, and a fomenting sexual revolution, yet she oddly slumbers through all this. Her very pose suggests both fecundity and a contorted self-absorption; like some Tennysonian "high-born maiden" anticipating a romantic encounter, she inhabits an inviolable world (perhaps a garden of pleasure instead of a garden of purity) that is far removed from reality. The great English depression and stagnation of economy of the 1890s exerted some paralyzing effects on public morale and faith in the Empire, and perhaps this goddess is in this respect an emblem of the national "state of health," or more aptly, one of listlessness.

In the final analysis, the heroicizing late-century goddesses, like the cozy nests of bourgeois harmony and the forlorn social martyrs and laborers, all sustained an invented myth or fantasy of aesthetic artifice. The fictional image of woman seemed to eclipse her real-life character, and many Victorian pictures thus seem to modern eyes to be "underpainted" with varying degrees of nostalgia, escapism, and wishful thinking. Nevertheless, these divergent approaches cumulatively tended to manufacture an eroticism out of feminine chastity, casting females into one extreme of sexuality or another without a more balanced viewpoint. The middle-class lady was thus often the literal substance of mainstream Victorian art, with the shadow or spectral side of womanhood personified by the aberrant female, the New Woman, and the *femme fatale;* yet suspended somewhere between these poles was a dimension of femininity that remained largely untouched by either dialectic. Whether or not these sterotypes remain unavoidable and eradicable is a question for twentieth-century viewers to resolve, in their attitudes toward art and to society in general.

Notes

CHAPTER 1. HER MAJESTY THE QUEEN

1. In 1918 the vote was given to married women for local government elections, and parliamentary vote accorded to females over the age of thirty who were landowners and registered with local electoral authorities; women were also granted the right to be candidates. The 1928 act granted full suffrage to women at the age of twenty-one.

2. Peter Gay, *The Bourgeois Experience: Victoria to Freud. Vol. 1. Education of the Senses* (New York: Oxford University Press, 1984), 4.

3. Vineta Colby, *Yesterday's Women: Domestic Realism in the English Novel* (Princeton: Princeton University Press, 1974), 5.

4. Richard Ormond, *Early Victorian Portraits*, 1 (London: Her Majesty's Stationery Office, 1973), 478. This source is invaluable in listing the known portraits and sculptures of Victoria and their locations.

5. For additional examples on this subject, see Christopher Wood, *Victorian Panorama: Paintings of Victorian Life* (London: Faber & Faber Ltd., 1976), 19–27.

6. Elizabeth Longford, *Victoria R.I.* (New York: Harper & Row, 1973), 80.

7. Ibid.

8. This interpretation is noted as well in Richard Ormond, *Sir Edwin Landseer* (Philadelphia and London: Philadelphia Museum of Art, 1981), 151–52.

9. Dorothy Marshall, *The Life and Times of Victoria* (London: Weidenfeld & Nicolson, 1972), 50.

10. As quoted in Herbert Tingsten, *Victoria and the Victorians* (London: George Allen & Unwin Ltd., 1972), 106.

11. Marshall, *The Life and Times of Victoria*, 7.

12. David Duff, *Albert & Victoria* (London: Frederick Muller Ltd., 1972), 223–24.

CHAPTER 2. THE RIGHTS AND DUTIES OF ENGLISHWOMEN

1. The most authoritative discussions of women's changing legal rights in Great Britain are to be found in Erna Reiss, *Rights and Duties of Englishwomen, A Study in Law and Public Opinion* (Manchester: Sherratt & Hughes, 1934) and Lee Holcombe, *Wives and Property: The Reform of the Married Women's Property Law in Nineteenth-Century England* (Toronto: University of Toronto Press, 1983).

2. Barbara Leigh Smith Bodichon, "Married Women and the Law," as quoted in Janet Murray, *Strong-Minded Women & Other Lost Voices from 19th Century England* (New York: Pantheon Books, 1982), 119–20.

3. Ibid., 120.

4. "The Royal Academy," *Art-Journal* 57 (1895): 166.

5. "Fine Arts: The Royal Academy," *Athenaeum* 68 (1 June 1895): 711.

6. As quoted in Andrea Rose, *The Pre-Raphaelites* (Oxford: Phaidon, 1981), 12.

7. The ballerina-pose idea is noted also in Ibid., 13.

8. The interrelations betwen Brown's personal life and this painting are examined in Arthur S. Marks, "Ford Madox Brown's 'Take Your Son, Sir!'", *Arts Magazine* 54 (January 1980): 135–41.

9. Jeffrey Weeks, *Sex, Politics, and Society. The Regulation of Sexuality since 1800* (London: Longman, 1981), 29–30.

10. Sarah Stickney Ellis, *The Daughters of England* (New York: D. Appleton, 1842), 73.

11. William Makepeace Thackeray, *Vanity Fair* (London: Hodder & Stoughton, 1908), 501.

12. John Stuart Mill, *The Subjection of Women* (London: Longmans, Green, Reader, & Dyer, 1869), 59.

CHAPTER 3. THE IDEAL OF VICTORIAN GIRLHOOD

1. On the education of females, see, for example, Joan N. Burstyn, *Victorian Education and the Ideal of Womanhood* (London: Croom Helm, 1980); Josephine Kamm, *Hope Deferred: Girls' Education in English History* (London: Methuen, 1965); and Carol Dyhouse, *Girls Growing Up in Late Victorian and Edwardian England* (London: Routledge & Kegan Paul, 1981).

2. Elizabeth Missing Sewell, *Principles of Education, Drawn from Nature and Revelation, and Applied to Female Education in the Upper Classes* (London: Longman, Brown, Green, & Longmans 1865), 396.

3. Sarah Tytler, "Girls," *Mother's Companion* 1 (1887): 14.

4. Oxford University gave women degrees in 1920. Cambridge awarded females titular degrees that year, but it was not

until 1948 that women there were awarded full academic degrees. On this subject, see Rita McWilliams-Tullberg, "Women and Degrees at Cambridge University 1862–1897," in Martha Vicinus, ed., *A Widening Sphere—Changing Roles of Victorian Women* (Bloomington and London: Indiana University Press, 1977), 117–45.

5. See catalogue entry on a related picture, *Holy Motherhood*, in Arts Council of Great Britain, *Great Victorian Pictures—Their Paths to Fame* (London: Arts Council, 1978), 40.

6. This and all other quotations for Royal Academy entries cited in this book are found in the multiple volumes of Algernon Graves, *The Royal Academy of Arts: A Complete Dictionary of Contributors and their Work from its Foundation in 1769 to 1904* (London: George Bell & Sons, 1906).

7. On this theme, see the interesting dichotomy of the girl as "sunbeam" or "hoyden" in Deborah Gorham, *The Victorian Girl and the Feminine Ideal* (London: Croom Helm, 1982), 37–58. Also see Gillian Avery, *Childhood's Pattern: A Study of Heroes and Heroines of Children's Fiction 1770–1950* (London: Hodder and Stoughton, 1976); M. Cadogan and P. Craig, *You're a Brick, Angela! A New Look at Girls' Fiction from 1840–1975* (London: Golancz, 1977); and Robert Pattison, *The Child Figure in English Literature* (Athens, Georgia: University of Georgia Press, 1978).

8. Contemporary adulation of the holy influence of sisters is noted, for example, in Sarah Stickney Ellis, *The Women of England, Their Social Duties and Domestic Habits* (Philadelphia: E. L. Carey and A. Hart, 1839), 78–80. An excellent modern analysis of this concept is Carroll Smith-Rosenberg, "The Female World of Love and Ritual: Relations Between Women in Nineteenth-Century America," *Signs, A Journal of Women in Culture and Society,* 1 (Autumn 1975): 1–30.

9. "The Royal Academy," *Art-Journal* 24 (1862): 133.

10. "Fine-Art Gossip," *Athenaeum* 35 (15 Feb. 1862): 232.

11. Ellis, *The Women of England,* 75.

12. More commentary on the cult of the little girl can be found in Ronald Pearsall, *The Worm in the Bud: The World of Victorian Sexuality* (London: Macmillan & Co., 1969), 289–305 and 350–63.

13. The implications of this innocent yet sexy slumber are explored, for example, in Adeline R. Tintner, "The Sleeping Woman: A Victorian Fantasy," *Pre-Raphaelite Review* 2 (November 1978): 12–26. See also Chapter 11 in this book on fantasies of feminity with goddesses and personifications, etc.

14. See, for example, David Duff, *PUNCH on Children: A Panorama 1845–1865* (London: Frederick Muller Ltd., 1975), especially 119–86 and 197–208.

15. On the realities of this high mortality rate for the young, see, for example, Margaret Hewitt, *Wives and Mothers in Victorian Industry* (London: Rockcliff, 1958), 141–67.

16. The orphan theme in literature is one of the subjects, for example, in John R. Reed, *Victorian Conventions* (Athens, Ohio: Ohio University Press, 1975), passim.

17. "The Royal Academy," *Spectator* 49 (27 May 1876): 682.

CHAPTER 4. "OF QUEENS' GARDENS" AND THE MODEL VICTORIAN LADY

1. John Ruskin, "Of Queens' Gardens," in E. T. Cook and Alexander Wedderburn, eds., *The Works of John Ruskin,* 18 (London: George Allen, 1903), 121–22. On this reverential attitude towards women, see especially Walter E. Houghton, *The Victorian Frame of Mind* (New Haven: Yale University Press, 1957), 341–53 on the cult of domesticity. See also Kate Millet, "The Debate Over Women—Ruskin vs. Mill," in Martha Vicinus, ed., *Suffer and Be Still: Women in the Victorian Age* (Bloomington: Indiana University Press, 1972), 121–39; J. A. and Olive Banks, *Feminism and Family Planning in Victorian*

England (New York: Schocken Books, 1964), 58–59; H. R. Hays, *The Dangerous Sex, The Myth of Feminine Evil* (New York: G. P. Putnam's Sons, 1964), 226–27; and Barbara Welter, *Dimity Convictions* (Athens, Ohio: Ohio University Press, 1976).

2. "The Royal Academy Exhibition," *Times* 27 May 1863, 6.

3. From a 23 June 1900 letter in the Hicks family, as quoted in Rosamond Allwood and Rosemary Treble, *George Elgar Hicks. Painter of Victorian Life* (London: The Geffrye Museum, 1983), 33.

4. "The Royal Academy," *Art-Journal* 25 (1 June 1863): 111.

5. Sarah Stickney Ellis, *The Women of England, Their Social Duties, and Domestic Habits* (Philadelphia: E. L. Carey and A. Hart, 1839), 32.

6. *Art-Journal* 25:111.

7. The "male-centered" and propagandistic aspects of this image are also discussed in Lynn Nead, "The Magdalen in Modern Times: The Mythology of the Fallen Woman in Pre-Raphaelite Painting," *Oxford Art Journal* 7 (1984): 28–29.

8. This point is also made in Allwood and Treble, *George Elgar Hicks,* 22.

9. William Acton, *Functions and Disorders of the Reproductive Organs* (London: Sutton & Co., Ltd., 1857), 102. Among recent studies on Victorian sexuality are Eric Trudgill, *Madonnas and Magdalens* (London, 1976); Stephen Marcus, *The Other Victorians: A Study of Sexuality and Pornography in Mid-Nineteenth Century England* (New York: Basic Books, Inc., 1966); Peter T. Cominos, "Late Victorian Sexual Respectability and the Social System," *International Review of Social History* 8 (1963), part 1, 18–48, and part 2, 216–50; Keith Thomas, "The Double Standard," *Journal of the History of Ideas* 20 (April 1959): 195–216; Peter T. Cominos, "Innocent Femina Sensualis in Unconscious Conflict," in *Suffer and Be Still,* 155–72; Peter Gay, *The Bourgeois Experience: Victoria to Freud. Vol. 1. Education of the Senses* (New York: Oxford University Press, 1984); and Jeffrey Weeks, *Sex, Politics and Society. The regulation of sexuality since 1800* (London: Longman, 1981). As Weeks and Gay have most recently pointed out, Acton's theories were contested by other physicians and Victorian writers, so that his pronouncements are not to be accepted at face value by readers.

10. William Powell Frith, *My Autobiography and Reminiscences* (London: R. Bentley, 1888), 31.

11. This term has become a common sentimental hyperbole and synonym for the Victorian lady and originated in Coventry Patmore, *The Angel in the House: The Betrothal* (London: J. W. Parker & Son, 1854).

12. Analysis of some of the literary images of women enclosed or entrapped is found in Jennifer Gribble, *The Lady of Shalott in the Victorian Novel* (London: Macmillan, 1983), passim.

13. "The Royal Academy," *Art-Journal* 24 (1862): 134.

14. "Fine Arts: The Royal Academy," *Athenaeum* 35 (3 May 1862): 602.

15. Ibid.

16. On the *hortus conclusus* and the doxology of the Virgin in Christian art, see, for example, Erwin Panofsky, *Early Netherlandish Painting* (Cambridge: Harvard University Press, 1958), 101 and 132, or Stanley Stewart, *The Enclosed Garden: The Tradition and the Image in 17th Century Poetry* (Madison: University of Wisconsin Press, 1966). This subject is also examined in chapter 2 of Susan P. Casteras, "Down The Garden Path: Courtship Culture and Its Imagery in Victorian Painting" (Ph.D. diss., Yale University, 1977).

17. Wilkie Collins, *Basil: A Story of Modern Life* (London: R. Bentley, 1890), 37.

18. 2 Nov. 1853 letter from W. M. Rossetti to F. M. Brown, as cited in Frances Deverell and W. M. Rossetti, "The P.R.B. and Walter Howell Deverell," Huntington Library manuscript, 128.

19. Ibid.

20. This information was obtained from the curatorial files

on *A Pet* in the Tate Gallery. Elizabeth Siddal has also been suggested as the model here, in Elaine Shefer, "Deverell, Rossetti, Siddal, and 'The Bird in the Cage,'" *Art Bulletin* 67 (September 1985): 437–48.

21. On this subject see especially Mary Frances Durantini, *The Child in Seventeenth-Century Dutch Painting* (Ann Arbor: UMI Research Press, 1980), 263–66. Other sources include E. de Jongh, "Erotica in Vogelperspectief: De dubbelzinnigheid van een reeks 17de eeuwse genrevorstelligen," *Simiolus*, 3 (1968–69): 73–74, and Lorenz Eitner, "Cages, Prisons, and Captives in Eighteenth-Century Art," in K. Kroeber and W. Walling, eds., *Images of Romanticism: Verbal and Visual Affinities* (New Haven and London: Yale University Press, 1978), 15–19.

22. Mary Wollstonecraft, *A Vindication of the Rights of Woman* (London: Macmillan, 1929), 62.

23. "The Royal Academy," *Art-Journal* 27 (1 June 1865): 166.

24. "Fine Arts: Royal Academy," *Athenaeum* 28 (29 April 1865): 593. This critic also said that the tableau was set in Baden, although Elmore's visit there had been in the 1840s.

25. "The Royal Academy," *Illustrated London News* (13 May 1865): 451.

26. A provocative exegesis of this painting is found in Lynda Nead, "Seduction, Prostitution, Suicide: *On the Brink* by Alfred Elmore," *Art History* 5 (September 1982): 310–22.

27. Marsh's novel and the 1857 legislation is discussed in T. J. Edelstein, "Augustus Egg's triptych: a narrative of Victorian Adultery," *Burlington Magazine* 125 (April 1983): 202–11.

28. "Fine Arts: Royal Academy," *Athenaeum* 31 (1 May 1858): 566.

29. T. J. Edelstein, "'But who shall paint the grief of those oppress'd'—The Social Theme in Victorian Painting" (Ph.D. diss., University of Pennsylvania, 1979), 207–8.

30. "The Royal Academy," *Art Journal* 20 (1858): 168.

31. *Athenaeum* 31 (1858): 566.

32. "The Royal Academy," *Art-Journal* 18 (1856): 166.

33. Although the gentleman on the davenport may be a wounded officer, an interesting alternative explanation of the figure (making him a satire of a smug officer) is found in Matthew Lalumia, "Realism and Anti-Aristocratic Sentiment in Victorian Depictions of the Crimean War" (Ph.D. diss., Yale University, 1981), 188–93.

34. George Eliot, *Amos Barton: Scenes of Clerical Life* (London: William Blackwood & Sons, 1858), 101.

35. "The Royal Academy Exhibition," *Spectator* 29 (17 May 1856): 535.

36. This much larger version, in a private collection in Wales, is briefly discussed, along with its alleged pendant, in Christopher Wood, *Victorian Panorama: Paintings of Victorian Life* (London: 1976), 27.

37. This information comes from a 3 July 1857 letter by the artist in the National Portrait Gallery, London, files.

38. "Fine Arts: The Royal Academy," *Athenaeum* 31 (29 May 1858): 693.

39. These other engravings of the print are discussed in Hilary Beck, *Victorian Engravings* (London: Victoria & Albert Museum, 1973), 61, and in Hilary Guise, *Great Victorian Engravings* (London, 1980), 9, 146–47.

40. From "A Lady's Diary of the Siege of Lucknow," as reprinted in *Littell's Living Age*, 2d series, 20 (Jan.–Mar. 1858): 252.

41. Ibid.

42. Ibid.

43. Such pejorative epithets as "redundant" or "superfluous" appeared in articles such as W. R. Greg, "Why are Women Redundant?" *Literary and Social Judgments* (Boston: J. R. Osgood & Co., 1868) and Jessie Boucherett, "How to Provide for Superfluous Women," in Josephine Butler, ed., *Woman's Work and Woman's Culture* (London: Macmillan & Co., 1869). The census report of 1851 revealed that there were about 8,155,000 females over the age of ten in comparison to about 7,600,000 males of comparable age. (see E. Royston Pike, *Human Documents of the Victorian Golden Age, 1850–1875* [London: George Allen & Unwin Ltd., 1967], 155–56.) On female emigration schemes, see A. James Hammerton, *Emigrant Gentlewomen: Genteel Poverty and Female Emigration, 1830–1914* (London: Croom Helm, 1979) and also the same author's "Feminism and Female Emigration, 1861–1886" in *A Widening Sphere*, 52–71.

44. Ford Madox Ford, *Ford Madox Brown: A Record of his Life and Work* (London: Longmans, Green & Co., 1896), 42.

45. Ibid., 91. Moreover, the artist wrote in 1865 about this noble wife that "The circle of her love moves with her," an idea carried out too by the shape of the canvas. See [Ford Madox Brown], *The Exhibition of Work and other paintings by Ford Madox Brown at the Gallery, 191 Piccadilly* (London, 1865), 8.

46. John Ruskin, "Of Queens' Gardens," 122–23.

47. See, for example, C. Willett Cunnington, *Feminine Attitudes in the Nineteenth Century* (New York: William Heinemann Ltd., 1936) or the same author's *English Women's Clothing in the Nineteenth Century* (London, 1937); Duncan Crow, *The Victorian Woman* (London: George Allen & Unwin Ltd., 1971), James Laver, *The Concise History of Costume and Fashion* (New York: H. N. Abrams, 1969); Herbert Norris and Oswald Curtis, *Costumes and Fashion, Volume 6: The Nineteenth Century* (London: J. M. Dent & Sons, 1933); Doreen Yarwood, *English Costume* (London: Batsford, 1952); and Stella Mary Newton, *Health, Art, and Reason: Dress Reformers of the Nineteenth Century* (London and New York, 1974).

48. "Art of Dress," *Quarterly Review* 79 (1847): 375–76.

49. Ibid.

50. For additional examples of women's magazines, see Walter E. Houghton, *The Wellesley Index to Victorian Periodicals, 1824–1900*, 3 vols. (Toronto: University of Toronto Press, 1966, 1973, 1979) and Margaret Barrow, *Women 1870–1928—A Selected Guide to Printed and Archival Sources in the United Kingdom* (London: Mansell Publications, 1981).

51. On this subject, see especially Norah Waugh, *Corsets and Crinolines* (London: B. T. Batsford, 1954): C. Willett and Phillis Cunnington, *The History of Underclothes* (London: Michael Joseph, 1951); Helene E. Roberts, "The Exquisite Slave: The Role of Clothes in the Making of the Victorian Woman," *Signs: Journal of Women in Culture and Society* 2 (Spring 1977): 554–69; David Kunzle, "Dress Reform as Antifeminism," *Signs: Journal of Women in Culture and Society* 2 (Spring, 1977), 570–79; and David Kunzle, "The Corset as Erotic Alchemy," in Thomas B. Hess and Linda Nochlin, eds., *Woman as Sex Object* (New York: Newsweek, 1972), 92–165.

52. "Royal Academy," *Critic* 3 (30 May 1846): 622–23.

53. Ibid.

54. "The Royal Academy," *Art-Union* 8 (June 1846): 177.

55. On the codification of these rituals, see, e.g., Barbara Rees, *The Victorian Lady* (New York: Gordon & Cremonisi, 1977), 122.

56. See, e.g., Sir Charles Petrie, *Scenes of Edwardian Life* (London: Eyre & Spottiswoode, 1965), 43.

57. An invaluable guide to these customs is Hilary and Mary Evans, *The Party that Lasted 100 Days—The Late Victorian Season: A Social Study* (London: Macdonald and Jane's, 1978).

58. "Fine Arts: The Royal Academy," *Athenaeum* 29 (17 May 1856): 621.

59. "The Royal Academy," *Art-Journal* 18 (1856): 172.

60. This interpretation of a romantic dream is made more plausible by the fact that the work forms a kind of pendant, intentionally or otherwise, to Solomon's other 1856 Royal Academy entry, *The Bride*, which virtually reverses the composition of *Doubtful Fortune* and includes similar-looking women.

61. The stipulations for being presented at court are out-

lined in Evans, *The Party that Lasted 100 Days*, 131–35.

62. "The Grosvenor Gallery Exhibition," *Athenaeum* 52 (10 May 1879): 607. The best source on Tissot's work is Michael Wentworth, *James Tissot* (Oxford, 1984).

CHAPTER 5. THE VICTORIAN "SISTER OF CHARITY"

1. Proper philanthropic activities for women are discussed in Harriet Warm Schupf, "Single Women and Social Reform in Mid-Nineteenth Century England: The Case of Mary Carpenter," *Victorian Studies* 17 (March 1974): 301–18 and Brian Harrison, "Philanthropy and the Victorians," *Victorian Studies* 9 (June 1966): 353–74.

2. Patricia Thomson, *The Victorian Heroine. A Changing Ideal 1837–1873* (London: Oxford University Press, 1956), 13.

3. "Exhibition of the British Artists Society," *Art-Journal* 14 (1852): 137.

4. Isabella Beeton, *The Book of Household Management* (London: S. O. Beeton, 1861), 5.

5. [J. H. Newman], "Letters on the Church of The Fathers," *British Magazine* 6 (June 1835): 667.

6. "Convent of the Belgravians," *Punch* 19 (1850): 163.

7. Ibid.

8. For additional details, see Susan P. Casteras, "Virgin Vows: the Early Victorian Artists' Portrayals of Nuns and Novices," *Victorian Studies* 24 (Winter 1981): 157–84.

9. "Selected Pictures," *Art-Journal* 29 (1867): 184.

10. This location is noted on a label on the back of the painting and cited in the Ashmolean files. Written by Collins's original purchaser of *Convent Thoughts*, Thomas Combe, the label also indicates that Collins worked diligently at portraying each flower individually, for Combe remarks that "I know that a flower of one of the lilies occupied a whole day. . . ." It is not clear what order the novice may belong to, but the color of her robes confirms her only being a postulant, since black or grey was generally worn only after final vows were taken.

11. For this painting and all subsequent interpretations in succeeding chapters of floral imagery, I have relied primarily on two sources: the *Etiquette of Flowers: Their Language and Sentiments* (London: Simpkin & Co., 1852) and Kate Greenaway, *Language of Flowers* (New York [reprint], 1972). There were scores of floral "lexicons" but most were repetitious and almost identical in content, typically anonymous, unpaged, and arranged alphabetically by flower. For the specifically Christian connotations of various blossoms, I tend to rely on George Ferguson, *Signs and Symbols in Christian Art* (New York: Oxford University Press, 1964).

12. 13 May 1851 letter from Ruskin to the *Times*, as cited in E. T. Cook and Alexander Wedderburn, eds., *The Works of John Ruskin*, 12 (London: George Allen, 1904), 320–21. After his May 13 comments, Ruskin apparently received a letter from Collins that caused him to change his interpretation of *Convent Thoughts* in a 30 May 1851 letter to the *Times*, as cited in Cook and Wedderburn, 12:327.

13. "Fine Arts: The Royal Academy," *Athenaeum* 32 (30 April 1859): 586.

14. This excerpt is cited in Owen Chadwick, *The Mind of the Oxford Movement* (Stanford: Stanford University Press, 1960): 211–13.

CHAPTER 6. COURTSHIP AND MARRIAGE

1. Various categories of romantic subjects are analyzed and given a statistical treatment as well as in the appendix in Susan P. Casteras, "Down the Garden Path: Courtship Culture and Its Imagery in Victorian Painting" (Ph.D. diss., Yale University, 1977).

2. Two useful twentieth-century discussions of courtship ritual are Lawrence Stone, *Sex, Family and Marriage in England 1500–1800* (London and New York, 1977) and Jenni Calder, *Women and Marriage in Victorian Fiction* (London: Thames & Hudson, 1976).

3. This term appears, for example, in *The Etiquette of Courtship and Marriage* (London: David Bogue 1844), 13.

4. See, for example, *The Etiquette of Love* (Halifax: William Milner, 1849), 28–31. "Female coquetry . . . [is] but once removed from that position to which society gives *no character* at all." Another anonymous author in "Shreds and Patches: Flirts and Flirtation," *The Englishwoman*, June 1835, 456, wrote, "Flirtation in a woman is equivalent to libertinism in a man; it is the manifestation of the same loose principles. . . ."

5. *The Etiquette of Courtship and Marriage*, 39.

6. Ann Richelieu Lamb, excerpt from *Can Woman Regenerate Society?*, as quoted in Janet Murray, *Strong Minded Women and Other Lost Voices from 19th Century England* (New York: Pantheon Books, 1982), 108.

7. See especially chapter one in Casteras, *Down the Garden Path*, also Barbara Stein Frankle, "The Genteel Family and High Victorian Concepts of Domesticity and Good Behavior" (Ph.D. diss., University of Wisconsin, 1969).

8. See especially chapters 2, 5, and 7, in Casteras; on medieval antecedents, see especially Roberta Smith Favis, "The Garden of Love in Fifteenth Century Netherlandish and German Engravings: Some Studies in Secular Iconography in the Late Middle Ages and Early Renaissance" (Ph.D. diss., University of Pennsylvania, 1974).

9. In a letter to a friend in November of 1851, Millais outlined his plans for *A Huguenot*, stating "I am in high spirits about the subject, *as it is entirely my own*, and I think contains the highest moral. It will be very quiet, and but slightly suggest the horror of a massacre. The figures will be talking against a secret-looking garden wall. . . ." This statement appears in John Guille Millais, *The Life and Letters of Sir John Everett Millais*, 1 (London: Methuen & Co., 1900), 135.

10. That Millais knew this opera is confirmed in William Holman Hunt, *Pre-Raphaelitism and the Pre-Raphaelite Brotherhood* (London: Macmillan & Co., Ltd., 1905), 1:138 and 141. See also Malcolm Warner, "Notes on Millais' Use of Subjects from the Opera 1851–4," *Pre-Raphaelite Review* 2 (November 1978): 73–76.

11. John Ruskin, *Notes on Some of the Principal Pictures of Sir John Everett Millais* (London: William Reese, 1885), 6–7.

12. This passage is cited from an unpublished notebook of Calderon now in the possession of Jeremy Maas, London, unpaged and undated.

13. H. Schutz Wilson, "Our Living Artists—John Everett Millais, R.A.," *Magazine of Art* 2 (1879): 37.

14. Ibid.

15. According to Ford Madox Ford, *Ford Madox Brown: A Record of His Work* (London: Longmans, Green & Co., 1896), 107, the artist's daughter posed for both the younger and older females here, a feat made possible by the fact the painting was not completed until twenty-four years after it was begun.

16. Ford Madox Brown, "The Progress of English art as now shown at the Manchester Exhibition," *Magazine of Art* 11 (1888): 122.

17. "The Royal Academy," *The National Magazine* 6 (1859): 163.

18. John Ruskin, *Academy Notes, 1859*, as cited in E. T. Cook and Alexander Wedderburn, eds., *The Works of John Ruskin*, 14 (London: George Allen, 1904), 234.

19. Brown, *Magazine of Art* 11:122.

20. *The Etiquette of Courtship and Marriage* (London: Frederick Warne & Co., 1866), 14. Most courtesy books recommended

only a year or two period of betrothal, in contrast to Ruskin's excessive term.

21. "The Royal Academy," *Architect*, 6 May 1871, from a scrapbook filled with twenty-six contemporary reviews and other materials now in the files of the Yale University Art Gallery. Eliza Lynn Linton the preceding week in the *Saturday Review* had characterized the "handsome harpy" as a pretty misanthrope who treated men as dogs, a comment worthy of Brown's *Stages of Cruelty.*

22. This is supported by the collected reviews cited in Ibid.

23. "Fine Arts: The Royal Academy," *Athenaeum* 50 (5 May 1877): 581.

24. On these and other nuptial rituals and superstitions, see Ann Monsarrat, *And the Bride Wore . . . The Story of the White Wedding* (London: Gentry Books, 1973).

25. "The Royal Academy," *Magazine of Art* 2 (1879): 218–19.

26. "The Royal Academy," *Art-Journal* 46 (1884): 210.

27. "Fine Arts: The Royal Academy," *Athenaeum* 59 (1886): 621.

CHAPTER 7. WOMEN WORKERS

1. Virginia Surtees, ed., *Sublime and Instructive: Letters from John Ruskin to Louisa, Marchioness of Waterford, Anna Blunden, and Ellen Heaton* (London: Michael Joseph, 1972), 90.

2. "The Royal Academy," *Art-Journal* 19 (1857): 170.

3. Isabella Beeton, *The Book of Household Management* (London: S. O. Beeton, 1861), 1. Twentieth-century evaluations of the Victorian home and its management include Marion Lochhead, *The Victorian Household* (London: J. Murray, 1964); Patricia Branca, *Silent Sisterhood: Middle-Class Women in the Victorian Home* (London: Croom Helm, 1975); and Jenni Calder, *The Victorian Home* (London: Batsford, 1977).

4. Deborah Gorham, "The 'Maiden Tribute of Modern Babylon' Reexamined: Child Prostitution in late Victorian England," *Victorian Studies* 21 (Spring 1978): 378.

5. Ibid.

6. On this general subject, see, e.g., Wanda F. Neff, *Women: A Historical and Literary Study of Women in British Industries and Professions 1832–1850* (New York: Columbia University Press, 1929) or Lee Holcombe, *Victorian Ladies at Work* (Devon, G. B.: David & Charles Ltd., 1973).

7. The best sources among the recent publications on the servant-keeping classes and their employees are Pamela Horn, *The Rise and Fall of the Victorian Servant* (New York: St. Martin's Press, 1975) and Theresa McBride, *The Domestic Revolution: The Modernization of Household Service in England and France, 1820–1920* (New York: Croom Helm, 1976).

8. "The Royal Academy, *Art-Union* 5 (1843): 163.

9. Ibid.

10. "The Royal Academy, *Art-Journal* 18 (1856): 162.

11. "Fine Arts: The Royal Academy," *Athenaeum* 29 (17 May 1856): 620.

12. Additional discussion of the Dutch influence on Egg is in Hilarie Faberman, "Augustus Leopold Egg, R.A." (Ph.D. diss., Yale University, 1983).

13. "Royal Academy Exhibition," *Illustrated London News*, 13 May 1876, 475.

14. See, for example, advertisements for the beverage "Bovril" in the 11 Feb. 1873 *Graphic* or for Fry's cocoa in the 5 Jan. 1901 *Graphic*. A less passive specimen of servant reads an issue of this periodical while her employers consult their own copy of this magazine in a 25 May 1901 *Graphic*.

15. Other treatments of this theme can be noted in earlier English literature, for example, in Timothy Arthur, *The Seamstress* (London: R. G. Berford, 1843).

16. An insightful exegesis of this subject is provided in T. J. Edelstein, "The 'Song of the Shirt': The Visual Iconology of the Seamstress," *Victorian Studies* 23 (Winter 1980): 183–210.

17. This letter from Redgrave to the *Art-Journal* in 1850 is quoted in Arts Council of Great Britain, *Great Victorian Pictures—Their Paths To Fame* (London: Arts Council, 1978), 71.

18. Thomas Hood, "The Song of the Shirt," in *The Poetical Works of Thomas Hood* (New York, 1881), 528.

19. "The Royal Academy," *Art-Union* 6 (June 1844): 16), 158.

20. Hood, "The Song of the Shirt," 530.

21. W. M. Thackeray, "May Gambols; or, Titmarsh in the Picture-Galleries," *Fraser's Magazine* 29 (June 1844): 704–5.

22. "The Needlewoman's Farewell," *Punch* 18 (1850): 14.

23. "Fine Arts: The Royal Academy," *Athenaeum* 20 (22 May 1847): 552.

24. Lady Elizabeth Eastlake offered a contemporary definition of the governess and her plight in her review of *Vanity Fair*, and this is discussed in M. Jeanne Peterson, "The Victorian Governess: Status Incongruence in Family and Society," in Martha Vicinus, ed., *Suffer and Be Still: Women in the Victorian Age* (Bloomington: Indiana University Press, 1972), 3–19.

25. This is quoted in Antony and Peter Miall, *The Victorian Nursery Book* (London: Dent & Sons Ltd., 1980), 162.

26. Martin Tupper, "Of Neglect," in *Proverbial Philosophy—A Book of Thoughts and Arguments* (Philadelphia: H. Hooker, 1843), 232.

27. "The Royal Academy," *Art-Journal* 16 (1854): 167.

28. Literary treatments of the governess abound and are analyzed in Katharine West, *Chapter of Governesses: A Study of the Governess in English Fiction, 1800–1949* (London: Cohen & West, 1949) and Patricia Thomson, *The Victorian Heroine: A Changing Ideal, 1837–1873* (London: Oxford University Press, 1956), chap. 2. The governess was not the same employee as the nursemaid or nanny, whose depiction in novels is examined in Jonathan Gathorne-Hardy, *The Unnatural History of the Nanny* (New York: The Dial Press, 1975).

29. See also contemporary writings on this subject, such as the periodical entitled *The Governess: A Representation of Female Education* (London, 1855); G. H. Miles, *The Governess: or, The Effects of Good Example* (London: Hedian & O'Brien, 1851); or George W. Reynolds, *The Governess, or the White Slave of England* (London: David Bogue, 1853).

30. Jane Redgrave was only twenty at the time, dying in 1829 but later inspiring her brother to treat the subject of the governess. F. M. Redgrave, *Richard Redgrave, A Memoir Compiled from his Diary* (London: Cassell & Co. Ltd, 1891), 26.

31. As noted in ibid., 43.

32. "The Royal Academy," *Illustrated London News*, 17 June 1843, 416. The writer also complimented the "heart-breaking sorrows of a gentle being, left by the death of her natural protector to struggle. . . . She has been torn by misfortune . . . and sent to beg her bread as a humble teacher of the village poor." The death of her only friend causes her to faint "and now . . . she resigns herself to the meekness of a tearful unquestioned despair."

33. "Royal Academy," *Art-Union* 5 (June 1845): 180.

34. W. M. Thackeray, "Picture Gossip: In a Letter from Michael Angelo Titmarsh," *Fraser's Magazine* 31 (June 1845): 716, acidly remarked that this painting was "spoony": "They have brought her her tea and bread and butter on a tray. She has drunk the tea, *she has not tasted the bread and butter*. There is pathos for you! There is art. This is, indeed, a love for lollypops with a vengeance, a regular babyhood of taste, about which a man with a manly stomach may be allowed to protest a little peevishly, and implore the public to give up such puling food."

35. "The Royal Academy," *Art-Journal* 36 (1864): 227.

36. "Fine Arts: The Royal Academy," *Athenaeum* 47 (1874): 657.

37. Ibid.

38. On this subject see especially Margaret Hewitt, *Wives*

and Mothers in Victorian Industry (London: Rockcliff, 1958).

39. Ibid., 119.

40. "Fine Arts: The Royal Academy," *Athenaeum* 47 (1874): 657. The vigor and health of Crowe's workers may be overstated, however, a point made in Helene Roberts, "Book Review of *Victorian Panorama* and *How the Rich Lived*," *Victorian Studies* 21 (Winter 1978): 262–63.

41. This point is also made in Howard D. Rodee, "Scenes of Rural and Urban Poverty in Victorian Painting and Their Development, 1850 to 1890" (Ph.D. diss., Columbia University, 1975), 206.

42. See ibid., 21 and passim for related themes of poverty.

43. "The Royal Academy," *Art-Journal* 37 (1875); 248.

44. Ibid.

45. An excerpt from a 1937 review of an exhibition at Leicester is included in Christopher Forbes, *The Royal Academy (1837–1901) Revisited* (New York: Forbes Publications, 1975), 30.

46. "The Royal Academy," *Art-Journal* 19 (1857): 167.

47. I am grateful to Sarah Phelps Smith for bringing this point to my attention. See Sarah Phelps Smith, "Dante Gabriel Rossetti's Flower Imagery and the Meaning of his Painting" (Ph.D. diss., University of Pittsburgh, 1978) for additional information on the floral language in Victorian art.

48. On the Terry/Watts relationship, see Ellen Terry, *The Story of My Life* (New York: Schocken Books, 1982 reprint) or Elizabeth Longford, *Eminent Victorian Women* (New York: Alfred A. Knopf, 1981), 151–77.

49. The Whitechapel Art Gallery, *G. F. Watts: A Nineteenth Century Phenomenon* (London: Whitechapel, 1974), catalogue entry 18, unpaged.

50. See also Rodee, "Scenes of Rural and Urban Poverty in Victorian Painting and their Development, 1850 to 1890," 231.

CHAPTER 8. THE WIDOW AND THE ELDERLY WOMAN

1. For other images of the widow, see Christopher Wood, *Victorian Panorama. Paintings of Victorian Life* (London: Faber & Faber Ltd., 1976), 109–14.

2. Mourning dress and etiquette are discussed, e.g., in John Morley, *Death, Heaven and the Victorians* (London: Studio Vista, 1971), 63–79.

3. "In Time of War," *National Magazine* 3 (1858): 24–25.

4. Ibid., 25.

5. Ibid.

6. On chaperonage in England, see, for example, Herta Engelman, "The Ideal English Gentlewoman in the Nineteenth Century: Her Education, Conduct, and Sphere" (Ph.D. diss., Northwestern University, 1956); Esther Aresty, *The Best Behavior: The Course of Good Manners from Antiquity to the Present as Seen Through Courtesy and Etiquette Books* (New York: Simon & Schuster, 1970); and a humorous perspective is found in various cartoons reprinted in Alison Adburgham, *A Punch History of Manners and Modes* (London: Hutchinson & Co., 1961). Innumerable primary sources of English courtship manuals reinforced the need for chaperonage by an older woman, perhaps a mother or aunt, or a married lady.

7. For details on the eighteenth-century iconology, see Susan P. Casteras, "Down the Garden Path: Courtship Culture and Its Imagery in Victorian Painting" (Ph.D. diss., Yale University, 1977), 154–69. A bibliography includes several dozen relevant courtesy and etiquette books.

8. A history of this dreaded institution is provided in Norman Longmate, *The Workhouse* (London: Temple Smith, 1974), especially 136–48.

9. Herkomer's picture is also briefly discussed in Howard D. Rodee, "Scenes of Rural and Urban Poverty in Victorian Painting and Their Development, 1850 to 1890" (Ph.D. diss., Columbia University, 1975), 194–97. Herkomer's other contributions to the imagery of urban despair are explored in Lee M. Edwards, "Hubert von Herkomer" (Ph.D. diss., Columbia University, 1984).

CHAPTER 9. THE WAYWARD AND THE FALLEN WOMAN

1. This preoccupation with the sexual poles of femininity has been the object of several recent studies, one of the best being Eric Trudgill, *Madonnas and Magdalens* (London: William Heinemann Ltd., 1976). See also Peter T. Cominos, "Late Victorian Sexual Respectability and the Social System," *International Review of Social History* 8 (1963), part 1, 18–48, and part 2, 216–50; Stephen Marcus, *The Other Victorians: A Study of Sexuality and Pornography in Mid-Nineteenth Century England* (New York: Basic Books Inc., 1966); Ronald Pearsall, *The Worm in the Bud: The World of Victorian Sexuality* (New York: Macmillan & Co., 1969); Nancy Cott, "Passionlessness: An Interpretation of Victorian Sexual Ideology, 1790–1851," *Signs: Journal of Women in Culture and Society* 4 (1979): 219–36; Gareth S. Jones, *Outcast London: A Study in the Relationship between Classes in Victorian Society* (Oxford: Oxford University Press, 1971); and Angus McLaren, *Birth Control in Nineteenth-Century England* (New York: Holmes & Moor, 1978).

2. Unidentified remark cited in Cominos, "Late Victorian Sexual Respectability and the Social System," 230. Grant Allen made a similar remark in "The Girl of the Future," *Universal Review* 2 (1890): 58: "Our existing system is really a joint system of marriage and prostitution in which the second element is a necessary corollary and safeguard of the first." Similar comments were made at the end of the century by the noted British psychologist Havelock Ellis, *Sex in Relation to Society*, vol. 6 of *Studies in the Psychology of Sex* (Philadelphia: F. A. Davis Co., 1928), chap. 7 passim.

3. William E. H. Lecky, *History of European Morals* (New York: D. Appleton & Co., 1877), 1:283.

4. William R. Greg, "Prostitution," *Westminster Review* 53 (1850): 449 and passim.

5. This increase in publications on prostitution is discussed, for example, in Brian Harrison, "Underneath the Victorians," *Victorian Studies* 10 (March 1967): 242, and also Jack Lewis Culross, "The Prostitute and the Image of Prostitution in Victorian Fiction" (Ph.D. diss., Louisiana State University and Agricultural and Mechanical College, 1970).

6. Barry Cornwall, "Within and Without," *Illustrated Family Journal* 1 (1845): 232–33.

7. Thomas Hood, "The Bridge of Sighs," in *The Poetical Works of Thomas Hood* (New York, 1881), 468–69.

8. Charles Dickens, *David Copperfield* (London: Bradbury & Evans, 1886), 770–73 passim.

9. William Acton, *Prostitution, Considered in Its Moral, Social, and Sanitary Aspects* (London: John Churchill & Sons, 1870), 24.

10. Harry Quilter, "The Art of Watts," *Contemporary Review* 84 (February 1882): 282.

11. Mrs. E. L. Barrington, *Catalogue of Paintings by George F. Watts of London on Exhibition at the Metropolitan Museum of Art* (New York, 1884–85), 22.

12. James Beard Talbot, *The Miseries of Prostitution* (London: James Maden & Co., 1844), 27.

13. Stephens's remarks from an article in the *Portfolio* of May 1894 are cited in Virginia Surtees, *The Paintings and Drawings of Dante Gabriel Rossetti (1828–1882), A Catalogue Raisonné* (Oxford: The Clarendon Press, 1971), 1:27.

14. Dante Gabriel Rossetti, "Jenny," in W. M. Rossetti, ed., *The Collected Works of Dante Gabriel Rossetti* (London: Ellis & Elvey, 1887), 1:87.

15. Dante Gabriel Rossetti, 1847–48 draft of "Jenny," Delaware Art Museum Collection, unpaged.

16. Stephens, as cited in Surtees, *The Paintings and Drawings of . . . Rossetti*, 1:27.

17. Rossetti, "Jenny," 91.

18. The poem can be found in Surtees, 1:26–27, or in W. M. Rossetti, *Collected Works*, 2:363.

19. Stephens, as cited in Surtees, vol. 1, 27.

20. A description of how these common prostitutes dressed is found in Judith R. Walkowitz, *Prostitution and Victorian Society: Women, Class, and the State* (Cambridge: Cambridge University Press, 1980), 26.

21. William Bell Scott, "Maryanne," in *Poems by William Bell Scott* (London: Smith, Elder, & Co., 1854), 41–42.

22. Tate Gallery files suggest the model was a Miss Jones, but George P. Boyce called on Stanhope in January 1858 and wrote, "He was painting his picture of a gay woman in her room by the side of the Thames at her toilet. Fanny was sitting next to him." Cited in Oswald Doughty, *A Victorian Romantic: Dante Gabriel Rossetti* (London: Oxford University Press, 1960), 251. Doughty also points out (265) that the use of Fanny, a rather loose woman in terms of morality, was not without significance here. In an earlier letter, Boyce had commented that his friend was working on a painting of "an 'unfortunate' in two different crises of her life," perhaps implying this canvas was only one of a two-part serial. (This is cited in A. I. Grieve, *The Art of Dante Gabriel Rossetti. 1. Found. 2. The Pre-Raphaelite Modern-Life Subject* (Hingham, G. B.: Real World Publications, 1976), 51.

23. "Fine Arts: The Royal Academy," *Athenaeum* 31 (1858): 566.

24. This intervening scene of dolorous "orphaned" daughters may have been influenced by James Northcote's *The Modest Girl in her Bedchamber* of 1794–96, the next to last work in a series of ten pictures entitled *Diligence and Dissipation*. By identifying these "good daughters" with Northcote's pious female, Egg has deepened further the meaning of this second scene: although the two girls are chaste and unlikely to emulate their mother's sin and misfortunes, their reputations have been permanently blemished by her transgressions. On this and the other pictures of *Past and Present*, see Susan P. Casteras, "Down the Garden Path: Courtship Culture and Its Imagery in Victorian Painting" (Ph.D. diss., Yale University, 1977), especially 401–20.

25. "The Royal Academy," *National Magazine* 4 (1858): 102.

26. On the sexual vulnerability of the milliner and her assistant, see Lynda Nead, "Seduction, Prostitution, Suicide: *On the Brink* by Alfred Elmore," *Art History* 5 (September 1982): 317–18.

27. Such derogatory popular names of streets where prostitutes worked are noted in Walkowitz, *Prostitution and Victorian Society*, 25.

28. John Ruskin, as quoted in W. Holman Hunt, *Pre-Raphaelitism and the Pre-Raphaelite Brotherhood* (London: Macmillan & Co. Ltd., 1905), 2:428.

29. This excerpt is from a 25 May 1854 letter from Ruskin to the *Times* as cited in E. T. Cook and Alexander Wedderburn, eds., *The Works of John Ruskin*, 12 (London: George Allen, 1905), 333–35 passim. A detailed exegesis both of *The Awakening Conscience* and *The Light of the World* can be found in Casteras, 421–71.

30. Hunt's remarks are cited in Mary Bennett, *William Holman Hunt* (Liverpool: Walker Art Gallery, 1969), 36.

31. Thomas Moore, "Oft in the Stilly Night," in *The Poetical Works of Thomas Moore* (Philadelphia: J. Crissy & J. Grigg, 1829), 353.

32. "Fine Arts: The Royal Academy," *Athenaeum* 27 (6 May 1854): 561.

33. Hunt, *Pre-Raphaelitism*, 2:430.

34. The sexual connotations of this animal are discussed in considerable depth in Mary Frances Durantini, *The Child in Seventeenth-Century Dutch Painting* (Ann Arbor: UMI Research Press, 1980), 269–78 passim.

35. Hunt, *Pre-Raphaelitism*, 2:429.

36. Ibid., 1:350–51.

37. Ibid., 2:430.

38. "Fine Arts: The Royal Academy," *Athenaeum* 33 (12 May 1860): 654. Discussion of this and related pictures (including *Found*) appears in Casteras, especially 363–400.

39. Ibid.

40. Ibid.

41. The sexual categorization of victim and victimizer and many related aspects of this issue are perceptively explored in Lynn Nead, "The Magdalen in Modern Times: The Mythology of the Fallen Woman in Pre-Raphaelite Painting," *Oxford Art Journal* 7 (1984): 26–37.

CHAPTER 10. LATER FEMININE ALTERNATIVES

1. The New Woman question is scrutinized in such works as Gail Cunningham, *The New Woman and the Victorian Novel* (London: Macmillan, 1978) and Amy Cruse, *The Victorians and Their Reading* (Boston: Allen & Unwin, 1962), 336–63.

2. Eliza Lynn Linton, *The Girl of the Period and Other Social Essays* (London: Richard Bentley, 1883), 1–9 passim.

3. See especially Alison Adburgham, *A Punch History of Manners and Modes* (London: Hutchinson & Co., 1961), 150–78.

4. William Powell Frith, *My Autobiography and Reminiscences* (London: R. Bentley, 1888), 27.

5. Robert Speaight, *William Rothenstein: The Portrait of an Artist in his Time* (London: Eyre & Spottiswoode, 1962), 134.

6. Ibid.

7. I am grateful to Margaret Stetz, assistant professor at the University of Virginia, for identifying this figure as George Egerton, who was also caricatured in *Punch* in the late 1890s.

8. On the romantic cult of invalidism, see, e.g., Lorna Duffin, "The Conspicuous Consumptive: Woman as Invalid," in Sara Delamont and Lorna Duffin, eds., *The Nineteenth Century Woman—Her Cultural and Physical World* (London: Croom Helm, 1978), 26–56, or Bruce Haley, *The Healthy Body and Victorian Culture* (Cambridge: Harvard University Press, 1978).

9. Costume changes occasioned by women's sports are documented in Phillis Cunnington, *English Costume for Sports and Outdoor Recreation* (London: Faber & Faber Ltd., 1969). Other books on this subject include Frances E. Slaughter, *The Sportswoman's Library* (Westminster, G. B.: A. Constable & Co., 1898).

10. This subject is treated, for example, in David Rubenstein, "Cycling in the 1890s," *Victorian Studies* 21 (Autumn 1977): 47–72.

11. Frith, *My Autobiography and Reminiscences*, 35.

12. As quoted in Phillis Cunnington and Alan Mansfield, *English Costume for Sports and Recreation: From the Sixteenth to the Nineteenth Centuries* (London: Black Publications, 1969), 180.

13. A. Lillie, *The Book of Croquet*, 1873, as quoted in Cunnington and Mansfield, 61.

14. "The Grosvenor Gallery," *Illustrated London News*, 11 May 1878, 435.

15. David S. Brooke, "James Tissot and the 'ravissante Irlandaise,'" *Connoisseur* 168 (May 1968): 57.

16. See Christopher Wood, "The Artistic Family Hayllar," part 2, *Connoisseur* 186 (May 1974): 6.

17. Among the best general sources on this subject are Elizabeth Aslin, *The Aesthetic Movement: Prelude to Art Nouveau* (New York: Praeger Books, 1969) and Robin Spencer, *The Aesthetic Movement* (London: Studio Vista, 1972).

18. Walter Hamilton, *The Aesthetic Movement in England*

(London: Reeves & Turner, 1882), 24.

19. Anna Haweis, *The Art of Beauty* (London, 1878), 273–74.

20. On Du Maurier's role in the Aesthetic Movement, see Leonée Ormond, *George Du Maurier* (London, 1969), 243–307.

21. "The Two Ideals," *Punch* 77 (13 Sept. 1879), 120.

22. Ibid.

23. The new range of colors is mentioned in Haweis, *The Art of Beauty,* 186–95, and also Aslin, *The Aesthetic Movement,* 157–58.

24. On the oriental and exotic aspects of Whistler's art, see in particular John Sandberg, " 'Japonisme' and Whistler," *Burlington Magazine* 106 (1964): 500–7, and Basil Gray, " 'Japonisme' and Whistler," *Burlington Magazine* 107 (1965): 324.

CHAPTER 11. CONCLUSION: THE END OF THE CENTURY AND CONFLICTING FANTASIES OF FEMININITY

1. Eliza Lynn Linton, *The Girl of the Period and Other Social Essays* (London: Richard Bentley, 1883), 1–9 passim. This preference for the simple and often simpering maiden of the past ran counter to the image of the turn-of-the century woman described in numerous magazines, however, as in an anonymous, untitled essay on contemporary womanhood in the supplement to the *Graphic* 24 (10 Sept. 1887), unpaged: "To describe the fashionable beauty of the present period, that complex many-sided paragon, is a . . . bewildering task. . . . She goes everywhere, she does everything. . . . She is a sportsman, an athlete, . . . a divinity in a ball-room; she is alternately a horsewoman, a huntress . . . and on occasions can even hold her own at cricket; she drives a pair of horses like a charioteer, pulls a pair of sculls like an Oxonian, competes in the universities with her masculine rivals; mounts the roof of a four-in-hand, or swiftly travels on a tricycle; she practices archery, she is great at private theatricals . . . designs, draws, models, and paints. . . . She is versed in the history of attire and epochs; is up in current literature, to which not infrequently she contributes. . . . She interests herself in everything, is an enthusiast of multifarious capabilities, and achieves a marked success in all she undertakes. Of the modern young lady *à la mode,* who wields alike the fiddle-bow, the billiard-cue, and the etching-needle, who climbs mountains, and is a presence in the gymnasium, none but herself can be her prototype."

2. Alfred Lys Baldry, "Marcus Stone, R. A.," supplement to the *Art-Journal* 57 (1896): 5.

3. On the cult of the *femme fatale,* see Derek Stanford, "Sex and Style in the Literature of the '90s," *Contemporary Review,* 216 (February 1970): 95–100; John Milner, *Symbolists and Decadents* (London: Studio Vista, 1971), 10–29; Phillipe Jullian, *Dreamers of Decadence: Symbolist Painters of the 1890s* (New York: Praeger, 1971); Patrick Bade, *Femme-Fatale: Images of Evil and Fascinating Women* (New York: Mayflower Books, 1979); Derek Stanford, "The Pre-Raphaelite Cult of Women: From Damozel to Demon," *Contemporary Review* 216 (July 1970): 26–33. Martha Kingsbury, "The Femme Fatale and her Sisters," in Thomas B. Hess and Linda Nochlin, eds., *Woman as Sex Object: Studies in Erotic Art* (New York: Newsweek, 1972), 182–205; and Mario Praz, *The Romantic Agony* (London, 1933), chaps. 1 and 4.

4. For an analysis of the imagery of this poem in relation to Rossetti's art, see Susan P. Casteras, "Down the Garden Path: Courtship Culture and Its Imagery in Victorian Painting" (Ph.D. diss., Yale University, 1977), 145–53. A literary explication is found, for example, in David Sonstroem, *Rossetti and the Fair Lady* (Middletown, 1970), 66–68.

5. Virginia Surtees, *The Paintings and Drawings of Dante Gabriel Rossetti (1828–1882), A Catalogue Raisonné* (Oxford: The Clarendon Press, 1971), 1:68.

6. As quoted in Virginia Mae Allen, "The Femme Fatale: A Study of the Early Development in Mid-Nineteenth Century Poetry and Painting" (Ph.D. diss., Boston University, 1979), 7.

7. F. Wedmore, "The Grosvenor Gallery Exhibition," *Temple Bar* 53 (July 1878): 339.

8. As quoted in Arts Council, *The paintings, graphics and decorative work of Sir Edward Burne-Jones 1833–98* (London, 1976), 53.

9. Algernon Swinburne, "Laus Veneris," in *Poems and Ballads by Algernon Charles Swinburne* (London: John Camden Hutten, 1866), 18. See also the catalogue entry on this painting in Tate Gallery, *The Pre-Raphaelites* (London: The Tate Gallery, 1984), 229–31.

10. Leonée and Richard Ormond, *Lord Leighton* (New Haven and London: Yale University Press, 1975), 131.

11. "The Royal Academy," *Art-Journal* 54 (1892): 188.

12. "The Royal Academy," *Art-Journal* 57 (1895): 164.

13. Edgcumbe Staley, *Lord Leighton of Stretton, P.R.A.* (London, 1906), 158.

14. "Fine Arts: The Royal Academy," *Athenaeum* 68 (4 May 1895): 576.

15. "Fine Arts: The Royal Academy," *Athenaeum* 49 (6 May 1876): 640.

16. These remarks were made about *Azaleas* when it was exhibited at the Royal Academy in 1868. Algernon C. Swinburne, "Notes on some Pictures of 1868," *Essays and Studies* (London: Chatto & Windus, 1874), 360.

Select Bibliography

Both primary and secondary sources, in addition to scholarly articles, from both the nineteenth and twentieth centuries are included here. However, I have not cited a number of the periodicals I used extensively in my research—primarily *The Art-Journal, The Athenaeum, The Illustrated London News, The Graphic, Punch, The Magazine of Art,* and *The Spectator*—since specific citations are commented upon in my footnotes.

Acton, William. *The Functions and Disorders of the Reproductive Organs.* London: Sutton Co. Ltd., 1857.

————. *Prostitution, Considered in its Moral, Social, and Sanitary Aspects.* London: John Churchill & Sons, 1870.

Adburgham, Alison. *A Punch History of Manners and Modes.* London: Hutchinson & Co., 1961.

————. *Women in Print.* London: George Allen & Unwin Ltd., 1972.

Allchin, A. M. *The Silent Rebellion: The Anglican Religious Communities 1845–1900.* London: S.C.M.P. Ltd., 1958.

Allen, Virginia Mae. "The Femme Fatale: A Study of the Early Development in Mid-Nineteenth Century Poetry and Painting." Ph.D. dissertation, Boston University, 1979.

Anson, Peter F. *The Call of the Cloister: Religious Communities and Kindred Religious Bodies in the Anglican Church.* London: S.P.C.K., 1956.

Aresty, Esther. *The Best Behavior: The Course of Good Manners from Antiquity to the Present as Seen through Courtesy and Etiquette Books.* New York: Simon & Schuster, 1970.

Art Gallery of New South Wales. *Victorian Social Conscience.* Sydney: Edwards & Shaw Ltd., 1976.

Arts Council of Great Britain. *Great Victorian Pictures: Their Paths to Fame.* London: Arts Council, 1978.

Auerbach, Nina. *Woman and the Demon: The Life of a Victorian Myth.* Cambridge: Harvard University Press, 1982.

Avery, Gillian. *Nineteenth Century Children: A Study of Heroes and Heroines of Children's Fiction 1770–1900.* London: Hodder and Stoughton, 1965.

Bade, Patrick. *Femme Fatale: Images of Evil and Fascinating Women.* New York: Mayflower Books, 1979.

Banks, Joseph A. *Prosperity and Parenthood: A Study of Family Planning Among the Victorian Middle Classes.* London: Routledge & Kegan Paul, 1965.

Banks, Joseph A., and Olive Banks. *Feminism and Family Planning in Victorian England.* New York: Schocken Books, 1964.

Barrow, Margaret. *Women 1870–1928: A Selected Guide to Printed and Archival Sources in the United Kingdom.* London: Mansell Publications, 1981.

Basch, Françoise. *Relative Creatures: Victorian Women in Society and the Novel.* New York: Schocken Books, 1974.

Beck, Hilary. *Victorian Engravings.* London: Victoria & Albert Museum, 1973.

Beeton, Isabella. *The Book of Household Management.* London: S. O. Beeton, 1861.

Branca, Patricia. *Silent Sisterhood: Middle Class Women in the Victorian Home.* London: Croom Helm, 1975.

Brittain, Vera. *Lady into Woman.* London: A. Dakers, 1953.

Brown, James Baldwin. *The Home in its Relation to Man and to Society.* London: James Clarke & Co., 1883.

Buckley, Jerome H. *The Victorian Temper: A Study in Literary Culture.* Cambridge: Harvard University Press, 1951.

Burstyn, Joan. *Victorian Education and the Ideal of Womanhood.* London: Croom Helm, 1980.

Butler, Josephine. *Woman's Work and Woman's Culture.* London: Macmillan & Co., 1869.

Cadogan, M., and P. Craig. *You're a Brick, Angela! A New Look at Girls' Fiction from 1840–1975.* London: Golancz, 1976.

Calder, Jenni. *Women and Marriage in Victorian Fiction.* London: Thames & Hudson, 1976.

Casteras, Susan P. "Down the Garden Path: Courtship Culture and Its Imagery in Victorian Painting." Ph.D. dissertation, Yale University, 1977.

————. *The Substance or the Shadow: Images of Victorian Womanhood.* New Haven: Yale Center for British Art, 1982.

————. "Virgin Vows: The Early Victorian Artists' Portrayal of Nuns and Novices." *Victorian Studies* 24 (Winter 1981): 157–84.

————. "John Everett Millais's 'Secret-Looking Garden Wall' and The Courtship Barrier in Victorian Painting," in

Adrienne Munich, ed. *Victorian Women and Men.* New York: Browning Institute Studies, 1986.

Cecil, Mirabel. *Heroines in Love 1750–1914.* London: Michael Joseph Ltd., 1975.

Clayton, Ellen C. *English Female Artists.* London: Tinsley Bros., 1976.

Cobbe, Francis Power. *The Duties of Women.* London: Williams & Norgate, 1881.

Colby, Vineta. *Yesterday's Women. Domestic Realism in the English Novel.* Princeton: Princeton University Press, 1974.

Cominos, Peter T. "Late Victorian Sexual Respectability and the Social System." *International Review of Social History,* 8 (1963), part 1, 18–48, and part 2, 216–50.

Cruse, Amy. *The Victorians and their Books.* London: Allen & Unwin, 1935.

Culross, Jack Lewis. "The Prostitute and the Image of Prostitution in Victorian Fiction." Ph.D. dissertation, Louisiana State University and Agricultural and Mechanical College, 1970.

Cunningham, Gail. *The New Woman and the Victorian Novel.* London: Macmillan, 1978.

Cunningham, C. Willett. *Feminine Attitudes in the Nineteenth Century.* New York: William Heinemann Ltd., 1936.

———. *English Women's Clothing in the Nineteenth Century.* London: Faber and Faber Ltd., 1937.

Davidoff, Leonore. *The Best Circles: Women and Society in Victorian England.* Totowa, N.J.: Rowman and Littlefield, 1973.

Delamont, Sara, and Lorna Duffin, eds. *The Nineteenth Century Woman—Her Cultural and Physical World.* London: Croom Helm, 1978.

Doughty, Oswald. *A Victorian Romantic: Dante Gabriel Rossetti.* London: Oxford University Press, 1960.

Duff, David. *PUNCH on Children: A Panorama 1845–1865.* London: Frederick Muller Ltd., 1975.

Dunbar, Janet. *The Early Victorian Woman: Some Aspects of her life. 1737–1857.* London: George C. Harrap & Co. Ltd., 1953.

Dutton, Ralph. *The Victorian Home.* London, B. T. Batsford Ltd., 1954.

Dyhouse, Carol. *Girls Growing up in Late Victorian and Edwardian England.* London: Routledge & Kegan Paul, 1981.

Dyos, Harold J., and Michael Wolff, eds. *The Victorian City: Images and Realities.* London: Routledge & Kegan Paul, 1973.

Edelstein, T. J. "Augustus Egg's triptych: a narrative of Victorian Adultery," *Burlington Magazine* 125 (April 1983): 202–11.

———. " 'But who shall paint the grief of those oppress'd'— The Social Theme in Victorian Painting." Ph.D. dissertation, University of Pennsylvania, 1979.

———. "The 'Song of the Shirt': The Visual Iconology of the Seamstress." *Victorian Studies* 23 (Winter 1980): 183–210.

Eley, Geoffrey. *The Ruined Maid: Modes of Manners of Victorian Women.* Royston, G. B.: The Priory Press, 1970.

Ellis, Sarah Stickney. *The Daughters of England: Their Positions in Society, Character, and Responsibilities.* New York: D. A. Appleton & Co., 1842.

———. *The Women of England, Their Social Duties, and Domestic Habits.* Philadelphia: E. L. Carey and A. Hart, 1839.

Engelman, Herta. "The Ideal English Gentlewoman in the Nineteenth Century: Her Education, Conduct, and Sphere." Ph.D. dissertation, Northwestern University, 1956.

Engen, Rodney K. *Victorian Engravings.* London: Academy Editions, 1975.

Errington, Lindsay M. "Social and Religious Themes in English Art, 1840–1860." Ph.D. dissertation, University of London, Courtauld Institute, 1968.

The Etiquette of Flowers: Their Language and Sentiment. London: Simpkin & Co., 1852.

Evans, Hilary and Mary. *The Party that lasted 100 Days—The Late Victorian Season: A Social Study.* London: Macdonald and Jane's, 1976.

Faberman, Hilarie. "Augustus Leopold Egg, R.A." Ph.D., dissertation, Yale University, 1983.

Forbes, Christopher. *The Royal Academy (1837–1901) Revisited: Victorian Paintings from the FORBES Magazine Collection.* New York: Forbes Publications, 1974.

Frankle, Barbara Stein. "The Genteel Family and High Victorian Concepts of Domesticity and Good Behavior." Ph.D. dissertation, University of Wisconsin, 1969.

Gay, Peter. *The Bourgeois Experience. Victoria to Freud. Vol. 1. Education of the Senses.* New York: Oxford University Press, 1984.

Gordon, Catherine. "The Novel in English Painting 1740–1870." Ph.D. dissertation, University of London, Courtauld Institute, 1978.

Gorham, Deborah. *The Victorian Girl and the Feminine Ideal.* London: Croom Helm, 1982.

Graves, Algernon. *The Royal Academy of Arts: A Complete Dictionary of Contributors and their Work from its Foundation in 1769 to 1904.* London: George Bell & Sons, 1906.

Greenaway, Kate. *Language of the Flowers.* London: Frederick Warne, 1888.

Gribble, Jennifer. *The Lady of Shalott in the Victorian Novel.* London: Macmillan, 1983.

Grieve, Alastair I. *The Pre-Raphaelite Period 1848–1850.* Hingham, G. B.: Real World Publications, 1973.

Guise, Hilary. *Great Victorian Engravings.* London: Astragal Books, 1980.

Hadfield, John. *Every Picture Tells A Story.* London: Herbert Press, 1985.

Haley, Bruce. "The Cult of Manliness in English Literature: A Victorian Controversy 1857–1880." Ph.D. dissertation, University of Illinois, Urbana, 1965.

Hamerton, A. James, *Emigrant Gentlewomen: Genteel Poverty and Female Emigration, 1830–1914.* London: Croom Helm, 1979.

Hardwick, Elizabeth. *Seduction and Betrayal: Women in Literature,* New York: Random House, 1974.

Harvey, J. P. *Victorian Novelists and their Illustrators.* New York: New York University Press, 1971.

Hellerstein, Erna Olaf, Leslie Parker Hume, and Karen M. Offen, eds. *Victorian Women: A Documentary Account of Women's Lives in Nineteenth-Century England, France and the United States.* Stanford: Stanford University Press, 1981.

Hess, Thomas B., and Linda Nochlin, eds. *Woman as Sex Object.* New York: Newsweek, 1972.

Hewitt, Margaret. *Wives and Mothers in Victorian Industry.* London: Rockcliff, 1958.

Himmelfarb, Gertrude. *Victorian Minds.* New York: Alfred A. Knopf, Inc., 1968.

Holcombe, Lee. *Victorian Ladies at Work.* Devon, G. B.: David & Charles Ltd., 1973.

———. *Wives and Property: The Reform of the Married Women's Property Law in Nineteenth-Century England.* Toronto: University of Toronto Press, 1983.

Hollis, Patricia. *Women in Public 1850–1900: Documents of the*

Victorian Women's Movement. London, Allen and Unwin, 1979.

Horn, Pamela. *The Rise and Fall of the Victorian Servant.* New York: St. Martin's Press, 1975.

Houghton, Walter E. *The Victorian Frame of Mind.* New Haven: Yale University Press, 1957.

———. *The Wellesley Index to Victorian Periodicals, 1824–1900.* Toronto: University of Toronto Press, 1966–70.

Jameson, Mrs. Anna. *Sisters of Charity: Catholic and Protestant—Abroad and at Home.* London: Longman, Brown & Co., 1860.

Johnson, Wendell S. *Sex and Marriage in Victorian Poetry.* Ithaca: Cornell University Press, 1975.

Jones, Gareth S. *Outcast London: A Study in the Relationship between Classes in Victorian Society.* Oxford: The Clarendon Press, 1971.

Kamm, Josephine. *Hope Deferred. Girls' Education in English History.* London: Methuen, 1965.

Linton, Eliza Lynn. *The Girl of the Period and other Social Essays.* London: Richard Bentley, 1883.

Lochhead, Marion. *The Victorian Household.* London: J. Murray, 1964.

Logan, William. *The Great Social Evil.* London: Hodder & Stoughton, 1871.

Longford, Elizabeth. *Eminent Victorian Women.* New York: Alfred A. Knopf, 1981.

———. *Victoria R. I.* New York: Harper & Row, 1973.

Maas, Jeremy. *Victorian Painters.* New York: G. P. Putnam's Sons, 1969.

McBride, Theresa. *The Domestic Revolution: The Modernization of Household Service in England and France, 1820–1920.* New York: Croom Helm, 1976.

Macgregor, Olive R. *Divorce in England: A Centenary Study.* London: William Heinemann Ltd., 1957.

McHugh, Paul. *Prostitution and Victorian Social Reform.* New York: St. Martin's Press, 1980.

Marcus, Stephen. *The Other Victorians: A Study of Sexuality and Pornography in Mid-Nineteenth Century England.* New York: Basic books Inc., 1966.

Marks, Arthur S. "Ford Madox Brown's 'Take Your Son, Sir!'" *Arts Magazine* 54 (January 1980): 135–41.

Mason, Philip. *The English Gentleman: The Rise and Fall of an Ideal.* New York: William Morrow & Co., 1982.

Mews, Hazel. *Frail Vessels: Woman's Role in Women's Novels from Fanny Burney to George Eliot.* London: The Athlone Press, 1969.

Moore, Katharine. *Victorian Wives.* London: The Anchor Press, 1974.

Murray, Janet. *Strong-Minded Women and Other Lost Voices from 19th Century England.* New York: Pantheon Books, 1982.

Nead, Lynda. "Representation, Sexuality and the Female Nude." *Art History* 6 (June 1982), 227–36.

———. "Seduction, Prostitution, Suicide: *On the Brink* by Alfred Elmore." *Art History* 5 (Sept. 1982): 310–22.

Nead, Lynn, "The Magdalen in Modern Times: The Mythology of the Fallen Woman in Pre-Raphaelite Painting." *Oxford Art Journal*, 7 (1984): 26–37.

Neff, Wanda Fraiken. *Women: A Historical and Literary Study of Women in British Industries and Professions 1832–1850.* New York: Columbia University Press, 1929.

Newton, Stella Mary. *Health, Art, and Reason: Dress Reformers of the Nineteenth Century.* London: J. Murray, 1974.

Nunn, Pamela Gerrish. "The Case-History of a Woman Artist: Henrietta Ward." *Art History* 1 (Sept. 1978): 296–308.

———. "Ruskin's Patronage of Women Artists." *Woman's Art Journal* 8 (Fall/Winter 1981): 8–13.

Ormond, Richard. *Early Victorian Portraits.* London: Her Majesty's Stationery Office 1973.

Ovenden, Graham, and Robert Melville. *Victorian Children.* London: Academy Editions, 1972.

Ovenden, Graham, and Peter Mendes. *Victorian Erotic Photography.* New York: St. Martin's Press, 1973.

Palmegiano, E. M. *Women and British Periodicals 1832–1867. A Bibliography.* New York: Garland Publishing Co., 1976.

Pattison, Robert. *The Child Figure in English Literature.* Athens, Ga.: University of Georgia Press, 1978.

Pearsall, Ronald. *Tell Me, Pretty Maiden: The Victorian and Edwardian Nude.* Exeter, G. B.: Webb & Bower, 1981.

———. *The Worm in the Bud: The World of Victorian Sexuality.* London: Macmillan & Co., 1969.

Quinlan, M. N. *Victorian Prelude: A History of English Manners 1700–1830.* New York: Anchon Books, 1941.

Reed, John R. *Victorian Conventions.* Athens, Ohio: Ohio University Press, 1975.

Rees, Barbara. *The Victorian Lady.* New York: Gordon & Cremonisi, 1977.

Reid, Forrest. *Illustrators of the Eighteen Sixties.* New York: Dover Publications Inc., 1976.

Reiss, Erna. *Rights and Duties of Englishwomen: A Study in Law and Public Opinion.* Manchester: Sherratt & Hughes, 1934.

Reynolds, Graham. *Painters of the Victorian Scene.* London: B. T. Batsford Ltd., 1963.

———. *Victorian Painting.* New York: Macmillan Co., 1966.

Roberts, Helene. "The Exquisite Slave: The Role of Clothes in the Making of the Victorian Woman," *Signs: Journal of Women in Culture and Society* 2 (Spring 1977): 554–69.

Robertson, Priscilla. *An Experience of Women: Pattern and Change in Nineteenth-Century Europe.* Philadelphia: Temple University Press, 1982.

Rodee, Howard D, "Scenes of Rural and Urban Poverty in Victorian Paintings and their Development, 1850 to 1890." Ph.D. dissertation, Columbia University, 1975.

Rose, Phyllis. *Parallel Lives: Five Victorian Marriages.* New York: Vintage Books, 1983.

Rover, Constance. *Love, Morals and the Feminists.* London: Routledge & Kegan Paul, 1970.

———. *The Punch Book of Women's Rights.* London: Hutchinson & Co., 1967.

Ruskin, John. *The Works of John Ruskin,* edited by E. T. Cook and Alexander Wedderburn. London: George Allen, 1903–12.

Ryan, Michael. *Prostitution with a Comparative View of that of Paris and New York.* New York: S. S. & W. Wood, 1839.

Sewell, Elizabeth Missing. *Principles of Education.* London: Longman, Brown, Green, & Longmans, 1865.

Smith, Sarah Phelps. "Dante Gabriel Rossetti's Flower Imagery and the Meaning of his Painting." Ph.D. dissertation, University of Pittsburgh, 1978.

Sockman, Ralph. *The Revival of Conventual Life in the Church of England in the Nineteenth Century.* New York: W. D. Gray, 1917.

Sonstroem, David. *Rossetti and the Fair Lady.* Middletown, Wesleyan University Press, 1970.

Stone, Lawrence. *The Family, Sex and Marriage in England 1500–1800.* New York: Harper & Row, 1979.

Surtees, Virginia. *The Paintings and Drawings of Dante Gabriel Rossetti (1828–1882), a Catalogue Raisonné.* Oxford: The Clarendon Press, 1971.

Tait, William. *Magdalenism.* Edinburgh: P. Rickard, 1842.

Talbot, James B. *The Miseries of Prostitution.* London: James Maden & Co., 1844.

Tate Gallery, *The Pre-Raphaelites.* London: The Tate Gallery, 1984.

Thomas, Keith. "The Double Standard." *Journal of the History of Ideas* 20 (April 1959): 195–216.

Thomson, Patricia. *The Victorian Heroine: A Changing Ideal 1857–1873.* London: Oxford University Press, 1956.

Tillotson, Kathryn. *The Novels of the Eighteen Forties.* London: Oxford University Press, 1962.

Trudgill, Eric. *Madonnas and Magdalens.* London: William Heinemann Ltd., 1976.

Vicinus, Martha, ed. *A Widening Sphere: Changing Roles of Victorian Women.* Bloomington: Indiana University Press, 1977.

Vicinus, Martha, ed. *Suffer and Be Still: Women in the Victorian Age.* Bloomington: Indiana University Press, 1973.

Walkowitz, Judith R. *Prostitution and Victorian Society. Women, class, and the state.* Cambridge: Cambridge University Press, 1980.

Wardlaw, Ralph. *Lectures on Female Prostitution: Its Nature, Extent, Effects, Guilt, Causes and Remedy.* Glasgow: James Maclehose, 1843.

Warner, Marina. *Alone of All Her Sex: The Myth and Cult of the Virgin Mary.* New York: Alfred A. Knopf, 1976.

Weeks, Jeffrey. *Sex, Politics and Society: The Regulation of Sexuality since 1800.* London: Longman, 1981.

West, Katharine. *Chapter of Governesses: A Study of the Governess in English Fiction, 1800–1949.* London: Cohen & West, 1949.

White, Cynthia L. *Women's Magazines 1693–1968.* London: Michael Joseph Ltd., 1970.

Wohl, Anthony, ed. *The Victorian Family: Structure and Stresses.* London: Croom Helm, 1978.

Wood, Christopher, *Dictionary of Victorian Painters.* Woodbridge G. B.: Baron Publishing, 1971.

———. *The Pre-Raphaelites.* New York: The Viking Press, 1981.

———. *Victorian Panorama: Paintings of Victorian Life.* London: Faber & Faber Ltd., 1976.

Zinn, Zea. "Love and Marriage in the Novels of English Women 1740–1840." Ph.D. dissertation, University of Wisconsin, 1935.

Index